BRUTAL VISION

BRUTAL VISION

The Neorealist Body in
Postwar Italian Cinema

KARL SCHOONOVER

 University of Minnesota Press
Minneapolis
London

Portions of chapter 2 appeared in earlier versions as "The Comfort of Carnage: Realism and America's World Understanding," in *Convergence Media History,* ed. Janet Staiger and Sabine Hake (New York: Routledge, 2009), 127–38, and "Neorealism at a Distance," *European Film Theory,* ed. Temenuga Trifonova (New York: Routledge, 2008), 301–18. Portions of chapter 5 first appeared as "*I pugni in tasca* (Fists in the Pocket)," *Senses of Cinema,* no. 40 (Summer 2006), http://www.sensesofcinema.com/2006/cteq/fists-in-the-pocket/.

Published by the University of Minnesota Press
111 Third Avenue South, Suite 290
Minneapolis, MN 55401-2520
http://www.upress.umn.edu

Library of Congress Cataloging-in-Publication Data

Schoonover, Karl.
 Brutal vision : the neorealist body in postwar Italian cinema / Karl Schoonover.
 Includes bibliographical references and index.
 ISBN 978-0-8166-7554-8 (hc : alk. paper) — ISBN 978-0-8166-7555-5 (pb : alk. paper)
1. Realism in motion pictures. 2. Motion pictures—Italy. I. Title.
 PN1995.9.R3S365 2012
 791.43´612—dc23

 2011047053

Printed in the United States of America on acid-free paper

The University of Minnesota is an equal-opportunity educator and employer.

20 19 18 17 16 15 14 13 12 10 9 8 7 6 5 4 3 2 1

For Lloyd

CONTENTS

ACKNOWLEDGMENTS

Expressing gratitude is by definition humbling, but the task of adequately acknowledging the people and institutions who helped to bring this book to completion feels monumental. The commitment of Mary Ann Doane to this endeavor was vital and sustaining. She believed in the necessity of this project from its earliest inception and has been an unfailing support throughout its realization. Phil Rosen's perspective was also essential, and I am grateful for his persistent willingness to engage with its ideas. Over the past four years, Michigan State University has supported this project in numerous ways, including a Humanities and Arts Research Production grant and a Global Literary and Cultural Studies grant. Especially vigorous in their commitment to the project have been Stephen Arch, Pat O'Donnell, Janet Swenson, Patrick McConeghy, and Dean Karin Wurst. There are many others in East Lansing who have helped to make this project happen, including Aimé Ellis, Tama Hamilton-Wray, Ken Harrow, Gary Hoppenstand, Scott Juengel, Sandra Logan, Ellen McCallum, Scott Michaelsen, Swarnavel Eswaran Pillai, Ellen Pollack, Steve Rachman, and Jeff Wray.

The research for this book was done in many archives, including the UCLA Film and Television Archive, the Film Study Center at Yale University, New York University's Avery Fisher Center, the Margaret Herrick Library at the Academy of Motion Picture Arts and Sciences, the Wisconsin Center for Film and Theater Research, Pacific Film Archive, the British Film Institute, and the Billy Rose Theatre Division of the New York Public Library. I am particularly grateful for the guidance of Charles Silver at the Museum of Modern Art's Film Study Center, Diana Ford at George Eastman House, Robert

Haller of Anthology Film Archives, and Brown University film archivist Richard Manning. I have also had wonderful research assistants over the last several years, including Greg Capaccio, Elizabeth White, Andrew Rusin, Matthew Wrobel, and the particularly valiant Sarah Hamblin, Hyunsoo Jang, and Nicole McCleese. I also owe a tremendous amount to my friends, especially Lucy Fox, Melissa Chmelar, Jhumpa Lahiri, Erik Reed, Ariella Ben-Dov, Rebecca McBride, Brett Vapnek, Simanti Lahiri, Laura McMullin, Susan Pollack, Wally Pansing, Susanna Vapnek, Jonathan Griffith, Tom Kastner, Rita Myers, Shoshana Ben-Yoar, Susan Simon, and Albino Marsetti. My aunt, Christine Treanor, has been a beacon of unconditional support the whole way through.

Earlier versions of portions of this book greatly benefited from the prudent guidance of Sabine Hake, Janet Staiger, and Temenuga Trifanova, as they did from the wise readings of Lynne Joyrich, Elena Gorfinkel, Chris Cagle, Jean Walton, Mary Cappello, Zarena Aslami, Jennifer Williams, Eng-Beng Lim, Kirsten Ostherr, Kirsten Lentz, and Jonna Eagle. Reactions to this project by audiences and in conversations played a critical role in its evolution. For these crucial exchanges and questions, I would like to thank Angela Dalle Vacche, Michele Pierson, Manishita Dass, Mark Williams, Daniel Hebert, Tom Gunning, Mark Betz, Jim Morrison, Anna McCarthy, Tim Corrigan, and Peter Brunnette. I am particularly indebted to the willingness of Dudley Andrew, Karen Beckman, John David Rhodes, and Marcia Landy to engage with this project and provide what has turned out to be necessary critique, essential leads, and insight. I am thankful for the enthusiasm and careful guidance of Jason Weideman, my editor at the University of Minnesota Press. His faith in the project was sustaining, as was his sage advice. Danielle Kasprzak, also at the press, has been essential to this project gaining a public life. Justus Nieland and Jennifer Wild have served as Great Lakes guardian angels, tirelessly reading and rereading the manuscript. I am truly indebted to Jennifer Fay for her fierce loyalty and intellect. I could not imagine a better colleague and friend.

The values, politics, and lives of my parents and grandparents greatly influenced the book, as did my family's past in Piedmonte, Lombardia, Cairo, Ramallah, and Rhode Island. Their own versions of humanism motivated its completion: Eric Schoonover, Charlotte Kastner, Kermit and Grace Schoonover, and Charles and Madeleine Villa.

It is difficult to fully express my gratitude to a dear friend, Rosalind Galt. She has revived my fortitude on too many occasions, providing countless jolts of encouragement and critique when I needed them most. Above all, I am grateful to Lloyd Pratt for the effect that his integrity and intellectual rigor have had on my life. This book would not have happened without his heroics, his brilliant stubborn refusal to give up on living a life with meaning. This work is dedicated to him.

INTRODUCTION

LATE TWENTIETH-CENTURY THINKERS often repeat a fateful parable of how World War II destroyed the photographic image. "After the camps," according to this parable, the camera image could only reveal its own inadequacy. The unprecedented death toll of World War II confounded the camera; the scale of the Holocaust, Hiroshima, and Nagasaki exceeded what its lens could capture. A diverse group of thinkers that spans three decades and includes Susan Sontag, Hayden White, Alain Resnais, and Jean Baudrillard describes the war's violence as having triggered the catastrophic breakdown of all traditional means of visually representing reality. The suffering caused by totalitarianism, attempted genocide, massive theaters of ground combat, and the deployment of the atom bomb rendered impotent any ordinary means of documentation and depiction. Once the pillar of evidentiary plentitude, the photographically generated image came to seem forever doomed by its inherent paucity. This parable describes a truth-telling picture that can only tell a partial truth, a photodocument that signifies only its own evidential limitations, and a realism that corrupts as it represents. This story stages the apocalypse of visual representation.

The film culture of the late 1940s and early 1950s told a different story. In the years immediately after the war and before the idea of representational apocalypse took hold, various American and European commentators heralded the cinematic image as a uniquely sensitive and complex form of graphic expression capable of assembling a global audience. These writers from across the political spectrum promoted filmgoing as a broadening activity that expanded the viewer's moral, cultural, and geographic perspectives. For them, an emergent realist aesthetic of cinema could build new vectors of postwar

globalism. The recently exposed scale of the human violence wrought by the war did not threaten to confound this aesthetic. In fact, this aesthetic showcased just how suited cinema was to the task of accounting for the war. The best-known and most often cited example of this new realism was Italian neorealism.

With their graphic depictions of the war's impact on daily life, neorealist films drew unprecedented foreign audiences, making the global distribution of non-Hollywood films viable again for the first time in decades. In this book, I argue that neorealism's interest in detailing the brutalized human body also underwrites the emergence of a new visual politics of liberal compassion that I call *brutal humanism*. I explore how *Rome Open City* (*Roma, città aperta,* Roberto Rossellini, 1945), *Shoeshine* (*Sciuscià,* Vittorio De Sica, 1946), *Bicycle Thieves* (*Ladri di biciclette,* De Sica, 1948), and other postwar Italian films use scenarios of physical suffering to dramatize the political stakes of vision and the need for an outside extranational eyewitness.[1] By grounding global empathy in cinematic corporeality, these films introduce a new species of what Hannah Arendt calls the "politics of pity." As Luc Boltanski points out, two components characterize Arendt's politics of pity. First, pity requires a clear-cut distinction between those who suffer and those who do not. Second, pity maintains the distinction between these two parties by way of a visually staged scenario of difference. In other words, pity always involves isolating the sufferers as to be seen or to be looked at and distancing them from the pitying subject or spectator.[2] Neorealism's visual narration of the imperiled body maps a similar spatial relationship of spectacles to spectators. The distinctions mapped by neorealism are also explicitly aligned with postwar geopolitical realignments, and they anticipate new arrangements of national and individual sovereignty, agency, and self-determination. This neorealist elaboration of vision speaks directly to the newly revamped geopolitical exchanges of the post–World War II North Atlantic. To say that the injured body becomes a central commodity in the system of international advocacy is not enough. These films are as careful to describe and to place the spectator as they are to depict suffering itself. In this sense, neorealism's particular brand of corporealism opens a new chapter in the politics of pity, one focused on internationalizing pity's spatial order. Yet many conventional readings of these films have obscured or evaded the role that the body and its beholder plays in them. To do so is to ignore neorealism's global character, its means

of international address, and its collaboration with the liberal rhetorics of postwar reconstruction that prioritized expanding commodity capitalism over endorsing local forms of sovereignty.

Standard histories of postwar Italian cinema identify location shooting as a prominent neorealist strategy that made these films appear newly real and vigorously relevant. According to these conventional accounts, neorealism's attention to Italy's war-ravaged landscape exemplifies the forceful impact of immediate history on the image and the building of a national audience. A rich critical literature has in more recent years updated our sense of this cinema's relationship to Italian social and cultural politics, and the theoretical rigor of this new work reasserts neorealism's centrality to the study of cinema. The best examples of this recent scholarship follow the trajectories of landscape, locality, and space to find the neorealist image at the center of a postwar visual politic.[3] *Brutal Vision* extends the impulses of this work by clarifying how the body functions for the realism of these films, a topic crucial to the films but less theorized of late. Anticipating a new era of realism, Visconti wrote of the cinema in the mid-1940s as a medium where the moral weight and aesthetic fullness of the image derives from its inscription of a profilmic body: "the heft of a human being, his presence, is the only thing which really fills the frame. . . . The most humble gesture of a man, his face, his hesitations and his impulses, impart poetry and life to the things which surround him and to the setting in which they take place."[4] Or as James Agee says in his review of *Rome Open City,* "the urgency of human beings always dominates this architectural poetry."[5] By returning to the body as a critical site, *Brutal Vision* builds on the questions posed by two important earlier studies: Karen Pinkus's *Bodily Regimes* and Angela Dalle Vacche's *The Body in the Mirror.*[6] Both books serve as crucial precedents for my analysis because they read history through the shifts in the representational rhetoric of corporeality. *Brutal Vision* looks beyond the parameters of the national, however, to the arena of neorealism's extranational aspirations. The book demonstrates that corporeality was as important as other aspects of the mise-en-scène to making these films appear newly real, relevant, and vital for filmgoers around the globe. Moreover, it argues that these films engage the imperiled body as the aesthetic catalyst of intercultural exchange. For neorealism, corporealism is a graphic force capable of opening Italy to the global spectator.

According to influential midcentury accounts of cinema that follow a similar logic as these films, the strength of the moving image comes not only from its ability to document history, but also from its power to transport political concern across partisan bias, national borders, cultural affiliations, and even oceans. Both anticipating and enacting this view, neorealist films welcome the foreign observer as a much-needed political participant and hope to persuade even the remotest viewer to join a global audience of ethical world citizens. Yet this citizenry's ethics is secretly hungry for aesthetic encounters with the imperiled body—encounters that neorealism repeatedly provides. Although postwar humanism aims to prevent the repetition of wartime atrocities, this aim is pursued cinematically through the virtual repetition of those atrocities.

In the most internationally successful neorealist films, the same scenario is repeated again and again: an imperiled body is offered to a bystander's gaze as an opportunity to exercise ethical judgment. These climatic viewings of the body direct attention beyond the diegesis to the position of the outsider. In doing so, they grant the foreigner's point of view a palpable textual presence. A film rarely seen today but distributed in the United States in the 1940s, Aldo Vergano's *Outcry* (*Il sole sorge ancora,* 1946) uses corpses to punctuate the endings of its most climatic chapters. These once-animate bodies lie dead before our eyes, their stillness marked by an oddly formalized composition devoid of the film's otherwise kinetic and almost documentary point-of-view structures. By framing and reframing these scenes of imperiled bodies, this film asks the viewer to contemplate the untenable prospect of a world without eyewitnesses. By reasserting the viewer's position outside these framings, this film issues a plea and expresses the political urgency of convening a world community of onlookers. Notwithstanding its explicit commitment to a radical leftist politics, it seeks to summon a public of atomized observers who are neither completely alone nor purely social—a public uncannily analogous to the cinema audience.

Neorealism's articulation of the outsider's gaze in this and other films thus both adopts and revises the structures that Arendt associates with pity. Arendt describes the sufferer being made into a spectacle for the nonsufferer through a process of generalization and distanciation. For Arendt, pity's dependence on spectacle reveals the inaction and condescension it entails. As Boltanksi explains:

What is meant by spectacle in this context? To a large extent Hannah
Arendt's demonstration consists in drawing out the latent implications of a
politics which is distinguished by not being centered directly on *action,* on
the power of the *strong* over the *weak,* but on *observation:* observation of the
unfortunate by those who do not share their suffering, who do not experience
it directly and who, as such, may be regarded as fortunate or *lucky* people.[7]

In this context, it is interesting to consider how urgently neorealist
films attempt to thematize ethical viewing as a form of action. Their
spectacular display of suffering is remarkable precisely for how it
compensates for the isolation and inactivity of those lucky people.[8] In
fact, these films seek to turn watching from a passive form of con-
sumption into an activity replete with palpable geopolitical conse-
quence. Through the staging of bodily violence for virtual witnessing,
these films offer up the activity of looking as an exercise of political
will. Cinematic encounters with the violenced or physically compro-
mised human form become a means of exploring the ethics of witness-
ing—but witnessing always from a distance.

Thus, in an important way, this new arrangement of pity figures
the film spectator as the emblematic postwar humanist, an imagined
subject who finds himself, just after the war, overcome with political
pathos, cosmopolitan goodwill, liberal guilt, and charitable impera-
tives. This apparently outward-looking subject revises what it means
to be in the world. He anticipates a different globalism for the post-
war world and underwrites a new world order, a Euro-American
politic dominated by large-scale international aid, NGOs, and neo-
colonialism. The cinema itself becomes a means of refining that sub-
ject's agency over the world, offering him a point of view that remains
outside and yet ethically engaged. This fantasy of limited involve-
ment conjoins two modes of watching: consuming a fictional diegesis
merges with eyewitnessing world events. As an ideological position,
this humanist subject reconciles the immensely diverse reactions to the
aftermath of the war into a hegemonic sensibility wherein political con-
cern is channeled through virtual experiences of connectivity. Neo-
realism's use of spectacles of suffering as a means of establishing a
newly humanist spectator might then be best understood as the ulti-
mate manifestation of a postwar cinematic politics of the image that
authorizes the foreign gaze to adjudicate local politics.

By acknowledging this clearly globalist trajectory of neorealism, I
pursue the question of its international life rather than mapping a

reflective relationship between postwar films and Italian sociopoliti-cal history. Although previous generations of scholarship made these films nearly synonymous with the idea of national cinema, in the last several years, several important studies and collections have reminded us that neorealist films carried an international address from the start.[9] As these studies have shown, and as I elaborate here, the foreign em-brace of these 1940s films always figured large in their foreign and Italian domestic promotion. The content of the films was not the only beacon for the moral spectator; their embrace by international audi-ences itself was said to evidence the growth of transatlantic compassion. In this context, I argue that the successful exportation of neorealism and its discovery of a global audience functioned as a crucial cultural harbinger of the postwar reconstruction.

The actual reach of this "global" audience was somewhat circum-scribed and circumspect: in many instances, the scale of this exchange simply traced the contours of the emerging North Atlantic community. This particular discourse of globalism and world citizenry endorsed a far-reaching subjective authority, while at the same time mostly limit-ing itself to an internationalism defined in the space between Europe and North America. Attempted corrections to the geopolitical scale of perception can be seen in gestures of liberalization such as the "broad-ening" of minds and the opening of markets. With these expansions, a larger and more perfect scale of the world is said to replace a flawed and inadequately humanist older one. The formation of NATO, the rise of NGOs, and the Marshall Plan respond to the call for a new way of knowing the world that more accurately mirrors its global character. I attempt not only to examine cinema's role in engaging its viewers in the construction of this new scale, but also to question the political realignment involved in this reorientation of scale. As Sergei Eisenstein remarks in a different context, "Absolute realism [of scale] is by no means the correct form of perception. It is simply the function of a certain form of social structure."[10] In this sense, I am responding to Miriam Hansen's prompt to think through the cin-ematic medium's unique capacities to create an international public— or what I am calling here a globalized scale—by analyzing how indi-vidual films "engender a public space, a horizon of at once sensory experience and discursive contestation."[11]

Of course, film culture of the mid-twentieth century is often seen as a hotbed of global humanism. Dudley Andrew's delineation of the

phases of world cinema reads the postwar period as a moment when film aesthetics seem to redeem the humanness of the foreign other in the eyes of the global film spectator. He writes that Japanese cinema of the early 1950s

> helped renew the modern art of cinema that was just then stepping forward to take the lead in the "universal humanism" that intellectuals everywhere held up in the face of the Korean and Cold Wars. This modern cinema, emerging at festivals and cine-clubs, could be shaped by developments anywhere on the globe, and could in turn enlarge the sensibility of humans everywhere, letting Westerners comprehend the world, for example, from within the feeling-structure of the Japanese, who only a decade before had been deemed essentially non-human.[12]

I do not doubt that cinema enabled the transfer of feeling-structures for such noble purposes, but this book does consider the costs of affective humanism in the period's film culture. In working through certain more brutal attractions of world cinema, I discover a form of humanism more reconciled with than resistant to the geopolitical affinities of large-scale capitalism and its multiple battle zones.

In his pioneering 1951 history of Italian cinema, published for readers of English, Vernon Jarratt recognizes violent corporealism as a key feature of *Rome Open City*'s international popularity, but not one that hinders its resounding humanism:

> *Roma Citta Aperta* [*sic*] won most of its fame, perhaps in Italy and certainly abroad, by the outspokenness of its realism, and the extraordinary convincingness of its torture scenes; these, indeed, are so real that it is not unusual for people to be overcome by them. But many a quite unworthy gangster film has had these qualities in almost the same degree; the great quality that shines out from the whole film is its humanity.[13]

I use the term *brutal humanism* to name the strange symbiosis of violence and humanitarianism, spectacular suffering and benefaction. Brutal humanism describes an inversion of commonsense understandings of the causal relation between the philosophies of liberal humanism and practices of humanitarianism. Ordinarily, the former term describes a basic belief that despite differences, all humans share a common character that unites us. The behavior that follows from that belief—the obligation to care for others because they are human—is what we then call humanitarianism.

Brutal humanism involves the opposite operation. It suggests that the exceptional corporeality of the imperiled body triggers charitable

dispositions. This means that we only have access to our common humanity in moments of seeing the suffering of others. Only through gestures of humanitarian caring are we able to define and experience our humanism. The short version is that a suffering body is needed to understand the category of the human. One of my attendant concerns is the desire to make a space for other practices of visual humanism that can substantiate the value of human life without curating a scenario of imperilment for the witnessing.

In pursuing neorealism's international life and the question of its humanism, I significantly depart from how these films have been narrated in general histories of cinema. Traditional accounts figure neorealism as the testimony of one people's painful resistance and their resolute recovery. Indeed, neorealism has so often been seen as the ultimate expression of a people striving to establish autonomy and democracy after years under fascism that my approach may appear unorthodox to some. I therefore want to state clearly that I am not saying that the films of Rossellini, for example, were intended as actual endorsements of the U.S. intervention into European political and social life. Nor am I suggesting that an explicitly communist film such as *Outcry* aimed to aid and abet the liberal capitalist order. What I am saying is that these films do and always did exist in the international space of the North Atlantic alliance. Two of the most famous of these films, *Paisan* (*Paisà,* Rossellini, 1946) and *Shoeshine,* for example, assert the priority of Italian–American relations in their titles: both titles redeploy colloquialisms used by American soldiers and Italians in their address to each other. In his careful unpacking of the history of *Rome Open City,* David Forgacs reminds us of the involvement of individual American investors in early postwar Italian filmmaking.[14] Christopher Wagstaff's industrial research on this period's policies, production modes, and audiences similarly troubles the traditional binary understanding of foreign (Hollywood) and domestic (Cinecittà) filmmakers as competing interests, suggesting how the relationship between the continents led to a productive tension that fostered and inhibited the development of a national cinema in a manner inconsistent with our received sense of this cinema's aspirant nationalist singularity.[15] Other recent histories of postwar Italian cinema productively trouble the nationalist bent of European film studies, suggesting that this persistent national bias has largely occluded the role of American interests—whether financial, sociopolitical, or governmental—in

shaping neorealist films, their distribution, and our received sense of their meanings.[16] From a different angle, scholars of film noir see the emergence of a coherent neorealist aesthetic as depending on Italian intellectual culture's early fascination with American hard-boiled fiction.[17]

Building on the momentum of these insights, one could imagine an even more radical postnational redefinition of the neorealistic aesthetic in which neorealism indexes the increasing role of U.S. interests in Italy as much as it showcases the peninsula's newfound independence. If we trace the role of Americans in early postwar efforts to make films in Italy, neorealism emerges as in some measure a progenitor to the coproduction model responsible for so many European art films later in the century.[18] There may even be evidence to support the claim that neorealism carries an American imprint. An American G.I., Rod Geiger, not only supplied critical finishing funds for *Rome Open City,* but also sold American distributors on the idea of importing the film and marketing it across the United States. According to historian Tino Balio, Geiger returned to Italy after the U.S. success of *Rome Open City* and told Rosellini to make *Paisan,* supplying the director with film stock and American actors. Others tell us that that same film received essential funds from American paragovernmental sources. American distributor Joseph Burstyn claims to have been in the editing suite during *Bicycle Thieves'* final edit and that De Sica asked him to help shape the film. Yet we do not even need to go so far as this polemical revised history to justify the need for a new geography of where and how neorealism was defined. The initial commercial success of Rossellini's and De Sica's films in the United States appears to have structured the Italian film industry's sense of what made for a viable export. The critical eye of a *Time* magazine review of *Paisan* reveals this transatlantic history: "The picture is painfully sycophantic towards the U.S.; so much of it is recorded in English that one wonders whether it was made for home [Italian] consumption at all."[19] Of course, this success in America was also of crucial importance to Italian film culture—and not only in the intellectual debates over postwar aesthetics happening in *Cinema* and *Bianco e Nero.*

In this book, I thus take seriously new evidence that critics and audiences beyond the peninsula played a decisive role in constituting the category of neorealism. By figuring neorealism as the exclusive property of Italian culture, as much of film studies has persisted in

doing, we have retrofitted the term with a nationalist character that its postwar utterances do not always support. The problem of definition has, of course, always haunted the historiography on neorealism. As others have noted, the term *neorealism* itself is almost radically overt in its a posteriori ontology. Neorealism did not originate as a conscious movement; it only became a recognizable aesthetic project after the fact.[20] Unlike futurism, third cinema, or Dogma '95, the term did not label works originating from a self-conscious cadre of artists with a proclaimed purpose or manifesto. As David Overbey remarks in his introduction to a collection of primary source texts on the topic, "the theory that was created by critics to support and define neo-realism was developed after the fact."[21] Overbey describes neorealism as "a 'movement' which was discussed by a large number of people, but to which no one, except Cesare Zavattini, would finally admit belonging."[22] The coherence of neorealist film practices emerges only in retrospect, through the facts of its consumption, its promotion, its critical championing, and its citation by later films. The films of Rossellini, De Sica, and others never become neorealist on their own. They needed to be seen from the outside, and they needed to be known as having been seen by the world.

In their anthology *Italian Neorealism and Global Cinema,* Laura Ruberto and Kristi Wilson go so far as to argue that the definitional variability of neorealism is symptomatic of its international character. They write that "the question of neorealism's contested identity seems related, in perhaps contradictory ways, to its tendency to be claimed and recontextualized by different national film movements in various time periods."[23] Here the editors are referencing the various film practices that neorealism influenced and that are mapped by their collection. I would argue, however, that the status of being claimed by an outsider's eye is inherent to neorealism's definition from the start. Zavattini argued that the task of the neorealist filmmaker "does not consist in bringing the audience to tears and indignation by means of transference, but, on the contrary, it consists in bringing them to reflect (and *then,* if you will, to stir up emotions and indignation) upon what they are doing and upon what others are doing."[24] In other words, the subject does not just substitute his perspective for a diegetic outlook, but stands empathically in a site of reflection, a space of critical alterity. From its earliest definitions, the neorealist aesthetic has set out to offer its viewer the role of an outsider, a position from which

that viewer can adopt a concerned stance at a safe distance. One early American reaction to neorealism called this mode of vision "shotgun seeing" and understood *Rome Open City* as the means by which Americans who had not been in the war could experience what it meant to be in combat as a paratrooper or to be an average Italian.[25] Strong political imperatives motivated the idea that cinema could broaden people's participation in the world. In fact, this period's notions of cinema's medium specificity often display an eager, almost anxious, anticipation of a humanist subject. New practices of cinema, then, offered up film consumption as a mode of expanded political engagement. Cinema and its unique brand of surrogate or secondary eyewitnessing suddenly appeared to be engineered for a newly liberalized world community. Millicent Marcus recounts that for many critics, neorealism was a means to "promote a true objectivity—one that would force viewers to abandon the limitations of a strictly personal perspective and to embrace the reality of the 'others,' be they persons or things, with all the ethical responsibility that such a vision entails."[26]

Even in Italy, the American consumption of neorealist films shaped their meaning and their popularity. According to several accounts, Italians were otherwise uninterested in reliving the horrors of the war or reviewing the war's aftermath that already surrounded them in daily life. Instead, they came to these films to see the Italy that American audiences were consuming and to see through the foreign gaze. This seems to be particularly important in the case of *Paisan,* which some historians have suggested only did well in the domestic box office after its run in the United States. Although *Rome Open City* was popular in Italy before its U.S. release, its box office grew even more after the film's run in America. Later we will see the lengths to which these films would go in order to absent a local point of view. This practice assists in the Italian spectator's masquerading gaze and in seeing himself from the outside. This history suggests a fascinating subjective process that is self-conscious of representation as representation. For a movement often conflated with historical fact and regularly regarded as authentic, its definition seems built from the very start on a subjective investment in relativism, self-reflexivity, and secondhand encounters. This gaze that looks at itself being looked at even echoes how Thomas Elsaesser describes the self-estrangement central to the domestic reception of new German cinema: "Germans are beginning to love their own cinema because it has been endorsed, confirmed, and

benevolently looked at by someone else: for the German cinema to exist, it first had to be seen by non-Germans. It enacts, as a national cinema, now in explicitly economic and cultural terms, yet another form of self-estranged exhibitionism."[27]

Neorealism, I argue, was similarly defined in reflecting back on postwar films as already seen. For example, critics elsewhere in Europe and in the United States recognized the successful distribution of postwar Italian films as evidence of a new world audience. The picture of these audiences outside of Italy embracing neorealist films provided international commentators with a means of arguing that a universal moral imperative for democracy was being issued and accepted. This was an imperative issued not just in the content of these films, but also in the very act of their global consumption. (It is interesting to note here that the Japanese press book of *Paisan* replicates the American press book, providing the same admats used to promote the film in the United States, suggesting that the U.S. market set the example for how the film was received on other continents.) On both sides of the Atlantic, neorealism comes into being only through a consciousness that we as viewers are watching what was already seen. In this structure of an outsider's gaze looking at looking, we gain access to the conceptual parameters of the postwar Italian film. The popularity of these films thus resonated in a postwar period anxiously anticipating its own interconnectivity. I aim to clarify a historically specific sense of that interconnectivity, one that undergirded the subjective foundations of a new North Atlantic community to endorse programs of relief, assistance, financial forgiveness, and dependency.[28]

Because the reconstruction of Europe after World War II represented one of the largest humanitarian aid projects to date, it is crucial to recognize how this project benefited (and perhaps required) textual structures that encouraged proxied benefaction. Routing justifications for aid through the affective practices of sympathy and distanced intimacy may appear to be no more than a necessary means for advancing international relations, facilitating concerned engagement, and generating humanist charity. However, we must also look carefully at the architecture of those textual structures. This task is especially important if we think about the ways that the European reconstruction was used as a template for the later large-scale humanitarian aid structures of neocolonialism. As the late-twentieth century history of West Africa, Latin America, and the Caribbean demonstrates, and as many

of the films from those regions so powerfully argue, the culture of humanitarian charity may help people in need, but it has also enabled a large-scale reorganization of political systems around a new economic world order that has had serious consequences for democratic politics and human rights worldwide.

Neorealism's most influential definition came of course from an outsider. Despite the story of national specificity that these films are usually understood to tell, it is the French film critic André Bazin's writings, which form the subject of my first chapter, that most often accompany introductory students as they watch neorealist films for the first time. In his impassioned account of these films, he values their address to and elaboration of a global viewing public. For Bazin, they confirmed the existence of "a wide moral audience among the Western nations" and continued to "open the hearts of everyone."[29] He famously warned against neorealism's reification by saying that neorealism should always remain a verb and never be confirmed as a noun. At one level, Bazin simply wants to prohibit any efforts to instrumentalize what were to him preciously vital works: to fix the radical contingency that these films exuded would violate their purpose. If we delve deeper, his prohibition also reminds us that the power of neorealism derives less from its depictions and more from how it issues those depictions. To pursue neorealism as a verb means finding it in the midst of being made—in its mode of address, its watching, its audiences, and its travels.

In his discussion of *Bicycle Thieves,* Bazin anticipates and rejects the idea of neorealism as a national cinema when he explicitly raises the issue of cultural difference and regional specificity only to dismiss its ultimate consequence. The purity of neorealism's acting is not, according to him, attributable to any innate Italianness. Neorealism does not necessarily demonstrate that "the urban Italian has a special gift for spontaneous histrionics." In an effort to link the directness of its acting to neorealism's other key components, Bazin goes so far as to state:

> Probably too much importance has been attached to the ethnic factor. Admittedly the Italians, like the Russians, are the most naturally theatrical of people. In Italy any little street urchin is the equal of a Jackie Coogan and life is a perpetual *commedia dell'arte.* However, it seems to me unlikely that these acting talents are shared equally by the Milanese, the Neapolitan, the peasants of the Po, or the fisherman of Sicily. Racial difference apart, the

contrasts in their history, language, and economic and social condition would suffice to cast doubt on a thesis that sought to attribute the natural acting ability of the Italian people simply to an ethnic quality.[30]

The implicit point here is that Italy is a collection of ethnicities and language communities that all appear foreign to each other. This quotation also typifies Bazin's insistence on the cinematic image itself as the source of immediacy. Bazin argues here as well for the universal accessibility of the film image—that is, the international comprehensibility of the cinema and of neorealism in particular.

The cinematic body functions throughout Bazin's work as an emblem of this transcultural legibility, and for this reason, Bazin is a major interlocutor for the theoretical argument in *Brutal Vision,* with chapter 1 focusing on his writings in detail. Here I use a series of close readings to argue that the body serves Bazin as a crucial example and metaphor through which to articulate his version of realism. Until recently, summations of his theories neglected the corporeal figures that populate Bazin's writings, instead emphasizing the importance of onscreen space to his polemic. Over the last several years, however, scholars have turned back to Bazin with a renewed vigor, putting pressure on his quasi-Bergsonian account of time, mining his evocative language describing the moving image as a theory of the politics of history, and fine-tuning how his theory of the image interfaces with later theories of the cinema's realism such as discussions of indexicality. Bazin's language of the body has been unavoidable in these conversations. In her influential anthology, *Rites of Realism,* Ivone Margulies uses Bazin's emphasis on contingency and death as the foundation around which to gather a diverse group of essays by film theorists.[31] Following from impulses of the suggestive essays in that collection, I argue that the body allows Bazin to foreground qualities of the image that are crucial not only to his ontology of the cinema, but also to his sense of cinema's moral humanism. For Bazin, the corporeal evidences the material stakes of the cinematic image; it is what matters. It is a site where cinema's sensitivity to the fragile and at risk materializes in the image. His religious devotion to the cinematic image derives in part from his belief that the medium provides a powerfully unique means of preserving contingency, the indeterminacy of the real. Throughout his work, contingency dynamizes both the object of the cinema's gaze and the subject, always threatening to unhinge

our control of what the image produces and what can be derived in its various scenarios of consumption. The body makes visible how contingency productively contaminates the well-planned image. The inadvertent gesture, the blinking eye, the unplanned spasm, the random detail noticed only after the fact—these are elements of the image that the camera cannot help but record, and they remind us of how photographic media make images without and even in spite of conscious intent. For Bazin, the realist strength of photographic media derives from their ability to create an image without the intervention of human psychology. Thus, sensitivity to contingency saves the image from reification, intentionality, and the concretization of any top-down semantics that might prevent the spectator from exercising her own democratic reading of the image. Bazin consistently celebrates camera work—in particular the uninterrupted shot—that allows the contingencies of the profilmic event to unfold in real time and develop within the open field of the image. He also suggests that the rigid semantic prescriptions of typical Hollywood editing patterns and Soviet montage threaten to constrict the expression of the contingent and hinder the viewer's chances of deriving meaning from the image alone. The long take, for example, increases the potential for contingencies to express themselves in the image; the film grows more and more dependent on means of expression beyond human control. For Bazin, this idea of an organically developing image is directly connected to how these same sequences invite a more democratic mode of spectatorship in which viewers are free to look where they wish within the frame of the image. What makes Bazin's narration of this idea particularly compelling is his refusal to regard contingency as an excuse to stop working on the image. Contingency, he seems to imply, never relieves the critic of her duty to produce a nuanced and engaged account of the image.

Because neorealism stands as a watershed moment in both Bazin's history and in the larger discursive history of the film image, I will approach the issue of contingency from two main perspectives. First, in this book, I regard contingency as an ever-present feature in the intellectual history of ideas that attempt to define the film image, a feature worth tracking, and a feature whose significance has resurged in recent years. In revisiting the postwar war period of this history, therefore, I pay particular attention to how contingency was mobilized in theories and practices of realism, especially neorealism. In her

important study of location in postwar Italian cinema, Noa Steimatsky argues that Bazin was "the first to analyze how a radicalization of contingency . . . induced neorealism's break with the illusionist transparency of the classical style."[32] If Bazin was the first, he was by no means the last, and recent film theory appears newly entranced by the contingency of the cinematic image. With digital technology's promise of invisible manipulation, the cinematic image will soon be infinitely perfectible, thus making the accidental and unexpected all the more interesting. In other words, cinema studies' present anticipates a moment in the near future when contingency's force will have been completely obliterated from the image. Fantasies of contingency's eventual obsolescence have led recent film theorists to embrace the image's inadvertent flaws or accidental inclusions, like scientists rushing to study an animal species on the brink of extinction. This impulse has also led to the reconsideration of auteurism and cinephilia as cults formed around a particularly sophisticated worship of filmic contingency.[33] This interest in contingency also parallels a broader shift in film theory away from the hegemony of space theory and toward a reassessment of cinematic time. Laura Mulvey, for example, investigates the persistence of stillness in moving image culture, in part for the ways that stillness invites a contemplation of photographic contingency, or the unexpected and unintended pleasures of the image. For Mary Ann Doane, early cinema's modernist temporality reveals an aesthetic enthrallment with accident and mishap, nature and the body. She argues that preindustrial practices of time attempt to fuse rationality and contingency in a manner that will be threatened, if not obliterated, by classical industrial narrative. Finally, contingency has been important to theorizing the enculturation of the film image as a documentary, evidentiary, or historiographic institution.[34]

The second approach of *Brutal Vision* will be to examine contingency as a discourse of the image. In other words, I will be considering how a discourse about contingency ends up defining the realist film image. I will argue that neorealist films, in particular, rhetorically instrumentalize the idea of contingency through their deployment of the imperiled body. The corporealism of neorealism and its visual idiom of bodily display sets off, animates, and amplifies a rhetoric of contingency in the image. On the one hand, neorealism does this by amplifying the actual contingency of the image: foregrounding the accidental, flaunting the unintended, embracing the unstyled. In these

cases, a diegetic fiction borrows from profilmic inadvertency: the consequential is made to parade as the incidental. On the other hand, these films construct a virtual contingency. They produce a false sense of spontaneity or risk to artificially inflate the automaticity of the image's production. The cinematic body often functions at the center of both strategies. More importantly, the body offers a particularly convenient bridge within the image between these two rhetorics of contingency, blurring the line between the intentioned and the unintended, between the fictional and the documentary. The body asserts the vitalism of all photographically generated images in particularly dynamic terms. The body allows a film to disguise its overt discourse in a staging of the prediscursive. It provides a means of self-authentication. Bodily contingency permits the image to trace or track its own making—to elaborate visually a theory of determinism. It lends the fictional film a kind of documentary verism. As my account of neorealism's relationship to postwar geopolitics suggests, this rhetorical instrumentalizing of the image's contingency is a betrayal of the radical qualities that traditional philosophy grants to this concept. True contingency cannot be implemented, repackaged, or lent. It perpetually dethrones semantic fixities and undoes the world as we know it. Yet for Bazin the phenomenon of cinema seemed to ask: why can't true contingency be in storage layaway and redeemed at a later date? In the 1940s and 1950s, films were particularly prone to instrumentalizing contingency and apt to construct bodily figurations of it. This rhetoric of the contingent sought to define the cinematic image as a beacon of openness, as an emancipator of an otherwise isolated spectator, and as a liberalizing force in a world newly aware of its vulnerability to totalitarian propaganda.

Working out from Bazin's vision of cinema as a medium able to invoke the sovereignty of a global spectator through its carnally inflected humanism, I next turn to look more closely at the transatlantic currents connecting Italian postwar film and the U.S. intervention in European politics in chapter 2, "The North Atlantic Ballyhoo of Liberal Humanism." Nowhere is the international life of neorealism more important than in the United States, where commentators were especially keen to assert the existence of a liberal humanist viewer and thereby to confirm that the American public was not returning to its prewar isolationist apathy. Recent revisions to industrial film history suggest that violence and other carnal attractions cemented

neorealism's American popularity. Through a study of archival distri-
bution and exhibition documents, this chapter reveals how neorealism's
U.S. promotional discourses venerate affect-generating spectacles of
the body as opportunities for heightened political awareness. Accord-
ing to the American exhibitor's manual for *Paisan,* for example, the
shocks and sensations attributed to realism's graphic revelations may
overwhelm the spectator, but this enthrallment never forecloses on
ethical judgment. Importantly, these promotional discourses in this
sense envision a new mode of spectatorial engagement that is com-
fortable with its intermittent embrace of different affective stances.
Indeed, enrapture and detachment are advanced as complementary
ethical postures. This promotional discourse seeks to reconfigure the
American subject's place in global politics and to give the budding
"world citizen" a subjective means to experience inclusive humanitar-
ian concern. Postwar movie critics, promoters, and even realist films
themselves imagined a viewer craving raw images of a war-torn world,
and in particular war-torn bodies. For postwar Americans, it would
seem, filmed sequences of the imperiled body demonstrated cinema's
political capacity as a medium, certified filmgoing as a resolutely
humanist pursuit, and proved the film spectator to be a consumer sen-
sitive to the moral imperatives of an increasingly interdependent and
politically fragile world community. These promotional materials also
provided a rubric of proximate distanciation whereby world citizens
could imagine their rapidly expanding geography of ethical obligations
fulfilled by the politics of international aid. In the postwar milieu,
imported films promised ethical involvement for American audiences,
but only by providing spaces of intimate foreignness. In these spaces,
the sensations of conflicting allegiances could cohabit, and disengage-
ment suddenly felt as committed as physical involvement. These were
particularly productive spaces for emerging ideologies of large-scale
international aid.

In the third and fourth chapters, I explore how the imperiled body
haunts the formal systems of canonical neorealist films by Roberto
Rossellini and Vittorio De Sica. Chapter 3, "Rossellini's Exemplary
Corpse and the Sovereign Bystander," begins by looking closely at the
first and best-known postwar film by Rossellini, *Rome Open City.* I
argue that this film lingers on scenarios of physical abuse, political tor-
ture, and execution in an attempt to underwrite a spectatorial protocol
that not only restricts where and how we look, but also describes how

the activity of looking should be valued. The film uses the chaotic deaths of its three protagonists, including Pina's shocking street assassination, to highlight the presence of the unseen eyewitness, thereby legitimating the presence of an outside onlooker and inviting the foreign viewer onto the scene as an authority. Its images of bodily violence serve as a venue through which the film spatializes a proposed international ethics of vision; the act of ocular witnessing becomes the exemplary moral experience that transcends subjective differences among normal individuals and that best serves history.

If Rossellini uses the suffering body to convene a global audience of moral onlookers, then other neorealists use it to expose the dangers of a society that hinders collective vision and lacks external oversight. In chapter 4, "Spectacular Suffering: De Sica's Bodies and Charity's Gaze," I turn to the films of Vittorio De Sica. According to these films, a society is dehumanized when a body suffers without eyewitnesses. De Sica's internationally popular *Shoeshine,* for example, cautions against the epistemological frailty of nonvisual perceptions: here the audible can lie in ways the visual cannot, for the narrative conflict of the film turns on a tragic aural misperception. The faked sounds of a bogus torture session destroy the loyal friendship between the two main characters and lead to mutual betrayals. Bonds of solidarity are threatened, this film proposes, when individuals base their actions on what they have heard but have not seen. Thus the characters in *Shoeshine* can only reconcile after each has watched the other's body being harmed. This narrative teaches its viewer that the moral truth of the world lies in ocular perception. It is only able to make this point by foregrounding the eyewitnessing of bodily injury and death. De Sica's *Bicycle Thieves,* which I also consider in this chapter, does not depict the violence of war, but its corporeal scenarios do work to raise the political ante of this film's moral story. The discovery of a drowned body, for instance, unexpectedly usurps the film's narrative structure, and the unsettling spectacle of a young man's seizure enables the film to illustrate a conflict between mob mentality and individual testimony. Finally, *The Roof (Il tetto,* De Sica, 1956) describes a gaze of charity and dramatizes how vision constitutes the relational category of "the less fortunate."

In chapter 5, "Neorealism Undone: The Resistant Physicalities of the Second Generation," I argue that Italian films from the 1950s and 1960s enact a critique of neorealism and the aesthetic means by which

it made humanism a visual commodity. By restaging scenes of suffering from the films of the 1940s, including many of the scenes I analyze in chapters 3 and 4, this second generation of postwar Italian films reproach neorealism's use of the image as a form of compassion-triggering testimony. In the 1955 film *Il bidone*, or *The Swindle* (Federico Fellini), for example, corporeal spectacle actually misleads the viewer: the film's narrational swindle hinges on the assumption that the spectacle of an injured body has triggered a humanitarian response in the film's otherwise ethically suspect protagonist, when in fact it has not. The other films discussed in this chapter, including *Mamma Roma* (Pier Paolo Pasolini, 1962), *Il grido* (Michelangelo Antonioni, 1957), and *Fists in the Pocket* (*I pugni in tasca,* Marco Bellocchio, 1965), also foreground corporeal spectacle to interrogate the spectator's investment in the position of onlooker as a practice of political compassion. In their appropriation and mimicry of neorealist body trauma, these later films imply that if movies such as *Paisan* and *Shoeshine* share anything in common, it is their effort to materialize a universal subjectivity of humanitarian patronage by specularizing the suffering physical form. This systematic citation serves both to identify neorealism's discourse on ethical vision and to dismantle its ideology of visual witnessing as a form of action. It is commonplace to point out the political disparities among the work of 1960s auteurs such as Fellini, Antonioni, Pasolini, and Bellocchio. However, I contend that most of these second-generation films assail neorealism's mode of vision. They collectively challenge rather than extend the bourgeois transnational sovereignty implied in the ideology of the "economic miracle," the Marshall Plan, and the postwar growth of NGOs.

Ultimately, this book's account of how the body works in neorealist cinema has significant implications for understanding how the many film practices that develop in its wake inherit its carnally inflected humanism. We know that key movements of world cinema and art cinema are unthinkable without neorealism's precedent, but the specifics of how they bear its mark have not been developed beyond the casual reference. Furthermore, remarkably little work has been done to describe how neorealism's aesthetics determined the representational logics of the cinemas of social change and political liberation. Given neorealism's centrality to the genealogies of modern cinema, I suggest in *Brutal Vision* that its particular idiom of encountering corporeality inflects not only postwar Italian cinema but also the broader

outlines of global film culture in the second half of the twentieth century. The presence of an imperiled body that grounds transcultural sympathy and endorses cinema as humanism's ultimate conduit is neorealism's mark. This book asks: Why is corporealism so central to the postwar vision of cinema as a language of universal comprehension? How do obscene depictions of violence endorse cinema as the mass medium best suited to the task of international sympathetic identification? How does the imperiled body come to be seen as a channel for world understanding? In pursuing answers to these questions, I seek to account for how this particularly influential idiom of encountering the human form permanently inflected the idea of political film, ratified a cold war version of liberal humanism, and in many ways made the idea of the international film spectator imaginable.

In this book, I aim to locate the historical specificity of brutal humanism's spectator. However, I do so recognizing that neorealism made a key idiomatic contribution to a visual culture whose politics have for the last sixty years been organized around witnessing and the testimony of the body. The questions raised by neorealism's optics of global responsibility remain with us as the world again strains to decide on the proper scale of engagement. In films such as *La promesse* (1996) and *Caché* (2005), the Dardenne brothers and Michael Haneke reignite the notion of shotgun seeing, constructing scenarios of bodily suffering as a means of making the responsibilities of onlooking uncomfortably obvious. As these fictional idioms attempt to broaden the sociopolitical receptivity of the filmgoing public, new mediums of testimony complicate the role of the surrogate eyewitness, whether it is the circulation of Abu Ghraib torture photographs, the Twitter martyrdom of the Iranian protestor Neda, or Internet videos of Taliban executions.

1 AN INEVITABLY OBSCENE CINEMA

Bazin and Neorealism

It is the mechanical genesis of photography that makes its specific properties different from those of painting. For the first time the realism of the image achieved entire objectivity and made of the photograph a sort of ontological equivalent of the model. (Because of this, the human body, a privileged object in all the plastic arts, is almost inevitably obscene or pornographic on the screen.)

—André Bazin, "On Realism"

ANDRÉ BAZIN'S WRITINGS EXEMPLIFY mid-twentieth-century arguments that locate cinema's representational richness in the photographic mechanics of image production. In the epigraph to this chapter, Bazin proposes that because cinema is based on the photograph and its physical relationship with the real, the film image is inherently more graphic than other kinds of pictures. This suggests that some images are more explicit than others, a seemingly redundant locution that implies that some photographs are more photographic than others. In turn, it means that certain films are more filmic than others. Indeed, while Bazin sees nearly all cinema as inherently photographic, he also argues across his writings that particular film images foreground this photographic nature more than others—especially when they exploit the physical qualities of cinematic representation. These more physical, more graphic, more explicit images recur in Bazin's essays as important exemplars of cinema's specificity. In its reference to the obscene and pornographic, my epigraph thus illustrates a strikingly consistent feature of Bazin's account of cinema: a rhetorical dependence on the corporeal to explain the film image's unique aesthetic weightiness. For Bazin, the intensities and densities of the realist image are

very often measured in bodily terms. When a movie screen includes an image of the body, he suggests, the film bears an exorbitant visuality. In such moments of bodily excess, moreover, the image transmits cinema's staggering ontology: "An hyperbole of incarnation because of the overwhelming physical presence of the image," Bazin argues, "the cinema is actually the most immodest of the arts."[1]

Bazin uses the word *pornographic* to describe a medium whose images carry a presence so startling as to be potentially prurient, brutal, or crude. The notion that cinema makes bodies indecent (and vice versa) will be familiar to anyone conversant with public debates over documentary, realism, and medium specificity. In fact, Linda Williams tells us that the Meese Commission's infamous 1986 report on pornography actually quotes Bazin's theory of realism when it warns against the special physical dangers of filmic genres of pornography. Paraphrasing the report's analysis, Williams writes, "The filmic representation of an 'actual person' engaged in sexual acts is exactly the same as if witnessed 'in the flesh.' Thus, the reasoning goes, film audiences bear 'direct' witness to any abuse or perversion therein enacted."[2] The commission reads Bazin as verifying the exchangeability of profilmic body and onscreen body. The perils of cinematic porn result from the indistinguishable character of these two bodies. In Bazin, however, it is not only porn films where this danger is felt. All cinema threatens to make indecent anything it represents, even the most innocent event. As Williams tells us, "Most realist theorists of the cinema seem to come up against this 'ultimate' obscenity of the medium at some point in their thinking. Stanley Cavell in *The World Viewed,* for example, asserts that the 'ontological conditions of the cinema reveal it as inherently pornographic.'"[3]

Intellectual historian Carolyn Dean argues that the word *pornographic,* once limited only to sexual images, began describing images of uncomfortably explicit violence in the years immediately after World War II. She connects this expansion of the term's meaning to the period's anxieties about duly responding to the atrocities of the war. For her, the discourse of the pornographic emerges as a shorthand for how the war's unprecedented scale of violence was seen to challenge the limits of the human witness's subjective capacities. The pornographic image is an image that invokes a scale so unfathomable that it triggers a kind of system overload for the subject in which his or her empathetic abilities are overwhelmed and exhausted. She identifies

James Agee's essay on war documentaries as one of the first instances of this usage.[4] However, Bazin also uses this word when describing spectacles of violence, specifically the depiction of an execution in a documentary. *Une pornographie ontologique,* he called it, suggesting the unavoidable or inevitable obscenity of cinematic representation. In Bazin, pornography and obscenity also reference the overwhelming of a subject, but his usage implies a more ambiguous double edge to the image, suggesting a subject defined as much by curiosity, resolve, and resilience as by withdrawal.[5]

In this chapter, I explore Bazin's persistent preoccupation with the corporeal and the inevitable obscenity of the cinematic image in order to open up the politics of the film image in the postwar period. The discourse of the brutal image was central to midcentury investments in a global spectator for cinema and inflected the international life of neorealist films. I also argue that Bazin's work needs the idea of inevitable obscenity both to elaborate the realist ontology of cinema and to make the humanist stakes of that ontology palpable, material, and measurable. This rhetorical dependence on corporeality to demonstrate cinema's special capabilities and moral potential echoes other midcentury proponents of realist cinema. In fact, the "hyperbole of incarnation" that Bazin attributes to the medium epitomizes a period-specific, corporeally inflected humanism that organizes the impassioned embrace of neorealism outside of Italy and that is the subject of this book. Bazin's cinema is a medium "immodest" not simply because of its bold revelation of content but also because of the responses it triggers. The overwhelming affective force of its physical presence on an implied spectator is as immodest as the scenes it depicts. Cinema becomes a venue wherein the image begins to look human and the global spectator cannot help but exhibit his or her own humaneness.

Bazin's emphasis on the filmed body often receives less attention in standard accounts of his writing than his discussions of space and landscape. Nonetheless, the corporeal plays a key role in his analysis of the film image. In particular, it often enlivens the dynamic potentialities of space and the more inanimate elements of mise-en-scène. For Bazin, the corporeal evidences the physical transfer at the basis of the cinematic image; it supplies instances when contingency is made visible in the image, a quality less available and less legible with landscape. Because the body frequently functions as Bazin's preferred natural guarantor of the image's realism, we might at first conclude

that the body should be taken as a ledger of the real—that it qualifies as evidence of experience in a manner similar to the film image. As mentioned in the introduction to this book, however, and as will be discussed in more detail here, Bazin's concern for the filmed body follows from an interest in the radical potentialities of contingency in the relations between the image and its viewer. For him, the inadvertent or unintended gesture stands as a primary means of locating the force of contingency in the image. This abiding emphasis on the consequences of contingency for the image bespeaks Bazin's refusal to reify either the contents of the cinematic image or the viewer's relationship to that image. The ambiguity of the image often seems most available at moments of urgent corporeality. Figuring the image's ability to compel in a bodily idiom in this sense allows Bazin to emphasize the image's obligations without hypostatizing it. Bazin calls this "the flesh and blood ambiguity of the cinematographic image: see and understand!"[6]

If we ordinarily think of any given moment as a unique juncture in time and space, a phenomenon manifested by a particular set of historical and geographical contingencies, Bazin's cinema uproots those contingencies and transports them in all their integrity and ambiguity. Here cinema can transfer a particular moment into a later moment produced by a different set of contingencies. This ability of the film image to carry the impact of one moment beyond the ordinary parameters of human perception has incredible geopolitical potential for Bazin. Films that recognize and respect in their practice this unique strength of cinema offer the potential of conjoining different realities. Such ideal films do not simply document the existence of other experiences; they expose their viewers to a virtual version of that experience. When used properly, cinema can in this sense be a form of virtual eye-witnessing. This version of eyewitnessing is not triggered simply by cinema tricking us through images of extreme resemblance. This eye-witnessing is not about the simple optical simulation that defines the trompe l'oeil. One of Bazin's central theses, and a point that he makes through recourse to cinematic corporealism, is that cinema's aptitude for realism isn't simply about the transmission of likenesses: even images showing little visual information as a result of a distorted picture or a shaking camera attest to a presence and thus engage us in the act of witnessing. Or as Bazin puts it, the image's incompleteness or "faults are equally witness to its authenticity."[7] The actual and the on screen are never exactly interchangeable, but the on screen has the

potential to lead viewers to a dynamically experiential means of thinking about worlds and times beyond their normal purview. Cinematic representation transfers the coordinates of seeing with such a physical precision that it offers the viewer not only different vistas, but also an encounter with an unfamiliar experiential register and a different intersubjective dynamic. Bazin thus describes the effect of a fully realized cinema as an infectious encounter with humanness that compels us to take compassion to the streets: "But does one not," Bazin writes, "when coming out of an Italian film, feel better, an urge to change the order of things, preferably by persuading people, at least those who can be persuaded, whom only blindness, prejudice, or ill-fortune had led to harm their fellow men?"[8] When properly triggered, humanism resonates in us automatically, instinctively, and inwardly, reforming our feelings, lending a new perspective on relations, and revealing the innocence of those who turn to violence. It also manifests outwardly, making us connect with others, proselytize.

From his earliest encounters with the French theorist's writings, Dudley Andrew has consistently stressed that a primary goal of Bazin's account of cinema is just such a deepening of our engagement with the world.[9] Bazin's prized films, Andrew tells us, "confront the complexities of a world outside the walls of the cinema. Cinema had literally to outdo itself to become itself, had to abandon its putative specificity in order to get at what lay beyond it."[10] These ideal films undo the "selfishness" of our habituated ways of perceiving the world.[11] Although Bazin frequently champions the realist image as uniquely able to capture the contingent, the specific, and the local, he does so in a way that ultimately privileges the foreignness of the gaze that cinema's image engenders. A dialectic exists in his realism between the internal and the external, a tension between the subject and the object of the gaze. Andrew also describes Bazin's period, the postwar years, as a time when "tension between the human and the alien, between the personal and the foreign, . . . came increasingly into play."[12] If for Bazin the best films orient the viewer to the contingencies of a foreign moment, then it would seem to follow that the ideal viewer is an outsider, a foreigner. In a way, cinema makes us all into outsiders.

Film theorist Philip Rosen has argued that Bazin's definitions of cinema's medium specificity always rest on preserving the particularities of a unique set of subject–object relations. He urges us to historicize Bazin's theory of the subject, to think of his subject less as the

ahistorical constant of human life, as Bazin would have it, and more as a cultural and historical entity. If Rosen is primarily concerned with the vectors of time, which are admittedly crucial for Bazin, it seems just as important to consider how Bazin's subject is constituted in historically specific spatial relations as well. I want to suggest that these apparently abstract relations—between subject and object, inside and outside, human and alien, personal and foreign, this moment and that one—get reconceived in Bazin's writings as geopolitical transactions. Bazin's arguments, including his account of spectatorship, emerge in service of his explicit political desire to foster cinema's ascendance as a medium of "fundamental humanism," an attribute that is itself a historically bounded desire.[13]

Bazin's Humanism and the Global Spectator

For Bazin, realizing and nurturing cinema's technological expansion of vision could never be more urgent than in the mid-twentieth century. He wrote his most famous essays between the last years of the war and his death in 1958, and he understood the late 1940s and early 1950s as a period living in the shadow of the recent history of large-scale totalitarianism and its rebirth. For Bazin, totalitarianism represents the violent reification of human subjectivity. Totalitarianism threatens to reduce all variances in experience, history, and identity to a single monolith. Its attack on the variability of human life parallels its attack on democracy and the sovereignty of individual humans as citizens. Bazin also sees totalitarianism's attempt to destroy the intersubjective dynamics of human life as connected to the scale of violence unleashed by World War II: torture, mass destruction, violent occupation, and genocide. When used properly, cinema acts to counterbalance totalitarianism's attacks on the human subject. It can reduce any momentum fascism gains by dilating constricted fields of human experience. Indeed, Bazin sees cinema's talent for engaging various modes of experience as facilitating a form of world understanding that would lead to global peace. By reminding any and all human viewers of their innate capacity for compassion, cinema's experiential alterity (or "alterities") has the potential to expand what Bazin sees as the audience of moral onlookers that was beginning to emerge as an alternative to the totalitarian mass crowd. According to Bazin, properly realist films extend "the intellectual and moral horizons of the

audience."[14] Neorealism's "portrayal of actuality" is the key to its historically specific audience appeal, guaranteeing it "a wide moral audience among the Western nations."[15] In this account, one of cinema's main contributions to world peace would be to encourage a specific kind of spectatorship.

In English, the word *onlooker* best captures Bazin's ideal spectator because it implies a viewer at the crux of a spatial tension between a place of remove and a place of exigent obligation. That this onlooker observes without taking part makes even more consequential his or her status as witness. Onlooking thus places the viewer in a plane of expanded observation and commitments. On the one hand, this onlooker is a looming but quasiabsented presence, a bystander, an agent yet to be part of the action. On the other hand, the term *moral*— cinema will widen "the intellectual and moral horizons of its audience"—adds a sense of obligation. This is a hovering but not completely disengaged kind of watching. Unlike conventional voyeurism, whose pleasures are premised on the voyeur's continued remove from the scene, this viewer is not beyond effecting change. Viewing is neither purely part of the diegesis nor fully exempt from responsibility for the world pictured. Alongside his famously bottom-up version of image production and democratic semantics, Bazin grants the viewer a top-down perspective. The sequestering of the ethical agent he describes is a familiar concept, and here we have it identified with the filmgoer. This is a reappropriation of many Western systems of justice, which seek out juridical authorities (justices, juries, tribunals) who are simultaneously within the community and outside it, agents who are not actors in a community but are charged with acting for the community. Bazin makes the case that cinema's unique spatial and temporal parameters can nurture this type of observation and adjudication. Furthermore, he sees the medium taking this vision to a global scale, and hence he expands the parameters of what we think of as an ethical community.

For Bazin, this version of spectatorship is particularly appropriate to the postwar period. His own approach to questions of historical specificity usually follows the model of a weak dialectic: the particular tendencies, tastes, and urgent needs of a given era gently tug against dominant transhistorical human desires (to escape death, to duplicate human movement in images). When it comes to descriptions of contemporary viewers, however, the postwar era seems more deterministic

than others in shaping human attitudes toward the image. In his essay aiming to explain a current "craze for war reports," for example, Bazin initially sets up a balance between ahistorical and historical explanations, or between what he calls "psychological [constants] and perhaps also moral exigencies [that is, historical variables]." Yet after the first couple of pages of the essay, Freudian complexes begin to fade as possible explanations, and the powerful influence of the war and its resulting military-industrial complex, are foregrounded. War has effected two changes in the spectator. On the one hand, "the cruelty and violence of war have taught us to respect—almost to make a cult of—actual facts, in comparison with which any reconstitution [that is, restaging], even made in good faith, seems dubious."[16] Elsewhere, he makes a similar claim suggesting how the war has made modern audiences able to see the value of documentary footage and caused them finally to reject the evidentiary value of reenactments.[17] On the other hand, the extreme popularity of war newsreels "reflects nothing if not modern man's will to be there, his need to observe history-in-the-making, not only because of political evolution, but also because of the evolution as well as irremediable intermingling of the technological means of communication and destruction."[18] We find a slightly more hopeful Bazin in the early 1950s, but one who still eagerly ties film aesthetics to the current historical state of the human subject: "Almost everything of importance in the cinema of the past five years reveals in some way a spiritualistic inspiration, an optimistic humanism, a re-embracing of the ethical as opposed to social criticism or moral pessimism."[19] When Bazin mentions humanist practices of cinema, they usually respond to a particularly contemporary urgency. It is almost as if the need for humanism in the 1940s and early 1950s reveals the truth of a medium long abused for purposes not suited to its essence.[20]

During the past decade, scholars have returned to Bazin after a period of comparative disinterest in his works and found his question, "what is cinema?," to be relevant once again as the medium weathers an identity crisis in the aftermath of its centennial celebrations. However, this neo-Bazinian turn has focused primarily on ontology, treating Bazin's writings as a kind of transhistorical phenomenon and therefore slighting Bazin's own tendency, described above, to frame his thoughts on cinema in terms of a particular moment. At times his ideas are taken as prophetic analyses deeply relevant to our current situation: What would Bazin say about digital cinema? Yet his ideas concerning cinema

have seldom been considered in his historical context or in relation to the specific humanist outlook with which he burdened the medium. Although the dynamic features of his realism (contingency, presence, obscenity) have received a rich reworking by the neo-Bazinians, his specific geopoliticization of cinema remains obscure.

This tendency on the part of the neo-Bazinians to be less interested in the context of Bazin's writing may derive in part from a reluctance to revisit some of the questions that precipitated the turn away from Bazin in the 1970s and 1980s. One of the key moments where Bazin articulates the potential democracy of the cinematic image comes, for example, in his endorsement of the sequence shot. In 1971, Jean-Louis Comolli famously identified Bazin's enthusiasm for such shots as ideologically suspect and as a place where a particularly American version of liberalism takes hold in the presumption of a neutral objective gaze. He counsels his reader to be wary of Bazin's advocacy of the sequence shot and its deep focus because

> it allows the reactivation of that "ambiguity" which leaves the spectator "free" [and] aims . . . at confirming the spectator in his or her "natural" relationship with the world, hence at reduplicating the conditions of his or her "spontaneous" vision and ideology. It is not for nothing that Bazin writes (not without humour) in the course of a discussion of *The Best Years of Our Lives:* "Deep focus in Wyler's film is meant to be liberal and democratic like the consciousness of the American spectator and the film's heroes."[21]

Comolli's argument is often taken to exemplify Bazin's condemnation by 1970s and 1980s film theory. Always already ideological in this account, Bazin's realism is thought to have suffered in these hands. Although Comolli's reading does tend toward generalizations about Bazin's liberalism that reflect a broad sense of historical periodicity in which midcentury humanism and renaissance humanism look the same, his critique contains a relevant provocation. Comolli was not wrong to ask how Bazin's democracy constituted liberty, nor to expose his Eurocentric suspicion and simultaneous embrace of American ideals. Indeed, these questions have continued value, especially in the context of globalization. Yet in order to rescue Bazin from Comolli and from the later *Screen* critique, the neo-Bazinian turn has largely sidestepped these questions about how Bazin's realism is articulated with and through the history, politics, and ideology of his period. It is worth exploring the overt political aspirations of Bazin's writings to

get a better sense of how his interest in the obscene image exposes the historical peculiarities of his version of the cinematic subject.

Indeed, returning to Bazin's prose complicates both the harsh critiques of earlier film theory and their more recent rebuttals. His writings on the sequence shot are no exception. Here we find Bazin celebrating the technique's spatial and temporal dilation as a means of opening the image, not only aesthetically and affectively, but also in that image's relationship to the real. Although his sense of openness definitely betrays a particular politics of freedom, or what Cardullo describes as a striving for American-style democracy in Bazin's aesthetic, it also suggests a radical instability at the heart of visuality.[22] Bazin favors the sequence shot because it is "more realistic and at the same time more intellectual, for in a way it forces the spectator to participate in the meaning of the film by distinguishing the implicit relations. . . . Obliged to exercise his liberty and his intelligence, the spectator perceives the ontological ambivalence of reality directly, in the very structure of its appearances."[23] Later in this chapter, I will discuss how an oscillation of presence and absence afflicts Bazin's image and characterizes its political aspirations. For now, I will merely point out that here democracy and its liberties emerge in the film image's partial but forceful presence—as much in its brute appearances as in its implications.

One way to understand the historical emplacement and geopolitics of Bazin's realism is to attend to his account of the body. How does the bodily image fit into (and fill out) Bazin's account of cinematic engagement, which figures the movie screen as a passageway through which to transcend national identity and cultural difference? On the surface, of course, Bazin's argument for cinema as a medium declares itself to be radically humanist. He continually seeks to understand how aesthetic practices engage, reflect, and trigger humanism. He praises De Sica and Zavattini's poetry of ambiguity, for instance, which aims to "open the heart of everyone."[24] The palpable presence of a body—suffering, gesturing, simply being—often turns up in these overt attempts to aestheticize a midcentury politics of liberal humanism, to find humanism's aesthetic equivalent in filmic terms, in a popular visual vernacular. Bazin often describes the humanism he imagines as Franciscan, and while like St. Francis, Bazin pursues a promiscuous compassion for all things and all living beings, this liberal love should also be read within the context of a transatlantic refashioning of cinema's medium specificity that emphasizes its capacity to broaden

the parameters of the Euro-American subject's engagement in the world and authority over it.[25] In this context, cinema's affective and perceptual virtualities coax spectators to arrogate to themselves an expanded frontier of moral responsibility. Cinema encourages the otherwise nationally concerned subject to lay claim to a larger world, and it does so through an account of the vulnerable body.

In an essay surveying the films at the 1946 Cannes Film Festival, to name one important example of how Bazin's thinking on the body takes shape in relationship to these transatlantic politics, he links together the imperiled body and the humanist image to make a political and historical claim about the role of cinema in facilitating neighborly goodwill. Throughout the essay, Bazin longs for a truly international film culture, one that would allow films to travel the globe freely and thus realize the medium's universal potential. For him, the principle value of Cannes as an event is "the opportunity it provides to establish comparisons" between different national cinemas and to process the value of such comparisons. In his vision for an ideal world cinema, we find a typical Bazinian dynamic between film culture and film practice:

> While a well-stocked book store has on its shelves enough foreign trans-
> lations and recent magazines to make it possible to follow contemporary
> international literature, only congresses like that in Cannes make it possi-
> ble to form an idea about world film production. From this point of view
> the geological cross-section made in cinema by the Festival was fascinat-
> ing to those interested in knowing where cinematic art and industry are
> heading.

It is not only international institutions of film distribution and exhibition that concern Bazin. He also looks for practices of world cinema, uses of the art form that recognize its innate ability to enable experience on a transnational register—or what later in the same essay he calls "a common affective denominator." So although it is true that cinema's "international if not universal" nature is embedded in its "technique," this aptitude is more apparent in some film practices than in others.[26]

Sociopolitical context shapes film practice in ways that lead to the creation of different scales of spectatorial engagement. Although some film practices present expanded geographies of spectator–world relations, others offer more limited frameworks. Bazin proposes a comparative analytic frame to gauge the scales of these geographies:

"a phenomenology of death in contemporary cinema."[27] Death in European films, Bazin explains, triggers concern in the spectator. By contrast, Hollywood's escapist fare contains only "movie deaths," imaginary scenarios that do little to involve the spectator ethically or otherwise.[28] All American films "seem suspended in a stratosphere in which problems of individual or collective life, of morality, or of politics are invoked only in the imagination, like death in a detective novel. The world in which the characters struggle is separated from us by a glass that their blood does not penetrate."[29]

Bazin's model of international cross-identification rests on this distinction between two styles of engagement. In Hollywood's "irrealism," the screen shields us with escapism. The cinema erects a barrier guaranteeing comfort for the weak of heart, the disimpassioned pleasure seeker, the isolationist. In realist cinema, by contrast, otherwise local histories of specific atrocities become an "experience that every man in every country immediately understands." These films speak "an international dialect that needs no subtitles or dubbing."[30] As he laments the dearth of French cinema that adequately captures recent history and admonishes Hollywood for its irrealism, a vision of a concerned international spectator comes into view.[31] Here war's imperiled bodies are central to cinema's humanism because they both cry out for a more humane world and reflect the injury felt by all humanity. Bazin suggests that films such as *Rome Open City* and the Danish film *The Red Meadows* (*De røde enge,* Bodil Ipsen/Lau Lauritzen, 1945) are more cinematic because of their unfettered approach to depiction, a quality indicated by their frank portrayal of torture. Corporeal violence extends the already "vigorous realism" of these films and their political relevance to underwrite a new practice of cinematic "human realism":

> The foreign films . . . are all dramas, practically documentaries. They are all marked by violence and atrocity. But if the variety of tone and genre of the French films is greater, the foreign works have gone further than ours when it comes to a human realism. No French director has dared show what was nevertheless the dominant fact about underground activity: torture. In France this seems to be a secret and sacred theme that art can at most evoke through allusion, ellipsis, and indirection. . . . The torture scene of *Open City* is a seamless and natural extension of the sober and vigorous realism of the action. In *The Earth Will Be Red,* the smashed hands of the hero make us momentarily turn our eyes away, but we do not question the necessity of the shot in the development of the film. The rotting corpses piled up

in Buchenwald were like that. It is doubtful if such descriptions would have been possible in literature without falling into turgidity or sadism. And yet how much stronger the cinematic image is. But cinema is the art of reality.[32]

Bazin grants these fictional depictions remarkable weight and political importance, going so far as to compare watching such virtual acts of violence with the act of serving as witness to the Holocaust. Bazin's human realism mutually implicates medium specificity and social issues: the unique fortitude of cinema allows the image of the body to speak of national history while at the same time serving as a catalyst for international spectatorship. According to Bazin, when other media attempt to capture the nature of violent acts such as torture, their mode of description produces excesses that are inappropriate, disrespectful, or what is sometimes loosely called exploitative. In cinema, the horrors of torture resonate with purpose and priority. The brutal image of filmic realism can be hard for the viewer to confront, but it is necessary to do so. The film image seems to be imperative and have a prerogative. His essay obliges us to confront the realist image, no matter how strong, startling, or upsetting:

> Italian cinema is also the only cinema in the world able to speak on every topic without immorality. The frank eroticism of *Il bandito* and *The Sun Rises Again [Outcry]* is just as natural as what one would find in a novel. In the United States, the same scenes would unleash the wrath of the censors, and in France they would be hard pressed to avoid licentious interpretations. In this conception of cinema, compelling sincerity and an unprejudiced love of reality are the principles necessary for us to be ashamed to smirk at human acts so central to our lives.
>
> As far as their content is concerned, I see the humanism of today's Italian cinema as its principal merit.[33]

In both instances, Bazin asks us to consider the image at the limits of acceptability, decency, and the grotesque (smashed hands make us avert our eyes for a moment, and then we peer back out). The cinema is in both cases "inevitably obscene" and necessarily so. He seems to be tempting us to protest that these images have gone too far, that they are exploitative or unacceptable. If we were to do so, he implies, then we would have to sit with the moral consequences of preventing their circulation. We would join the censors who here repress the testimony of history. Susan Sontag makes a similarly bold defense of photographs of suffering. She asks why we should assume that the world cannot

handle its own image. She writes: "To speak of reality becoming a spectacle is a breathtaking provincialism. It universalizes the viewing habits of a small, educated population living in the rich part of the world, where news has been converted into entertainment. . . . It assumes that everyone is a spectator."[34] Although not Bazin's contemporary, Sontag suggests just how forcefully the logic of Bazin's brutal humanism of the photographic image carries forward into the twenty-first century. If we turn these statements around, we can begin to see how this logic unfolds: Does witnessing violence qualify as a practice of antiprovincialism? Does Bazin's sense of cinema's power contain within it a vision of a durable subject of the world who is never world-weary but always world-wise?

In and after Bazin, cinema's unique modes of observation are often imagined to predicate a new era of globalism, one in which the networks of ethical scrutiny extend beyond national borders and moral

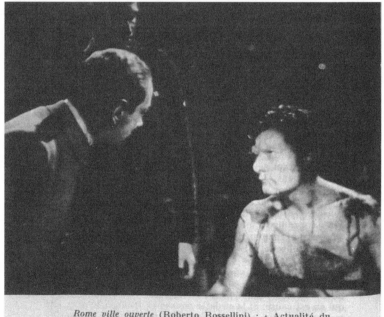

Rome ville ouverte (Roberto Rossellini) : « Actualité du scénario, vérité de l'acteur ne sont pourtant encore que la matière première de l'esthétique du film italien. »

A page from an early edition of What Is Cinema? *uses the torture sequence of* Rome Open City *to illustrate the impact of the film's realism.* Qu'est-ce Que Le Cinéma? *(Paris: Les Éditions du Cerf, 1962), 29.*

responsibility expands the traditional frontiers afforded individual sovereignty. In a conversation with Bazin, for example, Jean Renoir described what inspired him to go to India and make *The River* (1951). Renoir's description of his wanderlust reveals a similar desire to connect and discover the world through cinema that reflects a historically new and distinct politics of awareness: "I felt rise in me . . . this desire to touch my neighbor with my finger, my neighbor whom I believe to be the neighbor of the whole world of today." Like Bazin, Renoir here imagines taking his personal interactions to a global scale, transforming a private sentiment into a public, even global, act. This instinct to reach out carries a moral imperative not simply to touch but also to investigate the outside world:

> Evil forces are perhaps turning aside the course of events. But I sense in the hearts of men a desire—I will not say for brotherhood but, more simply, for investigation. This curiosity still remains on the surface in my film. But it's better than nothing. Men are tired of wars, privations, fear and doubt. We have not yet arrived at the period of great enthusiasms. But we are entering the period of benevolence.[35]

Renoir's commentary is nostalgic for a colonial encounter as much as it reflects other contemporaneous gestures of globalism. But what fascinates me here and in Bazin's writings on this film is how the specificity of this gesture of outreach bleeds into larger world relations: the end of isolationism, the necessity of international awareness and charity. The colonist's compensatory gesture of atonement represents a desire to return to the position of patron—a position that the 1947 independence has officially outlawed. *The River* makes palpable the impossibility of returning to the old order of things while ensconcing those old subject positions through nostalgia rather than destroying them, as one might prefer, with the rejoicing of emancipation. Although the cold war looms in his sense of "evil forces," and so perhaps do the decolonizing efforts that *The River* so ambivalently captures,[36] Renoir nevertheless describes to Bazin a passionate neighborliness and characterizes it as a historically driven force generated by the end of isolationism.

The 1956 essay on Renoir in *Yale French Studies* that reprinted these words recognizes Bazin as a prominent player on the North Atlantic circuit of ideas about cinema. As early as 1950, however, *Hollywood Quarterly* had already urged "intellectuals of all countries" to

follow "the example of André Bazin" and proclaimed him "a veritable apostle of the cinema,"[37] and *Commonweal* summarized his argument about *Monsieur Verdoux* in an essay on *Limelight* that focuses on audiences' relationship to the tragic and suffering characters of Chaplin's films. These references urge us to ask how well Anglo-American audiences knew Bazin before the 1960s translations of his essays so familiar to us today, which appeared first in *Film Quarterly* and then in *What Is Cinema?*. The currency of Bazin's ideas in Anglo-American intellectual circles exposes a crucial transatlantic circuit of ideas and how central the medium of cinema is to discussions of geopolitics, internationalism, and an emerging globalism.

Bert Cardullo describes Bazin as a key agent of international film culture during the decade leading up to his untimely death in 1958. Traveling comfortably in a variety of social and political milieus, Bazin was a conduit and courier of ideas about cinema in this period. Although he contributed frequently to foreign magazines and was a fixture at the important film festivals that took place just after the war's end (and that Andrew sees as responsible for the internationalization of realism), Cardullo nevertheless describes Bazin's foreign influence as mostly limited to continental Europe.[38] In one sense confirming Cardullo's view of Bazin's limited circulation, his influence on Anglo-American film culture can seem difficult to substantiate. Just after his death, for example, *Sight and Sound* reprinted his interview with Rossellini. Accompanying the interview was an impassioned obituary by Louis Marcorelles that lamented how Bazin's international popularity had yet to extend to "the English speaking world": "Widely recognised and admired, not only in France, but in Spain, Portugal, and Latin America, his work has so far scarcely reached an Anglo-Saxon public."[39] It is then surprising to find how frequently Bazin's writings are mentioned by American bibliographic resources of the period, as well as to discover that several of his essays were excerpted or published in full in English.[40] The December 1950 issue of the *American Political Science Review,* for example, listed his essay "The Myth of Stalin" under their review of key current materials for the study of the Soviet Union and Eastern Europe. *Audio Visual Communication Review* enthusiastically endorsed Bazin's essay in a collection titled, appropriately enough, *Cinema: Un Oeil Ouvert sur le Monde (An Eye Open to the World)*. A journal published by UNESCO, *Reports and Papers on Mass Communication,* cites two of his essays

in its short list of key publications on cinema from France.[41] These references remind us that many journals and magazines presumed not only a bilingual readership but also one that regularly purchased foreign books. Elite film magazines reflect this trend as well. *Hollywood Quarterly* (later to become *Film Quarterly*) and the young upstart *Film Culture* routinely, and at times systematically, reviewed the major books on cinema published in Europe.[42] In this discursive field concerned with world politics, mass forms of communication, and the redefinition of cinema as a medium, Bazin's work itself highlighted cinema as a means of nourishing an emergent global humanism. A 1952 volume celebrating the twentieth anniversary of the Venice film festival and published in English contains an essay by Bazin titled "Montage," a version of which would appear in *What Is Cinema?* as "The Evolution of the Language of Cinema." In it Bazin famously asks: "Is not neo-realism after all a new kind of humanism more than a new line in film directing?"[43]

When *Yale French Studies* published a translation of Henri Agel's essay "Celluloid and the Soul" in 1956, two years before Marcorelles would complain of Bazin's obscurity, Bazin again appeared as a key interlocutor in Agel's discussion of cinema's humanist project. Agel recounts how Zavattini told Bazin that for him cinema is "the art that best permits me to know and thus to love my neighbor." Agel expands on Zavattini's thoughts here, writing,

> The cinema must allow a fraternal hand-clasp, a spiritual embrace with one's neighbor. Because of this, fidelity to life as it is going on, to the humble and true reality of the present, is an esthetic requirement that springs from a moral one. . . . What [Zavattini] seeks is to grasp life in its creative spontaneity, in its contingency and the unforeseeable and pathetic moments of its becomingness. It is understandable that he could conclude his interview by writing that neo-realism, as expressed by Zavattini, "is the specific art of charity."[44]

For Renoir, in his comments on *The River,* cinema's ability to touch enables an era of "benevolence," or what Bazin will call "an age of goodwill."[45] For Agel, cinema's outstretched hand and firm embrace can lend a moral clarity to human relations. In either case, it is cinema's unique realism that enables an urgently necessary intimacy that can transform the other or the foreigner into a neighbor or brother.[46]

Bazin was one of neorealism's first champions, and today he remains one of its primary expositors. His writings on neorealism continue to

be taught alongside neorealist films, included in Criterion DVDs, and quoted when newspaper critics invoke neorealism to describe a current film. Interestingly, Bazin's definitive explanations don't always provide basic clarity, invoking platitudes like "love." At times, he defines neorealism more by what is it not than by what it is. Bazin, the critic who once wrote that realism was "a morality rather than an aesthetic," sees neorealism as less a style than a humanism.[47] Neorealism engages the viewer in a sociology more than in existing political dogma.[48] Its narratives are "biological rather than dramatic."[49] Neorealism, Bazin said, should never be used as noun. Instead, as Daniel Morgan suggests, Bazin saw it as "a verb, an activity, an aesthetic relation . . . a particular mode of responding to and articulating facts."[50] When Bazin describes neorealism as a morality, a humanism, a sociology, or a biology, then, he is defining it as a particular relationality.

Italian neorealist films came to prominence alongside Bazin's writings, and with them a new mode of filmgoing—a new type of spectatorship. Cinema, it seemed, was anxious to offer a new way of imagining oneself in the world. In what follows, I work to clarify Bazin's theory of the cinematic body because I believe that the corporeal is the ultimate means by which he (and others in this period) make film matter, suggesting realist cinema as the primary venue for the world's most pressing questions about the affective terms of international relations—questions about world democracy, intercultural sympathy, the status of the human, the rise of an interventionist extranational sovereignty, and the politics of charity.

The Body as Example

The semiotician and philosopher Charles Peirce once offered the peculiar rolling gait of a sailor as an example of an indexical sign. According to Peirce, this man's wide and swaggering steps reveal not only who he is, but also where he has been.[51] The mariner's body serves as a sign of the past marked in the present. In the adaptive morphology of its movement, the body transmits the man's identity by how its form maintains a residue of his historical experience. We can see this man's current occupation because of what it has done to his body in the past. Peirce invokes the historiographic qualities of the wearied body to demonstrate the unique capacity of the indexical sign to transmit meaning across a great expanse of time and space. By reminding

us of the way we read into bodies, Peirce shows us the index's power as a sign. The indexical sign offers a physical continuum between multiple planes of existence that are otherwise incommensurate. Two temporalities ordinarily understood as radically distinct experiential vectors—the present instant and the course of many years—are accessible simultaneously in the indexical sign. Of course, not all indexical signs carry the same historical depth as the sailor, and not all of Peirce's examples are quite so corporeal. Nonetheless, Pierce is able to animate the distinction by using this bodily example.

Bazin's account of how cinema represents similarly deploys corporeal examples to foreground the unusual materiality of the film image. The camera's record of bodily excesses (the body at risk, in pain, or injured) and details (markings, postures, gestures, tics, or facial expressions) fundamentally structures his thinking on the realist character of the film image and the physical nature of cinema's mediation. At our current juncture in the intellectual history of debates about cinematic realism, however, it perhaps seems coy to introduce this claim with a casual comparison to Peirce: the relationship of Bazin's ideas to Peirce's semiology has been a matter of contentious debate for some time now. In the late 1960s, Peter Wollen pointed out the similarity between Bazin's cinematic image and Peirce's indexical sign: "[Bazin's] conclusions are remarkably close to those of Peirce. . . . Bazin repeatedly stresses the existential bond between sign and object which, for Peirce, was the determining characteristic of the indexical sign."[52] Film theory's recent return to Bazin has been fraught, moreover, with the question of whether Bazin meant to describe the indexical sign when he described the medium specificity of cinema. On the one hand, scholars such as Laura Mulvey suggest that Bazin used an intricate set of metaphors and analogies to approximate what later theorists of cinema would call the indexicality of the film image.[53] Christian Keathley concurs: "Though Bazin did not use this word, he was clearly referring to . . . indexicality."[54] On the other hand, an increasingly vocal group of scholars have attempted to liberate Bazin from the analogy to Peirce. Tom Gunning and Daniel Morgan provocatively argue for considering what is lost when we align Bazin's project too closely with Peircian semiology.[55] Both sides are, however, equally committed to redeeming Bazin as relevant for understanding the major questions that have confronted film theory over the last ten years: the cinema in the digital age (is cinema's ontology changing as it leaves behind the

photographic?); the updating of ideology critique (are the surpluses provided by realist films always in service of the "ideology effect"?); poststructuralism (isn't presence actually the abiding experience of absence?); the attention to affect and the experience of viewers (how do we account for the participatory dimensions of the image?); and Deleuzian-inflected film theory (can the cinema be said to have an *image* if it is defined as the description of motion as indivisible temporality?). I return to the neo-Bazinian turn of film studies at the end of this chapter, but for now, these debates demonstrate how divided we remain on just what cinema is. Like Bazin, we seem unable to wrench ourselves away from the ambivalences of the film image. The cinematic body offers a venue through which to encounter the image's ambivalences and navigate its nuances, but if we choose to engage the body as exemplar of the cinematic image, we must remain theoretically conscious of the allures, provocations, and slippages that the idea of embodiment has too often held.

This debate between the proindex and antiindex schools of thought reflects the complexity of how Bazin understands the materiality of the cinematic image. Indeed, part of what has made Bazin a simultaneously divisively controversial and wildly productive thinker for film theory debates is that his writings are in general hard to pin down. A constant guiding force in the study of Bazin has been the work of Dudley Andrew, and he suggests at least one reason for this complexity. He argues that Bazin's conceptual framework rests in large part on "a constructive dependence on examples." Believing, along with Andrew, that Bazin's ideas cohere in his examples, I wish to perform a polemical survey of Bazin's exemplary bodies.[56] My goal in attending to Bazin's bodies in this way is twofold. I want first to open up aspects of current film theory debates: the sense that animation might be cinema's defining feature, the question of realism's modernist tendencies, the shifting terrain of presence in the film image, and the intentional inclusion of the accidental and the contingent by postwar cultural forms. I want in addition to use these examples to articulate a theory of the cinematic body that will guide the remainder of this book.

On this second count, my claim is that the corporeality of Bazin's examples—his cinematic bodies—are more than idiosyncratic textual excesses. They are consistent reference points that have in an unacknowledged way underwritten our understanding of his oeuvre. In other words, these bodies support a larger rhetoric that spans the

breadth of his writings and organizes much of our thinking on his work. How these examples support this rhetoric tells us, I also propose, something specific about postwar and later assumptions about the political nature of cinema as a medium. By returning again and again to corporeal images as examples, Bazin's oeuvre reveals the historical specificity of a postwar articulation of realism—a realism that adheres to the filmed body as the emblem of the film image's special capacities, the measure of cinema's geopolitical currency, and as a nodal point for aspirant imaginings of cross-cultural spectatorial engagement. Across Bazin's work and in its wake, the body has repeatedly supplied the metric for measuring how effectively the film image has carried the profilmic event into the viewing scenario. The body is made out to be the conduit that allows us to see the profilmic event brought semantically and sensually before the eyes of film's spectator. It is a ground on which the indelible contingencies of the profilmic are written for consumption later and elsewhere. Bazin's fascination with particular gaits, characteristic gestures, injury, and scars is in this sense not just about the inscription of a document. It is also about the storage and transport of a body: through cinema the body gains transfer to other times and spaces. But not only does the cinematic image move the body; the body also moves the image.

Animation versus Automatism

In "The Myth of Total Cinema," Bazin describes how the need to recreate "the world in its own image" has plagued the human imagination for all time. Bazin troubles the givens of film history with his elaboration of this transhistorical urge. Responding to what he sees as the technological determinism apparent in most accounts of cinema's invention, he asks that we conceive the medium more as a cultural phenomenon than as a triumph of mechanical ingenuity. He argues that a desire for cinema—part prophetic phantasm and part unconscious driving force—preceded the technological conditions that allowed its final realization. To find evidence of this abiding impetus for cinema over the course of human history, Bazin returns again and again to the dream of an image able to apprehend the moving body. Although the eventual duplication of animate forms does not complete the cinema or qualify it as "total," it is an important milestone to which Bazin continually returns. Rhetorically, Bazin's argument relies on the moving body

as the telltale mark of "the guiding myth" and as an indication that "integral realism" will be fully realized.[57] It makes sense then that Akira Lippit positions Bazin as a key figure in understanding "the photographic relation between bodies in the world and bodies on film." "The Myth" essay fits into what Lippit calls "the idiom of corporeality" that runs through both classical and contemporary film theory and suggests that cinema is in essence about the capture of bodies in motion.[58]

Although Bazin states in "The Myth" that "the primacy of the image is historically and technically accidental," the majority of his synthetic history focuses on the moment when lifelike visualizations of human movement guided the invention and elaboration of cinematic form. At one point in the essay, he demonstrates this by describing the deflated reactions of early photographers to the stillness of the very first photographs. Their nearly immediate disappointment reveals how tenacious was the drive for cinema, even in these moments of imagistic triumph. When confronted by the force with which their first cameras rendered a human being into a static and inert image, these photographers knew they had yet to achieve their "idealistic phenomenon": "Seeing people immobile in space, the photographers realized that what they needed was movement if their photographs were to become a picture of life and a faithful copy of nature."[59] Importantly, the photograph's lack is measured according to the metric of the human body. The desire that motivates cinema becomes most unbearably palpable when we are confronted by still photography's paralyzing effects on the body.

Emphasizing how the drive for cinema can be seen at certain historical junctures as a drive toward a specific kind of animation, Bazin cites Villiers de l'Isle-Adam's novel *L'Eve Future* to argue that the idea of cinema can be found more clearly articulated in abstract speculations and literary imaginings than in proto-cinematic technologies. The French novelist, writing two years before Edison had begun his research on animated photography, imagines the realization of this representational achievement:

> The vision, its transparent flesh miraculously photographed in color and wearing a spangled costume, danced a kind of popular Mexican dance. Her movements had the flow of life itself, thanks to the process of successive photography which can retain six minutes of movement on microscopic glass, which is subsequently reflected by means of a powerful lampascope.[60]

From Bazin's perspective, this novelistic fantasy more accurately anticipates cinema than do optical toys and scientific inventions of the eighteenth and nineteenth centuries that refined the mechanics of moving images. Animation comes to serve a primal psychological need to reanimate life, a desire deeply rooted in human consciousness and its history.

Bazin uses the idea of animation to describe the movement of bodies in cinema and contrasts that animation to mechanical replications of bodily movement, such as moving dolls, automatons, mechanical or windup amusements, and optical toys. For the sake of contrast, I will call this latter category *automatism*. According to Bazin, what earlier writers had characterized as protocinematic devices break faith with the inner essence of cinema. For him, eighteenth-century automatons and even the experimental equipment of Marey display an impulse to analyze movement that has nothing to do with cinema. They take the movement of the body apart into pieces in order to dissect and, we might say, demystify it, assigning it a status separate from other aspects of nature. Across his essays, he uses these examples of automatism to connote a degradation of the body and expose the futility of humankind before nature and the real. By contrast to automatism's analysis of movement, true cinema originates from and through synthesizing movement. Cinema is a fulfillment of the dream-urge for an animated image.

For Bazin, animation describes cinema's photographic (re)generation of body movement. It indicates a synthetic and indivisible motion. Several decades later, Deleuze writes in a related way that cinema "does not give us a figure described in a unique moment, but the continuity of the movement which describes the figure." In other words, cinema is not just a bunch of photograms. Cinema is the "description of a figure which is always in the process of being formed."[61] Bazin's impulses also anticipate recent work by Lippit and others that urges film theory to think of animation as the basis of the cinematic experience, the precondition of any image that we might call filmic.[62] In Gunning's recent efforts to revise conventional ontologies of cinema, he claims a similarly expanded definition of our sense of animation, arguing that movement is the primary draw of the film image. Cinema is a kinetic art, according to Gunning, one that moves and moves us in doing so: "We do not just *see* motion and we are not simply affected emotionally by its role within the plot; we *feel* it in our guts or

throughout our bodies."[63] Gunning's larger point here is that the index school has reduced our sense of what constitutes the cinematic experience, distracting us from the obvious centrality of motion to the medium's specificity. The index argument threatens to stop the image, misleading us into thinking that we can still the cinema and it will still be cinema.

In fact, we could say that for Bazin, the onscreen body's animation by cinema fundamentally enlivens the photographic image. We walk in our minds along with Chaplin; we almost feel his body in our own body. Even before we know the specifics of his particular role in a film, his form is enough to "grip" us. For this reason, the animation of human bodies holds a special place in Bazin's paradigm of cinematic representation. Given the viewer's quasiphysical engagement of the animated human form, the body emerges as the crucial experiential bridge between the moment of the profilmic and a much later moment of viewing. This body is a medium-specific entity whose corporeal presence results neither purely from the profilmic moment nor exclusively from the exhibition scenario. Its embodiment germinates from the bodies photographed, as well as from their projection and their perception by the viewer. This odd corporeal presence is a collaboration of the real, the mechanism, the apparatus, and the viewer.[64] Borrowing from Edward Branigan's definition of Bazin's realism, we could say that the cinematic body is constituted in "a complex interaction between conditions forced on a camera by both the profilmic and the postfilmic."[65]

In Bazin's sense of animation, cinema retains a level of modesty before nature. Although it is a human invention, cinema remains a mechanical form of image production. The value of cinema as a medium is that it is automated. This may be slightly confusing at first, given Bazin's distaste for what I have called automatism. Yet Bazin's account of the cinematic image is decidedly automatic, and this automatic quality is what redeems its form of replicating bodily movement. Here the camera is a device of self-activating serial image capture, which means that it is a machine that cannot dissect or reorder the dynamism of the real according to human will. Through this idea of automatic animation, Bazin shows us how the cinema remains in awe of nature. By contrast, automatism is a perverse form of drawing that is at odds with the automatic process that generates a photographic image. The fakery of automatism and the figure of the automaton

reveal the hubris of any human effort to master movement and repro-
duce its essence. As Bazin argues in some of the most compelling
analyses written on Chaplin, Chaplin's comedy effectively mocks this
hubris in its depictions of the little tramp stubbornly attempting to
make himself into—or part of—a machine while his body fights back.
Bazin's figure of the automaton is like the sci-fi film's evil robot of the
future. It exposes the futility and dangers of thinking that humans can
replicate the living body by isolating its individual traits and putting
them back together again. Would nature be less sublime at the micro-
scopic level? Would time seem any less mysterious if truly experienced
in shorter intervals? Here, in Bazin, lurks a certain antimodernist im-
pulse to refuse the avant-garde's fragmentation of the body.

As the windup toy version of movement, automatism produces a
body that is completely divorced from any vital forces of natural
movement and never vulnerable to the organic contingencies of a liv-
ing body. It is thus detached from the real or aspiration to the real. It
is a form of movement that exists in spite of the contingencies of real
bodies and that carries a dangerous artificiality for Bazin. Automa-
tism spits in the face of "integral realism." It refuses the totality that
cinema strives for—the drive toward completeness (however unattain-
able) that defines cinema for Bazin. For Bazin, automatism is an arro-
gant and doomed illusion. It is a deeply inauthentic and inevitably
unsatisfying attempt to recreate movement through a kind of secu-
larization of the vital and dynamic forces of life. As such, this kind
of trickery is a form of prosthetics—an unnatural extension of the
body that attempts recklessly to amend the agency of the individual
and hubristically to extend the faculties of human power. This Bazin
calls pseudorealism: the acquisition of resemblance without authentic
or natural origins, a form of illusionism whose creation requires con-
scious human intervention in the workings of the body.

Across his essays, Bazin targets a locus within the practice of cin-
ema that is susceptible to the dangerous prosthetics of automatism:
editing. Particularly aggressive forms of editing that effect false move-
ment and illusory vectors of action evoke the automaton, and as such,
they are antihuman and anticinematic. In an essay discussing war
documentaries, Bazin points out how Hitler's infamous dance at the
Rethondes crossroads—now fixed as a historic fact—was actually a
fabrication of editing.[66] The dictator never actually performed this
dance, and it could only be seen after John Grierson toyed with footage

of the fascist leader, running his filmed gestures back and forth in the optical printer to create a stomping jig. Because the dance arises not from any actual event but is imposed on the footage by postproduction manipulation, Bazin argues that it leaves the film spectator disadvantaged in relation to the truth, knowing less than an eyewitness, unable now to differentiate between what actually did and did not occur. In further examples, Bazin shows how fragmentary documentary footage of historical events is reedited to establish a cohesive architecture of an event. This postproduction fabrication imposes a structure of reality not present in the original images. Again, Bazin opposes the imposition of movement on the image because it makes the viewer unable to determine the origin of truth or meaning. Bazin uses the example of Hitler's dance to highlight the serious consequences of fabricating a sequence through disrespecting and perverting the image's relationship to an actual body in motion.[67] Editing operates as an aesthetic contortionist of history or worse. Grierson becomes for the French critic a "ventriloquist of this extraordinary prosopopoeia."[68] In manipulating Hitler's body and constructing an artificial historical physicality, Grierson's role is prosopopoetic; akin to a force that animates a dead or absented body, he falsely attributes life to a fleshless form. This documentary has reneged on cinema's potential to produce a truly democratic image, and it has done so by violating the sanctity of the human body on film.

Contingency, Democracy, and the Long Take

Bazin regarded the long take's innate respect for spatiotemporal unity not simply as a means of realistically approximating the real. He also posits it as a means of keeping the filmic image open for the viewer to experience according to his or her own will. The long take, or an uninterrupted shot, allows the viewer's cognition and even interpretation of the scene on screen to wander and follow its own course rather than being tethered to the guidance of an overly dominating visual narration. (Bazin associates the latter with analytical editing, or what he calls doorknob realism). Here, too, Bazin's argument hinges on the body to elaborate the politics of the image. "The Evolution of the Language of Cinema," for example, measures the power of the long take in bodily terms. By avoiding editing, a scene is able to keep intact "the unity of the image in time and space," letting details emerge from within the

framing and over real time, thus allowing the viewer a more demo-
cratic access to the consumption of the film's event. Sequences that
depend instead on editing as a form of narration stand in opposition
to this democratic approach. In contrast to the long take, "montage . . .
rules out ambiguity of expression." Kuleshov's famous examples of
editing force one meaning onto the face that appears in the reaction
shot. From Bazin's perspective, such a sequence of juxtaposed shots
dictates meaning and imposes affect on the spectator by imposing
affect and meaning on the face depicted. "The meaning is not in the
image, it is in the shadow of the image projected by montage onto
the field of consciousness of the spectator." In one key example, Bazin
compares this instrumentalization of the face by Soviet modernism
to the careful, slow, and constant meditations on a boy's face in one
canonical neorealist film: "The preoccupation of Rossellini when deal-
ing with the face of the child in *Allemania Anno Zero* is the exact
opposite of that of Kuleshov with the close-up of Mozhukhin. Rossel-
lini is concerned to preserve its mystery."[69] Here the viewer draws
directly from the image (the body) and not from its "shadow." *Ger-
many Year Zero* devotes special attention to the boy's face but refuses
to juxtapose his facial expressions with shots that would symbolize his
character or explain his actions. The film's indulgence of corporeality
does not aim to fix the meaning of the events it represents, nor does
it install the image as the single interpretation of a material world.
Rather, it uses the cinematic body to accentuate a virtual but none-
theless powerful impression of presence. This impression of presence
should not be confused with the conventional experience of presence
as direct and absolute thereness, though in many ways it approximates
that feeling in the spectator. Cinema makes possible the rewatching
of being. The image invites us to watch while telling us that we are
just watching. In other words, the image is a visual field that is becom-
ing, something that just is, but it also asks to be witnessed, a quality
that I characterize below as cinepresence. Even so, this cinepresence
confronts the viewer with the profound ambiguity of the real. This
ambiguity is not that of a blank face on which we can project just any-
thing. Fully realized, this realist cinematic body carries a vibrantly
insistent quality. This body makes visible an image that is as open as
it is certain, an image degraded when encoded, made discursive, or
appended with any semantic stability. The democratic potential of
the film image is unleashed by film styles that not only preserve the

dynamism of the body, but also are structured around encounters with that body's dynamism.

Indeed, when describing a film that depends too heavily on montage, Bazin uses the absence of bodily images as a way of characterizing how the film forecloses the "active mental attitude on the part of the spectator." In recounting a scene from the film *Quai des orfèvres* (Henri-Georges Clouzot, 1947), for example, in which sex is implied by metaphor and ellipsis (stockings thrown on the bed, milk overflowing in a glass), Bazin explains that, "a sense or meaning [is] not objectively contained in the images themselves but derived exclusively from their juxtaposition."[70] The spectator is made cognizant that sex is occurring by implication rather than display. Here meaning is not something that originates from the image or is triggered by the viewer's engagement with that image; meaning is something imposed onto the image from the outside. Bazin would have us assume that only a corporeal performance can grant an image semantic fullness while maintaining the cinematic quality of the event's representation. However, the film has chosen to elide a bodily event, and thus the basic semantics of the event must be actualized in postproduction. Editing here qualifies as what Bazin calls "aesthetic transformation." Because meaning is produced through combining individual shots of differing time/space origins into a coherent unified sequence, montage betrays both the image and the profilmic event.

In this same essay, montage appears to suppress the transformations that naturally overtake the onscreen body, foreclosing on the possibility that meaning would emerge from the image and thus from the contingencies of a profilmic body. Montage thus not only prevents the spectator from witnessing a transformation as it occurs in real time, but also regulates the spectator's epistemological relationship to the film text. Bazin quotes Renoir: "The more I learn about my trade the more I incline to direction in depth relative to the screen. The better it works, the less I use the kind of set-up that shows two actors facing the camera, like two well-behaved subjects posing for a still portrait."[71] In other words, Renoir has discovered that breaking up a scene into rigidly framed compositions negatively affects the fluidity of his actors and limits what he can achieve within the image. Renoir suggests that using greater depth allows the image to achieve greater cinematicity, or less of the stilling effects of the photograph, and frees the body from overly self-conscious and formal posing. Renoir's

mission, according to Bazin, was to strive for a "film form that would permit everything to be said without chopping the world up into little fragments, that would reveal the hidden meanings in people and things without disturbing the unity natural to them."[72] This respect for space and duration is realized best in the reanimation of the body, in reengaging the body's natural and spontaneous presence.

In "Theater and Cinema—Part One, " Bazin turns to one of the least realistic, most physical genres of cinema, slapstick, to make this point about film realism's photographic basis. Although rooted in the theatrical genres, slapstick films are classified as "purely and specifically cinematic."[73] Slapstick is an example of how certain key elements of cinematic representation led to the resuscitation of cultural forms long on the wane. The "flesh and blood farce" of music halls and circuses would otherwise have soon died out had cinema not rebirthed them in the form of slapstick.[74] In "The Virtues and Limitations of Montage," film slapstick is also important to Bazin because it predates montage and analytical editing. It succeeded as a genre "because most of its gags derived from a comedy of space, from the relation of man to things and to the surrounding world." Films like *The Circus* (Chaplin, 1928), made after the invention of montage, continue the preediting traditions of the genre, now actively suppressing editing at certain key moments in order to reestablish the image's spatial density. "In *The Circus,* Chaplin is truly in the lion's cage and both are enclosed within the framework of the screen."[75] By keeping all elements of the action within the frame, this much later film allows the gag to play out with a certain comedic force that would be foreclosed in an edited sequence of similar events. The underlying premise of this uninterrupted deep focus shot, its spatial density, is the possibility of physical danger. Although the refusal to cut the shot or break up the action into a series of different shots preserves the integrity of the event, the shot's density (its rich combination of comedy and suspense) develops just as much, and perhaps even more, from the presence of a body in harm's way.[76] Looking at the structure of Bazin's argument, we notice that the vulnerable body dilates the spatial parameters of the screen image and expands the range of spectatorial engagement. In other words, cinema's democratic strength emerges in spaces hazardous for bodies. The scenario of witnessing an endangered body triggers an opening out of the viewing subject's authority over the world viewed.

Elsewhere in the essay, Bazin rails against sequences that build tension and show action only through editing tricks precisely because they dilute the sense of danger's presence. He states, "The apparent action and the meaning we attribute to it do not exist . . . prior to the assembling of the film. . . . The use of montage was not just one way of making this film, it was the *only* way." A film event based completely on postproduction work poses a problem for Bazin because montage is both an "abstract creator of meaning" and the preserver of "unreality." For example, a crucial scene in *Crin blanc* (Albert Lamorisse, 1953), a film about a boy and his horse, fails to impress Bazin because at a pivotal moment during a rabbit hunt, as the boy is being dragged by his horse, the film divides the event into separate shots. This separation destroys the suspense of the sequence, a tension originally built on the "physical proximity" shared by the horse and the child. Although the film avoids the potential "harmful results" of fully recreating such a dangerous event, it also "thereby interrupts the lovely spatial flow of the action." He contrasts this flawed sequence in *Crin blanc* to a scene from another film in which a child is in danger. This time an angry lion corners a child. At first, this latter film's sequence establishes suspense through crosscutting and parallel editing: "Then suddenly, to our horror, the director abandons his montage of separate shots that has kept the protagonists apart and gives us instead parents, child, and lioness all in the same full shot. This single frame in which trickery is out of the question gives immediate and retroactive authenticity to the very banal montage that has preceded it." Bazin goes on to say that if the film had continued to use montage, the meaning would have remained the same but the image would have been lost, sacrificing the unfolding of the scene in "physical and spatial reality." As Bazin continues, he seems to let go of the "physical" reality, conceding that the lion was pretrained: "The question is not whether the child really ran the risk it seemed to run but that the episode was shot with due respect for its spatial unity. Realism here resides in homogeneity of space."[77] Bazin admits that the shot may not be referencing any actual profilmic danger, and yet the charge of the scene still revolves around a narrative presumption of physical vulnerability.[78] The presence of both the child and the lion in the shot are necessary; their copresence delimits Bazin's homogeneity. As Serge Daney emphatically states,

What justifies the prohibition of editing, of fragmentation, is not only, as has often been said, the exploitation of depth of field, the birth of cinemascope, or the ever-greater mobility of the camera in an increasingly homogenous space but also, and above all, the *nature* of what is being filmed, the status of the protagonist (in this case men and animals) who are forced to share the screen, sometimes at the risk of their lives.[79]

In other words, the long take emerges as a prized technique for Bazin because it maintains the contiguity of not only spaces but of bodies, thereby offering a contingency to the image that is unavailable in shorter takes. Bazin urges that "whenever the import of the action . . . depends upon physical contiguity," montage must be ruled out. Continuing to stress this point, he turns not to further examples of children's fairy tale films but to documentaries, such as *Nanook of the North* (Robert Flaherty, 1922) and *Louisiana Story* (Flaherty, 1948). Here, how a film depicts a human body in danger, whether hunting seals or alligators, serves as the best measure of whether or not a film respects "the spatial unity of an event."[80] Realism is premised on a spatial unity best made visible through the body in the midst or on the brink of suffering. Analytical editing assaults the strength of the cinematic image not because it disrupts compositional balance or diminishes the information made available through the image, but because it quells danger. It dispels the emergent contingency that the film image is always about to unleash.[81] Danger is one of the most valuable features of that image, and danger is most often measured in Bazin's writings as human imperilment.

In another essay compiled from writings in the mid-1950s, "Cinema and Exploration," Bazin begins from a different set of questions, but his conclusions about film aesthetics reveal a similar interest in contingency and the physicality of cinema's "fluid and trembling images."[82] The documentaries he discusses exhibit a "compromise between the exigencies of the action and the demands of reporting. A cinematographic witness to an event is what a man can seize of it on film while at the same time being part of it." As examples of contingency, Bazin cites both the extreme conditions endured by the cameraman in recording the final moments in the lives of his fellow arctic explorers (for example, his hands were frostbitten while reloading film) and the often accidental recordings of two scientists attempting to navigate the breadth of the Pacific Ocean with only a raft (for example, their camera happens to be

on when a killer whale collides with their tiny craft). Unlike the human explorers and the fragility of their memory, cinema defies death and defines itself against death's certainty, supplying an "objective image that gives [memory] eternal substance." "The camera is there," Bazin writes, "like the veil of Veronica pressed to the face of human suffering."[83]

The cinematic image keeps the world open to Bazin's spectator even after the fact and even at a far distance. Although seemingly obvious and general, this statement carries a particularly heavy burden in the period after the war. In the context of my particular concerns about the geopolitics of the neorealist body, this condensation of sociocultural space through the expansion of cinematic space is an interesting dynamic. Proximate to distanced views, the spectator for the long take needs something to dynamize the space, to make its impact visible. In reimagining how cinema mediated a rearrangement of spatial relations between the profilmic and the spectator, Bazin often turns to the presence of bodily spectacle to certify the openness of the image. Onscreen corporeality is rhetorically crucial to Bazin's redefinition of cinema as a medium for the transmission of spatial unity across geographical, historical, and political divides. The spatial dimensions of Bazin's humanism would therefore seem to depend on bodies. In this sense, Bazin's humanism is quintessentially liberal, to the extent that it uses an encounter with the exceptional body (or people in exceptional states of embodiment) to confirm the unity of a world community. Exceptional bodies are the exemplars of the potentiality of a human community. For understanding to transcend boundaries, it must have a vehicle of traversing these borders. The cinema's bodies are that vehicle for Bazin. For him and for many others in this period, as we will see, cinematic bodies carry the subject beyond the dangerously outmoded localism or provincialism of viewers' definitions of the human or the world. The spatiality of Bazin's spectatorship also suggests that compassion requires a subject who has unlimited access to the world—or at least to the experience of a visual field whose borders are always expanding.

Old and New Forms of Presence

Nowhere do the themes of corporeality and the transcendence of situadedness converge more complexly than in Bazin's irreverent descriptions of the presence of the cinematic image. He deploys the word *presence* as a euphemism for the odd vitality of movies: films so

tenaciously insist on something being alive that they paradoxically evoke enshrinement. Put another way, with the word *presence,* Bazin characterizes the cinematic image as the compelling but odd corollary for the experience of human existence. His discussions of presence attempt to describe the transfer of the contingency associated with physical transcription of the discrete moment and specific space of the profilmic to the time and space of exhibition. For this critic, cinema establishes a new aesthetic register—a new affective order—and in doing so, it enables a politics of being in the world. Presence is no longer limited to discrete physical spaces, and thus a new geography of being is established. This supraterritorial being is defined not just as passive existing, but as an attentive accompanying, participatory witnessing. It is, in other words, a new way of being present that is also a being present to or present for.

In "Theater and Cinema—Part Two," Bazin uses a comparison of the two media of the essay's title as a starting point in a discussion, the direct purpose of which is to evaluate the potentials and pitfalls of filmed theater. In more tacit ways, Bazin uses this comparison to argue for cinema's unique political potential, suggesting that its form of virtual "presence" has the capacity to engage viewers in a fashion more democratic and multifarious than the theater. Bazin specifically differentiates the two media by exploring their distinct modes of presence. A play requires the presence of at least two groups of humans in order to qualify as theater: actors performing onstage and an audience watching from its seats. A film requires neither performers who enact the text nor an audience in attendance. Because a film can render a performance without a human agent being present, many assume that cinema lacks flesh and blood. Cinema, Bazin states, "accommodates every form of reality save one—the physical presence of the actor."[84] At first, Bazin suggests that a theatrical production without an audience is just a rehearsal and not a performance, whereas a film can be loaded into a projector, switched on, and left to be shown to an empty room. Even without an audience of living bodies, a film's projection remains cinema. The fact that theater necessitates two physical presences (actor and audience) qualifies it as an anthropocentric medium in a way that cinema is not. But almost immediately after elaborating this commonsense opposition between plays and films, Bazin emphatically states, "It is false to say that the screen is incapable of putting us 'in the presence of' the actor."[85] Hence, within the first few pages of

this essay, Bazin has begun to overturn a conventional distinction that he originally presents as irrefutable.[86] He achieves this rhetorically by redefining the concept of presence.

Bazin states, "Presence, naturally, is defined in terms of time and space."[87] Traditionally, a person is present to us when he or she "comes within the actual range of our senses."[88] Thus, precinematic notions of presence were actually about the copresence of at least two parties intersecting at a single time and in a specific place. Cinema redefines our concept of presence because it bifurcates the temporality associated with performance. In cinema, performing bodies occupy a different space and time than viewing bodies. The camera's presence at the profilmic event compensates, however, for the viewer's absence. The camera is our surrogate, standing in for us in a place we could not get to; it is also a link to an event for which we could not arrive in time. Bazin takes further liberties with the idea of presence, explaining that the cinematic version of presence is a "relay," a "recapitulation," an offering of "artificial proximity." What makes these semantic modifications so interesting is the way that they contradict the basic dictionary definition of presence, underscoring Bazin's theory that cinema has not only made us more aware of presence as a concept, but has also both challenged our understanding of presence and extended our opportunities for experiencing live action. Through offering surrogate proximities, Bazin suggests, cinema becomes a means of geographically expanding the agency of the subject. Elsewhere in this book, I explore in greater detail the importance of this expanded agency to the politics of the postwar period. For now, let us simply note how Bazin's fairly abstract and quasiphilosophical distinction takes on a certain ideological force during a period when various national groups are being reorganized into a North Atlantic community. In this period, it is worth recalling, individuals are being asked to identify with the agency of a kind of global governance and also to accept local and national communities defined by constricted versions of democracy—or what in the Italian case was described as "limited sovereignty." That is to say, some postwar subjects experienced an expansion of their sovereignty and its purview while others were asked to accept a self-imposed limited sovereignty.

By the end of "Theater and Cinema—Part Two," Bazin leaves the reader wondering whether the pseudopresences resulting from photographic technology might engage and vitalize the spectator in ways that rival the theater.[89] Bazin's conception of cinematic presence—

what I call *cinepresence*—is radical in two ways. It suggests not only that we experience a kind of presence via a prerecorded and replayable image, but also that such an experience has historically altered our conception of presence, expanding its definition to include experiences of delay and dislocation. He argues, for example, that it is no longer redundant for a cinema's marquee to proclaim that its actors are appearing "in flesh and blood," because the idea of presence has become "ambiguous" for current audiences and does not necessitate a live performance.[90] The distinction has become necessary in a way that it formerly was not. Bazin's example of the marquee implies that viewing filmed images of the body may in fact count as a kind of physical encounter, and that the definition of physical coexistence is more pliable as a result of cinematic images.

To understand the origins and shape of his reconception of the term *presence,* we must remember that Bazin regards cinema as a medium that evolved more from the plastic arts than from the performing arts. Before photography, the distinctions between image and reality were clear. A painting, for example, presented the spectator with a view of a particular time and space now lost. The painting existed entirely distinct from the object that it represented. Portraits offered the viewer not the presence of the sitter but a reminder, a resemblance rendered through a conscious application of certain time-proven techniques. The physical presence of a portrait was rarely, if ever, confused with the sitter's physical being. Instead, the image was an "intermediary between actual physical presence and absence." For Bazin, the photograph, and later the cinema, redefine the idea of the image because they preserve the organic integrity of the world's physical relations. The automatic and physical processes that create the photographic image, combined with cinema's ability to capture chunks of time, alter the status of the image in relation to reality and resurrect the possibility that an image carries a presence. The photograph offers an impartial tracing, an automatic impression, and therefore, the photograph carries "more than mere resemblance, namely a kind of identity—the card we call by that name being only conceivable in an age of photography." Cinema adds to photography by taking "the imprint of the duration of the object."[91] Cinema makes a molding of the time in which the represented object exists and evolves.

The distinction Bazin makes here between photography and cinema is crucial to consider in relation to cinematic realism: "But photography

is a feeble technique in the sense that its instantaneity compels it to capture time only piecemeal. The cinema does something strangely paradoxical. It makes a molding of the object as it exists in time and, furthermore, makes an imprint of the duration of the object."[92] In this passage, Bazin suggests that we experience the photograph as a long-completed image. To look at a photograph is to experience the past-ness of its completion as an image. This experience thus ascribes to photography a fragmentary relationship to the event it represents. It yanks instants out of time in a "piecemeal" fashion. By contrast, Bazin suggests, most cinema spectators experience film as both a completed image and an unfolding image—a processed image and an image in process. Bazin does not claim here that the profilmic is truly simulta-neous to reception, as is arguably the case with a live video feed. The strange paradox of cinema stems from its dueling presences: we expe-rience the film image both as an account of a presence that once existed or an event that once occurred, and as an account of presence coming into being or an event unfolding. The last sentence of this quo-tation suggests, in other words, that the cinematic image gives form to both the profilmic subject matter and the time in which it exists. With his intricate phrasing, Bazin suggests that in its ability to record time, cinema provides greater substantiality to its subject by capturing it *in* time, which provides us a broader experience of the profilmic. In a photograph, the subject matter is a fixed entity bound to a past moment forever. Cinema elevates its subject to the status of a living experience, a condition; the mere object becomes an event. Bazin sug-gests further that because cinema renders its subject in time, the film image also provides an imprint *of* time. In a circle of symbiotic recip-rocation, time grants the profilmic subject substantiality, and the pro-filmic subject grants time substantiality. Bazin uses the word *duration* to indicate this substantiality. Here, in a Bergsonian fashion, time has itself become a subject. Implied in this passage is the idea that move-ment gives visible shape to time, without which time would be less perceptible, less present in the image, and hence, the image would lose its quality of presence.

Looking back at the statement, "presence, naturally, is defined in terms of time and space," we can now see that his sentence suggests at least two viable readings. On the one hand, Bazin is saying that time and space determine presence; time and space confer presence on the object. On the other hand, Bazin suggests that presence determines

time and space; here, the object lends time and space a material speci-
ficity, its solid experience tagging an otherwise random or undifferen-
tiated particular moment, and provides a signpost on an otherwise
unmappable terrain. For Bazin, the most cinematic uses of filmmak-
ing invoke the activation of both kinds of presence, keeping the two in
tension. Consequently, the image achieves presence both because it
testifies to the fact that certain things were present at the profilmic
event (it records real stuff that existed at a specific time and place) and
because it supplies the viewer with a visual experience comparable
to the behavior of things in real time and space—a virtual beingness,
or pseudopresence. Bazin's examples of presence thus follow from
what he identifies as the two main features of the cinematic image:
first, mise-en-scène as an authoritative report of the profilmic event, or
what we can call the presence of evidence; and second, the registering
of movement in uninterrupted time, or the evidence of presence. Mise-
en-scène details testify to the presence of evidence; specific objects
and organisms imprint their presence on the film's emulsion. That the
recorded image is actually based on the camera's measurement of
light reflected off the surfaces of these objects testifies to the physi-
cality of the representation. The camera's attendance at an event—
its grounding in a particular time and space—is attested to by the
appearance of these objects within the image. Neorealism, for exam-
ple, "knows only immanence. It is from appearance only, the simple
appearance of beings and of the world, that it knows how to deduce
the ideas it unearths."[93] But Bazin's realism of space is not simply
about how cinema fixes places in images. Rather, it speaks of cinema's
ability to activate space while registering an image. For Bazin, cinema
is the only medium "capable of *re-presenting* the spatial order as com-
pleted in its own block of time."[94] The dynamism allowed in spatial
unity, what Bazin elsewhere refers to as ambiguity, is relevant only
if time is comparably dense. The word *block* suggests that this chunk
of time's passage—a movement only visible with the occurrence of
change—is as important to cinematic realism as space. In other words,
Bazin's realism of space is never constituted in a static space, and
thus, the empty interior or barren landscape offers little more than
what a photograph provides. Movement is how Bazin measures the
effectiveness with which a film privileges mise-en-scène over mon-
tage. His realism of space is endorsed only by action occurring within
the frame:

The cinema being of its essence a dramaturgy of Nature, there can be no cinema without the setting up of an open space in place of the universe rather than as part of it. The screen cannot give us the illusion of this feeling of space without calling on certain natural guarantees. But it is less a question of set construction or of architecture or of immensity than of isolating the aesthetic catalyst, which is sufficient to introduce in an infinitesimal dose, to have it immediately take on the reality of nature.[95]

The "catalyst" is an object within the frame that activates otherwise static space and may be something as simple as "one branch in the wind," the example Bazin offers next. Cinema's ability to stand in the place of the universe requires movement. Hence, for cinema to grant the viewer a sensation of presence comparable to the world we experience every day, its image must not only furnish the presence of evidence (that is, contain likenesses of material things), but also supply evidence of presence (that is, life animated or in the midst of transformation). The camera/projector reproduces motion in a manner that resembles our own natural perception of motion.[96] The seemingly natural quality of movement not only testifies to the continued presence over time of the film camera, but also endows the viewing situation with an illusory copresence with the profilmic event.

The filmed body in motion, animated across space and over time, supplies Bazin with the perfect summation of these two features of cinematic presence. In comparing a theatrical event to a filmic event, Bazin turns to the depiction of death in each genre. The film of a body in harm's way or dying reveals how much the projected image maintains a type of presence despite its temporal and spatial dislocation from the event it represents:

It is true that in the theater Molière can die on the stage and that we have the privilege of living in the biographical time of the actor. In the film about Manolete however we are present at the actual death of the famous matador and while our emotion may not be as deep as if we were actually present in the arena at that historic moment, its nature is the same.[97]

Bazin's remarkable claim for our presence at the scene of the death of the matador appears anchored here by how the corporeality of the event exposes the nature of the medium—its unparalleled aptitude for capturing and preserving the contingency of life. Cinepresence abides by no national borders. In fact, we can read this passage as being about the transposition of presence across national and historical boundaries.

In the context of Bazin's calls for the democratization of vision, we find that cinema enables an audience to be "actually present" in other moments and other parts of the world. Cinema expands the subject's mobility virtually, while its presence extends that subject's sense of sovereignty over a range of events from which she was previously excluded. This is an image that, when watched, can expand the purview of the viewer. Cinepresence has a bionic effect on the spatial and temporal limitations of the image's beholder.

Of course, many films have been made without depicting any bodies, and in this way, cinema is like the other plastic arts, able to produce a nonhuman image of interest. Bazin is aware of this when he states that filmmaking is not an anthropocentric medium. However, Bazin cannot help but engage bodily examples in his elaboration of fully cinematic films—that is, realist works that exploit the medium's potential. For example, *The Passion of Joan of Arc* (*La Passion de Jeanne d'Arc,* Carl Theodor Dreyer, 1928) is for Bazin as much a factual record of faces as it is a narrative. Dreyer registers this archive of countenances with an unflinching camera, and his images confronted viewers with a startlingly unprecedented graphic accuracy. Their appearance is so unusually innovative that their reception hearkens back to viewers' first encounters with the realism of early Renaissance paintings. Hence, Bazin calls this film a "prodigious fresco of heads" and states that it

> is the very opposite of an actor's film. It is a documentary of faces. It is not important how well the actors play, whereas the pockmarks on Bishop Cauchon's face and the red patches of Jean d'Yd are an integral part of the action. In this drama-through-the-microscope the whole of nature palpitates beneath every pore. The movement of a wrinkle, the pursing of a lip are seismic shocks and the flow of tides, the flux and reflux of this human epidermis.[98]

This passage demonstrates how body detail speaks to the contingency captured by the image and how corporeality testifies to the image's ability to register the currents and convulsions that course through nature and everyday life. The body makes visible a cinematic image ripe with contingency.

The actor on stage is separate from nature; his performance stands as inorganic perhaps because his performance is based on occupying an enclosed microcosm, a false sector outside the world and fairly

insulated from that world's contingencies. For Bazin, and counter-
intuitively, this theatrical body is safely out of harm's way, and the
drama presents no possibility of real danger. Theater is separate from
the world; it can never threaten us with contingency, and thus it
remains unable to establish the transits across time and space that
cinema establishes. Theater depends on the willed performance of an
actor addressing the audience in an active, if not direct, fashion. For
a play to succeed as theater, the actor's performance must be full of
conscious intention. The stage actor is for Bazin a verbal entity, in
a traditional sense: an agent of expression whose articulation enacts
the written text. The intention to fictionalize overtly dominates any
theatrical scenario and underscores how the theater is a realm of con-
stantly conscious fabrication. In cinema, by contrast, the idea of the
actor as conscious agent of meaning can drop away. In theater, the
fictional world emerges from an agreement between the audience
members and actors, a pact that is always held in a delicate balance of
conscious will. The fictional world is destroyed when one member
of either party fails to hold up his end of the agreement—when, for
example, an audience member calls out from his seat in the midst of
the action or an actor forgets his lines midstream. Cinema does not
depend on such a contract or pact: viewers can talk back all they want
without disturbing the actor's performance, and the performances of
film actors who misbehave are edited out.

Bazin continually encourages his reader to think of the onscreen
actor less as a performer and more as a filmed body. Bazin's film actor
shares more with the human subjects of documentary than she does
with the stage actor.[99] Hence the filmed image of a body offers a
pseudopresence that yields to the agency of the spectator. The cinema
allows for an actorless drama that may include humans. Actorlessness
is exactly what he suggests neorealist films radically propose.[100] For
Bazin, an actorless cinema would bring us closer to a pure cinema.
Cinema is able to tell stories freed from human agency and less de-
pendent on the conscious expression of its performers. The viewer is
given the sense that she is watching "caught unawares." The film
actor's body is not tied to intentional meaning in the same way it must
function on stage to make sense. Because on stage the actor is needed
to give voice to the text, the function of his body is keyed to the intent
of the script, tied to meaning in an a priori fashion. Oddly, then,
Bazin's essay, which begins with an assertion of theater's attendant

tangibility in comparison to cinema's glaring absences, ends up offering an argument for the superior power and potential of cinepresence. Because the body on film is automatically generated, the body neither speaks the text nor speaks for itself. Instead, it stands as an element of the cinematic experience Bazin celebrates: an image that activates the spectator's engagement in the ambiguities of the world.

The World in Detail

The real for Bazin is something like a mass of moving, fluid, organic matter that runs through us while enveloping and surpassing us. As Dudley Andrew has it, "cinema more than any other art is naturally able to capture and suggest the sense of a world which flows around and beyond us."[101] Because of its ability to seize time and space in chunks, cinema can grasp contingency like no other medium. Bazin measures a film's "adherence to actuality" by its details.[102] Celebrating realism's "meticulous and perceptive . . . choice of authentic and significant detail," Bazin can't seem to help but invoke a reciprocal perceptual acuity on the part of the spectator. In other words, the cinema spectator can be found "glimpsing the fleeting presence" of things and meanings that they would otherwise miss.[103] Detail is thus neither just icing on the cake nor an excessive flourish used to redeem an otherwise fantastical folly. Instead, detail is a symptom of a greater world. It is an integral part of an organic wholeness.

What we often discover in Bazin's examples of the detail, however, is that the realism of space—the image's connectedness to the event— only gains value with the arrival of a body. This physical contiguity is found in the most mundane details. Christian Keathley argues that Bazin's realism fetishizes "a moment of material contact." For example, in Bazin's analysis of *Umberto D.* (Vittorio De Sica, 1952), he focuses on the film's attention to a microevent in a young woman's otherwise mundane morning routine: she shuts the kitchen door with the brush of a foot. Bazin argues that the way the camera's gaze captures this gesture lets narrative loosen and "concentrates on her toes feeling the surface of the door."[104] Here a film has realized the radical sensitivity available to the cinematic medium. There are also moments when the camera penetrates artifice and discovers a truth below a fiction's surface. Again, it is the body that remains obstinate in its retort to the artificial. To make his point, Bazin borrows from Balázs: "Seen

from very close up, the actor's mask cracks. As the Hungarian critic Béla Balazs [*sic*] wrote, 'The camera penetrates every layer of the physiognomy. In addition to the expression one wears, the camera reveals one's true face. Seen from so close-up, the human face becomes the document.'"[105] Citing this same passage, Keathley comments that Bazin looks past the character's body to see the actor's irrepressible body, "for it is there that film's privileged relationship to the profilmic reality it records registers with greatest force."[106]

Bazin understands realism as a process of transfer rather than analysis or even description, both of which he rejects for their fragmenting of the world.[107] For him, the idea of transfer captures an approach to representation that evokes both tactility and tact. Neorealist shooting style is a "wonderfully sensitive antennae," diplomatically restrained at key moments and penetrating at others but never invasive in a way that violates the real. Transfer evokes a supple contact of two surfaces in which the slight abrasion of this encounter leaves one or both surfaces with traces of the other. Cinema's propensity for observation is something like this exchange of surfaces. With neorealism, the touching is done with the utmost care: "surgery could not call for a greater sureness of touch."[108]

Bazin's treatment of the detail also suggests that this physical connection carries no absolute, permanent, or totalizing meaning. He argues that in neorealism,

> the actors will take care never to dissociate their performance from the décor or from the performance of their fellow actors. Man himself is just one fact among others, to whom no pride of place should be given *a priori*. That is why the Italian film makers alone know how to shoot successful scenes in buses, trucks, or trains, namely because these scenes combine to create a special density within the framework of which they know how to portray an action without separating it from its material context and without loss of that uniquely human quality of which it is an integral part. The subtlety and suppleness of movement within these cluttered spaces, the naturalness of the behavior of everyone in the shooting area, make these scenes supreme bravura moments of the Italian cinema.[109]

Here the body's status—it first appears as one among many facts—establishes the neorealist film as more fully cinematic.[110] The body deflects from any mannered, theatrical, or artificial residues left in the filming. If we look closely at the passage above, we find that, at first, setting and acting share a common status. However, by the end of the

paragraph, the body emerges as a privileged term. On the one hand, the body is an example of mise-en-scène, something respected by a realism of space, like other aspects of the setting. On the other hand, it is something that exposes what is valuable about respecting that realism of space, something brought out and only made available by that preservation of the integrity of space. The body is both the stage for the event and the event itself. Thus, it both allows the connectedness to the event as its conduit and epitomizes that connection as its message or material.[111]

Bazin reads the details and excesses of the filmed body as the aesthetic activation of the real in the film image. They do not simply lend a realistic appearance to the mise-en-scène; they expose a dynamism of the image that other objects might not.[112] Body detail grants the image singularity, the mark of a particular juncture in time and space. As such, the image is unrepeatable not only because humans age and bodies have histories (that is, Teresa Wright could not play her role in *The Best Years of Our Lives* [William Wyler, 1946] today any more than Harold Russell could have done so before the war), but also because humans gesture in unexpected, unstaged, and inadvertent ways.[113] In this way, the latter features of the image activate the former—always reactivating meaning, making the experience somehow fresh every time over. As we will see in subsequent chapters, the neorealist gaze often lingers over physical pain and death because even fictionalized scenarios of irreversible corporeal transformation speak of cinema's potential to capture the moment that will never be regained.[114] The cinematographic rendering of the body offers a startlingly dynamic image that fixes the fleeting while simultaneously apprehending the ambiguity of movement, the abiding uncertainties of action, and the unconscious or unmotivated forces in everyday life. In his articulations of the two types of presence offered by cinema, Bazin assigns the historicity of the film image a complex duality: it is an image that offers itself as recorded document and living testimony, a means of registration that fixes the past as a certainty while imbuing it with all the fragile and volatile ambiguities of the present. As Ivone Margulies has noted, "Images that bear the marks of two heterogeneous realities, the filmmaking process and the filmed event, perfectly illuminate [Bazin's] search for visceral signifiers for the real."[115]

Bazin's well-known discussion of amateur actors in neorealist films offers us perspective on how he apprehends these "visceral signifiers"

and the conclusions he draws from them. Bazin makes clear that the significance of the nonprofessional actor depends on the presence of professional performances in the same films. This tension between the natural and the simulated stands at the heart of his conception of realist aesthetics. He writes: "It is not the absence of professional actors that is, historically, the hallmark of social realism nor of the Italian film. Rather, it is specifically the rejection of the star concept and the casual mixing of professionals and of those who just act occasionally." By "play[ing] their day-to-day selves," amateurs destabilize the aura that surrounds well-known actors. The strategy of casting these professionals in roles outside their visual milieu also achieves this effect. Neorealism borrows well-known actors from less serious genres of performance, such as the music hall, in Anna Magnani's case, and then inserts them into a social drama in a weightier, less fantastical register. By interrupting audience expectations of these performers, the film allows the audience to see the actors anew. This component of realism in this way reconfigures the viewer's understanding of performance. The neorealist film presents us with a unique mixing of two approaches to acting within one performance scenario: stars straining to meet the stylistic needs of a genre to which they are unaccustomed act alongside amateurs performing for the first time. This "amalgamation" speaks of a tension between professionalism as imitation, aligned here with conscious expressivity, and nonprofessionalism as an index of contingency, aligned here with a lack of self-consciousness or a fresh innocence akin to that of the child actor whose "inexperience and naiveté . . . cannot survive repetition."[116]

For Bazin, the ultimate merit of the amateur lies in his or her body and its history, much in the way that the rolling gait gives away Peirce's sailor. Bazin applauds the casting of nonprofessionals who share biographical features of their characters. For Bazin, the toothlessness of the mother in *Two Cents' Worth of Hope* (*Due soldi di speranza*, Renato Castellani, 1952) exemplifies what he sees as the film's casting philosophy: "All the characters are naturally drawn from the premises."[117] Bazin's belief in the potency of such performers should not, however, be seen as an abstract faith in reenacting recent history with the real agents of history. Their value comes not from any conscious knowledge they might impart to a film. In the film *The Last Chance* (*Die letzte Chance*, Leopold Lindtberg, 1945), actual "airmen shot down over Switzerland" play Allied soldiers,[118] but the value that

these veterans offer the film comes not in any expert advice, script consultation, or corrections to the authenticity of the scenario. Instead, it is physiognomic peculiarities that first fascinate Bazin, as if the lives of these amateurs can be read on their bodies and in their movements. Compared to the authentication supplied by the actual doctors behind the scenes of medical dramas, the contribution of the veterans is inadvertent and unwitting:

> The nonprofessionals are naturally chosen for their suitability for the part, either because they fit it physically or because there is some parallel between the role and their lives. When the amalgamation comes off . . . the result is precisely that extraordinary feeling of truth that one gets from the current Italian films. Their faithfulness to a script which stirs them deeply and which calls for the minimum of theatrical pretense sets up a kind of osmosis among the cast. The technical inexperience of the amateur is helped out by the experience of the professionals while the professionals themselves benefit from the general atmosphere of authenticity.[119]

If we look carefully at this passage, we find that the way the amateur literally embodies his character, his physical particulars, are accentuated, even made visible, by the presence of the professional actors. At the same time, the amateur's physiognomic authenticity also appears to rub off on the professional actor, and it marks the shift in the latter's status from performer to component of the spatial mise-en-scène. The authentic physicalities of some bodies underwrite the realism of others by contributing a "general atmosphere of authenticity." The incongruities of these two types of onscreen corporeality, one consciously and the other unconsciously motivated, form a crucial dialectic for Bazin.

In a similar fashion, Bazin argues in his *Bicycle Thieves* essay that neorealism's innovative style derives as much force from the movements and details of amateur performers' bodies as it does from "authentic settings." Describing the casting process, Bazin explains that De Sica went to exhaustive measures to find his lead. Refusing to settle for an actor who could only approximate a certain type, De Sica searched endlessly for a man who already fully embodied the character: the "worker had to be at once as perfect and as anonymous and as objective as his bicycle." When auditions were completed, De Sica had awarded none of the main roles to professional actors: "The workman came from the Breda factory, the child was found hanging around in the street, the wife was a journalist." Comparing the merits of the professional to the untrained actor, Bazin notes that the person reenacting

his own daily routine has a different but comparable number of "gifts of body and of mind."[120]

According to Bazin, the aesthetic scheme of this film is structured around the ways that these untrained bodies make faces and hold gestures, around that "purity of countenance and bearing that the common people have." *Bicycle Thieves* is told through a particular "walk," a contrasting kind of "dawdling," and the resonances of other gestures. The boy's body has a key function in both the story's structure and the mise-en-scène, and the boy who played the part was cast with the specifics of his body in mind: "Before choosing this particular child, De Sica did not ask him to perform, just to walk. He wanted to play off the striding gait of the man against the short trotting steps of the child, the harmony of this discord being for him of capital importance for the understanding of the film as a whole."[121] For Bazin, this film's independence from any scripted or artificial mise-en-scène frees the action of bodies and grants their onscreen presence a powerful immediacy, a palpable importance in the moment. Bodily performances are given full reign in *Bicycle Thieves;* they are authorized to dictate the shape of the narrative and narration in a manner that Bazin finds akin to Chaplin's privileging of physical antics over plot structure.

By referencing Chaplin here, Bazin illuminates another stylistic innovation of neorealism in general and of *Bicycle Thieves* in particular: a respect for the accidental. Bazin's example of nonnarrative episodes that take over the narration in otherwise story-driven sequences involves the body. "In the middle of the chase the boy suddenly needs to piss. So he does." With this film, cinema "has reached that stage of perfect luminosity which makes it possible for an art to unmask a nature which in the end resembles it."[122] Bodily contingency serves as a marker from which the predetermined and predelimited are redeemed. Unconscious gestures and movements counter the intended meanings of a rigid script. Although famous for his extensive planning, the beauty of De Sica's approach is how his aesthetic structure allows fugitive elements to come through in all their variance, ambiguity, and luminosity. Above, I mentioned how Bazin valued the amateur for the way in which his body contaminated the film image with its authenticity, inadvertently refracting and bolstering the performance of trained bodies. In his description of De Sica, Bazin positions corporeal contingency in a similar manner. The bodily accident appears

to liberate the preconceived aspects of a film, reanimating the cinematic image by infecting it with a certain vitality. According to Bazin, "chance and reality exhibit more talent than all the filmmakers in the world."[123]

A brief comparison to Roland Barthes's reality effect may help to clarify by way of contrast the general function of the detail in Bazin, and the specific function of bodily contingencies within his conception of realism. For Barthes, when a text lavishes attention on nonnarrative detail, it endeavors to produce the effect of authenticity; it makes false gestures to sources, poses as a gatherer of raw material, and flaunts a fallacious proximity to the real. Bazin's appreciation for detail comes close to endorsing what Barthes indicts; at times, Bazin appears to embody "the reality effect's" perfect dupe. For example, an otherwise highly aesthetic (which is to say unrealistic) film redeems itself in Bazin's eyes through its inclusion of small nonstylized features. These details, "chosen precisely for their 'indifference' to the action," function to "guarantee its reality." However, from Bazin's viewpoint, it would be ridiculous to think that films truly substitute for reality. In his existentialist cosmology, essence proceeds from experience, not the other way around. Sane people do not depend on cinema to get their physical bearings on reality: as Bazin points out, one would have to be highly imperceptive to "derive one's sense of reality from these accumulations of factual detail."[124] Rather, these details exemplify cinema's unique ability to respect the contours of the real and reveal how this medium engages its viewers in the registration of those contours:

> It is clear to what an extent this neorealism differs from the formal concept which consists of decking out a formal story with touches of reality. As for the technique, properly so called, *Ladri di Biciclette,* like a lot of other films, was shot in the street with nonprofessional actors but its true merit lies elsewhere: in not betraying the essence of things, in allowing them first of all to exist for their own sakes, freely; it is in loving them in their singular individuality.

In this passage, Bazin differentiates "decking out . . . with touches of reality" from a style of realism he celebrates. Elsewhere, he is careful to distinguish neorealism's observational approach from the use of detail in naturalism's "novel of reportage." Rather than a formula of filmmaking, a dogma demanding the presence of certain real elements, neorealism is a stance toward the things of the world. It is an attitude

that respects the shape of how those things exist. The source of De Sica's art derives from his "inexhaustible affection for his characters," the "tenderness" he shows toward "human fauna."[125]

For Bazin, the value of detail is the certainty of its uncertainty, reminding us that reality's meaning is not determined ahead of the image's consumption. The viewer encounters the image in a manner similar to encountering something in reality, and hence his or her reaction is never firmly set. In the essay "Cinema and Exploration," Bazin likens random and accidentally recorded moments of drama on the high seas to the idea of "flotsam."[126] These visual remnants reference a wholeness. They are left over, but they also offer us a way of experiencing a whole and a past we do not have access to without foreclosing the meaning of that past.

The Body as Trope

Bazin often wrote for journals and newspapers geared to general audiences. He saw himself as a film educator, aiming to deepen the public's intellectual and aesthetic engagement with the popular medium. Perhaps because of this public address, Bazin's writings employ a rich figurative language to ground his arguments, rather than using a logical procession of evidence or other forms of proof and logic. While drawing on the cultural milieu of the French middle class with references to theater, literature, and mythology, his rhetoric also heavily relies on detailed tropes and sensual metaphors meant to appeal to the reader's common sense, visual associations, and knowledge of nature. Dudley Andrew argues that Bazin's "endless store of metaphors and analogies" anchor his otherwise unruly theory of realism.[127] In the process of describing how Bazin uses metaphor as a form of proof, Andrew divulges the bodily nature of the most central of these figurations: "Bazin tried to demonstrate the reasonableness of the reality axiom through a store of metaphors which likened the film image to a deathmask, a molding of light, a veil of Veronica, and so on. These figures have the effect of seducing us into a belief in the axiom."[128] This next section of the chapter examines the corporeal quality that distinguishes so many of Bazin's metaphors, arguing that this particular implementation of the body as trope reflects a critical shift in how the medium of cinema was imagined over the course of the twentieth century. As we shall see, Bazin rarely imagines the technology of cinema

(the machines that produce moving pictures) in bodily terms, resisting the impulse to see the camera as an extension of the human body à la Vertov's camera eye. Instead, Bazin analogizes the results of that machinery through corporeal figurations. Of the many forms taken by these rhetorical devices, including Bazin's tropes of geological phenomena, it is corporeal figures that most dramatically bring to life— or perhaps haunt—Bazin's articulation of the resonance and power of the moving photographic image. On the one hand, the image often has the qualities of flesh in Bazin, standing "raw," "trembling," and naked in his prose. His writing is filled with statements such as, "With film, we can refer to facts in flesh and blood."[129] He also states that watching cinema is akin to seeing the "world stripped bare by film, a world that tends to peel off its own image."[130] On the other hand, the image is something that carries the trace of a physical contact with a body, as in the masks, moldings, and veils mentioned above by Andrew. Why does Bazin require these corporeal images in order to explain the image? What are the means with which these figures "seduce" us toward the axiomatic, to borrow from Andrew's characterizations? And what are the by-products and side effects of these seductions vis-à-vis our understanding of cinematic realism?

The body allows Bazin to figure the image's relationship to materiality as palpable and sublime, but also as politically and socially relevant. The body's force supplies Bazin with an essential metaphor for speaking more precisely about the image's paradoxical existence and cinema's ability to reawaken a transcultural humanism the world had neglected during the war. The figuration of a human *being*, the body alive, metaphorically brings to life the ever-changing and ambiguous wholeness of the world. In an era so familiar with the horrors unleashed by fascism, the costs of repressing the world's diversity and mutability were no longer simply abstractions. Only cinema seemed capable of acknowledging the fullnesses of this vital and ever-altering world. For Bazin, cinema not only accommodated itself to these qualities; in its radical ability to transfer chunks of existence, cinema could help to propel us to engage in that diversity and mutability. Unlike any other medium, Bazin argues, cinema can extract the momentary, the fleeting, and the uncertain in a portable form, making possible a diegetic experience comparable with our experience of the world and the contingencies it presents to us daily. Carnality inflects his descriptions of cinema's ability to render that world, and the real is anatomized.

Cinema seems to corporealize the world, both anatomizing the real and suggesting that an experience of the real is a bodily experience. "Renoir's films are made with the skin of things," Bazin remarks, going on to liken this director's camera style to a "caress," suggesting that the image results from a massaging of the event by the medium.[131] Here style is determined by the shape of the event. In fact, style seems constituted in these most minimal means, confined to merely the contouring of the profilmic material, carefully allowing the shape of reality to delimit and guide the camera work. From Bazin's perspective, Renoir refuses a traditional approach to film style. Renoir's strength comes from his modesty in relation to the event, his satisfaction with simply tracing reality's shape. When a film missteps, he suggests, it is often because it allows its story to predetermine its form—the shape of its images and of its story's telling. With this in mind, when we encounter Bazin using the body as a corollary for the filmed image, as he so frequently does, we should think of his broader political imperative: the body animates the postwar period's need to maintain its understanding of a mutable world and human *being*. Put more simply, Bazin uses a rhetoric of the bodily to remind his reader of the humanist stakes of the film image. With this rhetoric, he can reconceptualize cinema as an experiential venue for exploring the human and the humane. Cinema is not just an epiphenomenon of humanism. It is a humanism.

Bazin celebrates the work of De Sica because like Renoir's, it refuses to take a heavy hand in reshaping the world. The drama of *Umberto D.,* for example, emerges for Bazin from the simple and mundane moments that make up the existence of a "person to whom nothing in particular happens."[132] Bazin regards this film as a brilliant departure from most filmmaking because its subject is "entirely dissolved in the fact to which it has given rise."[133] This film provides "a cinematographic 'report,' a disconcerting and irrefutable observation on the human condition . . . making us aware of what it is to be a man."[134] Here the spectator realizes the truth of human existence through a mediated form. A mechanical recording grants the spectator the truth of lived experience. Bazin also uses *Umberto D.* as an example through which to admonish what he characterizes as an a priori style of filmmaking, an approach rigidly determined by a set of pregivens: "When a film is taken from a story, the latter continues to survive by itself like a skeleton without its muscles."[135]

Bazin argues that a respect for duration or "life time" is what differentiates *Umberto D.* Its success derives from its understanding that cinema "presents man only in the present." If De Sica's film has muscles and flesh, then this substantial materiality emerges from the long take, which exposes its audience to large uninterrupted blocks of time and space that take account of life's actualities in a perceptually familiar form and reveals states of being otherwise lost. In fact, the essential substance of what film can capture resists secondary or post hoc description. For Bazin, a recounting of a film's simple visual events to someone who has not seen it provides only an "impalpable show of gestures without meaning, from which the person I am talking to cannot derive the slightest idea of emotion that gripped the viewer."[136] Such secondhand accounts can never possess the dynamic physical attributes of the film image itself and thus cannot reproduce its "gripping" impact. Hence cinema exposes the paucity of language, the verbal, the linguistic, and the discursive.

Bazin's early foundational essay, "The Ontology of the Photographic Image," powerfully figures the preservation of durational time as the consecration of flesh. In this essay, corporeal figurations add weight to his central claim that the photograph carries a legacy of physical intimacy with the event it represents. Throughout his writings, when Bazin characterizes the photographic process as a kind of transfer or tracing, he uses repeated references to relics, fingerprints, death masks, and other moldings. But this highly productive family of analogies finds its first and strongest articulation in this early essay.

Given their frequent quotation, these potent metaphors demand careful reconsideration as figurations of the body. Toward the end of "The Ontology of the Photographic Image," for example, Bazin draws a momentary distinction between photography and cinema. He does not expand on the ontological differences of these two media in great detail. In fact, as he concludes his essay in the few paragraphs that follow, he appears to collapse cinema back into photography. Though brief, his comments clearly indicate that cinema moves beyond the limits of photographic representation. A nuanced opposition is compacted into a few analogies, and these analogies demand our closest attention.

In these few paragraphs, Bazin links photographs to the embalming of time, as in the stopping of an instant and then the freezing intact of a living moment.[137] Like the amber that suspends ancient bugs, the

medium that preserves the movement of time for later viewers also kills it. In comparison to cinema, photography's process imposes more on the reality it preserves; it is much more like the hunk of amber in which the insects are suspended. The amber is a clear medium that preserves their form and grants the insects a visibility. It also comes to radically define their materiality. The delicate, fragile, and tiny forms of the insects are confined to spend eternity stiff and subsumed by a piece of resin. The hard amber supersedes their living existence. It replaces the alive, evolving, and mobile qualities of these beings with a permanent record. By contrast, cinema's mode of capture does not deanimate. It can capture events *in* time. Cinema does not cheat time in the same fashion that produces the subjective convulsion induced by looking at a grandmother's high school graduation picture. It preserves more than an individual juncture in time; the instantaneous is not stuck but rather left in flux. Rather than arresting change, cinema transfers it, capturing not just basic movement but substantive transformation.

For Bazin, representation has always been driven historically by a desire for preservation of life. Over the ages, the human desire to cheat time, to win the battle with death, has led to ever more sensitive means of making images. Bazin's central imagery for describing these efforts is processes that preserve bodies in tombs. Similar to the uncanny visual impact of a mummy unwrapped several thousand years after death, films can often seem alive with a moment already passed. With his famous metaphor of the mummification of time, Bazin clarifies his sense of how cinema differs from the amber of the photograph. According to this metaphor's logic, techniques such as the long take supply the image with its fullest range of capturing duration. Duration allows expression of the contingent both within the image and at that image's reception. Through these means of preserving the mutable, cinema redeems itself from its traditions of spectatorial enslavement and opens up the possibility of a more engaged cinematic spectator. Reception is reformed, in this vision, to allow for openness, variability, and contingency.

The semantic power of the "change mummified" metaphor comes, however, from the dialectical outcome of the struggle between these paired antonyms. Bert Cardullo argues that "Bazin founds his critical method on the fecundity of paradox—dialectically speaking, something true that seems false and is all the truer for seeming so."[138] The

phrase "change mummified" suggests the preservation of change (a recorded duration). It also, and more subtly, suggests that cinema's mode of preservation is particularly adaptive. In this sense, "change mummified" implies an encapsulation of a forward movement in time, the potential of the preserved object to maintain its characteristic structures, and its transformation over time. The phrase ultimately captures the way cinema evokes the startling sense of nakedness— of witnessing past changes, present changes, and the in between at once—that consumes us when confronting the unwrapped visages of Egyptian royalty at the British Museum.

Philip Rosen has written on the English translation of this text, emphasizing how "change mummified" articulates cinema's ability to stop the passage of time through storage, and to provide unique access to the experience of living as change over time. Cinema preserves an event while keeping intact the integrity of the transformations of time through which that event evolves.[139] For Rosen, then, it is "the trope intertwining the time-filled with the timeless,"[140] and as such, it describes the oxymoronic qualities of Bazin's spectator: desiring to stop time without invoking death, to be both of time and outside it. As Laura Mulvey says of this phrase, it points to cinema's blurring of the boundary between duration/living and stasis/death.[141] Cinema is both alive deadness and living death.[142]

Cinema's preservation process is then more like enshrouding than it is embalming. To capture an image, the photograph fixes the world with an inflexible finality. Cinema aspires to account for reality without arresting the fluidity of life midstream. The filmed image is more about transcending the limits of time's passage and maintaining time's shape than it is about concretizing the moment. Although mummification is certainly a type of embalming, it differs from a method that simply replaces the body's fluids with foreign substances. As a preservation technique uniquely defined by wrapping the body with narrow strips of linen emphasizes, it involves touching the surface of the body. Mummification is a protective process that maintains the body's outer shape from the outside, rather than chemically altering the physical nature of the body.[143] We can begin to draw from this subtle distinction between embalming and mummification a contrast between the photograph and the film. Cinema allows the object that it represents to exist in a more dynamic condition than does photography.

Bazin does and does not objectify images produced by cameras. The sentence that ends a paragraph comparing painting to photography suggests that the photographic image is the same thing as the model.[144] At other points, Bazin insists that we not equate the image's objectness with that of its source. For example, he states that unlike the ancients, contemporary viewers do not mistake image for original. Egyptians were highly literal in their consumption of statues and paintings. To paraphrase Bazin, we might say that these ancients *reified* a living person in the body, a form that could, in turn, be fixed in an image. The essence of a living being was not lost when preserved by sculptural, taxidermic, or pictorial means. What Bazin stresses is that this naive belief in the preservation of life through the reification of the body was not simply a religious belief, but also characteristic of how Egyptians consumed images. For them, the distinction between representation and reality was either not visible or at least not acknowledged cognitively. The image became a thing itself, an entity that shared lifelike features.

Bazin's series of seemingly contradictory statements in this essay, I would argue, do not reveal logistical oversight but rather his stubborn refusal to hierarchize the object over the image. These paradoxical moments allow Bazin to discuss photographic representation without posing a battle between the original and the imitation. The richness of this essay comes from its description of representation and the represented as sharing different but parallel (equivalent) experiential ontologies. What may be confusing at first is that the ontology of photographic media is derived from a direct relationship with reality. In arguing for cinema's sensitivity to the shape of reality, Bazin emphasizes the connection between film and the real in tactile terms. The density of the resulting image encourages nearly the same variances in perception that the world itself enjoys. Yet the photographic image clearly has its own ontology, one distinct from reality. In other words, Bazin proposes a subtle account of representation as part of our world, an account that radically refuses to distinguish an experiential volumetric or intensity shift between the perception of an object and the perception of a representation of that object.

As Bazin writes, "cinema aids our discovery of nature," and for him, this discovery arrives to us through two physical materials: a film emulsion likened to skin, and the "supple" bared surface of the projected image. The certain fleshiness that Bazin attributes to the image

throughout his writing testifies to how fully mechanical reproduction preserves what he specifies as the "genetic"—we might say organic— nature of the world.[145] The medium emerges from these characterizations as indiscriminately exacting in its perception, especially when measured by its involuntary sensitivity to the more organic features of existence. This means that the photographic image is always infected with contingencies, and this guaranteed surplus of visual information or undifferentiated mass of data means that the image carries with it historical detail otherwise lost in more conscious means of representation. From this perspective, the image also avoids a fixed meaning. It admits from the outset that meaning's application is always problematic, that the past is never fully knowable, that our understanding of reality is always developing, and that our vision of history is always just emerging. By granting sensuality to the image, Bazin refers to the impressionability of the recording process. Bazin's metaphors here seem to imply that cinema touches the real, or that filming is a process that takes a rubbing or molding of nature in all its breadth.

In this complex elaboration of a new form of representation outside human intervention, Bazin radically deanthropomorphizes photographic media and their technical equipment. He refuses the early twentieth-century analogy of the camera and the eye, popular in both the European avant-garde and Soviet modernism. His spurning of this common metaphor also contrasts with important theories of cinema that postdate him, especially 1970s apparatus theory, which implied that the projection and exhibition of cinema anesthetized or numbed the body of the spectator by introducing a corpus of the apparatus. Bazin always addressed the camera as a nonliving agent of image production, and hence, described its automatic processes as "irrational," as in unthinking, impassive, nonselective, and unguided. The camera is a depersonalized machine in Bazin's writings, as is clear in his use of the word *objectif,* which, as translator Hugh Gray points out, plays with the fact that the French word for *lens* is close to the word for *objective.*

Bazin decorporealizes the photographic process in an effort to resuscitate the vital dynamism between image and viewer, vivifying both the object of the camera's gaze and the spectator's reception of that image. Following Branigan's impulse to read any theory's use of the word *camera* as a symptom that exposes the theory's presumptions about representation, I am stressing the importance of Bazin's

deanthropomorphized camera in the context of bodily examples and tropes.[146] His dependence on corporeal images offers us a way of specifying his version of the real, and by understanding how bodily metaphors typify relations between object, image, and viewer, we gain a more precise view on the politics of his aesthetic project: a vision of cinema that embraces automatic image production for the way that it liberates representation from human intervention. The action of the conscious mind deadens the resulting image, cutting down on its living qualities. The mind of a painter contaminates his painting with forced meanings and the rigidity of a single perspective, and thus forecloses on the viewer's engagement and the activation of her own judgment. By contrast, the film image comes to the viewer with an openness intact; the film camera's processing of rendering results in an image whose address is inclusive. For Bazin, then, the cinema becomes a tool for fostering a world less threatened by the whimsy of an individual will.

Given its sensitivity to movement, change, and hence the general flows and contours of physical reality, cinematic representation resists a reification of the world in a single image. Furthermore, when used to its fullest potential, as in the sequence shot, cinema does not demand a single psychological orientation to the event. By maintaining the dynamism of the profilmic, favored Bazinian techniques such as "decoupage in depth" encourage an uninhibited democracy of vision, a dispersal of attention, an unfettered and active scanning that must chase action within the visual field. Unlike amber, which fixes the living body in one position and grants the viewer a single frozen account of the life it preserves, cinema reanimates the living world, representing it in a more intricately sensitive and responsive fashion.

Bodily metaphors supply Bazin with a figuration of the instabilities of the automatic image. The human body demonstrates what about cinema stands outside conscious thought. The image always confounds human will, if even for just an instant. The body's inadvertent impulses and involuntary reflexes come to typify our inability to control completely the contents of the film image. The body certifies the ambiguity of the world and life, not the fixity or closing down of meaning. As Rosen points out, neither the pregivenness of the concrete nor its physical establishment in the image predetermine that image's meaning for Bazin.[147] Nowhere is this made more evident than in Bazin's recourse to examples of the filmed body and corporeal

metaphors. By endowing film with corporeality, Bazin does not mark its images with fixed or certain meanings. Instead, by granting film an "aesthetic biology," Bazin means to point out how effectively the image carries the organic and thus ambivalent nature of the real.[148]

Bazin's Presence Today

In previous decades, the image emerging from Bazin's essays was often considered unfashionably clunky and too material for film theory or for modernist envisionings of cinema. In the 1970s, for example, Raymond Durgnat was struck by how the critic's work was held back by its fixation on physicalities: "a certain 'fetishism' often cramps Bazin's intelligence."[149] Annette Michelson deemed his approach "fundamentally antipoetic, resolutely anti-modernist."[150] In a sense, these detractors read Bazin's interest in the image as a simplistic embodiment of presence. Perhaps in an effort to both redeem Bazin from 1970s film theory's accusations that his realism is naively complacent with dominant ideology and to posit his continued relevancy to contemporary visual culture, recent scholars have shifted away from this view and begun to point out how frequently Bazin describes the film image as an encounter with a conspicuous deficiency. In this more recent view, Bazin emerges as primarily "a theorist of absence."[151] These scholars reread his work in ways that suggestively connect his ideas to the theoretical moves of the last thirty years, passing his mummies, crabs, and corpses through deconstruction and postmodernism like a baptism.

This new work proposes that absence haunts Bazin's writings in three vectors: existence (a lack of thereness), volume (a lack of completeness), and temporality (a lack of nowness). The first claim is that Bazin's image proposes an emptying out, loss, and effacement of material existence. The image depicts death more than life.[152] The second claim is that a lack of solidity plagues Bazin's image, which allows only a partial view and is replete with a radical opacity or indeterminacy. So while we often find Bazin asserting the fullness of the image, such as when he champions a film style for its "limpidity," these recent scholars find a Bazin who is transfixed by images that lack clear completion and remain hardly knowable.[153] The third proposition aims at the presumed presentist aspirations often ascribed to Bazin's image. These rereadings propose that any living or contemporaneous

qualities that he grants to the film image are undercut by his attention to the image's evocation of delay, lag, and dislocation.[154] Each of these three rereadings proposes a variant of absence that describes not only the image's lack, or its inadequacies in comparison to the real, but also an experiential separation felt by the viewer toward the image. All three recognize a rift between the viewer's world and the image's content. The image addresses its viewer with a deficit, a limit point, an anachronism. Dudley Andrew's most recent reframing of Bazin's work emphasizes all three of these absences: "the clear Sartrean categories of presence and absence give way to intermediate concepts with names like 'trace,' 'fissure,' and 'deferral.'"[155]

In this context, my insistence on the bodily features of his realism may seem to unfairly forestall Bazin's reintegration with more current paradigms. Why drag Bazin's bodies back from the past? In the remaining pages of this chapter, I look briefly but closely at the neo-Bazinian turn. I do so in order to suggest that the current debates constituting this turn both refract and reflect something crucial about how realism functions in the 1940s and 1950s, when it becomes a structured approach to toggling between absence and presence, distance and proximity, foreignness and intimacy. Between the version of Bazin as a dangerously naive realist (the bête noire of 1970s film theory) and the version of Bazin as the protopoststructuralist modernist, there remains the Bazin who is trying to form a politics of the image geared to his current world situation—one who is just as ambivalent about the image's absence as he is about its presence.

In the preceding pages, I outlined how Bazin's notion of filmic embodiment emerges alongside an unconventional definition of materiality; his real is dynamic, perpetually in flux, and not always, if ever, accessible in its totality. In his elaboration of cinepresence, Bazin points out the vital but physically paradoxical forms of presence that cinema registers for its viewer. My persistent emphasis here on the corporealism of Bazin's work directly questions the tendency to understand Bazin as a theorist of either presence or of absence. My account of corporeality suggests, in other words, that while Bazin's notion of cinema reorients our relationship to the spaces in which materiality resides, the image's obdurate visual presence does not in fact disappear. In Bazin, as well as in other theories of realism from this period, it remains urgent to recognize the palpability, inadaptability, and insistency of the film image. He writes that the photographic nature of

cinema makes the presence of the image inescapable; even the most fantastical films cannot divorce themselves from "the inalienable realism of that which is shown."[156] As does this quotation from Bazin, my accounting of Bazin's cinematic bodies makes his particular juncture in the intellectual history of the realist image less amenable to a general twentieth-century modernism or an emergent late twentieth-century postmodernism. As I will suggest in just a moment, failing to recognize the corporeality of Bazin's cinema threatens to overlook the immediate political scenario that he aimed to address in his aesthetics.

Of course, not all neo-Bazinians see in the Bazinian image a total absence. In fact, many scholars have returned to Bazin for the precision with which he articulates the lush abundances of the image. In his intellectual history of cinephilia, for example, Christian Keathley regards Bazin's cinema as that which can recover "a sensuous experience of materiality in time."[157] In *The Material Image*, Brigitte Peucker foregrounds the bodily nature of Bazin's theory of the photographic image. Peucker tells us that Bazin insists on the photograph's "indexical quality, on the manner in which, in registering the body's imprint, the photograph records something of its materiality."[158] For both scholars, the image's amassing of sensuous or bodily materiality does little to endanger Bazin's intelligence, poeticism, or modernism. These qualities actually make his paradigm congruent with the sophisticated theorizations of cinema that have come to dominate the late twentieth and early twenty-first centuries. Bazin's fetishes are seen to anticipate the sensitivities of auteur criticism (Keathley) or to rival the sophistication of later film theory (Peucker).

It is perhaps Tom Gunning's work, however, that most forcefully activates the presence of Bazin's image in this way. In gathering evidence for his argument against the idea of cinema as an indexical medium, Gunning uses Bazin to reassert the cinema image's presence. As mentioned earlier in this chapter, Gunning proposes that the concept of the index has confused our sense of the film image's realism because the index always "points the image back into the past" and pulls us away from that extraordinarily vibrant and kinesthetic presence with which the film image confronts us. Our intent to find indexicality in the film image has distracted us, he argues, from cinema's most dynamic and essential feature: motion. Movement always avows the presentness of the image. Borrowing from Christian Metz's essay "The Impression of Reality," Gunning writes, "The movie spectator is

absorbed, not by a 'has been there' but by a sense of 'There it is.'"[159] This thereness, plus a palpable proximity and a feeling of participatory engagement, all emerge from Gunning's refashioning of the cinema's ontology around movement. Here Bazin's writings provide a crucial account of the image as nonindexical. Bazin interests Gunning for the way he "assert[s] a nearly magical sense of the presence delivered by the photographic image."[160] Elsewhere, Gunning describes Bazin's account of this image as "putting us in the presence of something," or as an emphatic "emanation" that includes "overwhelming detail" showing us things we might not otherwise see. For Gunning, Bazin is a theorist of presence as much as a theorist of absence. Lisabeth During shares a similar understanding of Bazin. To fully know his humanism, she argues, we must grasp how the idea of grace functions across his work and particularly in the image's temporality—its odd but insistent presentness. She suggestively characterizes his image as a "fragment" that is also "multiple and full . . . tangible . . . felt."[161]

If the body seems to pull the image toward the tangible in Bazin's writings, then it should also be clear from my readings so far that he does not use the body's gravitational pull on the filmed image to collapse cinematic representations into absolute truth or concrete certainty. As much as the body draws the image toward denotation and identity, it also draws that same image toward the ambiguous and the unknowable. Our experience of the cinematic image does not always permit us access to exactitude, certainty, or even specification. In some cases, it may even refuse to verify the parameters of the known. The filmed body demonstrates how cinema's graphic engagement with the finite, material, or concrete coexists alongside promises of the indefinite, perpetual, limitless, and living. The image appears to stop the world in a way that allows inspection and documentation, but the image also lets the world loose by allowing its contents to be prone to accident and guided by the random—as in, for example, the long take. The filmed body unites fixity and fluidity, and thus the captured photographic document and living motion picture exist not as binary opposites but cohabit the same image dialectically. The disputes within the neo-Bazinian turn mirror this duality. Theorists writing about Bazin's work today seem alternately to favor one or the other side of the image's ontology, as if they can be shorn from each other. The debate between those who emphasize the absence of the image and those who emphasize its presence reflects a duality that

remains profoundly irresolvable in Bazin's own work. It is a duality that I would argue should be maintained.

What During and Gunning describe as presence does not always align with absolute presence. This is not exactly the unmediated presence that we are accustomed to imagining as the force that governs our everyday experience and sets the parameters for the vectors of our physical agency. Yet its virtuality references precisely that brand of presence. Bazin's presence, a fragment that is full, does not require a totality, an absolute plentitude, as its prerequisite.

Indeed, if we return to a primary proponent of Bazin's as primarily a theory of absence, Andrew, we find a definition not so far from Gunning's or During's presence. Andrew's account describes an almost supernatural naturalism in Bazin, one in which "cinema confronts us with something resistant, to be sure, but not necessarily with the solid body of the world. Through cinema, the world 'appears'; that is, it takes on the qualities and status of an apparition."[162] For Andrew's Bazin, the film image is an absence that comes back with a ghostly vengeance. This emphasis on the spectral quality of Bazin's image will ring true to anyone familiar with his most canonical essays. Edgar Morin's books on cinema published in the mid- and late 1950s expand on Bazin's notion of cinema as a kind of ghost-making machine. For Cardullo, Bazin's image "is a kind of double of the world, a reflection petrified in time, brought back to life by cinematic projection."[163]

Bazin is himself a figure of absence whose presence haunts Roland Barthes's treatise on photography, *Camera Lucida,* a book that appears to be indebted to Bazin's metaphors and language but only mentions him once. That single citation draws not from the death imagery or mummies that populate Bazin's "Ontology" essay and that most likely supplied a key inspiration for Barthes's book. Instead, Bazin appears in Barthes's description of the cinema's screen as a site of living motion whose presence opens up exactly that which is not depicted. "The screen (as Bazin has remarked) is not a frame but a hideout; the man or woman who emerges from it continues living: a 'blind field' constantly doubles our partial vision."[164] Thus, the presence of a moving body carries a certain potentiality of an event before and/or after that which we do not see.

If cinema has a plenitude, it comes from its image's negations as much as from its positivist affirmations. Andrew reminds us that for Bazin, editing (including ellipsis) and the frame leave things out, and

thus the film image overtly admits the incompleteness of what is being shown. The blatancy of these omissions (as compared to the covert exclusions and seamless continuities of analytical editing) makes the completeness of the world beyond them an unavoidable presence. In other words, the absence of a totality on screen grants the viewer an experience of totality's existence. To borrow from Lippit's analysis of a similar terrain, cinema presents us with "a figure of the absent figure."[165] For Lippit, however, the oscillation of cinema's bodies between absence and presence is found not only in the interplay of onscreen/offscreen spaces or within/beyond the frame, but also in the very image of the filmed body itself. Lippit posits this oscillation as one of the central paradoxes of the cinematic image: "The indexical presence of the photographed body . . . effects an inverse sense of deep absence. The fact that the body is there, that it appears to be there, photographically transposed and cinematographically animated, underscores the realizations of its absence."[166] This uncanny materiality, an imagistic physicality of the image that evokes a physical absence, has also been a productive feature of Bazin's image for Laura Mulvey, who describes cinema as the exploration of the threshold between the animate and inanimate, the incarnated and reincarnated.[167]

If these several examples suggest how the neo-Bazinian turn, as well as earlier understandings of Bazin, have tended to lock onto either presence or absence (or in the most interesting instances, a refiguring of presence as absence and vice versa), then to end this chapter and to bring the stakes of this question to a head, we must finally return to Bazin's encounter with the obscenity of the realist image with which we began. For Linda Williams, Bazin is profoundly inconsistent in his relationship with the obscene image, always approaching it and then retreating from it. It was as though his conventional (or cultural) moral limits interfered with his commitment to the radical expressivity of the image. She writes,

> Bazin is disturbed by the "obscenity" [the image of death] and by the analogous specter of hard-core pornography. By the logic of his realist ontology, the vision of such ultimate or extreme "truths" should be admitted to view no matter how shocking, simply because they exist. But the idea of going to the cinema to watch a death spasm is obscene. . . . Yet elsewhere in his writing Bazin has celebrated documentary realism in fictional contexts, and he is honest enough here to acknowledge the inconsistency: "To grant the novel the privilege of evoking everything, and yet to deny the cinema, which is so

similar, the right of showing everything, is a critical contradiction which I note without resolving."[168]

Bazin's self-awareness provides startling insight into how the war may have created a conflict between the need to show everything (the removal of any and all constraints to vision) and the preexisting ethical boundaries of what can be shown. As a medium, cinema was in this period vexed with both supplying its viewers with the sights that they were suddenly desperate to see and with revealing things they "were unable or unwilling to see."[169] At least in the abstract, Bazin seems hesitant to fully abandon the obscene image, because when one begins turning away from threatening images, one risks forsaking all cinema.[170] Although cinema is not reality, this turning away was deeply problematic for Bazin. It was a tempting and socially condoned posture that, if exercised, could evolve into a reflexive movement to abandon reality by disregarding or neglecting it.

The paradox of filmic presence that seems so irresolvable in debates among scholars thus finds a corollary in the style of Bazin's own critical discourse. Rosen tells us that Bazin holds no absolutes, "refuses the finality of a constant criteria," and makes wide use of "deliberately oxymoronic" phrasings.[171] In this sense, the instability of Bazin's prose—his stylistic entwining of declaration and uncertainty—is not simply symptomatic of contradiction; it is in fact a central point in his argument. His language and rhetorical structure represent a stance taken, a manifestation of what he is arguing. As Morgan points out,

> The fact that Bazin continually shifts metaphors, that he never gives a sustained definition of a photograph, suggests that he never finds an account that satisfies him. . . . Bazin's hesitancy and experimentation . . . should not be read as an evasion of the problems inherent in the model of ontological identity. His metaphors represent a series of attempts at understanding the peculiar ability of photographs to give us more than a representation . . . a practical example of what Stanley Cavell calls photography's ability to generate a condition of ontological restlessness.[172]

In other words, Bazin doesn't steer clear of "ontological restlessness"; he invites it into his writing. His reluctance to specify the nature of cinematic presence actually performs one of the central theoretical moves of his work.

The current quandaries over whether Bazin's image represents plenitude or lack may all stem from this, his writing's performative

equivocation over presence and absence. In other words, these debates mirror Bazin's own approach and retreat from the obscene image. Rather than rush to resolve either this primary ambiguity or our current debates on the image, we might instead pause and take stock of how these debates reflect certain impulses of our current moment and of his. The shape of the current discussion of his work inherits Bazin's period-specific ambivalences about the power of the moving image, his sense of the image as overwhelming but necessarily and "inevitably obscene."

Nowhere does Bazin's ontological restlessness appear more prominent than in the essay "Death Every Afternoon," which has become increasingly important to the presence/absence debate.[173] Here Bazin explores how watching a film of the death of a matador makes plain the ontological disparities between life on screen and the spectator's life off screen. The onscreen body keeps dying and coming back to life in a way that makes it impossible to reconcile with our own existence. Cinema can reverse what was once supremely irretractable, and for this reason, Bazin finds this film troubling. Here he again associates the cinema's metaphysical ability to manipulate presence with the obscene. At certain points in Bazin's oeuvre, the obscene names that which cinema must apprehend or what cinema cannot avoid in its necessary pursuit of the real. At other times, the obscene is what cinema brings forever closer and closer to us but never actually allows us to brush against. The obscene marks the threshold where the image must not go. Both features of the obscene are present in "Death Every Afternoon." On the one hand, he implies that cinema's reversing of time pillages Bergson's prized "lived time," thus disgracing the fact of human *being*. The radical temporality of lived time, which is ordinarily and by definition "irreversible and qualitative," gains a disturbing mutability and repeatability in cinema. This desecration of being has an antihuman edge. With this repetition/reversal, cinema not only cheats death but also radically changes our sense of the directionality of our lives by robbing a living being of the uniqueness of his final moments, suddenly making it just one moment among many. On the other hand, filmic deaths can be more moving than when witnessed firsthand because the cinema magnifies certain qualities of the event and hence "confers on it an additional solemnity."[174]

Film theory's toggling back and forth about Bazin's image is in a way the perfect response to the qualities that I have just described

in this chapter. It is my sense that Bazin ultimately wished to keep this restlessness in play. He preferred images that kept him—and us—in this critical state. Ambiguity was one descriptor that Bazin used to point out images that induced restlessness. Inevitable obscenity was another. When Andrew describes Bazin's attraction to certain images that force deliberation on their viewers as images "quivering" in ambiguity, he aptly evokes equivocation as a reciprocal corporeal trembling of image and spectator.[175]

Realism often appears in Bazin as the name for a means of managing this equivocation, the perpetual uncertainty and obscenity unleashed by the image. Realism provides a structure through which to understand and grant significance to the ontological restlessness that a distanced proximity or an absent presence precipitates. As Lippit argues, "Realism is, in Bazin's thought, ultimately an antidotal idiom designed to address a symptom of cinema, which is the inevitable loss of bodies and things in their depiction."[176] Bazin's famous metaphor of the asymptote operates in just this way, as a fail-safe or circuit breaker, to manage the encounter with the obscene that cinema's pursuit of the real threatens to unleash. The asymptote is a mathematical phenomenon that Bazin used as a metaphor to describe the cinematic image's relationship to the real. Rosen glosses this metaphor as capturing the idea that "cinema will never quite achieve its own telos of grasping the real in all its concreteness."[177] The asymptote also describes, I would argue, the subject's relationship to the world that the image itself proposes, a stance crucial to realism's "antidotal" qualities and the geopolitics that its dance with absence/presence takes on for this period. The asymptote characterizes the image's relationship to the world, but it also characterizes how the cinema allows viewers access to the world only through the particular modes of engagement delimited by its imagist interface. An interesting spatial relation is contained within the asymptote that gets at the core logic of realism's "antidotal idiom." The asymptote ensures that we will always be approaching contact but that we will never reach what we grasp for. It inserts the guarantee of a small and ever-decreasing but never insignificant gap. Cinema facilitates a kind of engagement without connection or an intimacy without touching, indulging a desire to be simultaneously present and removed. This is the unique affective register of the asymptote.

Although we might think that this reaching and never getting could only result in endless dissatisfaction, this dynamic tension was

compelling to the subject of this period. Realism's asymptote was an emblematic gesture of the postwar period. In the following chapter, I consider how a North Atlantic culture of international aid, transatlantic charity, and extranational sympathy echoes the affective structures of this particular form of proxied engagement whose outreaching hand is assured that it will never actually touch that which it reaches for, but that is also assured that its power will not be compromised by the distance of its engagement.

For Bazin, corporeality becomes a touchstone for keeping the dialectical tension between presence and absence, and thus distance and proximity, as well as cinema's asymptotic qualities more generally, at play in the image. It is often the site where the spectator experiences most keenly the conflict between drawing closer to the realist image and remaining apart from its ethical messiness. The body is the place where realism negotiates these spatial politics. Does this mean that Bazin instrumentalizes figures of bodily contingency to enact the political urgencies of the day? Or does he find in bodily contingency the confirmation of cinema's radical indeterminacy? Is the body ever fully liberated from reification? Is it ever just pure unknowability? Let us return one more time to Bazin's descriptions of the face in Rossellini's *Germany Year Zero*. Here the face of a young boy who will soon commit suicide confronts Bazin with a kind of radical inscrutability; we "cannot penetrate its mystery," he says.[178] I have been arguing that the corporealism of the realist image carries a powerful duality. So it makes sense that one crucial feature of this film's realism—this image of a young face, where the workings of the film's stylistic practice are most visible—unleash a set of diegetic and extradiegetic ambiguities. Although it might seem tempting here to read this obstinate opacity as a movement away from realism and toward a modernist unleashing of the unknown, the illegible, and the nonsemantic,[179] Bazin clearly sees the realism of this film in its capture of this face and its other embodiments: "gesture, change, physical movement constitute for Rossellini the essence of human reality."[180] This face qualifies as what Bazin later calls "immanence," or the brute thereness of an image confronting us.[181] For Bazin, when a film uses the realist image to activate indeterminacy, it often does so to then propose realism as a rubric to aid us in managing our relationship to the very indeterminacy unleashed in the image. Realism can be thought of as a spatial function, one tasked with negotiating varying intensities of this indeterminacy, a formalization

of engaging with indeterminacy (that is, concretized into a stance), and at times, even a systemization of indeterminacy, albeit in the gentlest fashion. Bazin's equivocation over the realist image may foreshadow theoretical paradigms that recognize the "play of difference" and the "end of representation." Before we reconcile Bazin too quickly to these later understandings, we need to recognize how the unsettling discomfort aroused by the realist image was something particularly productive for the midcentury spectator, and that realism offered a protocol through which to experience that discomfort safely and lend it meaning. When we completely accommodate Bazin's ambivalence to a deconstructionist version of representation as deferral, we miss a crucial geopolitics staged in this reluctance to be fully on the scene paired with a continuing desire to exercise a sense of authority over that scene.

From the perspective of the postwar period and our current discussion, Bazin's shuttling between absence and presence starts to look less surreal. It bespeaks a desire to control our investment and engagement in the image, to manipulate at will our proximity and distance from its world. Bazin's ambivalence may in fact be a kind of racking in and out of focus, a virtual mobility that the spectator can effect on his own to instantly swap distanced viewings for dangerously intimate proximities. Bazin's famous ambivalence is not synonymous with indecision. It enacts a powerful oscillation of intimacy and foreignness. Bazin proposes a new geography of presence, remembering all of that term's potential geopolitical richness. In the very obscenity of its images, cinema offers the spectator a means to be more worldly and more adaptable; it also makes geographical, cultural, and political transcendence paradoxically and potently situatable. The asymptote describes the aspirations of a determined journeyman who knows that he will never fully arrive. He reaches out to the other, getting closer and closer to the foreign, but is guaranteed never to inhabit it. When the realist image threatens us with proximity, realism offers us the ability to manage distance. When the realist image draws us dangerously close to the world, realism guarantees our separation from that world. In the curve of the asymptote, we find the defining gesture of postwar liberal humanism's globalism: an ambivalence, an ontological restlessness, a perpetual reaching out that never forecloses on its ability to pull back.

2 THE NORTH ATLANTIC BALLYHOO OF LIBERAL HUMANISM

LIFE MAGAZINE PREDICTED IN 1952 that Italian cinema would pose an increasing commercial threat to Hollywood's domination of the U.S. market if Italy continued to produce both "provocative films" and "provocative beauties."[1] *Life* even went so far as to trace the recent American success of these European imports to the apparently contradictory lures of the realist image: the "raw honesty" of films like Rossellini's *Rome Open City* derives, *Life* argues, from both their "moral conscience" and their "frank treatment of sex and violence." Here neorealism provokes American spectators in two ways: it forces them to confront the urgent relevancy of foreign matters, while at the same time overwhelming them with prurient views of imperiled bodies. Above the headline "Italian Film Invasion," the magazine accordingly supplies a promotional still from a recent import, *Voice of Silence* (*La voce del silenzio*, 1953), to illustrate the characteristic allure of this new and raw aesthetic. The caption reads: "Heroine of new Italian film 'Voice of Silence,' a decent girl led into delinquency, auctions off her clothes to get money to buy a car." If for *Life* the still "sums up the mixture of sex and naturalism which is the trademark of postwar Italian film," then what does this image tell us about the period's understanding of the realist image? The right-hand side of the image shows the back of a young woman's bare legs and arms. The body of this "half-naked girl" looks awkwardly exposed and vulnerable, her flesh indecently white against the gloss of her high heels and the sheen of her black satin undergarments. Her legs, which like her arms hang limp, are suspended in front of a crowd of smartly dressed young men and boys. This image is as curious in what it displays as how it displays it, and for whom. It raises the question: How was the American

spectator for neorealism envisioned during this period? How would
we characterize that spectator's perspective?

Any attempt to theorize the arrival of Italian post–World War II
cinema on movie screens across the United States must contend with
two divergent accounts of the midcentury American filmgoer that
emerge during this period and anticipate these questions. On the one
hand, this period's critics suggested that the unprecedented success of
neorealist films such as *Bicycle Thieves, Shoeshine, Paisan, Germany
Year Zero,* and *Rome Open City* indicated the new commercial viabil-
ity of "human interest" stories.[2] For perhaps the first time, distribu-
tors and theater owners believed that by appealing to humanitarian

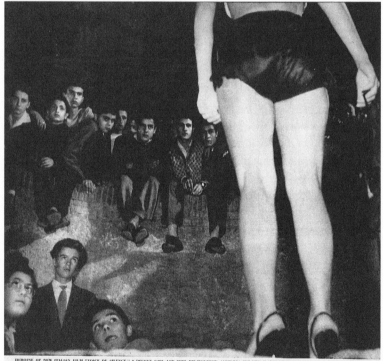

HEROINE OF NEW ITALIAN FILM "VOICE OF SILENCE," A DECENT GIRL LED INTO DELINQUENCY, AUCTIONS OFF HER CLOTHES TO GET MONEY TO BUY A CAR

ITALIAN FILM INVASION

A Life *magazine article from October 20, 1952, on the success of Italian films in
the United States illustrates its text with an image that suggests as much about
the international spectator as it does about the content of imported movies.*

concerns and global communalism, a film could increase its box office receipts.[3] On the other hand, neorealism's U.S. promotional discourse often emphasized the salacious character of these imported films, suggesting that their commercial viability depended on the films' unique exposure of a sexualized and/or violated body.

These contrasting accounts of humanitarianism and prurience combine in *Life* magazine's imagining of neorealism's audience. At first glance, we see the magazine aligning us—and, implicitly, the U.S. audience for neorealism—with the young male viewers in the photograph. As readers and as members of a potential audience for foreign films, we are asked to join the voyeuristic crowd. We provide another set of leering eyes focused on a body. Our spectatorship is keyed to the boys' reactions: their eager eyes stand in for the American audience for imported films. However, these boys not only correlate to our gaze. They are also its object: the limp, naked blankness of the woman's body forces us to ask serious questions about why and how these boys ended up partaking in this scenario in the first place. From this perspective, the female figure starts to look both sexualized and imperiled. On closer inspection, in fact, some of the boys appear more troubled and disoriented than stimulated. This image illustrates how the realist film's "raw honesty" invites two gazes at once: one defined by titillation, and the other characterized by concern.

If neorealism invites both the socially concerned contemplative gaze of art cinema and the sensationalized voyeuristic gaze of exploitation cinema, then should we simply describe its audience as an incoherent bundle of contradictions? Not exactly. At the most basic level, it is widely accepted that film audiences are internally diverse composite entities that often fail to conform to industrial reception categories. Nor do they line up neatly with any particular social grouping that exists outside of the movie theater. This fact should not dissuade us from analyzing how a period's dominant discourses imagine reception, anticipate engagement, and in so doing, condition the sociopolitical remunerations of filmgoing. Over the course of this chapter, I plan to do just this by returning to the archive of neorealism's U.S. promotion and criticism to see how it articulates a compelling vision of a mid-twentieth-century American spectator who is both less contradictory and more politically coherent than recent historicism would suggest. I discover in this archive an emerging affinity between the postwar subject's aspiration to join an ethical world citizenry and that

same subject's desire for explicit images and cheap thrills. I also suggest that the neorealist image actually lies precisely at the intersection of sensational rawness and world understanding, and that the humanist spectatorial mode it encourages tracks between the supposedly antithetical poles of affective engagement and reasoned ethical judgment.

The archival documents I examine, which include press kits, exhibitor manuals, and popular reviews, as well as film society pamphlets, government documents, and public education manuals, intuit this quality and promote the new mode of spectatorship these films allowed. In these materials, and in the emerging mode of spectatorship they both engender and track, realism marries enthrallment to a more detached viewing practice. Neorealism's critics, distributors, promoters, and exhibitors relied on the term *realism* and its associations to commingle what had previously been assumed to be distinct, inflexible, and opposing categories of spectatorial engagement. As a rubric, realism allowed the competing lures of the cinematic image and otherwise incommensurate scales of identification to cohabit in a single film, encouraging a spectatorial experience in which multiple modes of engagement might coexist without contradiction.

Easily looked past as discursive inconsistency, this spectatorial mode in fact proposed an important new politics of engagement. U.S. advertisements for these films imagined a spectator for whom the uncontrollable sensations produced in witnessing corporeal exposure enabled an ethical contemplation of grave world problems. Neorealism's spectacular displays of violence were figured as productive sites where Americans could glimpse their own widening moral responsibility for the North Atlantic community. In its concomitant address to both charitable humanism and puerile curiosity, I would suggest, neorealism mirrored and reinforced the structures of sympathy and disengagement underwriting large-scale international aid. These documents of neorealism's promotion in the United States imply that neorealism provided a platform for the articulation of this productively bifocal ethics of looking at the world, which was uniquely aligned with postwar U.S. foreign policy, the U.S. approach to international aid, and the primacy of the North Atlantic community in the emergence of the Marshall Plan, NGOs, and other bodies of world governance. The orthodoxy of current film reception history understands the audience as a multifarious shape-shifter that undermines much of spectatorship

theory. However, I argue that when applied to midcentury America, this exclusive focus on the pluralism of the spectator obscures an emergent ideal spectator envisaged by these films and their U.S. advocates. Apprehending the nature of this spectator, whom I will call the bystander, is crucial for understanding the political aspirations of these films and for reassessing their political impact. I am proposing the bystander as a descriptor for one of the period's exemplary subjectivities, one linked closely with the apparently liberalizing impulses of the period and its images, whereby older forms of seeing are dismissed because their range of vision cannot accommodate the contemporary world. The bystander embodies the broadened view. In fact, the bystander is nothing more than a discursive position in a visual field whose perspective matches the scale of the expanded parameters of the North Atlantic community. The space occupied by this bystander should always be understood as a virtual one, one that allows forms of engagements otherwise impossible in daily life. Defined by the activity of apparently innocent onlooking, the bystander always works toward assuming authority over what he or she sees and just as quickly can remove himself or herself from the geographical situatedness of the seen. The bystander occupies the paradoxical space of secondary eyewitnessing, a kind of surrogate seeing in which one can always be on the scene, but never of it or trapped in it. As such, the bystander is the name that I am giving to the subjective affinities of liberal humanism.

Being Both at Once

In traditional historical accounts of the postwar period, specific conditions altered the character of the American cinema spectator and triggered a new receptiveness to foreign films. The dramatic increase of travel during and after the war produced concern for other cultures. A zeitgeist of unprecedented international goodwill emerged as New York City was chosen as the location of the United Nations. The G.I. Bill and economic prosperity led to a sophisticated populous with more refined tastes and a greater interest in the arts.[4] These traditional accounts of the broader outline of postwar culture also imply that neorealism's success reflected the changing nature of American movie consumption in particular. A new American spectator with a worldly maturity—engendered perhaps by the experience of war—had little taste for the stale and mind-lulling confections of mainstream cinema.

As opposed to the passivity of Hollywood illusionism, imported films demanded the active mind that defined this new spectator. They provided a vehicle for the spectator's exercise of taste, refinement, and sensitive discernment vis-à-vis·art and social concerns. By watching imported films, the American spectator proves herself to be a thoughtful moviegoer—a viewer who is both somatically restrained and self-possessed. In describing the birth of the art house spectator, Peter Lev conveys these assumptions: "The art film . . . assumes a cosmopolitan, non-chauvinist spectator who can empathize with characters from many nations. . . . The art film spectator is expected to accept intercultural, as well as intracultural, communications. The intercultural communication is usually European in origin, which connects the art film to other high-culture pursuits (e.g., classical music, opera)."[5] Against this account of increasing global awareness and class ascension, recent revisionist histories have argued that postwar independent distributors turned profits on imported films only by marketing them as quasi-pornographic spectacles. Capitalizing on a cheap-thrills niche market, neorealism's unparalleled box office success resulted as much, these historians argue, from sensational enrapture and titillation of the spectator as it did from any burgeoning art appreciation or political awakening. Describing neorealism as the generic counterpart to burlesque shows, sideshow attractions, exploitation films, B-grade horror, and pornography, these histories imply a spectator who delights in the torrid possibilities of a war-ravaged mise-en-scène. The same realist image that prompted intellection in the earlier history now appears to overwhelm the spectator with involuntary sensations of shock, lust, and repulsion.[6] Offering evidence for this second view, an advertisement for *Bicycle Thieves* illustrates its banner headline, which promises "uncensored–uncut" content, with two highly suggestive scenarios.[7] A struggle either ecstatic or abusive occurs between a couple on the lower left. Meanwhile, the bicycle tryst pictured on the lower right is vigorous enough to toss hats off heads and bare the open legs and stilettos of a woman seemingly overcome by a man's passions.

In his metacritical essay on the historiography of this moment, "Art, Exploitation, Underground," Mark Betz evaluates how this evidence of neorealism's base exploitation campaigns presents a conundrum for the current historical accounts of early art house audiences. Betz concludes that historians sidestep neorealism's promotion rather than integrate its anomalies into their understandings of the period.

To get around neorealism's quasipornographic promises, historians use what Betz calls a "yes, but" gesture: yes, neorealism drew audiences by promising lurid content, but the popularity of these imports also points to the moral and cultural ascendancy of U.S. audiences.[8] This rhetorical evasion attempts to protect the idea of the newly reformed American viewer. In other words, this strategy sidelines any details that do not confirm conventional narratives of the American viewer's moral and cultural improvement after World War II. The "yes, but" gesture is only one way that historians retrofit the duality of the realist image. A second strategy, also noted by Betz, revels in neorealism's bivocal hailing of audiences, recognizing its heretical contradiction as historically significant. However, this inconsistent address is seen as either a harbinger of the fluid spectatorial affinities of the mid-century filmgoer or a symptom of a poststructuralist implosion of high and low genres. Coded taste distinctions that were once assumed to segregate social groups are, on closer inspection, turned topsy-turvy

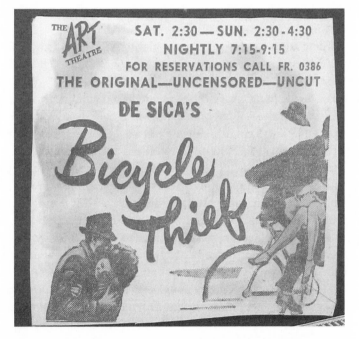

The American advertising campaign for Bicycle Thieves *implied an unexpurgated view onto the sordid details of a violent and sexually potent life.*

by this period's texts, resulting in a leveling of cultural hierarchies. Thomas Elsaesser captures this view in his description of the art film:

> What made the films famous was not always what made them successful. In the case of Italian neo-realism, for instance, the film-makers' aesthetic–moral agenda included a political engagement, a social conscience, a humanist vision. . . . Yet a film like *Rome, Open City* . . . became a success abroad for many reasons, including its erotic, melodramatic and atmospheric qualities[:] a glimpse of Anna Magnani's exposed thighs[,] a lesbian affair and . . . cocaine. To American audiences, unused to such fare, the labels "art" and "European" began to connote a very particular kind of realism, to do with explicit depiction of sex and drugs rather than political or aesthetic commitment.[9]

Several recent studies have attempted to explain this outwardly bifurcated appeal by proposing that art house cinemas gathered together otherwise incongruous audiences whose tastes, moral aspirations, class backgrounds, and viewing practices otherwise clashed.[10] The apparently contradictory address of neorealism's promotion in the United States is said to have spoken to these multiple groups at once. Other studies approach the duality of neorealism's address to U.S. audiences •by adopting a third strategy: a partial embrace of contradiction. Barbara Wilinsky thus draws on discourse theory to argue that neorealism's promotion marks an "inconsistent public rhetoric."[11] For this historian, contradictions in this promotion's doublespeak symptomatically expose the nature of an emerging art house ideology, where commercial interests commingle with a sociocultural mission of goodwill and art snobbery.

In their efforts to dismiss, account for, or repurpose the duality of the realist image, each of these critical strategies clings to certain ethical ambitions for the midcentury audience. Because this duality of the realist image troubles recent scholars more than it did criticism from the period, these more recent approaches seem committed to distinguishing ethos from pathos in a way that this period's film culture did not.[12] An odd reverse moralism lurks in many of these accounts and their recovery of prurient promotion. Does the fact that viewers came to these films for cheap thrills necessarily make impossible the idea that neorealism helped establish an audience aware of their global citizenry? Must ethical humanism begin with a bracketing of affect?

The realist image articulated in and by the U.S. promotion of neorealism is principled and illicit at once, refusing to preserve a traditional

distinction between pathos and ethos. It is simultaneously artful and trashy, sensitively observant and brazenly beguiling, morally attuned and salaciously corporeal, intellectually rigorous and dissolutely excessive. Even taking into account the various industrial shifts in censorship, theater ownership, and product shortages that characterized this period, it remains clear that neorealism's promotion imagined Americans embracing these imports for precisely this duality. Similarly, the early advocates of these films did not see the duality of the realist image as a flaw. Critics, distributors, promoters, and exhibitors used the term *realism* not only as a code word for carnally explicit content, as Thomas Guback and others suggest, but also to reference a new practice that allowed otherwise incommensurate extant modes of filmgoing to merge into a single viewing practice. As Betz explains of art cinema more generally, art house and exploitation cinemas "proceeded not simply as parallel alternate modes of film practice, but as shared discourses and means of address."[13] Realism reflects a similar history: the postwar realist image made what had been assumed to be distinct, inflexible, and opposing categories of spectatorship suddenly appear to be analogous, even coterminous.

The promotional materials from this period are particularly invested in postwar filmgoing as an experience that invokes, enlists, and manages the viewer's multiple and conflicted identifications with the world on screen. The same distributors that premiered *Rome Open City* as a benefit for the God Parents for Italian War Orphans Committee admit to developing poster images and advertising copy that played up torture as a sexual provocation in order to "tap the sadist trade."[14] The exhibitor's manual for *Germany Year Zero* brags that *Parents* magazine bestowed its highest rating for youth aged twelve to sixteen on the film, and it goes on to supply suggestions for promoting the film in elementary schools. With no segue, the next page of the manual lists fifteen catch lines with which to sell the film in print and on the radio. All but four of these fifteen sound bites promise a film rich with sordid content. Among the film's primary appeals are that it "delves deep into degradation, horror, and vice," contains "candid scenes of youthful debauchery," and shows children exploited through prostitution and abuse, including preteen sexual encounters.[15]

Similarly, period reviews of these films seldom defined the new realism of Italian films without considering both the contribution these films make to a cosmopolitan humanism and the voyeuristic pleasures

CATCH LINES

1. MATCHES 'OPEN CITY' AND 'PAISAN'. AN UNFORGETTABLE OFFERING.

2. ROSSELLINI'S MONUMENTAL FILM MASTERPIECE. EPITOMIZES THE PLIGHT OF A LOST GENERATION.

3. FASCINATING, IMPORTANT AND PROVOCATIVE. A TALE OF CORRUPTION AND IMMORALITY.

4. A REFLECTION OF HUMANITY IN AN ABYSS OF DESPAIR AND CORRUPTION.

5. THE ROSSELLINI EYES SEEK OUT THE EVIL, THE DEGRADATION, THE ABNORMAL.

6. CANDID DETAILS IN THE SCENES OF YOUTHFUL DEBAUCHERY.

7. CHILDREN STEAL, ROAM THE STREETS, WITHOUT GUIDANCE, GROW WISE BEYOND THEIR YEARS IN THE WAYS OF SEX.

8. A YOUNG BOY DRIVEN TO THE DEPTHS IMMORALITY.

9. EDMUND SEES HIS SISTER EVA GO OUT FURTIVELY EACH EVENING AND SUSPECTS THE WORST. EVERYONE ELSE IS ACTING LIKE THAT. WHY NOT EVA!

10. GERMAN GIRLS FREQUENT BASEMENT NIGHTCLUBS FOR A HANDFUL OF CIGARETTES OR SOMETHING MORE SUBSTANTIAL.

11. SINISTER FIGURES LURK IN THE DARK CORNERS AND SHADOWY STREETS OF BERLIN.

12. DEMORALIZED YOUTH IN A DEPRAVED SOCIETY.

13. HOW GIRLS LIVE IN TODAY'S GERMANY.

14. A SHOCKING STORY, DELVES DEEP INTO DEGRADATION, HORROR AND VICE.

15. AN ELECTRIFYING DRAMA. BEARS THE STAMP OF ROSSELLINI'S GENIUS.

The more lurid implications of these "catch lines" proposed by U.S. distributors to promote Germany Year Zero *appear in a manual that also boasts of the film's sensitive humanism and its appropriateness for young children.*

of their sordid images. U.S. film critics suggest that the shocks and sensations induced by realism's graphic revelations overwhelm the spectator but never foreclose on ethical eyewitnessing. Take, for example, Harold Barnes's 1949 review of *Germany Year Zero,* which proclaims that the film is "relentless," "savage and shattering."[16] In spite of this "inexorable impact" on the viewer (or perhaps because of it), the film is able to make a "coldly dispassionate appraisal" of the situation it depicts. This review anticipates and seeks to cue the moral fortitude of the spectator by suggesting that reverberations of shock are never so disruptive as to inhibit an emerging geopolitical ethic. Along with Barnes, neorealism's other early advocates repeatedly posit sensate spectating as an experience integral to the new American postwar humanism. In their view, the experiential structure of the realist image works by assaulting the viewer with both affective onslaught and an ethical

plea. In this account of realism's impact, an acutely postwar version of humanism appears in which somatic arousal grounds geopolitical sympathy and spectatorial sensation underwrites political judgment. A specifically postwar mode of spectatorship gets lost when we read these critical and promotional materials as simply casting the widest possible net into a disparate marketplace of audiences or as the implosion of high and low. It is important to recognize and engage the fact that the fluid allegiances articulated by the American discourses on neorealism are more than the product of (for example) opportunistic audience cross-marketing. They also enunciate a particular subjective stance toward the world. Overemphasizing hybrid audiences and generic ambiguity masks the geopolitical specificity of the American spectator limned in neorealism's promotion—a bystander affectively engaged and effectively distanced. This outwardly contradictory address of neorealist promotional materials actually cues a single spectatorial protocol.

Realism's Overbearing Image

In an early review championing *Rome Open City,* the *Philadelphia Evening Bulletin* takes an apologetic stance, as if praising a foreign film runs against the newspaper's better instincts. The review promises American viewers that the film will move them, notwithstanding the challenges that its subtitles and nationally biased version of history will pose to non-Italian viewers. In the midst of this overly self-conscious praise for an imported film, the *Bulletin* offers a striking account of the U.S. spectator's affective relationship to the realist image: "'Open City' has an almost documentary air," it explains, "and an insistent fervor that makes you believe it, sometimes against your will."[17] This review would appear to celebrate realism as a collision of document and impassioned plea; it also imagines the reception of the realist image as an overbearing absorption that threatens to consume conscious thought and intent. Why would a film about a nation's liberation from totalitarian dictatorship and Nazi occupation employ an aesthetic that violates the viewer's will?

Comparing this typical U.S. review to the writings of neorealism's major proponent in Europe, André Bazin, reveals an implicit dispute over the brand of democracy enacted by the realist image. As we saw in the previous chapter, Bazin's enthusiasm for neorealism and

the realist image more generally comes from his interest in fostering film practices that allow the spectator greater freedom in parsing the image.[18] The *Bulletin*'s description above frames the realist image in similar terms—in this case, emphasizing its capacity to reform the U.S. audience by derailing their preconditioned view of the world. Like Bazin, the *Bulletin* imagines realism to offer an ideological alternative to dominant modes of cinematic consciousness. On its first reading, the review's text and similar passages from other reviews suggest the potential of neorealism to retrain visually and perceptually how Americans engage with the world. It is able to interrupt the perceptual status quo through the indulgence of certain kinds of images. However, unlike Bazin's image, which democratizes viewers by reorienting them to "the ontological ambivalence of reality directly" and bringing them back to "the real conditions of perception, a perception which is never completely determined a priori," this realist image constrains the range of a viewer's possible responses. It enacts reformation through ruthless insistence and the imposition of affect.[19]

Other U.S. critics similarly define the impact of realism on the spectator as an overinvolvement or enrapturement of the senses. The *New York Times* review of *Paisan,* Rossellini's second neorealist success in the United States, exhibits this rhetorical impulse: "Told in a smack-in-the-face fashion, which is the way it should be done," the film has a "shattering impact [and] cannot fail to rattle the windowpanes of your eyes and leave the emotions limp."[20] The image assaults the viewer; its fervency exhausts the viewer's perceptual apparatus and numbs his or her conscious capacities. Like the ballyhoo slogan of grind houses—"You won't believe your eyes!"—these reviews describe realism as threatening to shear perception away from cognition, suggesting that particularly assertive images can topple belief in a "slam bang-up" fashion: from this perspective, seeing precludes thinking, perceptual data overturn conscious thought, and enthrallment seems to engulf mental acuity. Bazin might have opposed neorealism if given only American accounts of these films because here a film's content appears to be ethically at odds with its form, its antifascist narrative contradicting the imperiousness of its overbearing images.

In thinking through the various declensions of this rhetoric of cinematic sensation, it is important to remember that the midcentury lobby cards and posters for nearly all genres of U.S. films are littered with promises of strong spectatorial impact. However, the American

advertising for neorealist films features an exceptionally provocative language of shattering shocks and overpowering engulfment in affect.[21] Borrowing selectively from the reviews, including the *Times* text above, promoters envisaged a grossly somatic reception for neorealism. Advertisements for *Paisan* guarantee "terrifying dramatic impact" and "cinematic shock," describing the film as "a pulse quickener." In its collage of quotations from reviews, the *Rome Open City* press book highlights the nearly devastating effects of realism, its image not only "gripping," but "overpowering," and "pulverizing" the spectator with "lurid[ness]," "white-hot anger," "brutal frank[ness]," and "fervent" force.[22]

Film scholars often regard excesses of sensation such as those imagined here to be a defining characteristic of low-genre films. Linda Williams argues, for example, that low genres might be known as "body genres," not only because they often feature corporeality but also because they imply a more embodied spectator.[23] Spectatorial enrapture, affective overinvolvement, and embodied consumption all mark low genres as undeniably distinct from prestige pictures. Body genres gain their generic distinction from a unique correspondence of onscreen corporeal spectacle to audience affect. Anticipation of a particular type of bodily enthrallment gives the lower genres—for example, tearjerkers and thrillers—their very names. Looking back at the taglines used in the promotion of *Paisan* and *Rome Open City,* it may be tempting to categorize neorealism as a body genre. After all, many of the newspaper advertisements for these imports appeared in the same zone of the page as the low-genre attractions, and Eric Schaeffer points out that grind houses, or theaters known for showing exploitation movies, were often the first to embrace long runs of foreign films.[24]

At least through the early 1950s, however, neorealism's promotional discourse aggressively hailed the existing spectatorial protocols of both high and low genres, often at the same time. The U.S. exhibitor's manual for *Paisan,* for example, encourages exhibitors to market the film with a two-pronged address, one attracting a "mass" audience and the other a "class" audience. It suggests luring a mass audience through a campaign emphasizing the film's "daring" content and playing up the "impact," "shock," or "blushing" that the film will induce with its "revelations of immoral conditions." Taken alone, the mass campaign for *Paisan* appears to follow the rubric of Williams's body genre. Meanwhile, the press book's plan to attract a class audience suggests

Scenes No Man Can Forget—Scenes No Man Can Forgive!

See The most astounding story ever filmed! A movie that brings a new era of greatness to the screen!

Scene Mat No. 201

See A drama of love and lust, courage and cowardice, blood and beauty that will long be remembered in your heart and mind!

Scene Mat No. 202

See The strange and startling love of two beautiful women and the dramatic climax that will move you to new emotional heights!

Scene Mat No. 203

See The film drama that has been acclaimed throughout the world as the great motion picture of our time!

Scene Mat No. 204

See The film people whispered about and today are shouting its praises as the most exciting and memorable story ever brought to the screen!

Scene Mat No. 205

The layout of this page from the U.S. exhibitor's manual of Rome Open City *sets up a dialogue between proposed ad copy and spectacular promotional stills. This arrangement encourages theater owners to play up the "lusty" and "strange" features of the film, making it as unforgivable as it is unforgettable.*

emphasizing Rossellini as auteur while framing the film as both a historic milestone and an instant classic in the canon of film history. At first glance, the layout of the press book—mass on one page, class on the facing page—appears to observe a traditional bifurcated hierarchy characterizing both audience and genre. A closer inspection reveals, however, that the press book does as much to conflate as it does to distinguish the two audiences.[25] The words and phrases "more daring than 'Open City,'" "daring displayed," "thrilling," and "arresting" all appear under the "class" appeals section of the press book, infecting the language of thoughtful aesthetic reflection ("a milestone," "eloquent," "a really brilliant director enriched the screen!") with an affective over-involvement. The class campaign advertising uses the same suggestive images used by the mass advertisement: a man lies in bed holding a cigarette, the ascending smoke of which sensuously follows the form of a woman in revealing lingerie who sits next to him. Elsewhere in the

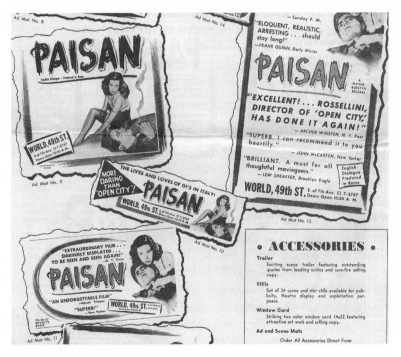

In Mayer-Burstyn exhibitor's manual for Paisan, *the "Special Ad Campaign for the Class Audience" boldly mixes modes of address typical of both high- and low-genre film campaigns.*

press book and in the advertisements, the targeted strategy of redeploying critical commentary demonstrates how freely an address to the mass audience overlaps with an address to the class audience. Exhibitors extended this confusion by opting for ads where pledges of the educational value or artistic merit of a film mix freely with promises of pornographic spectacle. In even the smallest ads, very little differentiates mass from class when it comes to imagining spectatorial affect.

In short, this press book emphasizes *Paisan*'s corporeal imagery and impact while avoiding the generic bracketing described by Williams. The press book advises theater owners to play up the social realist import of this film through appeals to special interest groups and educational institutions: initiate a dialogue with recent veterans; establish a teacher outreach program; stage a student essay contest. At the same time, the press book also suggests that vigorous realism allows for not only supreme artistic expression and social import, but also cheap thrills. It even advocates promoting the film by using a pull quote from a less than glowing *Time* magazine review: "Rossellini spoils an otherwise perfect scene with [a] corny bit of breast peeping Hollywood would blush at." Meanwhile, an otherwise innocent definition of the film's realist style that appears in the press book's same collage of potential pull quotes—"a searching intensity that makes every detail, every person come alive"—takes on lurid connotations when juxtaposed to another excerpt that suggests the film "contains a very bold seduction scene and shows the immoral conditions that prevailed." The advertisements supplied by the press book celebrate the raw chills and thrills of a neorealist film's uncensored spectacle while at the same time recognizing its artistic achievement, the beauty of aesthetic classicism, and the redeeming social function of cinema as a form of political testimony.[26] Indeed, the press book recommends that exhibitors promote ethical humanist realism as necessarily connected to uncensored imagery, suggesting that graphic bodily spectacle actually precipitates intellection. Thoughtful explication, it seems, requires an initial encounter or two with the explicit.

By interchangeably invoking the shattering salaciousness and the political urgency of the realist image, these promotional and critical discourses suggest an evolutionary trajectory of sensation within the viewer. Again and again, we find affective overload the bedfellow of emerging world awareness and crude rawness in the company of conscious humanist outreach. In this sense, the promotional materials

imagine a remarkably adaptive spectator: this viewer is not identified with a specific preconstituted audience, allied with an established viewer subgroup, or seen to enact existing generic responses. The *Newsweek* review of *Germany Year Zero,* for example, defines the film as a "unique study in human degradation," warning that certain scenes may be "too terrible for the squeamish." Yet for "the discriminating moviegoer," it "should stand out as one of the greatest films."[27] We might understand this passage to mean that elite viewers are adult or discriminating enough to endure such disturbing images. However, in its suggestion that this film involves many types of viewing, the review allows for and even encourages multiple modes of spectatorship over the course of a single film viewing. The ideal viewer is both "discriminating" and drawn to the aberrant or degraded; this spectator can discern artistic accomplishment while testing his or her own affective limits. Although to the weak an explicit film might be unpalatable, for more civilized viewers, explicit images facilitate tolerance and good taste.[28] This spectator will come to experience his or her bodily enthrallment in relationship to other competing modes of spectatorship presented by the same film. Here the neorealist film cues its viewer to transform overwhelming somatic impulses into a detached and managed response. Spectatorial enrapture does not rule out analysis; enthrallment does not foreclose intellection; hypercorporeal viewing does not preclude judgment. These American accounts of realism imagine a sophisticated mode of physically sentient knowing and intellectualized sensation that mixes divergent spectatorial modes of engagement and collapses distinctions between genres of varying social prestige. In this respect, these materials suggest that neorealist films can function as a training ground for moving American spectators from intimate involvement to concerned detachment.

The Dispassionate Enthrallment of Shocking Images

In his *Theory of Film,* Siegfried Kracauer theorizes how films containing "appalling sights" force the spectator to negotiate different registers of affect. Under the heading "phenomena overwhelming consciousness," Kracauer reformulates the standard tension between affect and intellection. Kracauer will eventually claim that cinematic besiegement offers potential awareness, but he begins his discussion by revisiting a commonsense version of representation wherein referent,

image, and viewer all share the same affective ontology. He suggests, at first, that images of brutality can cloud the subject's cognition and hamper recollection in the same way that witnessing actual brutality does: images that "overwhelm consciousness . . . call forth excitements and agonies bound to thwart detached observation. No one witnessing such an event, let alone playing an active part in it, should therefore be expected accurately to account for what he has seen. . . . The medium has always shown a predilection for events of this type."[29] In this passage, Kracauer rehearses a traditional binary opposing the careful reflection involved in detached observation to the infirmity of the always overinvolved eyewitness. He initially posits a homology between trauma experienced firsthand and trauma experienced as cinematic enthrallment. This correspondence almost immediately breaks down when he next suggests that cinema also offers an alternative position. The cinematic spectator remains overwhelmed and enthralled, but he or she is less burdened by the event than the eyewitness. With its persistent predilection for representing trauma, cinema continually opens up a viewing position that is neither coldly clinical in its detachment nor submerged in the frailty of firsthand perception: cinema *"insists on rendering visible what is commonly drowned in inner agitation.* Of course, such revelations conform all the more to the cinematic approach if they bear on actual catastrophes and horrors. In deliberately detailing feats of sadism in their films, Rossellini and Buñuel force the spectator to take in these appalling sights and at the same time impress them on him as real-life events recorded by the imperturbable camera."[30] Cinema and its process of rendering the world visually act to contain sights that would ordinarily traumatize the viewing subject. The film image introduces a form of mediated looking that allows for both enthrallment in and detachment from the scene represented.

By citing the torture sequence in *Rome Open City*, among other examples, Kracauer defines this as a specifically political mode of spectating. Certain directors, such as Rossellini, take advantage of cinema's predilection for the torrid and the violent, "deliberately detailing feats of sadism" so as initially to overwhelm consciousness and thereby evoke a uniquely conscious mode of observation: "The cinema, then, aims at *transforming the agitated witness into a conscious observer.* Nothing could be more legitimate than its lack of inhibitions in picturing spectacles which upset the mind. Thus it keeps us from shutting

our eyes to the 'blind drive of things.'"[31] Kracauer suggests here that conscious observation derives from how cinema draws the spectator in two directions, persistently pulling us toward appalling scenarios while simultaneously dislocating us from them.

In this respect, Kracauer's overwhelmed but conscious and readied onlooker forces us to reconsider the rhetoric of cinematic sensation, and Kracauer points toward a distinct and historically specific expectation for cinematic spectatorship after the war. He also makes clear how dividing neorealism's audience into passive and active spectators may miss the way in which realist films bombard the viewer with different modes of engagement. He values an image that lacks inhibitions because it has the potential to transform agitated raw reactions into conscious observation and preparedness. The camera's inner compulsion to depict the horrific side of things becomes an opportunity for social change. Cinema's political potential thus comes neither from its capacity to put the viewer in the position of direct eyewitness nor from the image as a form of potted testimony. Instead, this potential arrives with the spectator's simultaneous or doubled affective awareness of the image as both raw experience and cinematic mediation.

While not as precise or self-aware in their account of spectatorship as Kracauer, many postwar U.S. critics attribute a similar doubleness to the neorealist image, and they also tie that doubleness to the corporealism of these films. In describing how *Paisan* "daringly display[s]" "a whole new way of expressing staggering ideas," Bosley Crowther demonstrates this approach to affect and the traumatic image:

> It is as though the camera were a reporter observing passing episodes, each one an invitation to an elaborated drama, if one wished, yet each so completely blending with the character of the general scene that the camera looks upon it dispassionately—and then moves on to the next.
>
> This is a method of observation—of cinematic "reportage"—that might seem the absolute assassin of cumulative emotional effect. . . . Yet it actually creates such conviction as the details of the episodes unfold via the cryptic and crude visualizations of Rossellini's "documentary" style . . . that this bluntness and studied anticlimax became the major descriptive of the whole[,] one more demonstration of [war's] cosmic irony. And a saturation with this feeling is the effect the film aims to achieve.[32]

Although we might easily assume that a film whose visual narration is characterized by dispassionate observation and roving nonattachment would flatten affect, Crowther emphatically declares that *Paisan*'s

"reportage" is a form of feeling. Detachment can, in fact, affectively saturate a subject as overwhelmingly as an emotion might. Cinema appears uniquely equipped to deliver this counterintuitive mode of dispassionate enthrallment. The unbridled desire to see does not prevent but rather evolves into distanciation.

Remarkably, the corporealism of these films is understood both to make the stakes of geopolitical interdependencies urgently palpable for Americans and also to provide those same Americans the means by which to manage the anxieties brought on by international obligations. Thus the *Philadelphia Sunday Record* likens watching *Rome Open City* to seeing a friend being beaten: "When somebody in military boots kicks somebody you know in the face, you aren't going to be indifferent about it." Despite the fact that Italy was once filled with collaborators, fascists, and other no-good characters, and although Italians are still "mere foreigners lacking our advantages and ignorant of our customs. . . . We Americans are fellows of these foreigners."[33] Across the course of this review, the spectator undergoes a form of evolution. Mapping the trajectory of affect in Kracauer's argument, violence first besieges the viewer imagined by this review with immediate and overwhelming impulses. It then leads that viewer to a detached vantage point. Seeing our brethren brutalized triggers a nearly automatic protective fervor. Witnessing violence elicits in the viewer a furious passion or "moral fervor" that reminds us how "in our hearts" we are all brothers. This gut reaction then triggers a conscious realization of our common humanity with all people. However, despite the review's explicit project to redeem Italians as our counterparts, it can only imagine this compatriotism through the subjection of Italian bodies—a boot kicking them in the face. Furthermore, suggesting that Europeans are attempting to build a national character and moral fortitude that Americans have already had for two centuries, this review uses the idea of watching *Rome Open City*'s violence as ground on which Americans can see themselves as more advanced citizens of the world community. Rather than provoking simply an ambiguous spectatorship, realism's ostensibly contradictory effects on the viewer anticipate the ambivalences of the American subject in this period: an anxiety about America's social and political proximities to Europe, a certain skepticism regarding the status of Italians as victims, an uncertainty with comparisons likening Italians to Americans. By dramatizing the capture of Italians and their experiences in a self-consciously

adjudicatory gaze, U.S. critics implicitly resolve these ambivalences by figuring the American subject as an impassioned outside observer, a bystanding world citizen who is impelled to watch but who remains at the periphery.

The Bystander

When we return to *Life*'s use of the still from *Voice of Silence* in this context, the unusual point of view that the realist image grants us comes into sharper focus. In that image, our gaze originates from an extremely low and slightly canted angle that lends our perspective an exteriority. Alongside the image's contextualization by the article, this exteriority suggests that our relationship to corporeal spectacle does not exactly overlap with that of the audience of boys pictured. We are detached onlookers who take in the spectacle of the female body and also watch that body's viewing audience.[34] The view granted here allows an ambivalent proximity, suggesting a nearly indecent revelation in the foreground, but this intimacy does not confine its viewer to the necessarily nearby. If *Life*'s text uses the photograph to allegorize the U.S. spectator's encounter with recent Italian cinema, then we discover that realism not only expands the parameters of what the movie screen contains, but also revises the terms of our engagement with that screen. The realist image provokes curiosity, generates enthrallment, and offers a venue for increased awareness through its lurid and unseemly implications. However, according to *Life*'s visualization of neorealist spectatorship, the viewer often encounters the most startling of neorealism's spectacles through the safeness of an outside viewpoint. In this sense, if the realist image supplies the immediacy of affect, it also offers the viewer a measure of spatial remove.

In the service of this obliged but remote bystander, many of the promotional materials and reviews restage the scenario of an outsider looking in. One of the posters for *Paisan* invokes the illicit thrills of voyeurism. In the foreground, a male and female figure peer into an apparently explicit scene of forbidden passion. These two onlookers function compositionally to frame the main event, emphasizing the unfolding of corporeal spectacle. These figures also justify our own curiosity, our desire for unbridled viewing, and they codify the reception of the film.[35] The poster's text further underscores the voyeuristic lures of realism when it describes *Paisan* as a film "delving" into

uncharted territories and "approaching things Hollywood would never approach." The press book promises that the film "gives you a sense of what it is like to be on the ground," and it brags about providing "first time" access to G.I.s' "loves," "private lives," and "intimate personal" experiences, playing on fears and fantasies of an American soldier's sexual encounters during the war.[36] Like our position toward the boys in the *Voice of Silence* still or the peering figures in the poster, the press book foregrounds cinematic vision as a kind of safe proxy, guaranteeing that any encounter with war's bodies will be mediated. Here, the carnal intimacies of combat are refigured with an intervening distance. The figures on the borders of the image contaminate the brotherly promises of the film's title. Like the photographic account of the collective gaze in *Voice of Silence,* the promotional logic of the *Paisan* press book employs corporeal spectacle to lure U.S. audiences to Italian films and to transform scenarios of looking into virtual spaces of transnational exchange. The American viewer is offered a position that allows an experience of eyewitnessing while maintaining a safe distance.

The text in *Life*'s article emblematizes the American approach to neorealism, partaking in precisely this rhetoric set up by distributors, exhibitors, and critics to cultivate U.S. audiences for postwar Italian cinema. As the article continues, it describes a crisis in Italy over whether to continue making realist films:

> A paradox weighing on the Italian movie industry is that the films which made its reputation abroad are the least appreciated at home. . . . [Neorealist] films have concentrated on the pathetic or the cruel, on poverty or crime. . . . The Italian public, which sees plenty of misery in its daily life, has never shown enthusiasm for seeing the misery all over again on film. It prefers escapist fare.[37]

This article recounts how neorealism found its first audiences in the less war-torn geographies, implying that the appreciation of the realist image depends on the spectator's distance and distinction from the contingencies represented. Film consumption, in other words, maps geopolitical differentiation. According to this article, neorealism is less popular in Italy because Italians are living pitiful and miserable daily lives. Neorealism positions its spectator not in an emphatic equivalence between the onscreen world and the world of the audience, but through the experiential disparity of these two realms.

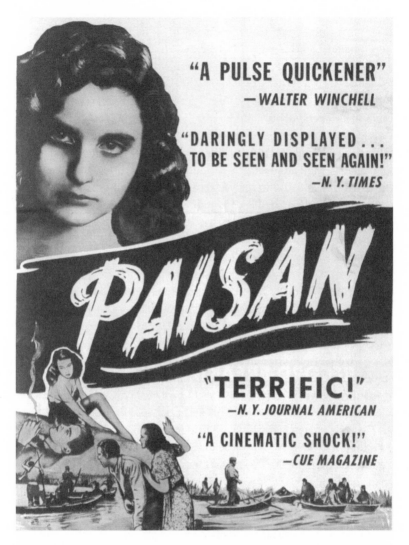

In the bottom left corner of this poster for the U.S. release of Paisan, *two figures peer in at an apparently illicit scene of life in wartime. These onlookers appear in many of the film's advertisements, suggesting the spectator's own voyeuristic and yet detached perspective.*

The writings of midcentury critic Manny Farber articulate this movement between immediacy and alterity. In his review of *Rome Open City*, Farber never quite resolves how depictions of war-torn Italy affect him.[38] He begins his assessment as if beleaguered by the film, suggesting that the onscreen world of worrisome destitution wears and tears on the spectator: "There is a spirit of such depression, leadenness, consuming exhaustion and poverty in every note of . . . 'Open City' . . . that you wonder whether its extreme morbidity was intended." Then Farber suddenly switches tone, delightedly spying on Italy's sordid physical and moral disrepair: "a dope addict, a 15-year-old prostitute, plus a lot of people on the fringes of scenes who look wonderfully shady and as if they would murder you for a cabfare." For this critic, realism allows the viewer to confront and dismiss his or her reactions to the wretchedness of war. Farber is conscious of how the film utilizes—even exploits—displays of corporeality to secure the realism of the image and to build audiences: the bodies of the actors are, he explains, all too convincingly worn down and shrunken as a "wet string," as if from "years-long strain, bread-crumb existence, tension and rebellion." Yet if "'Open City' shocks you because of its excessively realistic look," this realism is not without its pleasures—pleasures that Farber both critiques and indulges in. He admonishes the film for attempting to exploit moments of "seaminess" and sex to generate box office revenue, only to change his moral course midsentence by adding snidely that *Rome Open City*'s treatment of sex should teach Hollywood how better to depict women undressing. We can in fact trace a patterned repetition of these alternating responses to the realist image in Farber's essay. Despite the "burdensome, graveyard quality" of watching this "grayest of all war movies," there are "flashes" when the film seems particularly fresh, and "these moments have the effect of a draft in the theatre." These graphic sequences not only distinguish the film aesthetically but also provide the viewer with intermittent flares of voyeuristic glee that pop out of an otherwise worrisome mix of poverty and oppression. Each seems to offer Farber a kind of compulsive pleasure akin to either rubbernecking or the common somatic response to fireworks: "The most graphic scenes [of violence and suffering] develop with the burst and intensity of an oil-dump fire." For Farber, cinema itself supplies an effective device for juggling contradictory political affects: neorealism invites viewers to experience the realist image as both a form of overwhelming engagement and a means of divesture.

Farber's account demonstrates the contiguity of two seemingly opposed ethics of viewing. His constant alternation between immediate empathic response and distanced viewing reflects neither the incidental doublespeak of crass commercialism nor a simple reshuffling of taste and sociopolitical allegiances. Rather, this approach and retreat perform a spatial function. It evinces a historically productive rearranging of the political work of spectatorship by reenvisioning the parameters of the cinematic experience. The new spectator that emerges in the imagination of this period is, like Farber, a moviegoer comfortable with what would appear to be an irreconcilable oscillation between overwhelmed engagement and conscious detachment. This spectator is also ultimately reconciled to a paradoxically intimate distancing from the onscreen world. In the movement between these two poles of intellection and agitation, a space opens up for a new spectatorial position; this is the space of bystanding, a mode of seeing the world that assuages the subjective discrepancies between wartime engagements and postwar disengagements, and Farber was not alone in his attention to it. The *Christian Science Monitor,* to name just one example, outlines a similar journey for *Germany Year Zero's* spectators: "As the violent shock . . . subsides, a perspective begins to emerge. . . . [The film's achievement] lies in the fact that each member of the world audience with what Mr. Rossellini calls 'a heart capable of loving and a brain capable of thinking' will feel himself compelled to grasp for the deeper answers to hard questions."[39] For this reviewer, international humanism depends on an audience both sharing experiences of shock and detaching from them. If the film initially devastates the viewer with troubling images, it eventually offers that same viewer a spatialized means of transcending problematic particularities. The *Monitor* review imagines that a new mode of world understanding develops in the wake of spectatorial devastation. The film has granted the viewer a special entry into and status in the world community.

Notwithstanding standard arguments for the postwar viewer's substantial and direct engagement with international culture, these promotional and critical documents suggest that the American experience of watching a postwar foreign film may have been as much about disengagement from the horrors of war and its aftermath as it was about an intimate empathy for, direct contact with, or lasting physical involvement in an international community. The presence of this new spectatorial mode, "the bystander," gave the budding "world"—read

"American"—citizen a subjective space in which to experience a nascent and inclusive humanitarian concern, as well as a rubric of proximate distanciation whereby that citizen could imagine a rapidly expanding geography of ethical obligations fulfilled by the politics of international aid. If cinema enabled ethical involvement during the postwar period, in other words, it did so only by providing spaces of intimate foreignness. These were spaces where the sensations of conflicting allegiances could cohabit, spaces where disengagement suddenly felt as committed as physical involvement, and thus spaces particularly productive for emerging ideologies of large-scale international aid.

Cinema: The Medium of World Understanding

In the late 1940s United States, cultural, social, and political discourses anxiously and self-consciously anticipated a shift in the postwar American subject's relationship to the world. Peacetime necessitated revising the subjective terms of international engagement, it seemed, and propositions for reimagining transnational interdependencies came from many sectors of film culture. Voices from within Hollywood and from along its periphery argued that cinema was a necessary facilitator of the coming new world order. Writing for the *Boston Globe,* Dorothy Thompson boldly proclaimed that watching *Rome Open City* would force world leaders to confront our planet's shared destiny and the necessity of unleashing humanist ethics from the bindings of national and social boundaries: "This film should be addressed to the peace-makers, sternly to remind them that, however frontiers, spheres of influence, and ideological lines may be drawn, humanity, whatever its class, or creed, shares common hopes, faith, vices, and virtues, and an indivisible destiny."[40] Alongside Thompson, we could easily gather a diverse group—Hollywood lobbyists, policy makers, fledgling film society organizers, industry journalists, independent exhibitors, educators—who also argued that cinema's cross-cultural comprehensibility, ease of circulation through existing global networks of exchange, and essential realism ensured its status as the medium best able to expand world understanding. Testifying before a 1946 congressional hearing on postwar cultural and economic priorities, Hollywood studio executives justified their industry's capitalist expansion with arguments about international ethics and transcultural communication.

Exploiting popular political discourses, they proposed that the goal of forming a world community governed by peace and democracy would not be realized without the proper means of mediation. Unsurprisingly, given the commitments of these officials, moving images and institutionalized film exhibition provided a means of "expanding world horizons" and improving human relations.[41]

Gerald M. Mayer, the managing director of the Motion Picture Association of America's international division, called this "world understanding" in an essay widely read at the time entitled "American Motion Pictures in World Trade." Although Mayer clearly aims to defend the unbridled export of Hollywood films and predicts the continued triumph of Hollywood against the threat of foreign production, his argument yokes transcultural empathy to the medium specificity of cinema in a manner strikingly similar to promotional and critical accounts of the neorealist image. He suggests that a peaceful world community rests on cinema's inherent realism:

> Because the moving, talking images on the screen have all the immediacy and vitality of life itself, film spectators all over the world come into each other's presence and live together in the same reality. The community of film spectators is a symbol of the world community yet to come. Knowing each other through the film, the most widely diverse human groups begin to get the feeling of what it means to be residents of the same planet and members of the same race.[42]

For Mayer, film distribution and exhibition already provide a demonstration of "internationalism in actual practice."[43]

The widespread theatrical distribution of neorealism, with the more popular films traveling to a wide range of large and small cities across the United States, should be understood in the context of a wider culture of visual humanism that includes film education movements, the expansion of public library film holdings, and the explosion of film societies. In 1948, the United Nations began publishing news of its activities in film to illustrate "the role of films and other visual media in promoting international co-operation and understanding."[44] *Library Journal* from the late 1940s and early 1950s testifies to the expansion of film in public collections and the prominence of neorealist films in a wider landscape of humanitarian films offered to libraries for purchase.[45] Jack Ellis's comments in the 1954 published proceedings of the Film Council of America argue for the adoption of *Shoeshine* and *Bicycle Thieves* in high school classrooms. Compared to more

"didactic" instructional films, these Italian features "take students out of the textbook into life itself."[46] Publications catering to schoolteachers and other educators, such as *Educational Screen and Audio-Visual Guide* and *Educational Film Guide,* echo these sentiments in their resource listings, which feature descriptions and distributor information for neorealist films alongside categories of films about "civilian relief," "human relations," and "reconstruction."[47] *Educational Screen* also published essays proclaiming the particular strengths of cinema as a medium of global peace. In "Wanted: Bridge-Builders," the journal proclaims the screen as the "most potent" tool for bridging cultural barriers:

> The screen can weld into one all the myriad people of the earth. It can make the culture and progress of each the common property of all. . . . It can create that common understanding of Man by men which alone can assure peace and progress in our world. . . . It can inspire that unity of action among men that will fuse our world into one community.

The merger of humanitarian posturing and an aggressive form of American liberalism at play here becomes apparent when the same magazine publishes John Dugan's essay, "The Film and International Understanding," next to an advertisement for an educational slide show that features a large image of the mushroom cloud of an atomic bomb.[48] Distributors like the nonprofit company Films of the Nations began marketing to adult groups, as well as to schools and libraries, with the mission "to create better understanding and friendship among the nations of the world by means of films."[49] Brandon Films promoted an animated film calling for "the inherent equality of men whatever their race or color" and adding the tagline "The Ideal Film for the Ideas of UNESCO."

In the mid-1950s, Cecile Starr collected reports from a wide range of regional film societies across the United States. The resulting volume indicates the many other noncommercial venues where neorealist films were shown, as well as how often these societies cited goals like cultural internationalism. In 1949, an American magazine for early fans of art cinema, *Foreign Film News,* announced the launch of its national movie club organized around precisely the bifocal qualities of the humanist spectator described throughout this chapter: "Thousands of moviegoers from coast to coast are joining this new type of film society because they enjoy a different kind of screen entertainment and

are interested in seeing foreign films gain in popularity throughout the nation."[50] A benefit of becoming one of the club's "discriminating moviegoers" was the opportunity to view "complete versions of those films of adult entertainment that have not passed the censorship boards for release to the general public." Alongside this promise of uncensored content, the *News* reveals the club's lofty mission: "The Foreign Film Movie Club hopes it will be instrumental in fostering international good will and world wide understanding through the medium of the motion picture."

Given this context, it is perhaps unsurprising that what many consider to be the most important federal ruling on cinema censorship happened in this period and in relationship to a neorealist film. In Rossellini's short film *The Miracle* (*Il miracolo,* 1948), the screenplay of which was written by Fellini, a peasant played by Anna Magnani becomes pregnant after sleeping with a man she believes to be Saint Joseph and who is played by Fellini. No images in this film could be considered graphic or even corporeal, with the possible exception of the silhouette of a pregnant woman. However, what the film implies was deemed "vile and harmful" by Catholic authorities in the United States in 1950. Under intense pressure from the Legion of Decency, the Board of Regents of New York State acted to shut down the exhibition of the film by stripping it of its license of public exhibition.[51] The case was fought and eventually won by the maverick film distributor of *Rome Open City* and *Bicycle Thieves,* Joseph Burstyn. Burstyn first appealed the ruling in the New York Supreme Court and lost. Working with the prominent anticensorship lawyer Ephraim London, Burstyn then brought the case to the U.S. Supreme Court, which overturned New York State's ban by ruling that "motion pictures are a significant medium for the communication of ideas."[52] This decision entitled films to the constitutional protection of free speech under the First Amendment. This pronouncement dramatically changed the legal status of the motion pictures, reversing a 1915 decision of the court in which motion pictures were defined as commercial products and not as works of art.

The Miracle case stands at a crucial historical intersection of competing industrial, legal, and cultural values relevant to my arguments in this book. Some of the anger toward the film spilled over from public resentment toward Rossellini and his public extramarital affair with Ingrid Bergman, which had resulted in the birth of a child. The couple's

infamy raged in gossip magazines and even led to their being publicly denounced in the U.S. Congress. In this context, the court's ruling reflects an expansion of what's permissible in film and a revision of the cultural status of movies, as well as an increased awareness of the political importance of filmgoing. Because the court's ruling deemed films to be vessels of ideas, it validated a shift toward understanding the medium not simply as a venue for artistic expression, but also as a form of political speech. What looked like the most official acceptance of cinema as an art form was in this sense actually part of a larger identification of cinema as a form of political expression. Cinema garnered its artistic validity through a legal logic that recognized its essential value to democracy. The midcentury interest in film realism willingly accepted that the pursuit of a raw living image risked raising the specter of obscenity. Meanwhile, many critics arguing against Hollywood's production code describe its cost to realism. Bosley Crowther's 1951 essay on *The Miracle* case, for example, suggests the danger of censorship to films "which look at life in its rawness and reality, without disguise."[53] Here the danger of censorship becomes most critically measurable in relation to realism, keeping Bazin's tension between democracy and obscenity in play. The logic followed is that unless we want to limit our access to reality and to ideas, then we must risk having the obscene image at play in public culture. Censorship is untenable in a world of ideas and of films that have ideas. In the year before this ruling, Raymond Spottiswoode had expanded the category of "idea films" to include nondocumentary films such as early neorealist releases, which he called eyewitness films.[54] The court's bold language similarly forces us to think dynamically about the relationship between information and visuality, ideas and pictures, and brings us to question how the gaze works in a cinema when cinema is understood as a medium of ideas.

The Marshall Plan and Realist Spectatorship

The revamping of film spectatorship adopted the language of a liberalism that emerges with the formation of large-scale governmental aid packages and NGOs, suggesting that an affective engagement with the realist image be considered equivalent to actual involvement in the global community. Through the experience of cinema, viewers could feel themselves participating in world politics without leaving

their hometown. In this sense, if we are to accept the traditional notion that neorealism both fostered the American audience's intimacy with postwar Europe's condition and provided an aesthetic venue for the international ethics of sympathy, then we must also understand the exact terms that neorealist films and their U.S. proponents negotiated for this transnational engagement. As I have argued is the case with promotional discourse, Kracauer's account of cinema spectatorship, and the example of *The Miracle,* midcentury discourses characterize the experience of the film image as neither total subjective immersion nor pure principled intellection, but as a productive oscillation between the thrills of proximate shocks and the comforts of a distanced vantage point. In the context of the postwar United States, that ability to manage one's affective relationship to near and far, home and abroad, domestic and foreign could not have been more important. State-mediated charity and reconstruction projects offered the U.S. subject a means of exercising his or her urgent sympathetic and moral outreach, but only in indirect, impersonal, and mediated terms.

The most prominent of these reconstruction efforts was the U.S. government's European Recovery Program (ERC), better known as the Marshall Plan. From 1947 until the early 1950s, the U.S. government allotted over $13 billion in subsidies and loans to European countries. Although the dollar amount was immense, this plan involved an even larger scope of renovation that included modernizing Europe's infrastructure, furthering the dependence of its industries on U.S. materials, constricting the power of labor unions, and Americanizing markets through stimulating commodity consumerism. The Marshall Plan is commonly understood as one of the largest peacetime efforts to reorganize the economic, political, social, and cultural life of foreign populations. One history sympathetic to its mission describes the plan as "the most ambitious and profound economic development initiative ever undertaken by a government outside its national borders."[55] This account seems to ignore the history of colonialism and neocolonialism, but it does signal how broadly the project reenvisioned the parameters of the U.S. government's sphere of activity. As less enthusiastic accounts tell us, the plan also inaugurated an era in which international aid was increasingly deployed as a form of extranational governance.

The official rationale for the plan was famously outlined by a 1947 Harvard graduation speech given by George Marshall, the secretary of state, whose name the ERC would come to adopt in public parlance.[56]

His speech warns of a current economic and social system on the verge of collapse, and it boldly alludes to Europe's physical and emotional vulnerability to further "political deterioration." It argues for an unprecedented scale of U.S. peacetime intervention with the aim of stabilizing Europe and guaranteeing the "health" of the world. European desperation was not simply a terrible fact; it was a condition making the region susceptible to enemy infiltration. As if describing a weak body fighting off infection, Marshall's speech suggests that a large-scale economic and social intervention by the U.S. government could "provide a cure." A firm guiding hand was needed to guarantee a free world. The plan's imperative, then, was to "[revive] a working economy in the world so as to permit the emergence of political and social conditions in which free institutions can exist." Although great assistance was needed in Europe, the rhetoric of this speech justified a particularly aggressive style of assistance, and one that had already decided on the shape of a new world order. Marshall's speech anticipated the way the plan structured political reorganization into reconstruction.

Marshall's speech begins and ends with the problem of the American subject. For him, the greatest obstacle to reconstruction is the isolationist attitude of average Americans. The problem as he puts it is one of distance: Americans are "remote from the scene of troubles" or "distant from the troubled areas of the earth." How can we start making people care about the lives of those who are neither geographically nor nationally nearby? Here Marshall stages a central geopolitical "problem" of this period: the urgent political necessity of transforming distances into intimacies. Without this transformation, we will continue to live in a world that is dangerously segmented, ill, weak, and unconscious. A process of liberalization is called for so that we can begin to care for foreigners.

The question of sovereignty also lurks in Marshall's comments. His speech admits its address as preaching to the converted ("I need not tell you that the world situation is very serious. That must be apparent to all intelligent people"), and it was written as much for its subsequent European audiences as the one in Harvard Yard. Yet he represents the crux of the problem as one of American consciousness. He frames the fate of the globe as one decided by Americans and their affective relation to the outside world: the future of the world "hangs" on Americans' realization of the world's "sufferings."

Here we may wish to question the sincerity of Marshall's interest in the will of Americans: there were many forces encouraging an interventionist U.S. foreign policy, not the least of which were corporate interests pursuing a government-facilitated reopening of European markets and a further liberalizing of European economies. Historical change in Marshall's argument, however, does not hinge on these forces but rather on the will of the American people—or more accurately on collapsing their sense of affective proximity to those in need. Here we find free-market liberalization concealed in the call for a more liberal humanism. Victoria de Grazia has argued that the Marshall Plan is less about "enlightened benefaction" and more about the need to expand a "Market Empire," a virulent mode of commodity consumerism that aimed to replace notions of the social citizen with a sovereign consumer. "In the struggle with totalitarianism," she writes, "liberal political theory anguished over the capacity of individuals to make free choices. In consumer freedoms it saw the potential for society to develop people who were not only economically wise but also politically rational and ethically good. In sum, 'consumer sovereignty and the liberal system . . . stand or fall together.'" De Grazia contends that by prioritizing the liberalization of markets over humanitarian aid, the Marshall Plan "turned out to be as harsh on lower-class consumers as [the priorities] imposed within the Soviet bloc by the various Five-Year Plans."[57]

In the context of Italy, consumerist market expansion directly interfered with democratic freedom when, in March 1948, George Marshall warned that the U.S. would stop all aid to Italy if the national elections resulted in a victory for the communists. Marshall's Harvard speech also anticipates then the ideological glossing over of a central contradiction in the Marshall Plan's definition of freedom. The imposition of political will beyond U.S. borders presumably traduces the stated values of American democracy. Doesn't a kind of proxied agency imply the limited sovereignty of those in need? In Marshall's rhetoric, however, the political necessity of a mode of distanced witnessing seems to overshadow the serious questions of democracy in an era of globalization.[58]

Just two years after the Harvard graduation speech, and with the Marshall Plan at full-scale implementation, American cinematographer and photographer Paul Strand gave a speech on realism in which film aesthetics themselves are explicitly charged with collapsing affective distances and thus given the prerogative to change the world.

Strand begins by evaluating the relative moral strength of various realist practices according to how they manage the question of distance. Conventionally, what he calls "venal" realisms operated at a condescending and dispassionate distance from things, depicting their world as "isolated" from the viewer. He rejects these realisms along with "slice-of-life naturalism" and its "unwillingness to be involved." From here, his speech reads like a plea for a different scale of engagement, with the latest Italian films, such as *Rome Open City,* offering a clear call to shift our sense of distance:

> We should conceive of realism as dynamic, as truth which sees and understands a changing world and in its turn is capable of changing it, in the interests of peace, human progress, and the eradication of human misery and cruelty, and towards the unity of all people. . . . *Open City* . . . is no mere recording of events, from some sort of impersonal height above the battle for human freedom.[59]

Although Strand's vision of cinema as a medium of world understanding identifies with the Italian Resistance on the surface, it also suggests that *Rome Open City*'s political strength derives from its commitment to the "interests of all people."[60] In doing so, Strand's essay participates in a discourse of realism that works in concert with a move toward globalized citizenry and inadvertently obscures the very undoing of the Resistance's political will by the U.S. government's pressure on the elections just over a year earlier.

The sociopolitical and geographical flexibility of film lent itself perfectly to this project, as did a reinvestment in the particular mode of mediation the film image enables. Cinema is seen as the engine of liberalism and a new world order based on the bonds of a North Atlantic community. In fact, alongside Stand, we can see many mid-century writers further burdening the movies with the responsibility of acting as a platform for global spectating. They see cinema's sensorium—that is, the medium's uniquely immersive interface—enabling a new practice of political awareness that has a particularly global attitude. Looking at the specific industrial discourses that endorse realism and the formal structures of looking articulated within films, we find that cinema allows for a liberal humanism because it expands the subjective space of viewers (broadening their horizons) and because of the ways that it imbricates proximity and distance, connection and disengagement. In this sense, the discourse of realism allowed

a discussion of viewer engagement to take on geopolitical weight, frequently encouraging us to see the spectator's proximity and distanciation—his or her overinvolvement and detachment—as analogous to political, national, and geographic spaces. Realism emerged as an affective means to manage the dueling proximities of empathy and worldly goodwill. The promotion and criticism of Italian postwar films not only offer American audiences a way to reorient themselves to the consumption of cinema, but they also permit those audiences to imaginatively remap their place in world politics.

If the spectator proposed by these discourses appears oddly bifurcated or ambivalent today, it is perhaps because such a spectator served a historically specific ideology of American internationalism whose importance has waned—or has at least been reorganized in other directions. More than simply a marketing hybrid of low-genre and high-genre viewers, the spectatorial mode of the bystander imagined by these discourses participates in the larger ideology of U.S. engagement in the postwar European recovery. It lubricates a Marshall Plan ethos of global communalism involving troop divesture, humanitarian aid, and the liberalization of markets, which at the same time endorses cultural imperialism as a means of political suppression and economic doctrine. The U.S. promotion and criticism of neorealism should encourage us to return to these canonical films with new eyes. These archival texts expose how neorealist films, often canonized for their leftist leanings, in certain respects served to confirm the logic of postwar American U.S. foreign policy. Here a realist orientation to the image still fosters a version of global ethical citizenry, but one that proposes a world community without physical contiguity. This particular citizenry finds expression only through an intimate but distanced proximity to the outside world.

Incurable Distances

At least one American critic, James Agee, was vocally suspicious of realism's graphic quality and its apparent embrace of bystanding as a moral position. He expressed concern over how cinematic corporeality might actually detach the American psyche from the urgent social frailties brought on by the war. Like Farber and others, he appears to acknowledge the strangely proximate distance afforded by realism. But more than these other critics, Agee remains deeply unsure of its

political potential. He chastises Hollywood for the "safe fearlessness" of the social problem film and remains unimpressed by the caricatured realism of *The Best Years of Our Lives* (William Wyler, 1946), which "makes every punch [seem like] a kind of self-caress."[61] Elsewhere, he identifies Hollywood's moral and political subject matter more with posturing than with the taking of a real political stand. The social critique of *Crossfire* (Edward Dmytryk, 1947), for example, he brands as disingenuous and cowardly: "In a way it is as embarrassing to see a movie Come Right Out Against Anti-Semitism as it would be to see a movie Come Right Out Against torturing children."[62] Agee accepts that a Hollywood promilitary film, like Paramount's *Wake Island* (John Farrow, 1942), strives to "convince, startle, move and involve an audience."[63] In other words, the film reaches for complete spectatorial enthrallment in "an effort to fill civilians with the image and meaning of a terrible and magnificent human event. . . . Toward that end, faces, bodies, machines, rhythms, darkness, light, silence & sound must build up a tension which is a plausible parallel to human fact." Yet for Agee, "*Wake Island* is a cinematic defeat because it builds up this tension for brief moments, then relaxes."[64] At stake in this review is Agee's fear that films can cheapen the witnessing of violence, eroding the culpability of all Americans in the violence of war. In his critique of *Wake Island*'s technique, Agee writes: "The silky panchromatic light which properly drenches a grade-A romance softens the strongest images of courage or death into a comfortable fiction."[65]

Agee finds this dangerous sequestering of affect at play in documentary as well as fictional realism. As he ends his 1945 review of an American combat documentary, Agee suddenly questions why he has, just sentences earlier, advised readers to see the film, suggesting that its violent imagery may have unhinged his own critical equanimity: "I am beginning to believe that, for all that may be said in favor of our seeing these terrible records of war, we have no business seeing this sort of experience except through our presence and participation."[66] For Agee, the shattering sensations of documentary realism so warp our perception that we gradually lose touch with political reality. The realist image of violence compares to the effects of pornography, and thus leads to the almost certain degradation of the viewer. These comments may sound retrograde and iconophobic at first, but Agee will proceed to make a startling link between realism's dependence on the corporeal and the self-righteous geopolitical orientation of the postwar

American subject. What these quasipornographic images threaten to degrade in the viewer is not what we would immediately assume. The consumption of pornographic images leads neither to psychological deviance nor to socially destructive behaviors. Rather, it encourages a self-satisfied smugness in the American viewer about his or her own place in the world. Pornography, it seems, is the guardian of a complacent status quo.[67]

As Agee describes this danger, his writing participates in a larger discourse seeking to imagine the postwar U.S. moviegoer as a bystander, but he also harshly condemns that position:

> If at an incurable distance from participation, hopelessly incapable of reactions adequate to the event, we watch men killing each other, we may be quite as profoundly degrading ourselves and, in the process, betraying and separating ourselves the farther from those we are trying to identify ourselves with; not the less because we tell ourselves sincerely that we sit in comfort and watch carnage in order to nurture our patriotism, our conscience, our understanding, and our sympathies.[68]

Unlike other cautionary tales of subjective numbness and affective lethargy resulting in subsequent misbehavior, Agee's warning arises from his fear that graphic images disorient American viewers spatially and permit them to disengage from a true political situatedness by projecting themselves into the sphere of false sympathy where conscience and understanding are mere affectations. Here Agee is most troubled by the American viewer's willingness to accept a position of an "incurable distance" from the sphere of any actual participation. The comfortable consumption of carnage precipitates a dangerous political complacency. As I have suggested so far, and as I will argue in the rest of this book, Agee cannily anticipates the affective scale that American critical discourses would attribute to neorealism: the viewer enjoys the questionable comforts of subjective alterity achieved at a distance. Inasmuch as the explicitness of the realist image can be said to trigger an automatic ethical outreach, that outreach extends into a transnational space in which spectators can ascertain their own political sovereignty in the new geopolitics of postwar recovery by bearing witness even when viewing from afar. This spectator embraces the separation offered by the corporeal image because it strengthens the rightness of his or her inaction. In other words, the realist image imagined by American critical discourse perpetuates complacency by bolstering the idea that political action is best carried out by proxy.

Perhaps for these reasons, Agee's praise for neorealism is more fraught than that of other U.S. critics. Agee does admire how neorealist films transform affect into information and vice versa. In this respect, his assessment of these Italian imports seems similar to that of his colleagues. For example, the effectiveness of *Shoeshine*'s realism, a film "bursting at the seams with humane sympathy," is that it makes "information eloquent to the eye."[69] Agee also agrees that neorealist films uniquely enable "understanding." However, his version of understanding does not originate from witnessing bodily violence. In fact, he applauds the American censors for proposing to cut details of *Rome Open City*'s torture scenes, arguing that the original release print would only further indulge the "backstairs sadism" of American audiences. What makes Agee especially unique is how he uses his reviews of Italian films to insist on the incongruence of U.S. foreign policy and an ethics of humanism. For him, patriotism can never be humane. In his review of Luigi Zampa's *To Live in Peace* (*Vivere in pace,* 1947), he daringly identifies himself as, first and foremost, "a human being, who would rather be a citizen of the world than of the United States."[70] Agee points out that the film's "deeply humane" outlook results from the way it dismantles the same all-knowing and morally superior spectatorship so often fostered by lesser realisms. The film condemns as delusional any aspiration to impartial judgment by making all such positions untenable. The strength of this film's extreme perspectivalism is that no one escapes its soaring gaze; not even the filmgoer's point of view avoids its ruthless pitying or mocking scrutiny. Agee applauds the film for its interrogation of a spectatorial mode that we have seen elaborated in other texts and that I have called bystanding. Agee claims that Zampa's film provokes distanciation as a means of achieving a true humanism, but he also suggests that the film simultaneously exposes the hypocritical moralism of a false humanism based on the observer's detachment, removal, and self-appointed distinction from the object of his or her gaze.

Considering the weight that American film history accords neorealist films in the postwar transformation of film style and exhibition, it is tempting to read their initial box office success as a sign of an emergent global humanist ethics in America. Even today, critics continue to cite postwar realism when they advocate for a cinematic "fostering [of] international good will and world wide understanding." Jonathan Rosenbaum, for example, points to Bazin's religious faith in

photographic registration as an effective premise for arguing that cinema is "a way for the world to keep in touch with itself—and that's clearly an issue today, even an urgent one when faced with the consequences of, say, American isolationism."[71] However, if we are to embrace the idea that neorealism both fostered the American audience's intimacy with the postwar European condition and provided an aesthetic venue for the international ethics of sympathy, then, like Agee, we must also understand the exact aesthetic terms that neorealism and its promotion negotiated for this transnational engagement. A postwar geopolitical attitude emerged from the interplay of distanced knowing and immersive affect that the realist image enabled. For all its rawness and shattering effects, the realist image left the American viewer with a version of "world understanding" unexpectedly sympathetic to the political and social priorities of postwar U.S. policy. These texts conceived a spectator who was happy to have reaffirmed just how "incurable" was the distance between human rubble and the movie theater. This surrogate mode of engaging in the world proposed an active involvement that came at a low cost to the spectator. In the end, we find the popularity of human-interest and imported films in this period entangled with a paradoxical internationalism requiring gestures of sympathy, outreach, and aid.

To conclude this chapter, and in anticipation of the next one, I want to highlight again a central feature of this internationalism, the proxying of national sovereignty, and how cinema comes to address two of the challenges that this alteration of sovereignty poses to nationalist politics. First, Americans were asked to accept a more interventionist U.S. foreign policy during peacetime. Reaching the goal of a more democratic world and protecting the already-free world, it seemed, required the Pentagon and the State Department meddling in the political and social life of former enemy nations like Italy, Germany, and Japan. This required Americans being comfortable with (or apathetic toward) the U.S. government expanding its political will over "democratic" countries like Italy. The U.S. government could be seen as usurping political power extranationally, and if nothing else, we could call this the assertion of an engorged sovereignty. I have tried to show how it is possible to read the distanced proximity offered to the American spectator by the neorealist image in tandem with these geopolitics and their redefinition of national sovereignty. Adapting Jonathan Crary's analysis of the optics of *cultural* enfranchisement, we might

define neorealism's optics as a particular orientation of viewer to image that grants the foreign subject—and emblematically the American subject—a *transcultural* enfranchisement.[72]

Second, I began this chapter by unpacking how the promotional discourse of the first important postwar Italian film, Rossellini's *Rome Open City*, attempts to articulate the stakes of openness for its spectator while depicting the horrors of an occupied Rome. The liberal humanism that I describe above depends on this selective opening or liberalization, which extends the liberties of its central subject while contracting the liberties of others. Liberalism's expansion of the parameters of affect, understanding, moral obligation, and political action to suit the new world order involves an accompanying constriction. With this structure in mind, we can return to the visual language of the film narratives and ask one final question about their compatibility with postwar North Atlantic politics. As I have already suggested, the U.S. government threatened, in an infamous maneuver of interventionist politics, to withhold massive reconstruction funds and other much-needed aid if the Communist Party won the national elections in Italy in 1948.[73] Political scientists working on this period dubbed the failure of the left to win the ensuing election a manifestation of Italian nationalism as a form of "self-imposed limited sovereignty."

In the next chapter, I explore the possibility that the spectatorship proposed in the point-of-view structures of Rossellini's films engage this relationship between constricted democracy (limited sovereignty) and expanded interventionism (engorged sovereignty). My readings suggest that in their elaboration of the body as the site of political struggle and looking as a form of action, these films work through a geopolitics of variable sovereignty. The next chapter asks, in other words, whether and how neorealist films might have met an American need to see the Italian as willing to accept his or her own limited sovereignty.

3 ROSSELLINI'S EXEMPLARY CORPSE AND THE SOVEREIGN BYSTANDER

IN HIS 1999 DOCUMENTARY *My Voyage to Italy,* Martin Scorsese describes his personal devotion to Italian cinema. The film begins with the director sharing a memory from his childhood in the late 1940s and early 1950s, when every Friday night, his extended family gathered to watch the Italian films broadcast on television. In his narration, Scorsese argues that seeing these films introduced him to cinema's potential to engage its audiences with social experiences and political realities outside of themselves. Exactly which images allowed the act of spectatorship to attain such significance?[1] Scorsese's voice-over claims it was those uniquely "powerful" and "strong" moments of neorealist films that sparked his boyhood discovery of cinema's social and political import. As he narrates his account of neorealism's power, the documentary replays some of the most gruesome and disturbing scenes from Roberto Rossellini's two canonical neorealist features, *Rome Open City* and *Paisan.* By juxtaposing Scorsese's personal revelations with the torture sequences of the former film and the floating corpses sequence of the latter, this documentary locates the affective power of Italian cinema in neorealism's depictions of the imperiled body. Surprisingly, however, Scorsese himself does not directly speak of neorealism's violence. When he later explicates how postwar Italian cinema set a new standard of realism, he cites a number of definitional features: the use of nonprofessional actors in starring roles, for example, and shooting on actual streets instead of studio sets. He never mentions that the narratives of many neorealist classics pivot on scenarios of the violenced body. In this sense, *My Voyage to Italy* exploits neorealism's corporeal imagery as visual evidence to support the claim that these films had an affective impact on the lives and perspectives

of their international audiences. Yet Scorsese's film remains curiously silent on the topic of violence, never naming the unprecedented corporeality of these films, let alone explicitly considering it as an essential element of the neorealist aesthetic or a key component of their global appeal.[2] This silence is symptomatic of how the act of watching Italian films gets remembered in the United States and in film studies more broadly.

In this chapter, I seek to break with this tradition and confront the imperiled bodies that populate *Rome Open City* and *Paisan*. I argue that these displays of the imperiled body offer a narrational opportunity for the films to reach out to a postwar international viewer. These films utilize explicit depictions of the suffering body to grant the international spectator a place of agency in otherwise foreign terrain. Their visual narration of violence underwrites, I propose, a new transcultural protocol of spectatorship: images of physical abuse, political torture, and execution supply a venue through which these films promote looking as a form of political engagement. By placing ocular witnessing at the center of their narratives, these films seek to transform seeing from a passive state of consumption into a powerful means of moral reckoning. Cinema spectatorship becomes a virtual mode of bearing witness that emerges from these films as the exemplary experience of postwar politics.

Perhaps this should not surprise us. Asked whether he considered himself a neorealist, Roberto Rossellini replied, "Neo-realism, but what does that mean? . . . For me, it is above all, a moral position from which to look at the world. It then became an aesthetic position, but at the beginning it was moral."[3] According to Rossellini, the original mission of a neorealist filmmaker was to provide his audience with a unique vantage point from which to see the world in moral terms. He suggests that the appeal to this morality, which was seemingly urgent and necessary at the moment of neorealism's conception, was best made through point of view: it was a "moral position from which to look at the world." In Rossellini's account, neorealism's emergence as a coherent aesthetic tradition follows from the implementation of point of view as a means of making a moral position available to its audiences. It is a new means of being able to look at the world *as* the world. In the context of the mid-1940s, that word, *world,* resonates with both ontological realism and geopolitics. In Rossellini's view, cinematic realism will help to effect a realignment of vision from a

regional or national to a global frame. In what follows, however, I will show how Rossellini's early neorealist films foster a particular global view: a bystander vantage point. These films not only open us to this position, but also seek to familiarize us with its newfound moral authority. In addition to describing the formal and ideological emergence of this point of view, I will suggest that it is through scenarios of corporeality that this perspective gains visibility.

Scholars have tended to read Rossellini's commentaries as they do his camera work—that is, as performances of restraint or postures of humility that disingenuously defer to the profilmic. Passages like the one just cited have come to exemplify for later scholars how Rossellini's professed modesty justifies not only a suspiciously transparent realism but also a lack of self-reflection in his mode of depiction.[4] Yet Rossellini's realism fosters anything but a viewer's naïveté toward seeing. His films rarely adopt a completely impassive attitude toward the profilmic. According to Rossellini, as we have already seen, the neorealist film expresses its moral prerogative through point of view: its agenda finds expression in the activity of seeing.[5] In this sense, Rossellini's words expose a central aspiration of Italian postwar film: the neorealist film attempts not only to expand what audiences see of the world, but also to bring audience awareness to the activity of looking as a kind of worldly engagement. The political content of neorealism is to be found as much in the image's structures of point of view— its framing, angles, and shot order—as it is in what those images depict. By drawing audiences' attention to looking as a means of ethical engagement, Rossellini and his films suggest that moral imperatives proceed from full visual access to the world.

Through a detailed analysis of how *Rome Open City* visually narrates violence, I read neorealism as an aesthetic attempt to establish an ethical position cinematically and to make vision into the privileged site of ethical action. I then turn to *Paisan* to show how neorealism uses the imperiled body to strictly delineate the moral and ethical parameters of this international bystander. Endorsing the detached observation entailed in simply looking on, the narration of these two films simultaneously condemns the nationalist totalitarianism of the Nazi occupation and anticipates Italy's acceptance of the Marshall Plan. Surprisingly, perhaps, the films' thematic exploration of the problems of openness does not formally trouble the idea of the outsider's agency. Instead, this narration welcomes the authority of a foreign

presence. The rejection of the German occupation comes not through the restoration of the local, but through an embrace of the global that allows a North Atlantic communal authority to take hold. The world when seen through these eyes makes palatable the limited sovereignty that Italy was coerced to self-impose in the years leading up to the 1948 elections, and it even endorses that limited sovereignty as a position of moral rectitude. Throughout this discussion, I return repeatedly to the idea that neorealism's liberal humanist perspective comes most clearly into view when we unpack the point-of-view structures of its most grisly scenarios.

Neorealism's success in establishing the social currency of international cinema is indisputable. However, my closer look at the aesthetic means by which these films proposed their new mode of international spectatorship suggests that neorealist films, while aiming to invoke a transnational and transhistorical empathy, risked excluding other, less universal forms of testimony and experience. These films promote a universalist conception of human compassion by reifying a particular response to violence as the exclusively moral one. In doing so, they refuse to depict the insidious lures of war, to represent the contradictory origins of mass violence, and to consider what the nearly unfathomable scale of the war's atrocities might mean for traditional means of representing suffering.

Rome Open City

Rossellini's 1945 *Rome Open City* was the first Italian film imported to America after the war and remains one of the key exemplars of neorealism for global audiences. Many critics have discounted the scenes depicting violence in *Rome Open City,* viewing the sequences that visually indulge the corporeality of violence either as flourishes of verisimilitude that exemplify the loosening of narrative economy by postwar realism or as a graphic excess that threatens to cheapen the humanist project of the film. In my view, however, neorealism carefully narrates its cinematic encounters with the corporeal, providing the viewer with a comparison of proper and improper responses to these bodily displays. Moreover, I want to suggest that *Rome Open City* uses explicit depictions of the body at key junctures throughout its narrative to align the viewer's perspective with a particular spectatorial protocol at times in tension with Bazin's democratic aspirations

for both neorealist aesthetics and cinematic spectatorship. This proto-col has two trajectories, and both depend on scenarios of violence. On the one hand, the spectacular executions of three central characters—Pina, Manfredi, and Don Pietro—provide a visual venue for the in-tersection of diegetic looks and the spectatorial gaze. In other words, the correlation of onscreen looks and spectatorial gazes gains a cen-tral, moral significance only through the violent deaths of three of the film's main characters. On the other hand, these same scenarios shear spectatorial identification away from Resistance characters and their point of view. With each death, the film disables the formal means of identifying with these particular characters while simultaneously opening up a new protocol of vision removed from the diegesis, "a moral position from which to look at the world." Importantly, the elaboration of a generalized moral position can in this respect only develop in opposition to viewer identification with the gaze of a par-ticular character. The spectatorial protocol of looking must reject the specificity of onscreen subjects. This emphasis asks the spectator to single out the diegetic look, and by association all forms of vision, as the carrier of difference. Yet the film cannot render this difference aes-thetically. How characters react to spectacles of violence serves as the basis for distinguishing among different ethical character types.

In this regard, *Rome Open City* is quite consistent with the codes of mainstream cinema, in which it would be taboo to allow a character's subjective perspective to taint the film's visual delivery of diegetic facts to the spectator.[6] Although the act of seeing serves to dramatize the distinctions between humans and monsters in *Rome Open City,* the quality of the image itself can never be infected or marked with such a distinction, regardless of point of view. The content of point-of-view shots in mainstream cinema rarely reveals much about the character who originates the look beyond his or her position in the diegetic space. A film like *Rome Open City* must therefore invent a way to mark distinctions between the points of view of different char-acters without either introducing the fallibility of all vision or endan-gering the stability of the image itself. Visual narration poses a further problem for a film like *Rome Open City,* which lends itself, like many later realist political films, to portraying underrepresented perspec-tives while endorsing the singularity of objective reality.[7] To elaborate a position unfamiliar to most audiences, this film must devise a frame-work in which to grant these lesser-known perspectives a means of

articulation without destabilizing the realism of the image.[8] Corporeal spectacles allow the film to "order" and "articulate" the world for the viewer in this way.[9] Specifically, depictions of the brutalized body enable a redefinition of the nature of the film's own narration midstream. Starting with the sudden death of Pina, the film disrupts the position it provided the viewer in relation to the first third of the narrative. Through its initial positioning and then repositioning of the viewer, the film addresses an international audience, building a spectatorial protocol that leaves open a space of subjective agency for the foreigner.

Depiction versus Documentation:
The Sudden Loss of Pina's Gaze

For Millicent Marcus, the death of Pina constitutes a major "generic transformation" of *Rome Open City,* ending the film's oscillation between the two registers of comedy and drama that it had thus far engaged.[10] I want to extend Marcus's characterization to argue that Pina's troubling death represents a radical shift not only in the genre and tone of the film, but also in its very narrative premise. By upsetting audience expectations of both what the story will bring and how that story is told, *Rome Open City* specularizes Pina's brutalized body, indulging its depiction through graphic detail, as a way to induce a sudden shift. Furthermore, I will suggest that this shift should not be regarded as outside the general logic of the film, but as integral to how the film attempts to direct and control the gaze of the spectator. In other words, the film's episodes of intense corporeality, of which Pina's death is perhaps the most important, should not be regarded as mere excess.[11] This film's depiction of violence and its detailed descriptions of the body are more than simply a graphic surplus that verifies the realism and material precision of *Rome Open City*'s images.[12] They rest at the center of the film's invention of a moral position of bystanding.

Until her sudden death, Pina is a key character in the narrative and a central perspective through which the film visually narrates its story. Her death thus not only disrupts the narrative, but also affects its delivery, introducing uncertainty into the epistemology of the film and radically altering how we know what we know. To fully understand the impact of Pina's death requires a brief explanation of how the film

sets up a correlation between character looks and spectatorial gazes. Several times during its first third, the film links a member or members of the Resistance to an omniscient perspective. The film accomplishes this in three steps: it represents a character looking off screen; it then cuts to his or her point-of-view shot; and finally it releases this embodied point of view to a series of omniscient gazes that transcend the human ability to move through space. Thus, what begins as a subjective point-of-view shot originated by a Resistance character develops into a generalized omniscient gaze that exceeds the range of movement and perceptual scope possible for an individual.[13]

In two similar examples, for instance, the diegetic looks and strong sight lines of Resistance figures initiate an expansion of spectatorial vision. Both happen in Francesco's apartment with Manfredi and Pina present. In the first instance, the noise of an explosion from outside interrupts a conversation among the three characters. They all look in the direction of the sound (offscreen left), and then they move toward the noise, standing together looking out the window. In an eye-line match shot that follows, we get a view of the street from the apartment. From here on, the sequence abruptly abandons the characters' points of view. Exploring the cause of the explosion, the roving camera follows the street activity in an omniscient manner, completely disembodied from the characters whose points of view initiate our access to the outside. In a second instance, the scene begins with Pina bursting into the same room. Manfredi and Francesco are already present. She cries, "The Germans and Fascists are surrounding the building." The three characters hurry to the window; the camera then adopts an aerial view, a point of view at an angle above looking down onto the street below. The shots that follow represent activity on the street from perspectives unavailable to any of the three characters. Eventually, the film returns to the three characters in the window. Manfredi and Francesco step back into the room so as not to be seen by the Germans. Pina continues to look down, and the film once again adopts an omniscient gaze exploring the goings-on below. During these window sequences, we are shown much more than either Pina or the others are able to see, and yet the film indicates that it is their looks that initiate our gaze. These sequences in this way link the perspective of these Resistance characters fighting for Italy's liberation to a central all-knowing gaze.

In both cases, Pina's movement initially triggers the relay of looks and determines our access to vision. While Manfredi and Francesco

immediately rush to the window, the camera follows Pina's lead as she moves to turn off the lights and then to the window in the first sequence. Because her actions and point of view determine what we see, Pina emerges as a character more closely aligned with the visual narration than either Manfredi or Francesco. While a progression from eye-line matches to omniscient shots is common in mainstream filmmaking traditions, here an association of Pina with the narration serves to amplify the viewer's shock when, only moments after the second of these two sequences, she is shot and killed. Her killing has, of course, been described as "one of the film's most powerful moments."[14] Her onscreen murder startles the viewer on the level of both narrative and narration.

It is shocking to realize that a film that overtly memorializes the activities of the Resistance kills off the Resistance character that its narrative has most closely aligned with seeing and knowledge: Pina.[15] As the film's first example of extreme violence, the killing of Pina not only causes a sudden disruption of our expectations for the narrative, but also introduces a radical break in the film's narration: a move away from the association of Resistance gazes with an omniscient point of view. Her death unsettles the viewer because it brings an abrupt change in the method of depicting events—a rupturing of how events are shown to the viewer. Violence happens before our eyes without warning. Unlike the earlier violent acts recounted for us, we get no warning of Pina's imminent death, either from offscreen sound cues or reaction shots of onscreen characters.[16]

The street-side sequence that precedes Pina's death initially appears to follow her sight lines, and in this sense, it encourages us to invest again in her perspective. The activity of her seeing follows our need to see. The sequence begins on the sidewalk of what is presumably the interior courtyard of an apartment building, where Pina stands with a group of other women evacuated by German soldiers who are searching the building for hidden members of the Resistance. Pina squirms in discomfort under the leering gaze of the soldier who has been sent to retain this crowd. She glares back at him and eventually slaps him. The sight of her fiancé, Francesco, captured and escorted out of the building by the Germans, causes Pina to take action, breaking free of the watchful gaze and physical restraint of the German solider. In the next shot, she runs down the building's *portone,* a corridor connecting an interior courtyard to the street, her arms flaying

and splaying outward, silhouetted against the light background. Reframed and contained within the architectural and lighting effects of the shot, her body moves in an atypically erratic manner. It is here that Anna Magnani's expressive and dramatically gestural performance begins to take its most extreme form. The brightness of the entryway to the street contrasts to the dark interior walls of the *portone* on either side of the image to create a frame within a frame, enabling the shot to maintain a classically balanced composition. The irregular movements of the actress's body are confined within a formal performance space. With the next shots, the camera work loosens and deviates from the style established during the first third of the film.

At the end of the *portone,* Pina's sprint is halted momentarily by another group of soldiers and Don Pietro, who try to hold her back from running into the street. In the background of the shot, her son has joined the chase and is also held back by the soldiers. Strikingly and only for a few moments, the film slows the motion of the bodies here. This slowing of motion is almost undetectable because the frenzied struggle continues to occur naturalistically on the sound track as a continuous event. However, this slightly slowed image greatly affects the structure of the sequence by dilating the erratic kineticism of these struggling forms and amplifying the loosening of camera work, which increasingly relinquishes its composed framings to the erratic shifts of bodies in motion. This effect, along with apparently dechoreographing the bodies in relationship to the camera work, trains our gaze on the body of Pina. As Pina chases after Francesco, the camera movement and framing appear to respond to the action within the profilmic event. Rather than defining a formal performance space within which that movement must occur, the frame here adapts its composition to the movement of the character and the event. The camera follows the lead of the diegetic action, tracing first the course of Pina's body as it chases after the truck, and then this figure's tumble to the ground after being gunned down. These shots are filmed with a narrow depth of field that blurs the background but that keeps the quick movements of the body as its central focal point. This shooting style resembles a camera tracing the unexpected movements of an animal in a wildlife documentary. The film does nothing to prepare its viewers for the gunfire. The murder happens quickly, and the gunshots come as if out of nowhere. As viewers, we are confused about the

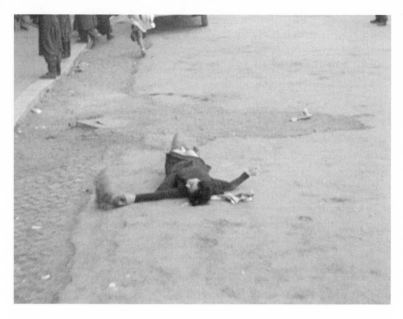

Rome Open City *amplifies the narrative disruption unleashed in Pina's sudden and unexpected death by shifting to a looser shooting style that accentuates the random fall of a body made vulnerable.*

location and identity of the assassin, as well as about whose perspective we are adopting as witnesses to this event.[17]

Here, within the context of a film that has previously celebrated the infallibility of human vision, we suddenly find ourselves questioning what we saw and through whose eyes we have seen it. How can an unarmed person be murdered for chasing a speeding truck on foot? How can one of the film's main characters be dead already? As with the murder of Marion in *Psycho* (Alfred Hitchcock, 1960), Pina's sudden death betrays the viewer's relationship to the narration. Her death poses such a disruption to the film's premise that it unleashes an uncertainty about how its story is being told: will we learn about (and be shown) events differently than we have been led to expect? How can we trust a narration that first encourages our identification with a character and then betrays our investment by eliminating her? If we didn't see this coming, then will the narrative betray us again? Formally, the depiction of her death also introduces further ambivalence about the narration, encouraging the viewer to question the

terms by which the film releases visual knowledge. Through whose eyes do we see reality? Whose point of view are we left to adopt? With whom are we aligned?

If the first third of the film forges a strong connection between emotionally intense narrative events and the point of view of Italian Resistance figures, then the visual narration of Pina's death interrupts this precedent. With her killing, the film begins to abandon the point of view of characters aligned with the Resistance. The final shot of this sequence positions the Italian crowd, Don Pietro, and Marcello (Pina's son) as the object of the gaze instead of its genesis. In a moment of narrative disruption, point of view bears no clear connection to Resistance subjectivity. Instead, the film depicts members of the Resistance as outside these scenarios looking in, showing armed guards restricting the crowds in a manner that foreshadows the later restraint of Don Pietro during Manfredi's torture and the children behind the chain-link fence at Don Pietro's execution. As Pina lies dead, it is neither Don Pietro's point of view that we inhabit nor that of the crowd, but rather two ambiguous, unspecified, and similar perspectives. One camera angle seems to originate from the area of the assassin, a German soldier holding a large gun, and the other from a more unmarked perspective less than forty-five degrees to the left. Although not strictly speaking a jump cut, the shift between these two similar perspectives is peculiar for how little additional narrative information it provides. However, the switching does lend both an immediacy and indeterminacy to the scenario, as if Pina's death was not a fictional depiction but an actual event unfolding in real time, endowing the film with what Bazin identified, when referring to neorealism more generally, as a "documentary quality."[18] Like the editing of newsreels or television reporting that scramble together their coverage of an event by oscillating between footage from various on-scene cameras, *Rome Open City*'s movement between these only slightly different perspectives reveals both an intention to fully document the graphic uniqueness of Pina's gestural fall and an anxiety about capturing the completeness of the instant. The use of two similar angles to record the same event in this way accords the performance of the body special status.[19]

Pina's earlier sprint through the *portone* appears more preplanned, as if blocked out for performance, because the archway reframes and contains her body's movement within a balanced composition. As the sequence unfolds, the physically expressive performance of Magnani

no longer fits within the careful framing of the shot; her body appears to exceed the camera's ability to anticipate movement. Rather than supplying a virtual proscenium for a performance, the frame must adjust itself to the diegetic world. The frame appears to chase after Magnani's performance, as if her movements were a spontaneous dance being documented on film.[20] Over the course of this short series of shots, the film produces a conspicuous treatise on representation by comparing separate traditions of photographing the body. The sequence progresses from an aesthetic of fictional depiction toward an aesthetic associated with documentation. This evolution formally antic- ipates the conclusion of this sequence with the shocking death of Pina.

The final image of Pina comes from an odd, oblique, low-angle shot that emphasizes the awkwardness and vulnerability of her slain body lying on the pavement. Her body spills beyond the edges of the frame, as if her final pose were neither constructed for the camera nor preconceived. The unbalanced composition also reflects an atypi- cal intimacy with the character's body. Up until these final moments, the viewer has come to know Pina mostly through standard frontal medium close-up shots or long shots. Here, the character's face, the conduit of spectatorial identification in mainstream film, cannot be fully seen. The revelation of Pina's body and certain of its intimate details supplies the final disorienting horror of this scene: her skirt is hiked up above her garters, her legs are awkwardly splayed, her stock- ings torn. This shot records the discomforting spectacle of a body ex- posed. Over the course of this short sequence, an expressively gestural performance of the body appears to alter the relationship of the cam- era to the profilmic event.

In an interview with Eric Rohmer and François Truffaut, Rossel- lini recounted how the press seemed troubled by the apparent mix- ture of fiction and documentary evident in scenes such as Pina's death: "It's funny to re-read what the critics said about my early films. [About] *Rome, Open City* [they wrote]: 'Rossellini confuses art with reportage. The film is a piece of Grand Guignol.'"[21] These reviews maligned the film's mixture of two modes of representation: what the critics call *art* and which appears in my argument as *depiction*—that is, the narrative conventions of constructed fiction; and what the critics call *reportage* and I term *documentation*—that is, the recording of a real- time event that would have occurred regardless of whether a cam- era was present. In reprimanding Rossellini's irreverence for generic

convention, these critics liken the film to the Grand Guignol, the grotesque and corporeal spectacles popular in late nineteenth- and early twentieth-century Paris. Elsewhere in this same interview, Rossellini himself disavows the idea that his films followed one cohesive style, seeming to concede his critics' point. Yet he also speaks of his filmmaking as a refusal of manipulation and effects, such as montage, which he regarded as a form of conjuring. Instead of emphasizing the complex aptitude of postproduction wizardry, he meant his films to embody impassivity and humility toward the events they depicted, as if they were recording life with its contingency left raw.[22] Pina's death stands as the moment in the film that appears closest to documentary. Without a doubt, this scene aspires to resemble reportage. Here the film seems to dismantle its previously established style, trading the idea of depiction for that of documentation.

The director's admitted goals of self-effacement and extreme humility should not prevent us from understanding this sequence as a construction.[23] In fact, what is striking about Rossellini's admitted intentions is how much they echo the film's internal shift away from character point of view and toward bystanding. His comments belie a fascination with the idea of pure observation, and as *Rome Open City*'s drama of the gaze and looking unfolds, the film increasingly offers the spectator a fantasy of "pure observation." Yet Rossellini is not in fact refusing to manage the viewer's gaze. He instead orchestrates certain sequences to *effect* immediacy and to *simulate* firsthand observation of unstaged events. In *Rome Open City,* the observation of virtual spontaneity (anticipated contingency) is a highly constructed proceeding, one that serves a clear purpose: to call attention to this shift of narration as a move away from depiction and toward impassive documentation. Here I am arguing against reading sequences that depict the body in extremis, such as the death of Pina, as accidental and outside stylistic manipulation or the constrictions of a spectatorial protocol.

In fact, we might say that the film attempts to harness the idea of cinema's contingency, effecting a kind of documentary look by emphasizing what might appear to be random or accidental. The violenced body provides the film with a particularly productive site to undertake such maneuvers: the dynamics of the imperiled body seem to foreground the randomness of vulnerability, its unforeseen flailings of desperation and the haphazard gesticulations of the fall. In this

context, Peter Bondanella's and Serge Daney's comments regarding the death of Pina are instructive. Bondanella suggests that salacious bodily details are symbols essential to the political morality constructed by the film: the "right leg bared to the garter belt, an image underlining the obscenity of her unnecessary death."[24] Daney considers the cruelty of this image in his larger discussion of accidental details found in cinema's images. Here Daney is raising suspicions about the aestheticization of violence, questioning the politics of film practices that add "an extra parasitic beauty or complicit information to scenes that did not need it." As he continues, his comments provide a fascinating meditation on the nature of postwar realism:

> The wind that blows back, like a shroud, the white parachute over a dead soldier's body in Fuller's *Merrill's Marauders* troubled me for years. Less though than Ana [*sic*] Magnani's revealing skirt after she is shot dead in *Rome Open City*. Rossellini too was hitting "below the belt," but in such a new way that it would take years to understand towards which abyss it was taking us. When is the event over? Where is the cruelty? Where does obscenity begin and where does pornography end? I knew these were questions constitutive of cinema "after the camps."[25]

Pina's body exemplifies for Daney his inability to locate the ultimate violence of this sequence: Is it in the diegetic death? Or is it in the representation of that death and that representation's ideological premise? Daney appears concerned about the tendency of postwar cinema to exploit the documentary qualities of the image. According to Daney, when it exaggerates certain elements of the image, a film can be accused of indulging a rhetoric of the contingent in which the obscenity of the world becomes instrumentalized or, as he suggests, made pornographic.

Like Daney, I want to emphasize the importance of attending to how films utilize the contingencies of the image or create economies of virtual contingency in a single shot or across a film. These are crucial sites of self-reflexive discourse—sites of the ideological hiding behind the vitalism of the cinematic body. As such, critics often overlook them. Alan Millen's comments on the actors in the final episode of *Paisan* are particularly illuminating to consider in this context:

> The episode is especially poignant because the partisans are recapitulating the parts they played in the Resistance at a time before their roles in the film, and at a time when, as the dialogue puts it, they were "fighting for their lives." The formal strategy used in this sequence invites the spectator to

follow the means, the procedure, whereby the body is rescued and buried. The value of its consequences is left to the response of the spectator. The pious motives behind Rossellini's employment of real partisans playing their previous roles in the war serve in part to give the film a guarantee of authenticity within the conventions of documentary realism. But their performance is also to show how things were done during a period of intense personal danger, and therefore the tacit contract with the director is aleatory and, as with their survival during the war, dependent upon certain contingences. . . . The effect upon the audience . . . carries an element of risk.[26]

Toward the end of this chapter, I supply my own analysis of the body in this later film, but I am mentioning Millen's analysis here because I believe it empathically identifies the mortgaging of cinematic contingency so common to Rossellini's films. Here the authenticity lent by actual members of the Resistance to this film can be seen in their bodies and the history of risk inscribed in their physicality. The danger they felt during the war is transferred to the narrative of the film and then to the spectator. Rossellini invites the randomness of gesture and improvisation into reenactments because he believes that through these corporeal maneuvers a sense of danger will trickle down to the viewer. It is crucial to note here that the body itself stands at the threshold of two distinctly different definitions of contingency. The body is the catalyst that sutures these two registers of contingency together, the fictional borrowing from the actual.

Many directors take a casual approach to shooting action, purposefully leaving aspects of the profilmic scenario less planned in hopes of later mining for effect the contingencies of improvised or less rigidly choreographed moments. They do so for various reasons: *On the Waterfront* (Elia Kazan, 1954) does not exploit profilmic "indeterminacy" in at all the same manner as *Opening Night* (John Cassavetes, 1977). How Rossellini's films instrumentalize contingency is here quite central to the film's story about vision. Examining these films' specific deployment of bodily contingency forces us to confront not only their intimation of historicity, but also their attempt to reorient how the viewer understands the narrational authority of the image—shifting away from a character-motivated point of view and toward a mode of narration associated with a broader subjective engagement with the world.

In *Rome Open City*'s representation of bodily violence, both in Pina's death and afterward, the film accentuates a potent contradiction

central to almost all mainstream films: a conflict between the look of character agency and the look of the disembodied spectator. Whereas most films try to repress or smooth over the formal problem of a narration with competing origins, *Rome Open City* brings to the foreground this conflict between obviously diegetic looks and bystanding.[27] The corporeal spectacle of Pina's death, the rhetoric of contingency it aims to mobilize, and the narrational uncertainty it unleashes are crucial for understanding how this film invites this contradiction and aims to resolve it. The spectatorial ambivalence let loose by this sequence serves a purpose. The gestural and fully animated body plays a central role here by amplifying the rhetoric of contingency and by supplying the necessary spectacle around which narration unhinges from the narrative. In this way, the sequence pierces the narration's authority that the film so firmly established in the earlier sequences. The film uses Pina's death (and later Manfredi's torture) to stage a breakdown of its initial project: visually dramatizing the disengagement of the Resistance point of view from the visual narration of events allows the film to open up another point of view for the spectator, a nondiegetic gaze, an outsider's authority.

Made to Watch: The Torture of Manfredi

Rome Open City offers a fictional version of the actual events of the Resistance movement and overtly associates itself with the political project of the Resistance. Judging from its story alone, this film would appear to encourage a spectatorial identification with characters from the Resistance. However, as we have just seen, the narration eventually encourages a different set of investments: Pina's death destabilizes the epistemological premises of the film. With Manfredi's torture and eventual death, the film continues to exacerbate the tension between our investment in the events of the story and the means of their depiction, and the narration continues to upset the expectations laid out by the narrative. The narration resists identifying itself with the characters and groups with which the narrative events provoke us to identify, encouraging us instead to transfer our identification from the Resistance point of view to a broadly inclusive humanist looking-on or bystanding.

On the one hand, *Rome Open City* promotes the idea that Italians are both victims and resistors, and that they should therefore never

be mistaken for perpetrators of wartime atrocities. In this effort to represent Italians as undeniably and always already human and humane, the film sets out to produce a palpable distinction between Nazis and Resistance fighters, as well as between Germans and Italians. This distinction represents fascist subjectivity as inhuman and outside the bounds of the natural human subject.[28] The film promotes this binary opposition in its story: the struggles of Resistance fighters, who are clearly represented as heroic and valorized by the film, starkly contrast to the horrifying actions of Nazis and their collaborators. The logic of the film might in this sense be condensed into the following simple formula: Fascists are inhuman. Italians are human. Hence, Italians are not fascists.

On the other hand, if we look more closely at the formal and structural features of this narrative's articulation (that is, its narration), particularly in regard to vision and looking, we find an equally powerful but alternative drama with a more ambivalent struggle between sides. One by one, the central characters, each a member of the Resistance, are executed. We witness as their eyes close to the world around them. In the process, we lose access not only to their individual perspectives, but also to the Resistance point of view more generally. Although our sympathies may continue to lie with the anti-Nazi efforts throughout, the film transfers our identification from the particularized perspective of Resistance heroes to a generalized human ethical stance. As Bazin understood, and as we saw in his discussion of the film in chapter 1, its explicit depictions of violence precipitate a mode of outsider looking and suggest this surrogate form of eyewitnessing as a political necessity in the postwar world.

If Pina's death exploits a confusion of depiction and documentation to bring about this shift, then Manfredi's death engages a contradiction between identification and point of view to sever the correlation of onscreen perspectives to the spectatorial gaze. The means through which we are asked to view the spectacle of Manfredi's brutalized body unleashes more ambiguities and anxieties in terms of narration than at the level of plot or character. In its account of Manfredi's death, *Rome Open City* lays out an interdiscursive framework connecting the spectator and the onscreen world. This framework emerges from a carefully choreographed set of relationships between point of view, onscreen character looks, and omniscient camera perspectives that constitute a formal articulation of a series of oppositions: looking and

doing, apathy and action, powerlessness and agency, objective and subjective. By constructing this framework, the film engages the question of political spectatorship. It asks us to consider whether cinema can engage the spectator in such a way that viewing an event constitutes a form of political action.

The acts of torture performed on Manfredi's body constitute the climax of the moral and political tensions of the film. More than simply dramatic events in the narrative, these acts of violence operate in several ways to call attention to the act of seeing, the status of point of view, and the film's visual narration. They exploit the ambivalences of seeing as either inaction or action. They cause a squirming discomfort in the spectator that resonates with the forced restraint of the spectator's onscreen surrogate, Don Pietro, who has had his glasses destroyed and thus is forced to witness the torture more aurally than visually. These moments of violence also shear the spectator's perspective away from any point of view identified with a Resistance character. They thus provide a venue around which to stage a comparison of ethically distinct perspectives. However, the ultimate question of where the spectator stands in relation to the violence has been a matter of some critical debate. This debate turns on the question of whether the drama of this scene results from the visual exploration of violence or from the suggestion of violence performed off screen.

Some contemporary accounts of this film argue that the scene's horror derives from its refusal to fully depict the violent acts.[29] Yet as we saw in the previous chapter, many period critics recounted the film's description of violence as exceptionally visible, attributing the power of this film primarily to its visual rawness and its uncensored approach to the body more generally. In fact, I would argue that Manfredi's torture is far from left to the imagination.[30] Images of corporeality abound in this segment of the film. Manfredi's body is laid bare—stripped from the waist up—both for the torture and for the camera. He is strapped to a chair through most of the scene, and he is also chained to a wall with his arms shackled above his head. Often shown in a medium shot, Manfredi's bloodied body and swollen face become the central spectacles that, with the help of the sound track, organize the other narrative threads in this segment of the film. The long gashes and bruises marking his torso and face are not the only visual evidence of offscreen violence. At other points, his body is shown collapsed on the floor or hunched over in the chair, exhausted

by the torture it has received. In one shot, torture devices fill a table, including pincers, a lighted torch, needles, and a long instrument resembling a wine press. Many of these instruments, and the hands of the Gestapo officer handling them, are covered in Manfredi's blood. As this section of the film progresses, moreover, the torture increasingly takes place on camera. We witness his body as it writhes, jolts, and shakes, reacting to the pain inflicted by the Nazis, with four short sequences graphically depicting the violence being inflicted on Manfredi's body. In the first, a Gestapo guard quite convincingly injects a syringe into Manfredi's arm on camera to revive the victim so that he will be conscious during the violence that awaits him. In the second, Manfredi has just responded to Bergmann's taunting by spitting in the German officer's face. Bergmann retaliates, grabbing a whip, lashing Manfredi's face and upper body repeatedly. Quick edits and slapping noises underscore the violent display. Manfredi is later shown chained to a wall, being burned with a blowtorch. This third and most graphic instance of onscreen torture consists of two shots: we are shown his bloodied face in a close-up, screaming and thrashing, with smoke rising from the bottom of the screen. We then see a medium shot from the point of view of the torturer as he holds the flaming torch over Manfredi's body. This shot quickly tracks back, fully revealing Manfredi from the waist up with lesions still burning on his torso. A fourth and final disturbing shot depicts the officers putting one of the metal instruments under Manfredi's nails. This shot is brief and quickly cuts back to Bergmann's office.

It is not by accident that the spectator watching these torture sequences finds himself or herself positioned somewhere between the active pursuit of the body in pain as a form of visual evidence that confirms Italian victimization at the hands of the Germans and the condemnation of his desire to see what is happening. This uncomfortable position is precisely where the film engages its viewer. Each scenario of violence provides *Rome Open City* with a venue for comparing two types of eyewitnesses: those whose physical restraint prevents them from retaliating, and those whose monstrous inhumanity allows them to witness human suffering without remorse or the impulse to cease the violence. *Rome Open City* stages scenarios of bodily violence in order to unleash various kinds of looking, then recoups a way of identifying with the struggle of Italy as a nation that refuses fascism without fully embracing the Resistance point of view.

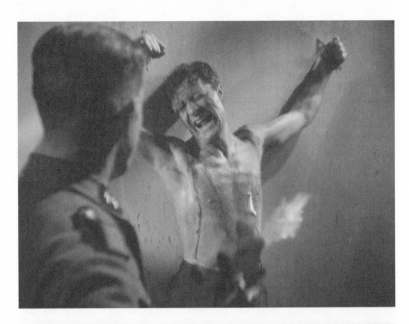

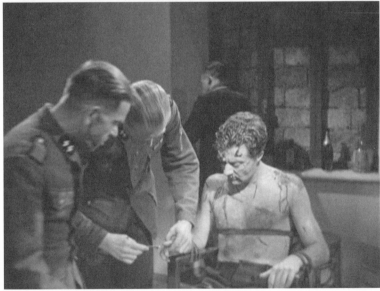

Rome Open City *depicts the torture of Manfredi in gruesome detail, such as the crack of a long leather whip or a close-up on a blood-splattered table full of sharp surgical instruments. The excruciating particulars of his abuse include the body oozing after being scorched with a blowtorch and hands being readied for sadistic nail treatment.*

To build this oddly invested but externalized subject, the film must repeatedly encourage its spectator to compare different modes of seeing. One way that the film emphasizes the activity of watching in the torture scene, for example, is by dividing the space of action from the space of observation. Thus, there are the two separate but adjoining zones of the torture room and Bergmann's office, where Don Pietro is confined to listen and watch as best he can. A doorway connects these two spaces and often functions to reframe the action of torture for Bergmann, Don Pietro, and the viewer. Later in the scene, others come to view Manfredi's dead and beaten body and stand between these two rooms. Formally, this doorway heightens our awareness of looking, enabling us to think of characters' looks as discrete entities without having to mark the differences on the image. The doorway resolves the problem of differentiating looks without calling into question the efficacy of looking in general. As the film asks us to watch the watching in this way, it also asks us to judge how others see. It indulges idioms of sexual perversion in particular as a means of condemning the Nazi perspective. The deviant vision of Bergmann and Ingrid seems underscored by the implications of their homosexuality. By constructing these characters as perverts via deeply coded affectations, appearance, and other innuendoes, the film reinforces their sadistic tolerance for—their capacity and even their desire to see— a type of violence clearly outside the bounds of normative human behavior.[31]

If these torture scenes diagram a hierarchy of different ways of seeing for the viewer, they also pose uncertain questions about spectatorial allegiances. The viewer's passive position is up for grabs: are we, like Don Pietro, innocent observers excruciatingly constricted from acting? Or might we be sadistic fascists able to watch violence without remorse?[32] The depiction of Manfredi's body being tortured enlists a wide variety of spectatorial responses, from eye-covering disgust to a rubbernecking predilection for violence. Like most mainstream films, *Rome Open City*'s narrative elements and modes of narration contain these variations and curtail instabilities in spectatorial response. Unlike horror films, however, *Rome Open City* goes beyond toying with the ambivalence between the points of view of the victim and perpetrator.[33] The film draws this ambivalence to the forefront, referencing the instabilities that documentary depictions of violence have the potential to unleash.

These scenarios of corporeality foreground the ambivalence of spectatorship by depicting the diegetic gaze as analogous to the passivity of the audience. Beginning with certain early scenes, the film questions the ethical nature of merely standing witness to an event, and restrained eyewitnesses are also present in the depictions of violence before and after Manfredi's torture. As Francesco is captured and escorted to the truck, for instance, an audience of onlookers is confined to the sidewalk. This same audience remains present for Pina's death, standing toward the rear of the final shots of this scene, held back by the Nazi soldiers.[34] It would be a mistake to view these early scenarios as presenting a simple binary between the agency of the film's villains and the imposed passivity of these diegetic onlookers. By condemning inactivity, or standing by and not acting, and distinguishing it from imposed passivity, the film suggests that watching can in fact be a political event. The film thus reveals its claim for cinema's importance to history and politics in general, and for its ability to grant Italy an international audience of eyewitnesses. In the final sequence of the film, Don Pietro's assassination is witnessed by a group of boys peering in from behind a chain-link fence. It is here that the film most clearly redeems the position of eyewitness and makes its claim for the ethical agency of spectatorship. However, with Manfredi's torture and death, ethical witnesses are harder to come by. Don Pietro's presence is as one condemned to witness the horrifying event but unable to see it. Here the film poses an interesting predicament: what does it mean to be forced to watch something that you can't quite see? The fact that Don Pietro has been barred from intervening in the torture draws a direct parallel between this impaired diegetic witness and the audience. Narratively, Don Pietro is also a victim of torture; his torture is being forced to "witness" the violence done to Manfredi's body. Unlike Don Pietro's earlier encounter with naked statues in a shop, he is unable to make an ethical move and turn the bodily spectacle away from his gaze.[35]

Don Pietro's position in this scene has, I am suggesting, several important implications for the spectator. Like Don Pietro, we are perceptually limited by what the film wants to show us: forced to stand by as disturbing and discomforting events unfold, the spectator cannot act and is, like him, left simply to witness and squirm. Don Pietro's position also provides an alibi for the explicit depiction of violence, satisfying our desire to indulge in the story without implicating this need

to see and know the spectacle of torture as a sadistic desire.[36] Yet his impaired vision and ethical presence burdens our role as witness. More broadly, it introduces the quandary of watching and agency: it asks whether witnessing is really a form of political action. The viewer never observes the violence being done to Manfredi through Don Pietro's eyes. The film portrays the acts of violence and their results (Manfredi's bleeding, bruised, and burned body) through the eyes of Nazi perpetrators, despite the fact that we are continually shown Don Pietro straining to see. The scene does grant the viewer several point-of-view shots from Don Pietro's perspective, but they are always directed at Bergmann and only when they are both outside the torture room.

After Manfredi's final beating, Bergmann brings Don Pietro closer to Manfredi and yells to the priest, "Look! . . . Are you satisfied?" This command and question are issued in a two shot containing both Bergmann and Don Pietro looking off screen right in the direction of Manfredi. Logically, the following shot should finally grant point of view to Don Pietro, one matched to the eye line in the previous shot. Instead, the next shot is a close-up of Manfredi and not matched to the angle of the previous shot. A few shots later, we are at last placed in the point of view of the priest, but this is only because he has stepped into the perspective established in the first close-up of Manfredi in this sequence. Only after the shot that confirms the death of Manfredi is the viewer granted Don Pietro's point of view. This scene thus invokes a narrative climax through comparing conflicting ethical responses to witnessing violence. If it represents these ethical distinctions via the activity of looking, then disallowing Don Pietro the camera's gaze interrupts a spectatorial inclination fostered by the narrative to identify through the priest and accept his gaze as our own. The film also deprives us of Manfredi's perspective. Even in Manfredi's heated exchanges with Bergmann, the film positions the Nazi soldiers in places that allow for over-the-shoulder reverse shots from Manfredi to Bergmann. In trying to establish a postfascist subjectivity, the film avoids sustaining a Resistance point of view. Victimhood is not a viable point of view for this film: the perspectives of the Nazi characters are privileged in the torture sequence, and their gazes often narrate the scene. The excruciating content of these sequences protects against any spectatorial instability incurred by the camera's privileging the sadistic viewpoint of the Nazis. Thus, the visibly brutalized body functions to

shift spectatorial identification away from both the victim and the per-
petrator, opening up the space for a third spectatorial identification,
one developed further in the final scene of the film.

Spectatorship Unbound: The Assassination of Don Pietro

The last scene of the film portrays the final execution, that of Don
Pietro, in a manner less graphically corporeal than with the deaths of
either Pina or Manfredi. Yet the assassination of Don Pietro shares
many of the formal components found in the earlier death scenes. The
priest's execution brings a tragic conclusion to the narrative and offers
a resolution to the instabilities unleashed by the narration in earlier
scenes. This execution supplies the third spectacle of violence in film—
a spectacle that again emphasizes onscreen looks, allows us to com-
pare various ethical perspectives, and keeps in play the question of
whether the activity of seeing constitutes political action. Moreover,
the status of spectatorship is thematized on screen just as forcefully as
in the earlier executions, but the outcome is importantly different. This
scene reinvokes the instabilities unleashed in earlier scenes: the loss of
character point of view, the uncertainty of cinematic space, and a ques-
tioning of film spectatorship and the agency of vision raised via the
depiction of onscreen observers. Yet this scene also most fully articu-
lates a vision of an international spectatorship: an outsider position
enabled by the complete release of the narration from the Resistance
point of view. With Don Pietro's execution, the Resistance perspective
that was put into question by the narration's deprival of point of view
is finally fully retracted by the film. As with Manfredi, the film confirms
Don Pietro's death by a loss of eyesight: a final blink of his eyes cued
to the sound of the lethal gunshot signals his death. A German officer
confirms the priest's death by lifting the priest's sunken head and
checking his eyes. The film has destroyed the vision of the Resistance.

 In many respects, this concluding scene involves the same instabil-
ity unleashed in the narration of Pina's death, particularly in its ini-
tial refusal to lay out the space of Don Pietro's execution with any clar-
ity. The scene's establishing shot offers little assistance to the viewer
who wishes to map the terrain. Once the action begins, we are even
more disoriented. The execution scene opens with a confusing sequence
of sight lines that frustrates our ability to visually map the location.
Because of these factors, the only way to orient the scene is to imagine

zones irrespective of physical space. The spectator could hardly map this scene with accuracy, but he or she retains a clear picture of intersecting power vectors: this is a virtual space composed of tensions between competing looks. That is, the viewer, while confused by the physical coordinates of the space depicted, accepts the scenario of Don Pietro's execution as an allegorical forum in which each historical party has been given a separate zone. By demanding that its spectator orient himself or herself in space by comparing onscreen looks rather than through scenic cues, this sequence echoes the framework of gazes constructed over the course of Manfredi's torture. Narratively, the event offers a venue through which to remind the viewer of the parties crucial to this historical moment: Nazi commanders, German officers of lesser rank, clergy, Italians soldiers serving the Nazis, the Resistance, and the local children who are Italy's future. That said, this scene can nevertheless still be understood without knowing the historical and political contingencies of wartime Italy. The chair containing the victim stands at the center, and around him are positioned different groups: morally depraved officers with an unending tolerance for brutality occupy one area, collaborators with questionable allegiances soon to be transcended by their inner moral truth stand in another area, and ethical if seemingly powerless witnesses stand along the perimeter.

These last observers are a group of young boys, including Pina's son, Marcello, who have gathered to witness the death of their beloved teacher from behind a chain-link fence. Like the crowd at the perimeter of Pina's death scene and the restrained Don Pietro during Manfredi's death, the boys at first seem condemned merely to watch. They do in fact initially remain outside the action. However, unlike the earlier executions, where observers can effect little change, here the whistling of these children prompts the firing squad, a group made up of Italians, to question their position as collaborators and eventually to disobey the order to shoot. In the moment that we realize their bullets have missed Don Pietro, the film redeems all Italians, even those fighting for the fascists. This group of boys in particular is transformed in front of the viewer. Once passive bystanders, together, the boys become agents of change. Their whistling constitutes a form of subversive action. The film links this ethical change to a crucial figurative change here. The boys enter the scene as outsiders, confined at the start behind the fence, but they leave liberated and freed from its

constraints. In the final shot of the film, the skyline of Rome lies before the group as they walk across the screen. This image portrays an atypically long vista in comparison to the rest of *Rome Open City*. It is one of the film's longest shots. According to Marcus, their march, suggesting a liberated future for Italy, operates as a visual retort to the procession of German soldiers at the start of the film.[37] They walk away saddened and perhaps rootless, but they are also symbolically unleashed from the restraints of the execution scenario in particular, and they have transcended, if only briefly, the more general role of inactive spectators. Importantly, this shift from passive bystander to agent of change defines the experience of the children but not that of the Resistance's actual organizers. One of the few instances of effective collective resistance to the Germans on screen, the boys represent a group of Italian nationals, but they are also an unthreatening and nonspecific vision of Italian nationality. Marcus, concluding her critical commentary, reads this last scene as the visual manifestation of the film's title: Rome as open—open to the "plurality of perspectives" and against "one, univocal truth."[38] The action taken by the boys appears less threatening than any organized act of insurgence that serves a distinct political mission. These children offer to the international audience a safe and palatable vision of the critical masses of Italians; their youthful innocence grants the political and social future of Italy an open-ended optimism. Unlike many of the main characters, who were based on actual heroes of the Resistance, the boys lack any exact historical corollaries. This historical nonspecificity and their youth play an important role in the conclusion of this film as a gesture of openness and its articulation of an international spectator.

There is a brief exchange at the beginning of the film that needs to be remembered in the context of this ending and its ambivalence about national political agency. In this early scene, a policeman friend of Pina finds her leaving a bread line and asks her: "Do these Americans really exist?" Nodding to a bombed-out building, Pina responds, "Looks that way, yes." The film uses his question to represent the frustrations with the endless food shortages and other forms of desperation that Romans experienced under German occupation while awaiting liberation. Her response is opaque. Michael Rogin has suggested that this exchange reflects how the film attempts to marginalize those who will invade Rome next: the Americans. This moment captures the contradictions at the core of this narrative: despite the film's efforts to

propel the agency of the Resistance into the postwar moment, Rogin argues, "this Popular Front antifacism, Rossellini's beautiful revolution, was losing out to an American-led Cold War political reorganization." This exchange is as much about the moment of the film's release as it is about the recent history it depicts.[39]

Seen from the perspective of this film's American reception, this scene would collapse questions of diegetic desperation (will the Americans ever reach Rome? do the Americans really respect the priorities of the Resistance?) with urgent questions of contemporary reconstruction (should the United States be doing more to help in the aftermath of the war?). I would argue that this conversation couldn't help but be overdetermined in the late 1940s foreign theaters where this film found great success. Taken alongside the period's other texts' pleading for extranational help (and in the context of what Rogin calls the film's "mourning" of the Resistance), this scene initiates a series of questions that cannot be separated from its development of a visual narration that authorizes the perspective of the foreign bystander.

Paisan's Catalyzing Corpses

Rossellini's next film, *Paisan,* continues to wrestle with the questions of an American intervention. Divided into six individual narrative episodes that are tied together by a documentary-style voice-of-god narration and animated map sequences, the film explores various types of interactions, allegiances, and liaisons between U.S. troops and Italian civilians, many of whom are members of the Resistance. In his analysis of the film, Peter Bondanella identifies how the "problem of linguistic communication" gives way to "the question of empathy and antipathy between the two countries and the individuals who represent them." For him, the film's title forms the bridge between the quotidian interchange and a broader humanism. Bondanella continues: "*Paisà* is the colloquial form of the word *paisano,* which in Italian means 'countryman,' 'neighbor,' 'kinsman,' even 'friend.' It was typically used by Italians and American soldiers as a friendly greeting, and the implications of its deeper human significance provide the basis for Rossellini's entire film."[40] The film's sound track promiscuously alternates between dialogue in Italian and English, and at certain points in German. The cast combines actors from various backgrounds, the least professional of whom appear to be the

Americans. Early on, the film establishes these Americans as hailing from various regions: one has a southern accent, and another talks about being from South Norwalk, Connecticut. There's a pedagogical quality to these regional semiotics, as if the film is insisting on an analogy between the two nations: each episode covers a different region of Italy during the final small battles just before and just after the liberation of Rome.

Even more overtly than *Rome Open City,* this second film in Rossellini's wartime trilogy interrupts the flow of classical feature film narration by mixing documentary elements into its fiction. The shooting style mixes a classical narration, a voyeuristic point of view, and documentary reportage. Formally, we might say that the film also concerns itself with the merger of opposing film styles previously seen to be unyielding to the other; it is a collaboration of genres. However, it is in the visual narration of death that the film most fluidly carries the viewer from the registers of regionalism, racism, and nationalism to a space of internationalist responsibility.[41] Although the film's outward structure literally maps a northward passage through the regions of Italy, beginning in Sicily and ending in the Po River valley, this geography depends less on the ravaged landscape than it does on the imperiled body to gradually evolve the viewer's affective relationship with this intercultural alliance.[42] The film's displays of various imperiled bodies, I want to suggest, not only dramatize the necessity of North Atlantic allegiances, but also extend the parameters of the spectator's authority in this transnational space. Tracing the arc of the film's narrative, the body progressively amplifies the stakes of this allegiance. This amplification happens both across the film taken as a whole and within a single episode. I will look closely at the first and the last episodes to expose how these modulations and intensifications guide the viewer and encourage the neorealist mode of spectating that I have been describing in this book.

The first section of the film, "Sicily," modulates the tensions between different generic registers, much like the raiding of the apartment complex in *Rome Open City,* which shifts from the narrative tension of escape, to the slapstick comedy of the frying pan violence, and then to the sudden and startling gunning down of Pina. It begins with the nighttime arrival of American troops on the island and their immediate encounter with local Italians befuddled by their appearance. Miscommunication plagues the initial exchanges between the Americans

and the locals. A series of jumbled but symptomatic interactions en-
sues, mostly premised on mutual suspicion. The Americans appear
untrusting of the locals, handling the Italians with condescending
briskness. The locals harbor deep ambivalences about the intentions
of the troops and concerns about the potential ramifications of Amer-
icans on their island. One mother seems overwhelmed by their pres-
ence and demands answers about her missing son, as if any American
metonymically embodies the entirety of the U.S. military operation:
"My son was in Licata. Did you harm him?" After an Italian-speaking
Sicilian American solider, Tony, steps in to calm the mother and re-
assure the restless crowd of the army's intent, the townspeople offer
the troops help in the form of a young woman, Carmela. She knows
the way through a particularly treacherous path lined with German
mines and will guide them through this terrain to get them closer to
the German forces.

Carmela helps the troops to find their way to a local fort, and from
there, most of the soldiers set out to explore the road ahead. However,
Carmela must spend the evening waiting under the protection of Joe
from Jersey, whom the Americans have left behind to protect her.
Alone together, the two strangers clash and then begin to flirt, swap-
ping small phrases and developing jokes from an improvised pidgin
language. Despite crossed wires of linguistic confusion and an excru-
ciating series of exchanges along the lines of "Me, Tarzan. You, Jane,"
the couple grows increasingly close. The subtitles ensure that even
monolingual viewers maintain a narrationally privileged position: we
are permitted to see mutual affection, good intentions, and common-
alities revealed even before Carmela and Joe see them in each other.
Only minutes after the budding of this romance, Carmela watches as
German soldiers shoot Joe from a distance. The depiction of the actual
attack is quick and the action opaque. The fall of his body has, how-
ever, been slowed, suggesting that an otherwise benign image of his
movement was dilated in a postproduction process of optical reprint-
ing to achieve the effect of his body receiving the bullet. In subsequent
shots, Joe lies face-down on the floor. These shots suggest that they
originate from Carmela's perspective while revealing little about her
reaction. When each of the two shots that follow the two shots of Joe's
body cuts back to her, she has her back to the camera, as if her look
initiated the gaze that the film extends. The sequence sets up for the
viewer a narrative quandary: Does witnessing his death provoke an

ethical response in Carmela? Why does she not look more concerned? Were Joe and the viewer wrong to trust her?

The Germans soon arrive at the fort and find Carmela, but not Joe's body. They discuss taking advantage of her, then ask her to fetch them water. With this excuse to leave the Germans, she returns to Joe's body alone. Here she stares longingly at him, says his name softly, and begins to cry. The film pauses in an unusually close framing on Carmela's face. She looks back in the direction of the Germans, then back at Joe's body, and then at the Germans again. In this movement, we see a tear has formed under her eyes. With her return to Joe's body and her reaction to his corpse, Carmela's moral rectitude is made clear to us. She grabs Joe's rifle, returns to the Germans, and shoots one of them to revenge Joe's killing. The Americans come back to the fort after hearing her gunfire. When they get to the fort, they discover Joe's mangled body on the fort's lower level by looking down through a hatch in the floor from the level above. The light from below outlines their profiles, accentuating their gazes and establishing a composition that will be repeated in a subsequent shot of the Germans. The American southerner curses Carmela: "Well that dirty little I-tie." They have misunderstood what has occurred. On the sound of a gunshot, the film then cuts to a parallel composition of the three remaining German officers, who are looking over a cliff, their faces lit from below. "She's finished . . . let's go," one remarks, and in the next shot, the camera tilts to reveal Carmela's limp body lying dead on a rocky coastline. In this moment, the film burdens the viewer with being the only worthy observer aware of Carmela's self-sacrificing heroism.

As the musical score swells melodramatically, the viewer is cued to understand that the narration of the film and its diegesis have parted ways. The film locates pathos in the disjoining of spectatorial awareness from diegetic awareness. The viewer feels his or her own distinction from both the callous nature of German violence and American bigotry. The episode's corporeal denouement immediately intensifies the frictions between American interests and the basic survival of Italian civilian life. The suspicions, ambivalences, false impressions, stereotyping, misplaced blaming, and name-calling that have simmered earlier are now reformulated as a pressing question: can American forces actually restore the humanity of Italian life? The film makes us witness these two corpses through Allied and Nazi eyes. Unlike

Carmela's ethical epiphany with Joe's body, neither group of soldiers finds transcendence in witnessing death. The parallel viewings confirm that Joe and Carmela are martyrs to a common cause and victims of a similar enemy. However, the reactions of the Americans betray the film's title and pose what will become the film's central narrative dilemma: Do Americans have the capacity to value human life? Or are they simply another version of the Nazis, uncaring and bigoted foreigners there to exploit and disgrace Italians as subhuman? In a manner similar to the establishment of narrative tension of the typical romantic comedy, whose suspenseful path to marital bliss must begin with a caustic first encounter, this first episode of the film both confirms and complicates the fate of these newly betrothed nations. Crucially, the film never redeems the official actions of the U.S. military at this point or later. Instead, if Americans become *paisans,* it is because they have witnessed or experienced the brutalities of German occupation otherwise unaccounted for by the U.S. military. By the end, the film offers the viewer extranational belonging as the only viable means of escaping the catastrophes of war. This is a form of belonging that blankets Italian and American lives with the protections of global humanism.

Before moving on, it is worth noting how this first episode builds within the spectator the subjective justification for implementing this new cross-national protectionism, a rationalization that will grow in urgency from episode to episode. As viewers, we do not question the morality of the scenario; we can clearly distinguish right from wrong. What disturbs us is the diegetic world's blind eye to these distinctions, its occlusion of a budding kind of kinship that is particularly vulnerable in war. The impossibility of diegetic vindication is meant to impassion the viewer, engendering an ethical agency derived not from nationalist affinities but from a zealous anti-isolationism. The film generates a kind of ethical suspense from the narration's extension of the viewer's knowledge beyond any of the individual diegetic perspectives, an extension that results in an "if only." If only the world were different. If only a different vision guided this world. If only politics were governed by a wider frame, a broader map of human interdependency. Italy's willing cooperation and America's benevolence seem within reach, but a form of myopia has prevented both countries from effecting a change in the world. What both lack is the broader perspective of the outside viewer. The episode's ending thus burdens us

with knowledge, asking us to carry that desire for vindication into the subsequent episodes. One by one, these later episodes contribute to resolving this frustration, but they never completely do so. They always propel the frustration forward and impose on the spectator a sense of their metageographical stance: standing quite literally above the map holds the key to a world in which human life is valued. By suggesting that authority rests in the spectator's extranational perspective, the film declares transnational sovereignty as a means of establishing global, or at least North Atlantic, stability.[43]

The film's final episode, "Po Valley," concerns a series of skirmishes in and around the desolate landscape of northern Italian marshes. Like its earlier episodes, this one uses the violenced body not only to describe the terrible devaluing of human life in war, but also to engage the viewer in the stakes of the American–Italian cooperation. Since the "Sicily" episode, however, the spectator's relationship to the American soldier has been reformed by the film. In the Po, we find Italians and Americans working together in a well-established and trusting collaboration. As if to indicate this merger of intentions, the Americans continue to speak English and the Italians only Italian, but their conversations together flow seamlessly as though they are speaking the same language. The episode betrays little of the ambivalence about American intentions seen earlier and captured in the phrase "dirty I-tie." It follows a U.S. army special operative named Dale who has been planted with the Resistance. He is one of the film's most compelling characters, and the Italian characters embrace him: their hospitality appears to be instinctive and instantaneous, even though harboring him endangers their lives. In return, Dale reaches across the human divide, offering, for example, his own medicine to treat a baby's many mosquito bites. When Dale and his American colleagues actively disregard the orders of their U.S. commanders and instead continue to support the insurgents, the film positions the Americans as selfless heroes.

This episode's famous opening sequence is gruesome and lyrical at the same time. In a series of shots and reverse shots, the camera follows the journey of a corpse as it floats downriver and is watched by a group of townspeople who walk alongside it on the riverbank. The corpse's upper torso has been strapped to a life preserver, and a large sign that reads "Partigiano," or partisan, has been attached to it. Sent down the river, this body of an assassinated member of the Resistance

has been instrumentalized by German forces. The Germans have used the body as a menacing public announcement, exploiting it as a warning beacon. The body has been degraded to serve as an effigy to the demise of the Resistance. To underscore the source of these cruel scare tactics, the film places an armed Nazi military officer on the riverbank, and he points to the body and proclaims to the crowd, "Partisan! Bandit!" This ploy of displaying the corpses of the enemy should remind us that part of this war's daily horror for Italians was its public culture of violent spectacle, documented by the film *Days of Glory* (*Giorni di gloria*, Giuseppe De Santis, Luchino Visconti, et al., 1945). Toward the end of World War II, German occupying forces and their Italian collaborators routinely displayed the dead bodies of the insurgents, turning their corpses into political spectacles. In response to the Nazis, the Italian Resistance used similar spectacles to publicly shame and threaten collaborators.[44] *Paisan* admits this history, and in doing so, it demonstrates a striking ambivalence toward such displays.

The opening shot of this sequence follows a pattern of withholding and revealing the partisan's floating body that will structure the remainder of the film. The corpse moves slowly toward the camera with its features turned away. From this position, the form is hardly legible. It could be a living person just as easily as it could be drifting refuse. As this form moves closer, it eventually turns, making two key facts legible to the viewer at precisely the same moment: first, the mortality of the body is confirmed as we glimpse its face in profile with the mouth hanging ajar, and second, we are at last able to read the sign branding the victim. However, no sooner do we get this detail than the film has pulled it out of view. The shots that follow keep the body at a far distance, holding us back from anything but a generalized inspection of the corpse until a later burial sequence. This final episode of the film begins where the first episode concluded: with the various warring factions disputing the meaning of a corpse. Unlike that earlier part of the film, however, here the film's spectator is not alone in the need to assert the true meaning of this death. The opening of this episode thus depicts a literal battle over the public meaning of the corpse. In the context of Carmela's misunderstood death, and in the nondiegetic narrative space of the viewer, the joint American–partisan rescue effort that pulls the body from the river provides redemption. Depicting the rescue and burial of the corpse also presents an interesting dilemma for the film. How can it both denounce

the tactics of gory exhibition and maintain the ethical stakes of this brutal war zone for the viewer? If it wishes to replicate this instance of Nazi visual culture, the film must also find a way to distinguish the body politics of totalitarianism from those of the Resistance—and from those of neorealism. *Paisan,* like many other neorealist films, displays corpses as a means of triggering humanist sympathy for Italians as victims and introducing the world to the atrocities of the German occupation. But it also seems eager, if not anxious, to differentiate its form of revelatory display from the scare tactics of public executions and corporeal effigy.

This episode's famous cinematography divulges this film's ambivalence toward corporeal spectacle. The film uses motion as one means of interrupting the structures of this latter genre of gruesome politicking. By keeping the corpses in motion over the first six minutes, the film literally resists allying the imperiled body to any particular politic. This motion is first achieved by the scenario, camera movement, and editing. The floating body and camera motion maintain a balletic tension. By staying in motion, the camera asks the viewer to maintain the body as a surveyed object and not a monument.[45] Sandro Bernardi describes this sequence as orchestrating a restless gaze that comes to characterize the entire film:

> The camera is constantly moving, like the partisans and the American soldiers, always low, in a hurry, brushing the surface of the water between the reeds that block the horizon, in a prolonged semi-subjective shot, to use Mitry's terms. It seems to be not just looking but also fighting, escaping, searching, following. It is a film, as Paul Eluard said, in which we too are actors; we see and are seen.[46]

Soon after the corpse is caught in the American–partisan gaze, the compositions persistently emphasize the cadaver's limpness, and in doing so, the camera rescues the partisan's body from the rigidity of a Nazi human effigy. The corpse itself continually returns to a flaccid posture: at times, its sagging torso curves toward the ground, and at other times, the head has dropped back, leaving the jaw dangling open.[47] In response, *Paisan* maintains its anxious mobility around the corpse until a crucial moment. When the film does finally bring the body to rest, the camera only partially participates in the moralizing and memorializing fixities of the status quo photodocument. The spectacle of the body can finally rest for a moment because it has found its

role: the revelatory stillness foregrounds the intercultural dynamic of Americans and partisans working separately together.

To understand the significance of this momentary stillness and the intercultural dynamic it frames requires an understanding of the narrative's focus at this point. When Dale comes to safely deliver the corpse to a group of partisans, he meets up with two other American operatives, Alan and Dan. Alan, a radio operator, has received a message from army headquarters to cease all activities that assist the partisans. The military command also wants the operatives to pass along the message to the partisans that they themselves should stay home. Dale's other colleague, Dan, seems dystopically pensive and joins the conversation only to offer cynical summations of their predicament, beginning with, "These people aren't fighting for the British Empire, they are fighting for their lives." As the conversation continues, Dale arrives with the logic of headquarters' plan. Without ammunition, food, or other means of defense, they are facing mortal desperation. As we continue to hear Dale describing the details of their desperate situation off screen, the film cuts to a shot of the cadaver being carried by the Italians, its head almost dragging on the ground. Sound and image together draw a striking analogy: Dale, Alan, and Dan are like the partisan victims. They are no longer fighting for an ideology or some abstracted international ally. They are simply fighting for their lives, and for the lives of those around them.

In the next shot, a mobile framing comes to rest on a symbolic composition. The three Americans occupy the right-hand two-thirds of the screen while in the background, on the left third of the frame, a group of partisans dig a hole to bury the body, which is to their left at the edge of the frame. Dale's frustration builds as he is told that headquarters has refused their desperate pleas for backup and has thus virtually abandoned Dale and the other operatives. Dan breaks into the conversation again: "Well, we'll all die one way or another, but that's a small matter for headquarters." Frustrated by the officials and the lack of support and backup, Dale remarks: "Alright, alright. Nothing can hurt us now anyway." Then he looks off screen. The next shot, representing the field of his look, is a medium close-up of the corpse from the chest up. Lines of draining blood run down the front of its face, teeth darkened; torn clothing reveals naked skin. This shot underlines the sarcasm of Dale's statement, echoing his and Dan's sense of imminent demise. Although their fate may be militaristically

inconsequential and their deaths guaranteed, no real harm can be done to the humanity that has passed among them and the Italians.

The film has already proven that Dale holds a moral outlook on human life that is compatible with the Italian way of life. With this shot, the film not only endorses the American by positioning him as the author of the ethical gaze, but also conjoins his identity to the Italian's body. Both are victims of the war; neither is its agent. Cinematic corporeality stands at the intersection of the vectors of geopolitical affect that define these identities. The stilled image of a body is held off until this moment precisely so that the film can utilize its revelation as a pivot point for the various powers at play: Nazi occupation and official Allied military policy stand on the antihumanist side of the equation, and Italians, the Resistance, and individual Americans stand on the humanist one. The film uses the image of the imperiled body to attempt to separate a genuine humanity of actual Americans from the insensitivity of the Allied/U.S. military command. In this sense, the body operates in almost a specular manner, allowing the intersection of various perspectives to cohabitate in one look and permitting various subjectivities of sympathy and identification a means of experiencing the stakes of international cooperation. Taken as a whole, this scene's sequence of shots routes the spectator's ability to finally look closely at the corpse through an American's affective relationship to the spectacle of victimization in a way that seals his fate to that of the Resistance in particular and of Italy in general. The film asks us to recognize his instincts as one of a *paisan* and to see him not as a representative of the Allied command, but as an American who has become suddenly as vulnerable—as human—as the Italians. The film anticipates, in other words, a foreign viewer whose sympathy for the partisans and interchangeability with them runs deeper than the Allied force's commitment to Italy.

Given that it is a film made after the end of the war, it is interesting to consider what it means for *Paisan* to excavate this particular mode of American sympathy during the desperate moment of Italy's postwar recovery. The film entrusts the foreigner with a kind of retroactive agency, imagining the benefaction of individual American intentions overshadowing the Allied rescue mission. If *Paisan* begins by proposing to fill out the official history of the Allied military presence on the peninsula, then by the end, this investigation has revealed an American affective commitment to Italy. The alliance forged here

derives from neither abstract political allegiance nor surrogate nationalism. Rather, it is a bond of global empathy: if you are human, it proposes, you are with us.

In her book on landscape in Italian cinema, Noa Steimatsky builds on Sandro Bernardi's idea that *Paisan*'s "landscapes of death" connect the film to the systematic troping of the ruin across Rossellini's films of the 1940s and 1950s. From her analysis emerges a startlingly useful description of the film's narration in relation to the image: it performs "a terse, elliptical mode wherein what remains unsaid, and only briefly seen, emerges as a resonant articulation strongly charged in the film's imaginary."[48] Outside the purview of her analysis of ruinous urbanity or the "corpse-city," *Paisan*'s final scene provides, I would argue, a particularly powerful foregrounding of what she calls the ruinous "mode of seeing that is itself haunted, fragmented, traumatic."[49] In the concluding moments of the film's final and most gruesome episode, Italian partisans have been bound and lined up on the edge of a Nazi boat, docked on the river's deep edge. On the shore, in an area adjacent to the boat, Dale and other Americans are being held. Dale and another American run toward the boat as the Nazis begin pushing the partisans off the boat. The rescue attempt meets with immediate gunfire. The two Americans twist in pain and collapse before our eyes, Dale's fall foregrounded by lighting and the frame composition. As the Nazis continue pushing the partisans to their deaths, the film shifts perspective from the long shot that has described this brutal scenario to a framing that is angled off the bow of the boat over the surface of the water. This final shot of the film is significant for its ambivalent point of view, which comes from the perspective of both the victims and the executioner but never moves and so cannot represent the view of either party. It is also remarkable for its paucity of information. The hull of the boat is not visible to anchor the shot. There is only the blank grayness of the water, like the gentle rippling of an almost blank movie screen. The bound partisans fall across our field of vision into the water, as if bursting through that frame. After the splash of impact, each of these bodies disappears below the blank surface, never to return to our view. The rippling, empty surface of the water ends the film as the voice-of-god narration returns: "By Spring the war was over."

One might read this shot as the film's victory over the gruesome publicity routines of Nazi fear campaigns. After all, the film has removed these bodies from view, finally foreclosing on the cooptation of

these partisan bodies as corporeal effigies. Yet the dark, mangled forms of the bodies as they tumble into the blank water is no less spectacular. Like the stills of the World Trade Center jumpers immortalized in *New York Times* photographs, these inextricable convulsions of vulnerability do not dismiss the ethical witness. As with the first floating corpse, the film fails to truly remove the imperiled body from its political publicity. Part of the horror of the violence in the final scene is its disappearing of the body. It cues a spectatorial desire to see the forms emerge from the water. Then the film makes us feel frustrated by the dearth of grisly detail. The final atrocity of this violence is that it removes the body from our eyes. The film constructs this scene in a way that burdens our gaze as onlookers by refusing to guarantee the survival of any of its diegetic eyewitnesses. It seems unlikely that a single American or Italian will survive this scene, and without them, only we can testify to its occurrence. If anything, the scene reminds us of our need to see violence's specificities revealed and recorded. The film leaves the spectator filled with a need to account for them, to reconcile them to the war's larger ledger. This is an apocalypse with no witnesses but us.

Ultimately, *Paisan*'s corpses are neither illustrative aids nor embellishments to a more fundamental barbarism, like wallpaper for the Grand Guignol. The film's bodies are far from simply strewn or littered in this landscape. Instead, they function as powerful catalysts for a series of exchanges of distrust and threats, but also of sympathy and compassion. These tortured forms remain at the center of this film's narrative frame, their awkward limpness unbalancing the image's composition. These corpses hone the viewer's attention to the affective orders of war, serving as catalysts for remapping the allegiances of Italians, Americans, and a world of spectators.

Conclusion

It has often been argued that films frequently distinguish their realism through a comparison to the realism of other films, defining themselves with and against other aesthetic practices. From this view, realism is less a stable, positive term than a highly relative morphing concept defined through citations, revisions, and negations.[50] As my analysis of *Rome Open City* and *Paisan* has made clear, realism is indeed never a static practice, not even within a single film. Realism develops anew

over the course of the film, formulated and then reformulated in the space and time of its narration, suggesting that realism establishes a relative definition even among scenes in a single film. If the term *neorealism* has any generic distinction or historical specificity, perhaps it can only be found in these continual acts of internal revision. Marcia Landy has argued that *Rome Open City* generates a self-reflexive awareness in the viewer by not only emphasizing a kind of formal and thematic openness, but also by engaging divergent modes of looking and opposing generic conventions. Through this mixing of address, the film "prevents perception from being put in the service of formula and cliché, so as to enable the possibility of challenging habitual modes of response."[51] From my perspective, *Rome Open City* and *Paisan*'s corporeal spectacles enable these sudden shifts in the mode of depiction. These shifts—whether upheavals in the generic register, disruptions in the status of narration, or displacements to the terms of spectatorial identification—both reflect on and rework the film's terms of engagement with the world and the audience. Both *Rome Open City* and *Paisan* also use the imperiled body as a means of opening up Italian national history and politics to international viewers while simultaneously imagining what it would mean to grant an international audience authority within the political arena of Italy. In this respect, neorealism's rendering of a world spectator is perhaps better considered in relationship to the ascendancy of the Marshall Plan and large-scale international aid than as an instance of left internationalism.

In these films, spectacles of the body untether the historical events of postwar Italy from a strictly Resistance perspective. Indeed, the narrative climaxes of these films do not intensify the historically specific point of view and gaze of Resistance subjectivity. Rather, they abandon the Resistance perspective for a general subjectivity more oriented to a globalized frame. By making available a spectatorial position beyond the limited parameters of diegetic sight lines, these two films offer the promise of boundless vision: they present cinematic perception as a common ground that transcends subjective differences between individuals. They also envision a viewing subject unmarked by regional, national, or ethnic distinctions. They struggle to extract a globalized homogeneity from the exposure of the heterogeneous particulars of local Resistance politics, because, were this subjectivity to be presented as an actual historical agent within the diegesis, it would stand out as an anachronism. In constructing this spectator, the film

envisages an alternative to the political oppositions that dominated postwar Italy, a perspective less defined by domestic politics than by the political and economic anxieties of the postwar international community. This virtual perspective allows the films to adopt an antifascist subjectivity while dissolving the Resistance. As much as *Rome Open City* and *Paisan* seem to invite us to join the members of the Resistance, as participants in the events of the recent past, the films also ask us to join a liberal humanist present. They ask us to understand Italy from the outside looking in and to dismiss the specificities of domestic politics if they in any way interrupt our sympathy for Italy or interrupt our sense that Italy deserves foreign aid. These films make us aware of our position as bystanders who are causal but needed onlookers, quiet but dogged observers determined to look back at the nationalist past from the globalized now.

4 SPECTACULAR SUFFERING

De Sica's Bodies and Charity's Gaze

VITTORIO DE SICA DESCRIBED his film *Bicycle Thieves* as "dedicated to the suffering of the humble."[1] He said that his *Shoeshine* arose from the desire to bring attention to "the indifference of humanity to the needs of others."[2] Over the course of the 1940s and early 1950s, De Sica developed a mise-en-scène that he hoped would redress this growing inconsequentiality of human life by challenging the way that most audiences saw the world around them. As Cesare Zavattini, his collaborator and the scriptwriter on many of his best-known neorealist films, put it, "The question is: how to give human life its historical importance at every minute." Both men believed that a reassessment of the film image itself would revise the terms of spectatorship and hence upend the dangerous apathy of the average person's perspective. Zavattini in particular thought that this moral reorientation of the spectator could best be achieved by radically altering the idea of cinematic spectacle. His version of postwar film was in this sense a new realism to the extent that it aimed to derealize the world around it in an effort to reform the spectator's gaze. According to Zavattini, "banal 'dailiness' . . . will become worthy of attention, it will even become 'spectacular.' But it will become spectacular not through its exceptional, but through its *normal* qualities; it will astonish us by showing so many things that happen every day under our eyes, things we have never noticed before."[3] This delicate dance between spectacle and antispectacle is nowhere more ambitiously described than in Bazin's famous essay on *Bicycle Thieves,* in which, after announcing that neorealism is the cinema of antispectacle, the critic concludes that film rehabilitates the notion of spectacle itself, declaring: "Yes, it *is* a spectacle, and what a spectacle!"[4] I return to

Bazin's thinking on this matter below, but for now, it is important to note how this idea of spectacle continues to haunt the neorealist image, even in a cinema that overtly aims to offer an alternative to Hollywood-style depiction.

In this chapter, I take three films from the De Sica–Zavattini collaboration—*Shoeshine, Bicycle Thieves,* and *The Roof*—and examine how each posits spectacle as a realist cinematic device capable of triggering and nourishing a charitable gaze in line with the nascent institutional practices of global humanism. Unlike Rossellini's war trilogy, these films are less willing to depict the violence of war directly, but as we will see, they do use the body to ground their claims for the necessity of realism after war. Although the war's casualties are not always a central narrative theme here, these films deploy an emphatic physicality to widen the ethical frame of vision and establish an audience of casual but concerned bystanders. As an American reviewer commented, "violence . . . pulses through the veins of the Italian importation, *Shoe-Shine.*"[5] These films argue for the importance of ethical eyewitnessing in the context of a broad commitment to the edifying potential of a spectacular realism, and their claims for the necessity of a well-monitored world are articulated around a corporeal stylistics.

The exhibition history of *Shoeshine* and *Bicycle Thieves* suggests that their realism appealed more to audiences outside of Italy than they did to De Sica's countrymen and -women. Despite the unprecedented success of his vision in the United States and across Europe, not everyone in Italy was convinced by his cinematic pleas for a more humane world. Many prominent members of the Italian press were actually offended by what his reformulation of spectacle revealed. These critics branded his films *stracci all'estero,* or "rags for abroad."[6] They accused him of airing domestic dirty laundry in public. Indeed, these films do not shy away from a visual politics of pity: when we closely examine these films' drama of vision, we find that they argue for making a spectacle when necessary. The redress of suffering often comes only after those in need make a public spectacle of themselves. According to the logic of these films, a humanist conscience could not be grasped until suffering entered the global public sphere as a consumable spectacle. *Bicycle Thieves* served as the model for a propaganda film produced by the Marshall Plan, *Aquila* (Jacopo Erbi, 1950). This adaptation vividly suggests how De Sica's film almost immediately consolidated the cinematic idiom for a new geopolitical era

based on the ideological justification of extranational charity. De Sica's films also proposed and enabled an extranational space for the North Atlantic gaze through a specularization of poverty. De Sica's humanistic makeover of vision in this sense not only made the country's "rags" travel; it also necessitated the delocalization of the gaze itself.[7] It was perhaps this threat to national integrity that De Sica's detractors recognized and rejected.

All three of the films discussed here up the political ante of otherwise simple stories through close attention to the physicality of onscreen bodies and the instrumentalization of bodily contingency as a rhetoric of authenticity that underwrites their delocalizing project. The filmed body functions as a transnational beacon for global transits of sympathy, and in this respect, De Sica's films identify their own consumption as a means to a more humane and humanitarian world. Recall here Zavattini's statement, discussed in chapter 1, suggesting that neorealism constitutes "the art of charity," and that by fully utilizing the cinema's fidelity to the contingences of life, neorealism "permits me to know and thus to love my neighbor."[8] The imperiled body makes plain the need for witnesses and points to cinema as an ideal means of collapsing geographical and cultural distance, lending an affective and scopic dimension to the networks of geopolitical compassion necessary to the ideologies of postwar reconstruction discussed throughout this book. Cinema emerges in this vision of the medium as the means best able to assemble a group of objective and ethical witnesses across international space and recent history.

As we saw in the previous chapter, neorealist films do not undertake their political work simply by equating the image with truth. They also align truth with the act of seeing; that is, the content of the image is not the exclusive measure of realism. For these films, realism is as much about seeing as it is about the sights. The content of the image often provides an opportunity to showcase vision as the only activity able to render reality. We might say that the typical neorealist image consists of content through which the film can overtly recast the act of seeing, shatter habituated perceptions, and elaborate the agency granted by just watching. It is a realism constituted through viewing as much as it is quantified in views. If eyewitnessing leads to ethical resolution and uninhibited seeing guarantees unfettered access to knowing, these films suggest, then any effort to limit vision invites moral catastrophe.

De Sica's films are no exception to this more general rule. They do not simply thematize the unleashing of vision, the opening of sight lines, and the enabling of visibility in their narratives. They establish suspense and viewer involvement through a narrational dialectic between diegetic blindness and spectatorial vision. When the films prompt a longing for resolution to social problems, they do so by contrasting a character's knowledge, which is limited by his or her constricted sight, and our knowledge as viewers, which is enabled by the different range of our vision. The realism of these films is not simply about revealing the woes of another's life. It is about realizing the burden of a wider perspective. De Sica's neorealism bespeaks the desire for an intersubjective space beyond national borders that makes immediately relevant otherwise distant concerns. These films portend the possibility of this intersubjective space by upsetting the hegemony of who is most visible in our world, expanding what the world is shown, and recognizing the full obligations of the eyes of the world's beholder. These films narrativize this process by using fictional scenarios to make palpable both the dilation of the spectator's sphere of belonging and the transgression of the geographical boundaries of that spectator's moral obligation. When we feel moved by watching these films, we are caught up in a drama of making a new world order visible.

De Sica's goal of nurturing a new form of spectatorial responsibility finds one of its first articulations in his exploration of the child character's perspective. Several of De Sica's films from this period center on children, and he admits that this focus derived from his belief that the point of view of adults had been poisoned by fascism and the war. At this historical juncture, according to De Sica, adult vision is corrupted by its loss of proportion. The limited vision of adults confines their political agency and distracts them from moral responsibility. For De Sica, adults desperately need to regain the breadth of their vision, and children offer a form of moral redemption in their mode of watching.

In his 1944 film, *The Children Are Watching Us (I bambini ci guardano),* De Sica accordingly focuses an intense level of attention on eyes and pathways of vision. Glances, looks, scenarios of vision are sites where morality is tested, evaluated, and negotiated. Furthermore, the eyes of the child character supply an aspirant perspective, a point of view we are asked to adopt as our surrogate and to invest in as our stance toward the social world. Widely regarded as a crucial

precursor to the neorealist aesthetic, *The Children Are Watching Us* covertly but nonetheless forcefully elaborates a critique of life under totalitarian rule. The immorality of society festers in a perversion of vision that afflicts most adults by rendering the value of human life invisible. By focusing on the perspective of a child, the film can be seen as hoping to liberate its viewers from the myopia of living as adults in early 1940s Italy.

Children are more than just reminders of innocence and humanity's potential; they can actually see a world that ideology prevents adults from seeing. "In those difficult times," De Sica remarked, "my thoughts turned more to the children than to the adults who had lost all sense of proportion. This was truly the moment when the children were watching us. They gave me the true picture of how our country was morally destroyed. They were the *sciuscia* [*sic*], the shoeshine boys."[9] With his next film, De Sica was able to proclaim more overtly his political dissatisfaction with adult vision and his interest in the perspective of a child, and he did so by focusing on just such boys—the shoeshine boys. If *Shoeshine* "contributed to the moral reconstruction" of society, as he claimed, then it did so by warning its viewers of the costs of restricted vision.[10] This and his other films from the period position unhindered seeing as a radically redemptive act, one central to being human and necessary for the nourishment of human community. I will therefore argue that De Sica's neorealism develops specific narrational procedures aimed at fostering a gaze of globalized concern. This reformed mode of looking attempts to transcend the constricted "sense of proportion" of intranational sight, thereby liberating the viewer from the circumscriptions of totalitarian subjectivity and a dependence on local and state resources. These films in this way align themselves with a gaze that anticipates the subjective structures necessary for large-scale international aid projects rather than endorsing regional or statist forms of assistance, dismissing these latter as corrupt, condescending, and ineffectual.

Shoeshine

Shoeshine warns of the epistemological frailty of senses other than sight. It cautions us that sound lies in ways that the seen cannot. The film explores the discord that ensues when a literal blinding impedes access to knowledge. Through its story, the film issues an empiricist

imperative: do not believe until you've seen. Trouble begins when belief precedes visual observation. With eyes distracted or sight obstructed, deception can abound. Blindness invites fraud, derails justice, and severs the human community's essential bonds.

The film's two main characters, Giuseppe and Pasquale, are homeless boys bonded like brothers who make a living shining shoes on the streets of Rome. Early in the film, they are arrested for their unknowing participation in a con game set up by Giuseppe's actual older brother, and they are condemned to a boy's prison. Their friendship then falls prey to the divisive scheming of the prison authorities' interrogation techniques. These tactics involve trying to extract a confession by dividing the boys and forcing Pasquale to listen to what he believes to be the beating of Giuseppe, an event that happens just beyond his range of sight. To stop the apparent violence, Pasquale agrees to confess what he knows. In many ways, this scene echoes the sequence in *Rome Open City* when Don Pietro is forced to watch (albeit without his glasses) and hear the sounds of Manfredi's torture. When Pasquale, who knows nothing of the bogus torture session, discovers that Giuseppe has confessed to their crimes, he believes his friend has selfishly betrayed him. Thus the faked sounds start a chain of mutual betrayals that eventually threatens to destroy their loyal friendship and that ends with Guiseppe's violent and accidental death at the hands of Pasquale.

It is crucial to point out here how the film constructs narrative tension by contrasting the spectator's omniscience to the characters' blindness. The film builds our investment by showing us information unknown to the key characters. It generates pathos in its dynamic of blindness and sight, splitting what characters believe from the fuller reality that we as viewers witness. Our wider range of vision triggers not only a desire for the resolution of the boys' conflict, but also a longing for a world made just through seeing. The film prompts us to desire a world in which justice follows from the sovereignty of the outside bystander. With the thwarting of Pasquale's perception, the film relays his protective paternalism to our vision: we must take on the responsibility of watching over the vulnerable. The only avenues of diegetic observation are either too corrupt or too vulnerable to enact this crucial social function. This is an ethical reorganization of the world based on a general notion of testimony and visual eyewitnessing. It is not so much that the film image itself testifies here, offering

evidence of the world's crimes. Rather, the film image proclaims the necessity of the eyewitness herself. Taking in the world visually is suddenly more than a quotidian or touristic activity. This film redeems the moral impulse of looking, points out the virtues of voyeurism, and endows cinematic consumption with the air of worldly engagement.

After exploring the consequences of faked suffering, and before Guiseppe's death, the film next spotlights several diegetic encounters with the narratively authentic suffering body. In a revenge strategy, Giuseppe has planted a nail file in Pasquale's belongings. When the guards discover the file, Pasquale is brutally beaten. Later, when the two boys encounter each other in the communal showers, Giuseppe notices Pasquale's scars from the beating, and for a moment in the film, resolution seems possible. The visual encounter with the wounded body confirms the tragedy of their separation. The attention of the boys to the scars reinforces our attention to those marks and their narrative centrality. Yet the possibility of reconciliation is known only in the moments when one of the friends sees the other's body as the object of violence. Here the film repeats its moral imperative about vision. All thoughts must be preceded by sight; all belief must be premised on what is seen.[11] Anything believed but unobserved remains hazardously hypothetical. The visually unconfirmed always harbors an imminent danger: discord, injustice, violence. The truth speaks in bodily terms.

If the film endorses corporeal seeing as the conduit to truth, it also asks us to see from a particular point in space and time. Pauline Kael described her first experience of watching *Shoeshine* in incredibly affective terms. For her, the strength of the film lies in its ability to provoke emotions. It does so thanks to its "raw," "rough," "naked," and unstructured nature. Walking out of the film in tears, she happens to overhear a conversation of other audience members who were unmoved. Kael immediately condemns the emotional incapacity of these fellow viewers ("For if people cannot feel *Shoeshine*, what *can* they feel?").[12] However, the fact that some viewers could not experience the film's "greatness of feeling" or "painful beauty" only amplifies her commitment to the film. For Kael, *Shoeshine* qualifies as a social protest film because of its invocation of emotion—a fostering of affect so strong that it is repeatedly described as having a violent physical impact. The film's means of protest are constituted in her comparison of the dispassionate frustration of her fellow American viewers to her own forceful identification with foreign characters. Her alienation

from these other viewers, a difference the film draws out, makes her hunger for a more compassionate and humane world.

Bert Cardullo also describes how the film extends its gaze extradiegetically in his often-reprinted essay "The Art of *Shoeshine*." Although Cardullo makes clear that the film refuses to offer any solutions to the social ills it presents, he implies at the end of the essay that the film suggests to us, as viewers, that we do have answers. In this way, the film imparts to us a sense of authority that is premised in our position as outside observers: "De Sica," Cardullo explains, "discourages us from seeking answers to all our questions on the screen. We are in a position to contemplate this social tragedy far better than any character in the film. . . . We are thus able to consider solutions to the problems that De Sica poses, or to consider the idea of abolishing war altogether. We are the ultimate recipients of De Sica's *Shoeshine*."[13] Cardullo's commentary carries of course a double meaning. De Sica is shining our shoes: we are the American G.I.s taking a moment to have an Italian polish our boots. Cardullo uses the luster of a shined boot to explain the film's true point of view: "The American GI who looks into his shined boots sees the image of his own victory and prosperity, but his image is tainted by the Italy that surrounds him—one that he has helped to destroy and whose rebuilding it is now his responsibility to oversee."[14] For Cardullo, the film's point of view rests not so much with the children looking up at the G.I.s, but with the American occupation troops themselves. The boys provide the reflective surface on which Americans see what they have done in Europe and the assistance they are impelled to provide. What Cardullo does not say, but what is implied by his reading, is that the American subject also catches a glimmer of his own global sovereignty in the world reflected in the shined shoe. From the image of desperation and subservience, the American senses both his responsibility to the world and the righteousness of his authoritative position in that world.[15]

Similar to *Paisan*, then, *Shoeshine* invokes a new space of American–Italian relations. The pidgin word that is the Italian title, *sciuscià*, describes a commercial and social relationship between the street urchins and American G.I.s. The word is linguistically rich only so far as it has a polyglot functionality. It suggests an established social relation where language need only provide the barest signification. It is all that is needed to facilitate an exchange of money; it represents the essence of a key transnational relationship. In other words, there is a

performative element to the invitation of *sciuscià*. It enacts a global space by speaking two languages just enough to establish the flow of sympathy and then dollars from the outside. As with *Paisan*, De Sica's film tries to flesh out that relationship and deepen the audience's understanding of those Italians who serve or live alongside the American G.I.s. As we have seen, however, both films endorse the sovereignty of a gaze outside the diegesis. In this way, they relocate sovereignty to a place at once inside and outside the borders of Italy.

Even within Zavattini's idea of cinema allowing the firm embrace of a neighbor, there is a structure of detachment implying that compassionate outreach flourishes in the virtual spaces of intimacy that cinema permits. Gestures of humanism require a structural distance. In some of his descriptions of neorealism, Zavattini emphasized that an alternation of affect enabled a powerful reflective subjectivity for the viewer that hovered outside the diegesis. The role of the realist filmmaker "does not consist in bringing the audience to tears and indignation by means of transference but, on the contrary, it consists in bringing them to reflect (and *then*, if you will, to stir up emotions and indignation) upon what they are doing and upon what others are doing."[16] Although Zavattini intends to argue for how realism forces its viewer to rethink reality and his or her position in it, in doing so, Zavattini validates the powerful awareness brought by adopting a foreign perspective.

Bicycle Thieves

At the same time that the critical scholarship on *Shoeshine*'s politics has remained theoretically tentative, much has been written about the political nature of De Sica's next and most famous film, *Bicycle Thieves*. Most of that commentary concerns the representation of domestic political parties and attempts to reconcile the success of this film with the imminent defeat of the PCI (Partito Comunista Italiano) by the political party backed by the U.S. government and right-leaning Italians, the Christian Democrats. As we read over the arguments for and against the politics of the film, however, the specter of international politics often lurks in descriptions of the film's mode of address. The Marshall Plan and its reworking of the political landscape of postwar Europe forms the subjective backdrop for realist cinema's attempts to figure a liberal audience.

In her compelling attempt to historicize how viewers came to rec-
ognize particular films as realist, Kristin Thompson describes the
aesthetic of *Bicycle Thieves* as emerging from its effort to merge com-
passion and political objectivity. The resulting realist style promotes
a "balanced, rational, humanist outlook," a point of view she credits
with the international popularity of the film. Thompson argues that
what Bazin sees as the film's "illusion of chance" was a highly engi-
neered and carefully calibrated filmic system that allowed spectators
around the world to engage with the film and underwrote the interna-
tional recognition of a coherent realist project. This success of this par-
ticular discourse of realism meant that the film transcended its local
specificity, speaking beyond Italy to an audience interested in "the
whole cosmic concept of right and wrong and of man's desperate need
of security."[17] Frank Tomasulo rereads the film's articulation of space
as a subjective means of allaying the central political contradictions
haunting Italian postwar culture. He sees the film's politics as any-
thing but revolutionary. Instead, his analysis reveals *Bicycle Thieves*
to be a text that enacts ideological compromise. Tomasulo regards the
film as a feature of a larger cultural process that readied the Italian
subject for bourgeois consumer capitalism by absenting class con-
sciousness and erasing the Marxism of the Resistance.[18] By contrast,
Marguerite Waller celebrates the film as a textual practice of decolo-
nization, an anti-imperialist rejoinder to the Marshall Plan's transfor-
mation of Italy's sociopolitical landscape.[19] Carlo Celli argues that the
film's critique of contemporary Italy faults both the lingering fascism
of the society and the current government's hesitance to utilize Ameri-
can aid money to boost the economy.[20] In what follows, I expand on the
suggestions of these theorists that De Sica's ethos of vision connects
to a larger reconfiguration of the socioeconomic ordering, not just of
Italy but also of the world.

 Bicycle Thieves depicts a world in which hardships, intolerance,
and corruption threaten to degrade the sanctity of human life and the
agency of the individual. It traces the moral dissolution of its main
character, Antonio, as he struggles to keep a job to support his family.
Even several years after the war, it appears that fascism's brutality
remains ingrained in the organization of Italian society and the cruel
infrastructure of Roman life. Totalitarianism continues to violate the
human spirit in ways that make both Catholic charity and leftist pol-
itics look impotent. The film depicts the loss of individual identity as

the result of a society that narrows the opportunities to sustain oneself and perverts the concept of personal property, and it allegorizes this theme in its locations and set decor. Anonymity is a threatening force that gets expressed visually in a mammoth library of bed linens, a similarly huge warehouse of bicycles, the bureaucracy of a police records office whose mailboxes formally echo the gridlike structure of the bed linen repository, the dark, hollow windows of housing projects, the disorganized vastness of a bicycle black market, and even the narrow winding streets of the *borgate*. Yet the film makes its point about threatened individuality even more strikingly in its optical narration.

Bicycle Thieves* is predominantly a narrative that is told visually, as if it could be told without words. As in *Shoeshine,* events unfold in an oscillation between temporary blindness and revelatory visions. Conflicts between the seen and the unseen frame the major moral dilemmas posed by the film's story. If Godfrey Cheshire has called the film "a symphony of looks,"[21] it is also a parable of vision itself. It is not unusual for any film to alternate the spectator's affinity between two competing perspectives: gazes that encourage our identification with central characters and their looks, and gazes that ask us to disengage with character perspectives.[22] However, in *Bicycle Thieves,* and in a fashion similar to what we have seen with *Rome Open City,* just how the viewer's relationship to diegetic point of view evolves over the course of the film is central to its meaning. Through continually revising the terms of our visual engagement, the film sketches an intricate narrational schema. It proclaims one viewing protocol for the viewer, only to then retract or revoke it. Eventually, the film calms this busy traffic of looks, exchanged glances, and omniscience. It does so by fortifying the viewer's sense of his or her own exteriority and alterity. As such, this narrational schema provides the film one of its central means of derealizing habituated perception so as to welcome humanist engagement in the world. Geopolitics finds root in the film's form when visual narration recognizes the viewer's authority grounded in a space of foreignness.

Many of the film's crucial events are told almost entirely through the image, often building tension and character through looks and gazes. The visual narration of key scenes encourages the viewer to anticipate what is about to happen. The film builds this pattern of anticipation by offering the viewer a field of vision that offers a perspective overtly wider than any onscreen character. The major losses

of the film occur when a character momentarily loses sight. The initial theft of the bicycle happens, for example, because Antonio has turned his back on the bicycle. In this moment, we have a wider range of vision than Antonio, who is concentrating on doing his new job. What is suspenseful and frustrating for the viewer is hoping that he will turn and see what is happening before it is too late. Here the film's open framing and use of real time in an uninterrupted, widely framed shot facilitates our desire for Antonio to see more. This brief moment of distraction from the protection of personal property has grave consequences, setting in motion the central conflict of the film. The theft is anticipated even earlier when Antonio leaves the bike unattended while visiting a psychic. The open framing of this shot triggers the viewer's anxiousness. Who is watching this bike upon which all future happiness depends? By attenuating our ability to see and not change the immediate scenario, the film prepares us for its eventual revaluation of looking. In other words, the film highlights our impotence to effect any change at the level of the diegesis in order to later orient us to the powerful agency of our gaze. Agency is, after all, always relative. The tension created in this scene derives from the agility of our gaze, and from the excruciating sense that we would know what to do if we were there. In these early instances, the film offers us this expanded visual perception, only to taunt us and to indicate the characters' lack of foresight and the limits of their vision.

The tension between attention and distraction structures another facet of this film's parable of poverty: the strained relationship between a father in crisis and his carefully attendant young son. The film depicts the emotional rift between father and son through a series of scenarios that demonstrate Antonio's intermittent neglect of Bruno, a plot device likely to cue conflicted compassions in the audience. The fault lines of compassion, then, are bound up with questions of sight and foresight, and here those questions take a more corporeal inflection. Bruno stumbling in one scene or narrowly escaping being run over by a car in another scene reveals how unaware Antonio has become in his parental responsibilities. At one point, the potential repercussions of Antonio's inattention materialize in a frighteningly physical vision of danger: father and son have just had a fight near the banks of the Tiber River. A distracted Antonio suddenly finds himself without Bruno and without the knowledge of Bruno's whereabouts. When he hears screaming from efforts to save a drowned body, he

panics. He runs to the bank of the river, where we learn a young boy has just drowned and is being dragged from the water. By means of offscreen sound and ambiguous shots of the commotion at the riverbank, the film leads the viewer to conclude, along with Antonio, that Bruno has drowned. Along with Antonio, we realize that we have jumped to the wrong conclusion when the limp body of a boy much older than Bruno is laid on the riverbank before our eyes. Our involvement in this ethical climax, which Bazin calls the "heart of the story," hinges on a sudden destabilizing of visibility and a relaxation of suspense with the revelation of a body.[23] Here again the injured body is burdened with not only supplying the truth of the event, but also substantiating the stakes of vision. However, the greater truth of the event is that lapsed vision leads to misperceptions of any event's reality. In this context, it is interesting to question why Antonio, as one of the few adults on the scene, offers the rescue party no help once he has found Bruno sitting safely on the riverbank. In a scene where our gaze is so closely associated with Antonio's looks and then detached from them, we discover that Antonio's gaze toward the imperiled body does not trigger in him any charitable action.

The lore of this film's making is filled with corporeal anecdotes that both confirm and complicate our understanding of its turn to the body. The casting decisions are legendary. De Sica refused much-needed Hollywood funds because the backing came with the stipulation that Cary Grant be cast as Antonio. Instead, De Sica looked through hundreds of auditioning actors before deciding on nonprofessionals whose physicality seemed authentic. His choice of Maggiorani was based on the fact that Maggiorani carried the weight of his personal history on his body. Another set of legends concern the methods by which De Sica tormented the young boy who played Bruno to get him to cry for a scene, including the recent claims that the director physically abused him to achieve the desired effect. Meanwhile, when looking for examples of realism in the film, critics often turn to the body as an authenticating force in the image. Bruno's body is often cited here as well: his sudden need to urinate in the middle of a chase, his dangerous tripping in traffic, his dawdling. In each of these examples, the film and its lore encourage the viewer to collapse the performer's body and the character's body.

In this context, it is peculiar how few critics and scholars discuss a particularly corporeal episode toward the end of the film in which

bodily spectacle again throws a wrench in any linear progression of the film's action. The sequence begins after Antonio and Bruno have finally apprehended the person who stole the bicycle, a scruffy young man named Alfredo. Their chase has led them back to Alfredo's neighborhood. No sooner has Antonio cornered Alfredo and begun his accusations than Alfredo begins to tremble uncontrollably and then slips into what looks like a grand mal epileptic seizure. The composition of the shot frames the body as on display. Recalling the recovery of the drowned teenager, the film focuses our attention on the corporeal by placing Alfredo's convulsing form at the center of a shot surrounded by a crowd and held in a pietà. Here the body's uncontrollable writhing appears both sincere and fraudulent. When the film cuts to a closer shot with light falling on his heavily sweating face, we see veins bulging in Alfredo's neck and his teeth violently clenched. From the viewer's perspective, this seizure abruptly derails the narrative tension that has built toward the recovery of the bicycle and the condemnation of the thief. The justice that had only moments before felt so close to being finally achieved in the diegesis suddenly

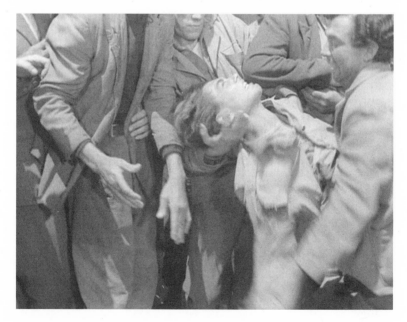

The question of spectacle comes to a head in the discomforting undulations of the young thief's seizing body in Bicycle Thieves.

slips away as it seems less apparent that Alfredo will be held responsible for the theft of Antonio's bicycle.

As the seizure frustrates narrative justice, it also destabilizes our knowledge. With this scene, the film brings the viewer closer to the epistemological and ethical crisis of the protagonist while simultaneously divorcing that same viewer from his or any other specific perspective. This sequence dramatizes the film's yearning for a reckoning of reality based on impartial public corroboration. What's interesting about the seizure and the chase as a whole is that although we may see more than any of the characters, we as viewers are haunted by a certain amount of ambivalence about the thief's identity. Until this scene, the film remains fairly coy about allowing us to remember where the thief actually is and refuses to leave his face on screen long enough for us to remember his appearance. We are provided only a fleeting glimpse of him, and we are haunted by the feeling that we are losing track of his face. From the first moments after the theft, we're not sure if we will know the thief when we see him. Along with Antonio, we strain our eyes in the initial chase in the tunnel. Darkness in this setting leads to a misrecognition. Our vision is obstructed at other moments during the chase as well; it is difficult to feel oriented in space or to feel like we've covered any ground. We search the crowds of faces. Then, when we finally have the thief in front of our eyes, the seizure forestalls any immediate reckoning. This writhing body makes suddenly moot any form of retribution. The body is placed at the ethical climax of tensions begun from misrecognitions and temporary blindness, but what does that body tell us? As Bazin writes, "We are not sure that the man who was chased by the workman is actually the bicycle thief, and we shall never know if the epileptic fit was a pretense or genuine. As an 'action' this episode would be meaningless had not its novel-like interest, its value as a fact, given it a dramatic meaning to boot."[24] Rather than seeing this undecidability thrusting the viewer into epistemological crisis, Bazin reads this ambiguity as part and parcel of the film's creation of narrative as "the 'integral' of reality."[25] He likens the seizure to the sudden burst of rain and the restaurant scene. These "events" do nothing to advance the narrative; they seem accidental because they are "seemingly interchangeable, no one seems to have arranged them in order on a dramatic spectrum."[26] Story disappears in this structure, and we are left with the effect of "supreme naturalness, the sense of events observed haphazardly."[27] For

Bazin, De Sica has created an unparalleled experience for the viewer via this unique narrational mode: events appear to us not as pre-existent entities arranged teleologically as story through incrementally increasing tension. Instead, the narrative seems structured around parallels and summations.

At one level, Bazin's account attests to a historically specific mode of watching this film. The spectator who is unable to decide whether Alfredo is the original thief is a spectator bound to theatrical viewing and unable to rewind or stop the action. Today, spectators can reverse the film's action at any point and confirm that it is the character Alfredo who stole the bicycle. Yet no amount of replaying will tell us whether the seizure should be taken as a diegetic fact or a diegetic put-on. The futility of such an inquiry points to precisely how the film seeks to redeploy the body as a spectacle. As Bazin, De Sica, and Zavattini understand it, this film introduces a new iteration of spectacle. This is not the kind of spectacle deployed by theatrical uses of cinema, where the spectacular qualities of the image are always at the service of advancing the action of the film. This form of spectacle is not instrumentalized by the forward movement of narrative. What the body in seizure captures for Bazin, and for De Sica and Zavattini at a less theoretical level, is the dialectical potential of cinema to produce spectacles that are also events and that carry the profound ambiguity of *durée*. The seized body is not evidential in any simple way. It allows the movement of cinema away from the rigid causality of theatrical narration and toward the naturalism that Bazin associates with the structure of the novel. For Bazin,

> De Sica's supreme achievement . . . is to have succeeded in discovering the cinematographic dialectic capable of transcending the contradiction between the action of a "spectacle" and of an event. For this reason, *Ladri di Biciclette* is one of the first examples of pure cinema. No more actors, no more story, no more sets, which is to say that in the perfect aesthetic illusion of reality there is no more cinema.[28]

The filmed image's propensity for spectacle pulls cinema both toward the theatrical and away from it.

Because Bazin uses the same word to describe two different operations, it might help us here to differentiate spectacle from the spectacular. The conflation of these two words reflects the constant confusion around the word *spectacle* and its multiple uses. Spectacle still exists

in realist cinema as it is understood by De Sica and Zavattini. To repeat Bazin: "Yes, it *is* a spectacle, and what a spectacle!" It is, however, a new kind of spectacle divorced from what we might call the spectacularized or the spectacular. On the one hand, the cinema cannot help but to be a *spectacle* because of its realism—that is, its interest in the human and in nature: think of Bazin's declaration, mentioned in chapter 1, that the film image is "inevitably obscene." On the other hand, cinema resists the *spectacular* in a theatrical sense because of its realism—that is, that same interest in the human and in nature. In the estimation of these theorists and practitioners of the realist image, film can actually work to oppose the spectacularization of theater through spectacle. For Bazin, the seizure provides a key example because it exemplifies a new kind of cinematic spectacle that combines both action and the event and so preserves the integrity of the real in all its rich ambiguity.

However, like much of his writing on neorealism, Bazin's argument about *Bicycle Thieves* in certain respects reveals a wishful relationship to the film's textuality that sometimes does not hold up to scrutiny when compared to the actual film. It helps to remember that Bazin wants to find instances of cinema's radical contingency in specific moments when a realist film brings to bear the same uncertainty that confounds us in daily life. Always on the lookout for indeterminacy, Bazin sometimes overreaches to find his examples, obscuring how films like this one exploit contingency, ambiguity, and indeterminacy for their rhetorics of realism. In his reading of the seizure in *Bicycle Thieves,* Bazin thus avoids the possibility that a film might deploy ambiguity with a particular semantic gain or in hopes of producing specific reactions in the viewer. Although there is an undecided quality to Vittorio Antonucci's performance of the seizure, it is important to resist Bazin's empathic adoption of the film's rhetoric of realism, which collapses diegetic ambivalence and imagistic ambiguity into the idea of a prediscursive or nonsemantic world, the image of pure observation. Despite Bazin's aspirations for cinema, not every instance of ambiguity translates to democratic seeing for the viewer.

Once a police officer arrives on the scene of the seizure, a debate unfolds about what constitutes testimony in a way that relates to this question of democratic seeing. The police appear to be complicit with what looks like neighborhood mafia control, represented here by an overly dapper paternal figure in dark sunglasses. When Antonio

questions why Alfredo is not being arrested, the officer supplies a jaded reply that seems unconcerned with the fact that a crime has been committed. He says that Antonio's testimony will be weak compared to the testimony of the neighborhood. The unsettling spectacle of a young man's apparent seizure is not just the backdrop to this discussion. The film uses the seizing body to illustrate a conflict between mob mentality and individual testimony. In this critical comparison of communal and individual modes of perception, a society is condemned because in pitting group opinion against individual testimony, the group always wins. Finding the thief would otherwise seem like a victory and a satisfying resolution, a moment in which the spectator's expectations and Antonio's desire are not only aligned but dramatically fulfilled. However, this scene frustrates the narrative progression of the film and diverts the moral suspense of the story. As it does so, the scene also untethers our spectatorial alignment from Antonio's perspective more firmly than ever before.

As viewers, the uncertain status of the seizure catches us in an affective glitch: is the film condemning the mob's use of bodily spectacle as a means of escaping conviction? Do we learn to mistrust a plea for sympathy premised on the body in pain? Perhaps the film is warning us that when mass mentality exploits the imperiled body as spectacle, injustice can topple the truth of individual experience? Or should the body elicit our sympathy for the thief? Does it humanize his behavior, underscore the abject poverty of his family's apartment, and thus echo the pleadings of his desperate mother?

The entire sequence in Alfredo's neighborhood is crucial for its interplay of various perspectives and multiplying sympathies, a dynamic shifting of point of view that is enabled by the counterpoint of the body. The body is the pivot around which the possibility of opening the viewer's compassion to various viewpoints rotates. Antonio's character stands here for an unwillingness to contemplate the ambiguities of the situation, and in this respect, we learn that his perspective will not be the impartial one of an outside authority. Regardless of whether it is real or a hoax, Alfredo's seizure is inconsequential to Antonio. Alfredo deserves condemnation no matter what. In this respect, the convulsing body further severs our identification with Antonio's perspective, as does the condition of Alfredo's apartment, which he shares with his family and which reflects circumstances more desperate than those of Antonio's family. By the conclusion of this scene, the film

leaves the viewer to wonder on what grounds we could ever condemn even the guiltiest Alfredo.

Bicycle Thieves initially draws its spectator's attention and identification from the crowd into the story of the plight of one man, Antonio, but the film's encouragement of an exclusive narrative identification devolves over the course of its narrative. As we have seen, it begins to unravel with Antonio's inattention to the bicycle and breaks down further in the drowning sequence, and then, in the seizure scene, the spectator is shown in the most overt fashion the limits of Antonio's subjectivity. Although we remain invested in Antonio's struggle, the narration uses the seizure and the surveying of Alfredo's apartment to pull us away from Antonio's perspective. The film begins to make an exclusive sympathetic identification with a single character increasingly confining and morally uncomfortable. In simple terms, *Bicycle Thieves* uses this sequence to shepherd the viewer's identification away from empathy and toward sympathy, asking us to imagine an ethical space for a perspective sustained outside the diegesis and beyond the epistemological frailties of this local scenario. The question of whether the seizure is legitimate or staged asks the viewer to ponder the larger question of which testimony is trustworthy: that of a group, or that of an individual eyewitness? By deploying and nurturing this ambiguity, the film prompts us to yearn for, and yearn to be, an impartial external authority. In other words, the film unleashes ambiguity in order to produce a desire for a particular resolution, a resolution that necessitates the viewer's disengagement from nearly all diegetic points of view. This turn has a broader implication: it recasts the cinematic spectator as the world's ideal eyewitness.

The end of the film represents one of film history's most emotionally compelling reversals: Antonio's decision to become a bicycle thief himself. The impact of this sequence derives from the oscillation of point of view, and it ultimately secures our disidentification with Antonio's perspective. At first, this sequence strongly associates our gaze with the points of view of three characters: Antonio, Bruno, and the owner of the bicycle that Antonio steals. In the first half of the sequence, the film forcefully relays our identification from residing with Antonio's optical point-of-view shots to Bruno's. During the second half of the sequence, the film drops the father–son points of view for that of the bicycle owner, who is a stranger in the narrative. This stranger is a random man in the crowd; the film offers him little

characterization and no psychological interiority. This sequence's complex relay of gazes and alternating points of view is crucial to my larger points about the film's politicization of vision and thus requires a detailed refinement of the overview above.

The sequence begins with Antonio and Bruno leaving Alfredo's neighborhood. As father and son move through the streets of the city, dejected and aimless, the camera draws closer and farther away from them in a series of shots joined with dissolves. Identification swings like a pendulum; we are carried forward with their movement in one shot, and the next shot lets these figures carry themselves away from us. The camera walks alongside them, and then it lets Antonio veer off deeper into the background of a shot. A subsequent shot will show him come toward and then career away from the camera. Along with our shifting perspective, the two figures themselves get farther apart, father and son first walking together, then getting separated. This sequence continues in the film's pattern of leaving Bruno behind or having him cut off by a moving train or car. In one shot, a trailing Bruno trips. Striving to keep up with his father and watch where he is headed, he is nearly run over twice. As they near the stadium area where the final bicycle theft will occur, the camera again moves with them, and we pick up Antonio's point of view. Tension grows in Antonio's face, and the ominous low chords that have dominated the musical score are now punctuated by the high-pitched wavering whines of violins, a motif echoing the scene in which Antonio's bike was stolen. Then a series of shots of various aspects of the surrounding scene are inserted between shots of Antonio looking around intently. These eye-line matches or glance-object shots represent an idea formulating in Antonio's mind: the stadium where a soccer game is just ending, a still forlorn Bruno, hundreds of bicycles parked in front of the stadium monitored by a uniformed guard, a lone bicycle parked on the side of a building, another shot of the bicycles in front of the stadium. In one shot, the camera picks up his pacing, and as he turns his back to the camera, the lone bicycle is again revealed, this time in back of the shot. This frame composition aligns his anxious gaze with our looking. We are looking over his shoulder.

Despite its overt insistence that we follow his looking, however, the film does not allow our perspective to rest with Antonio's optical point of view for long. In the following set of shots, it overtly disengages us from Antonio's point of view once and for all. This process begins

with a shot of the father and son sitting on the curb. An offscreen sound—the combination of the surging cheers of the crowd in the stadium and the return of the screeching violins to the musical score— seems to trigger Antonio's look offscreen right. The following shot appears to be the eye-line match: a rush of cyclists fills the screen. The camera pans left with the movement of the cyclists, only to reveal father and son in the frame. What we took to be a shot motivated by Antonio's gaze turns out to contain him. As the pace of the musical score grows more urgent, Antonio stands to look out. What follows seems like a repetition of the earlier glance–object shots, but this time less matched to eye lines. The shot of the stadium shows a crowd leaving, but from a moving perspective at an angle impossible for Antonio to inhabit. A shot of people retrieving their bikes and riding off also appears in an angle and proximity that cannot be Antonio's. The film repeats the over-the-shoulder shot described above, in which we see Antonio pacing and turning to look at the lone bicycle. With each repetition, the film loosens the link between our perspective and Antonio's optical point of view. One such transformation occurs when a shot of him looking is followed by a composition similar to the over-the-shoulder shot, but his figure is more centered in the frame, and the background of the shot contains no object for his gaze. The final shot of this type becomes more and more omniscient as it progresses, with Antonio's figure becoming more an object of our gaze than its authoring subject. This shot eventually shows him stealing the bicycle. Bruno's point of view now comes into play.

Before attempting the theft, Antonio has ordered his son to return home on a trolley that Bruno misses. We are shown the trolley moving on without him, but we are not immediately shown what happens to the boy. Instead, the film follows the narrative of Antonio stealing the bicycle. For several shots, the film keeps us in suspense about Bruno's whereabouts. It seems to be neglecting Bruno, leaving him unattended, in the way that his father has done earlier. His absence adds to the suspense of this scene, especially because the film has compelled us to look after him in so many sequences. The bicycle's owner almost immediately discovers Antonio stealing the bike, and as Antonio tries to escape, a group quickly assembles to chase him. The pace of the cuts picks up here as Antonio is being chased. As he rounds a sharp curve, the camera follows him to the left. Suddenly, the camera cuts to a medium close-up of Bruno, who whips his head around with an

urgent gaze. Bruno's point of view appears to motivate several of the subsequent shots. We must watch the humiliation of a father through the eyes of his adoring son. The difficulty of watching this scene, which director Charles Burnett suggests is almost too dreadful to watch even after multiple viewings, comes from not only our fear for Antonio's fate and our disappointment with his actions, but also from the publicness of this scene and our awareness that Bruno is watching the event.[29]

In this shot that finds Bruno witnessing the chase, the camera dramatically tracks in and toward Bruno. This emphasizes the directional intensity of Bruno's look to the left and expresses his visual shock. This shot admits to being composed: a complex choreography of actor and camera operator was obviously necessary to pull off such a shot. Its expressive quality carries an almost Hollywood studio level of stylization that contemporary mainstream films might use a quick dolly zoom to produce. Yet the shots that represent what Bruno sees carry none of this careful composition. In fact, the visual narration shifts its style dramatically as the vigilante group catches up with Antonio and begins shoving him around. Here the camera follows the action at a distance in an open framing. Like a news camera, the frame moves to keep the erratic movements of a marauding mob centered. A police officer appears on the perimeter of this mob, but he seems neither in control of the scene nor disapproving of the mob's intentions. In a medium shot, the film then cuts back to Bruno, who, with the exception of his trembling lip, is nearly stilled by the shock of what he sees. He then leaves the frame, moving offscreen left to get closer to the mob. As the camera pulls in closer, we witness members of the vigilante group jabbing Antonio and repeatedly slapping his face. The camera again must follow the movements of the scene, accommodating its frame to the violent undulation of bodies. Even before Bruno reaches this violent scene, these shots appear to show us his perspective. The sequence is fairly short, but the shuffle of abusive limbs is violent and almost sadistic in its abuse of Antonio, then of Bruno as he gets jostled among the legs of the mob.

By this point, the owner of the bicycle has caught up with the crowd. Just after he tells the vigilantes to bring Antonio to the police station, the owner pauses and looks toward the back of the shot and glimpses Bruno, who has worked his way back into the scene. As he walks forward in the frame toward the owner, Bruno steps into a

strong directional light from offscreen left. Bruno stands at the center of the shot and is reframed by the gray pants legs of the crowd on either side. He seems a sorry sight. His mismatched clothes look more like tattered rags than ever, and his hands clench his father's hat, which he recovered in an early moment of the frenzy. His face glistens from tears and sweat. This shot is an eye-line match clearly associated with the point of view of the bicycle's owner. The following shot shows the uncomfortable bicycle owner looking back at Antonio and then at Bruno again. He then tells the crowd not to call the police and to let the thief go. The sight of Bruno seems to have been too pitiful for this stranger.

Even before the final theft sequence starts, the film has already removed Antonio's point of view from our gaze. With what follows, Bruno's point of view is also worked out of the visual narration. Carlo Celli argues that De Sica's film forcefully rejects the impulses of conventional Italian film narrative, in particular the heroism of Maciste. For Celli, *Bicycle Thieves* distinguishes itself from popular genre films by refusing a puffed-up hero figure that serves as the always triumphant defender of the weak.[30] We might take this further to say that the film is actually structured around the narrative absence of such a figure. This absence is felt throughout the film, but most strikingly in the final sequence. Are there any heroes here? The young and diminutive figure of Bruno might qualify as a defender. Despite his best efforts, however, his agency seems found only in his capacity to effect a spectacle of pity. Certainly, this is no Hercules. What about the merciful stranger at the end? Perhaps he is our hero. The film honors the perspective of the stranger with one of the final embodied point of views of the film. Here the stranger's point of view provides mercy that no civic institution or social organization in the film can guarantee. Because his mercy carries no social specificity, no clear motivation other than pity, his actions appear to have no just cause. His mercy derives from nothing other than a humanism triggered by a pitiful spectacle. After the vigilantes release father and son, Antonio begins crying, and Bruno offers him his hand in comfort. Antonio's earlier inattentiveness to Bruno now pales in comparison to his other crimes. We are in a world where sons parent fathers. The two walk off into the crowd, and as the film feels to be drawing to a close, we realize that it will not release them from our charge. Like the stranger, we, the international spectator, have been asked to take mercy on the pitiful.

It is important to consider how the imperiled body functions in these final moments of this film to organize its address to this international spectator. The depiction of Antonio's beating is detailed and disturbingly realistic, but it is hardly graphic in a manner that would catch a censor's eye. When considered in the context of this film's tremendous international success, this scene cannot help but resonate with the ambiguity around the status of the Italian as the victim of the war. Throughout the film, it compellingly orchestrates for our gaze a variety of poverties that besiege Antonio's family and that will conspire to motivate the final theft. The film shows the viewer how others might come to make this same bad choice. The violence done to Antonio stands as the denouement of the film's parable of how scarcity and inequality, rather than ethical and organized means of social justice, structure this society. The mob's abuse here feels more sadistic than goal oriented. The violence surges and swells in an organic cacophony, emphasized further by the film's framing of his face and upper body in the center of the frame being continually hit from all sides. There is a chaos to these shots that echoes the earlier shots of Alfredo's seizure. Antonio hardly retaliates or even defends himself. Taking this violence in such a humiliating manner, Antonio appears to violate the conventions governing the bodies of male protagonists. As such, this violence seems offered by the film to test the fortitude of our sympathy, to deepen our compassion, and to heighten our anger toward an unjust and unmonitored society. This film makes the absence of moral fortitude a structural issue of the society, yet not for a moment does it question the moral proclivities of its viewer. In this gap between a diegesis lacking any moral guarantees and a narrational assumption of the audience's moral fortitude, the film proposes an extranational space of charity. We are left longing for outside help, for someone to adjudicate and regulate this world. We are left longing for who the film has asked us to become.

The Roof

This discussion would be incomplete without a consideration of an example of a film that appears to counter my thesis that the charitable gaze rests on spectacles of imperiled bodies. This consideration is especially crucial when discussing De Sica: many of his best-known films seem to evade the injured body, and for many film theorists, the

politics of his neorealist films are best apprehended through an analysis of location. Nowhere does this geographical and spatial emphasis seem more apparent than in *The Roof* (1956).[31] The suffering body is not a prominent feature of this film, and its ethical climaxes do not coincide with scenarios of torture or injury. However, I want to argue that a visual elaboration of the corporeal nonetheless helps the film explicate the conditions of poverty. Attending to the bodily qualities of its performers also enables the film to offer its viewer a mode of relating to those who are the neediest in the world. Moreover, the film brings to the fore the necessity of spectacle in the politics of raising attention to and advocating for the world's underserved, marginalized, or forgotten.

Before analyzing the function of corporeality in this project, we will need to understand how the film deploys a highly self-conscious visual narration to make the gaze of charity a palpable mode of engagement for its viewers. The suspense of one of the film's final sequences will be critical to my larger reading because its tension builds around a single character's willingness to be charitable. We watch as one person's look adjudicates the fate of the film's two protagonists. By turning its narrative over to the moment in which this character gazes and decides, the film not only underscores the act of looking as a practice of politics, but also presents a theory of the image as a venue for the recognition of political identity. Working back from this sequence, which initially seems to offer little to my larger argument about corporeal realism, I will then talk about how the body does in fact play a crucial role throughout this film's formal elaboration of the charitable gaze and how it remains critically at play throughout the film despite its lack of prominence in the mise-en-scène of the final sequence.

The Roof begins with a familiar neorealist trope: a documentary montage sequence of the postwar landscape. Reportage-style images of the ongoing redevelopment of Rome's periphery dissolve one after another in the familiar pattern of traditional nonfiction explication. The montage reveals new housing structures in various stages of completion, but little optimism or futurity can be gleaned from these shots. These tall apartment buildings are erected against an empty sky, rising up from a landscape all but barren were it not for the huge construction cranes and dust. Nearly every shot formally emphasizes the emptiness, uniformity, and cold modernism of these housing projects.[32]

At the conclusion of this introductory sequence, the film cuts to a wedding scene outside a church. In contrast to the loose documentary shooting style of the opening montage, with its dissolves and moving camera, the wedding scene is depicted in an immobile frame with a carefully balanced composition that seems to reflect the stiffly posed vernacular of a typical wedding portrait. The architecture of the church's facade reframes the image, adding formal structure and self-conscious intentionality to the composition, supplementing the tableaulike quality of the posed family. The wedding appears to have all the features of middle-class formality, with various generations dressed up and gathered around the bride, who is wearing a voluminous white gown. After the members of the wedding party have been reconfigured for the event's photographer (our position as viewers parallels that of the diegetic camera), the event begins to reveal itself as less comfortably middle-class than we were first led to believe. The bride's dress was rented and urgently needs to be returned; the honeymoon involves taking a bus to the bride's family's house; the couple did not invite the bride's parents to the wedding. Most surprisingly, we discover that the newlyweds, Luisa and Natale, have nowhere to live. The rest of the film follows their travails as they try to find a home together. After the failure of various plans that include moving in with relatives, renting an illegal sublet, and the like, the couple decides that building a squatter's hut is the only way they will be able to have a home.

After many snafus and obstacles, the couple is joined by a cohort of friends and relatives on a small patch of land that abuts the beds of railroad tracks, a ditch that is a no-man's-land in terms of property rights. On this site, the group has only a few hours to build the entire house, or squatter's hut, which will be a one-room structure made of concrete bricks. We watch anxiously as they rush to complete the house by dawn. The suspense of this building sequence comes from the fact that earlier in the film, we have seen the police discover such homes on their early morning rounds and demand the structures' immediate demolition. Squatters lose their claim to residency if a structure is substantially incomplete. If, however, the home is fully built, then residency can be immediately established and the police can do nothing to prevent the squatters from establishing a life there. For the legal protections of occupancy to be in effect, the squatters must have a structure with a door that closes and a roof that is intact.

With police officers quickly approaching the building site, the couple's friends scramble to remove any evidence of the construction. Meanwhile, their new neighbors devise another strategy of deception to guarantee a merciful reaction from the police officers: the couple is lent a baby, a young boy, and a surrogate grandmother to bring into the new house. With these stand-ins, the couple can construct a virtual family. Positioning themselves in the one-room home, they aim to perform the perfect picture of pity, a composition designed to trigger compassion in the police officers. This strategy works, but only after we have witnessed a grueling series of shots where the police officers decide whether or not the quickly assembled structure qualifies as a home. The final moments of this decision process involve one incredulous officer going around the new structure and looking through a large square opening in the back wall, where a window will eventually be installed. Standing on either side of this opening, the officer and the family exchange looks. Here a shot/reverse sequence—the officer looking in at the "family" for his first time, and them looking back at him—forms the narrative climax of the film. We wait along with

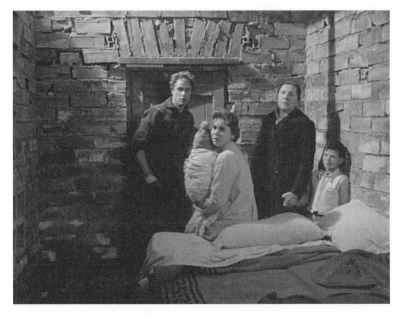

The Roof's *newlyweds enlist strangers—a grandmotherly type, a baby, and a scruffy boy—to help complete their simulated scene of a family in need.*

6. Un interno.

7. Una casetta uguale a quella che apparirà nel film.

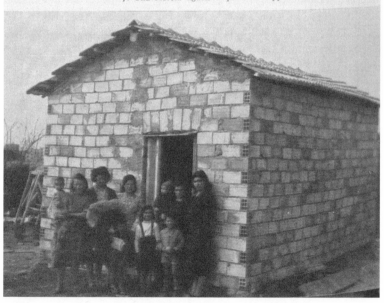

The production files of The Roof *include photographs documenting actual squatters' shacks with their occupants posed and framed in a manner echoed in the film's mise-en-scène. Michele Gandin,* Il tetto di Vittorio De Sica. *Bologna: Cappelli, 1956.*

the "family," anxiously trying to draw clues from the officer's illegible facial expression. The structure of these alternating shots makes the charitable gaze into a palpable expression. As the film cuts back to a view through the window frame of the "family," the picture of poverty, it is clear, according to the visual logic of this sequence, that the police officer should show mercy and deem the residency acceptable.

And yet the officer is being had. The couple is certainly desperate for a home, but they are not as needy as the characters they enact for the police. The film has made clear that their marriage was optional: they are young, and each could have stayed on with his or her family without problems developing. So this final moment is undercut by the same questions about aspirant middle-class heterosexuality as the wedding portrait in the beginning. In fact, the attention to framing a tableau formally echoes the formality of that early shot. It should also be pointed out that the couple is expecting a child, and one can argue that this home may in the near future look quite like the concocted scene of pity. Viewers invested in the romance and/or plight of this couple will naturalize this deception as a smart and necessary tactic. A key aspect of the suspense here is the officer deciding both whether the couple can stay together and whether their baby will be born with a roof over its head, because an earlier scene in the film depicts the mayhem that birth can bring to a home.

They win over the police officer because they perform being pitiful convincingly. What can be made of the fact that the narrative triumph of these characters is based on a deceitful representation of their lives? How odd is it that in this, De Sica and Zavattini's final neorealist collaboration, the primary image of suffering is something of a hoax? Like the other films I discuss in this book, *The Roof* poses its climax by constructing an ethical dilemma as a drama of vision, a dilemma that seems best resolved through a gesture of charity. However, this film's ethical dilemma is triggered by a partial sham. The couple's strategy does not simply bend or break the law; it involves purposefully creating an image that lies. In a film associated with realism and founded on an investment in the veracity of the image as a means of generating sympathy, the epistemology proposed in this moment is peculiar and fascinating to ponder. Here a supposedly realist film gets us to invest in a scene of deception and makes us hope that it will prompt the police to adopt a charitable stance toward the situation. We might say that the couple's deception is successful because it

so effectively commodifies their own situation, repackaging their invisible desperation into the easily consumed visible drag of hetero-familial need.

As with many of the neorealist films that I have discussed, a careful analysis quickly exposes two intertwined axes of charitable relating in this film. On the one hand, neorealist films such as this one ask us to observe the charitable networks developing within the diegesis: they carefully map the exchange of sympathy and goodwill from character to character. Most valued are random acts of charity from characters with nothing to gain: a homeless boy helps Luisa with a lantern, the neighbors help the couple to gather kids for the pitiful scene, the officer shows them pity. Only the viewer can fully observe and catalog this first form of charitableness. It is interpersonal, direct, local, and often inflected with the values of a particular community. At best, it serves as an example for the viewer, but it also implies a physical intimacy absent in the viewer's relation to the screen. On the other hand, the second form of charitable relating fostered by the film operates at a different scale. Here these films attempt to produce goodwill in the spectator by mediating the viewer's relationship to the screen. This form of relating may feel intersubjective, but it is never truly interpersonal. Within this second mode of charitability, there lies a proposition to extend the physical parameters of everyday social relations. In narrating the sympathetic relations of this second form, these films remind us of their role as a virtual form of connecting that can form a community among people who never meet. Neorealist films actively and often self-consciously promote this form of proxied sympathetic relating.

Traditional approaches to neorealism often conflate these two levels of charitable relating. Looking back at the narrative and narrational structures of the films, however, we find a distinction being made between the sympathy extended on screen by a character and the sympathy we are asked to assume in relation to the scenario on screen. These two sympathies often operate in a parallel structure. They may even act in tandem, but neorealist narration never fully synchronizes these two sympathies. By the end of the neorealist film, these sympathies are anything but interchangeable or commensurate. The final scene of *The Roof* makes this clear. In a way, the construction of a fake family makes visible to the police officer what the sympathetic spectator of the film sees. It makes the couple's vulnerability into a visual fact.

In the United States, the critical reaction to *The Roof* was tellingly mixed. The critical ambivalence regarding the film centered on the question of whether it brought awareness to key issues of European reconstruction or exploited spectacles of poverty for commercial gain. Many reviewers saw the film as formulaic. For these critics, the film exposed how rote the neorealist approach to style had become. Their reviews suggest that films which treat neorealism as a concrete style tend to instrumentalize otherwise sensitive subject matter, such as poverty and violence, simply for the sake of qualifying as neorealist. Harsher reviews condemned the filmmakers' realist trajectory. According to Lindsay Anderson, De Sica and Zavattini had "reached a point in their works in which they [were] exploiting rather than exploring the effects of poverty."[33] This exploitation of the poor for the sake of spectacle is called by today's critics "poverty porn" or "ghetto chic." In his review of De Sica's film, critic Arthur Knight also pointed to a growing degradation of the neorealist film: "Over the past decade, neorealism has taken many a sorry turn. Actuality was translated into sensationalism; for the true stories of simple people were substituted highly colored fictions about dope addicts, prostitutes, and wayward girls."[34] But Knight invokes the decline of neorealism in his review to celebrate *The Roof,* which he contrasts to this trend. For him, the film "is a confirmation of the power of neorealist principles to create an awareness of people and their problems far more affecting than fiction ever could. . . . The protagonists of this lovely film . . . are so affecting because they are so real; and they are so real because De Sica has seen to it that every incident, every detail in every shot contributes to a sense of unstrained, unforced actuality."[35]

The language of this unresolved critical debate brings us back to the question of what part corporeality plays in this film's discourse on the charitable gaze. Howard Curle has suggested that we think about this film as a parable of the human figure engulfed by landscape, and his readings suggest how the film demands that the viewer read physiognomies of characters comparatively.[36] I want to close my consideration of *The Roof* with a look at one of these physiognomies, Luisa's body and in particular her walk, to suggest that the film's ethics cannot function without this walk as an "affecting detail" for the viewer, to borrow from Knight's reading above.

A human walking was one of De Sica's central cinephilic fetishes, and many of the most famous stories about *Bicycle Thieves* involve

this fetish. He was drawn to how an actor performed his walk and firmly believed that viewers read into an actor's stride. He was obsessed with Chaplin, a performer more closely identified with his walk than any other. Perhaps unsurprisingly, there is a lot of walking in *The Roof,* as there is in most other De Sica films from this period. Luisa's walk, in particular, seems significant. Unbalanced and unstable, she appears constantly to be yanking herself out of a limp with every step she takes. When she runs, her body is slightly off kilter and looks as though she is repeatedly tripping. She never fully stumbles to the point of falling, but her movements always seem to alternate between a jerking staccato and a clenching tremor. This odd stutter haunts her otherwise exuberant energy with a deep exhaustion. The walk reveals something pitying about the camera's treatment of her character. Why does the camera seem to accentuate rather than hide this idiosyncrasy? Does this emphasis on her wearied and sporadic physicality constitute an attempt to represent the early months of pregnancy and hence a constant reminder of the precariousness of this family unit? In the context of mainstream cinematic romance and its conventional kinesthetics of youthful virility, it is odd to see a young female form so burdened by everyday motion.

Her vulnerable kinesthetics is made particularly visible by virtue of its comparison to other bodies, especially Natale's, such as in the sequence when Natale rushes from a work celebration to meet Luisa at a bus stop. In this sequence, Natale jumps onto a rope and shimmies gracefully down despite the warnings of his boss, who cautions

The photographic tests for the character of Luisa from the production files of The Roof *document De Sica's obsessive eye for finding physical types among hundreds of nonprofessionals. Michele Gandin,* Il tetto di Vittorio De Sica. *Bologna: Cappelli, 1956.*

of the danger of such maneuvers. From the rope climb at his job site, the film cuts to the place where he is to rendezvous with Luisa. She is across the street, eager to see him, and jolts across a busy intersection. From her lurching excitement the film cuts back to Natale on the opposing street corner, where he and a traffic police officer yell to Luisa to stop. She hasn't looked before crossing, and a car is turning. As she finally reaches the opposite side of the street, Natale paternally scolds her for her precipitous behavior, worried that it could have resulted in an accident or a reprimand from the police. In this scene and others involving crossing busy railroad tracks, her odd gait seems to underscore her vulnerability. Just as Bruno's stumbling and his near accidents crossing streets indicate his father's neglect in *Bicycle Thieves,* Luisa's walking mishaps signal her vulnerability and a potential rift between her and Natale. In both films, the walk doesn't just allegorize a society out of step or out of whack. The walk draws our attention to how this society's imbalances make even the most prized and supposedly sacred relationships vulnerable to destruction. The smallest things hold the potential for catastrophe.

Luisa's feeble and erratic stride performs a critical narrational function in the scene of pity with the police described above. Although her walk is not present here, it remains a vital part of our experience of the film by the time we get to this final sequence. This "affecting detail" remains seared in our mind and thus helps to qualify the couple as worthy of our perpetual sympathy throughout. In this regard, the body may indeed help the film prompt the viewer to not only justify this deceiving picture of poverty, but also to redeem it. The hoax is redeemed by the earlier moments as a truthful mode of representing. In a way, the eighty-odd minutes leading up to the final sequence are burdened with corroborating this picture of poverty for the viewer. The walk is one of those corroborations. In this performance of need, the viewer is able to recall the vulnerability of the couple's situation, and Luisa's walk contributes to that sense of vulnerability. Her odd gait persists in having narrative import, and this small detail endorses the performance of poverty they produce in their new home. Like so many of De Sica's stagings of charity, the ethical weight of this moment rests on our experience of the film as a whole. A true neediness resonates from our experience of the film and thus the commodification of their need seems perfectly justified to us. We have filled in the blanks, and in doing so, we affectively or subjectively endorse a wider politics

of aid in which the impoverished must perform their neediness in order to earn our benefaction. They must display their vulnerability in a consumable and palatable means for the world of donors.

Conclusion

By lingering on the vulnerability of the onscreen body, the films I discuss here issue a plea. They express the political urgency of a world community populated by outside onlookers. *Shoeshine*'s corporeal scenarios force the viewer to contemplate the costs of a world without eyewitnesses. *Bicycle Thieves* compels its audience to recognize the ethical obligations of the human community by exhibiting bodies susceptible to physical injury. *The Roof* invests in the spectacle of poverty, suggesting the necessity of performing "documentary truth" to the new world order. Together, these films imagine that a spectacular realism can convene an audience of detached observers. From this reformed view, the cinema gathers an ethical, unthreatening, and innocuous audience as compared to other prominent visions of human groups that dominate the midcentury imagination. Cinema's crowd is not the menacing mass of the totalitarian fascist state or the ascendant throngs associated with cold war communist states. These are not fascist or communist masses drinking in propaganda. Nor does the cinema audience recall the masses of bodies in Auschwitz or the growing populations in refugee camps. Cinema's audience is instead identified with a crucial form of agency.

The cinematic audience is of course never just those viewers assembled at a particular showing of a film. It is all those viewers implied as consumers of the film. In this sense, there is an odd collectivity at the heart of cinematic consumption. All of a film's audiences are there with you when you watch a film, but in other ways, they are not there. The odd presence of this gathering suited certain political agendas while containing others. According to the aspirations of these films, I have argued, cinema's gathering should not be thought of as a local or a community-based group. Neorealism refashions collectivism. The collective is a crucial experience of the early twentieth century and an entity in ideological turmoil at the middle of the century. Neorealist cinema and the mode of spectatorship it encourages never let go of the collective, but rather reworked its parameters and revised the vectors of its agency. These films debate the sovereignty of the individual

versus the power of the crowd. In doing so, they partake in a wider transnational cultural reformation of the idea of the mass. This process, however, is not simply achieved via representations of crowds and audiences. It is also enforced by the viewing structure of the films themselves.

Key neorealist films, especially those that traveled the globe, set the terms for renegotiating the idea of the audience. *Shoeshine, Bicycle Thieves,* and *The Roof* each pose a dialectic between onscreen looking and omniscient visual narration that culminates in bolstering the sovereignty of the foreign spectator's gaze. When films from other countries adapt Italian neorealism, and in particular its corporealism, they also adopt its politics of watching, agency, and mediation; its mode of representing struggle; and its charitable stance toward poverty. For better or for worse, these later films participate in neorealism's central problematic: finding a mode of collectivism that protects the dignity of human life without hindering the expansion of the free world—a world whose freedoms are increasingly defined as the circulation of commodities. How can we care for human life, promote a more just world community, and maintain an open North Atlantic community, these films ask, while simultaneously protecting the idea of private property and the personal freedoms of individual identity? Aesthetically, these films suggest forms of identification and identity that, if they are not tailored for a transatlantic geopolitics that recognizes the category of the human while allowing the flow of consumer capitalism to determine the shape of postwar recovery and emerging modes of international connectivity, certainly appear to be comfortable with it.

5 NEOREALISM UNDONE

The Resistant Physicalities of the Second Generation

ORDINARILY, WHEN THE DIEGESIS of one film overtly duplicates the diegesis of an earlier film, the cohesive homogeneity of fictional cinema implodes. Without an industrial rubric of star persona, adaptation, or sequeling, this form of diegetic repetition involves a disruptive intertextuality that departs from any conventional definition of realism. Yet well before the uncanny appearance of a fiction in another fiction came to be seen as postmodernist pastiche, a group of Italian films made in the 1950s and 1960s drew conspicuous comparisons between themselves and earlier neorealist classics through a series of stylistic quotations and restagings. In this chapter, I explore how this second generation of neorealism used citation as a means to critique the politics of vision proposed by the films discussed in the previous chapters. In order both to participate in Italian national film culture and to counter its hegemony, these second-generation films reference neorealism by narrating the daily lives of social and economic outcasts, often using barren or bombed-out landscapes as a backdrop, and by focusing on petty theft, prostitution, con games, and black market dealings. Given this citation process, these films might be thought to confirm neorealism's significance as an Italian national aesthetic tradition, or at least to have sustained the memory of neorealism as a crucial site in the heritage of national identity. However, it is my view that these films do not return to the neorealist vernacular to pay it homage or attract critical attention by referencing a legitimized genre. Instead, the early aesthetic of second-generation filmmakers such as Federico Fellini, Michelangelo Antonioni, Pier Paolo Pasolini, Marco Bellocchio, and Bernardo Bertolucci develops, I want to suggest, from a tension between alluding to and breaking

with neorealism. Although shot in black and white and still concerned, like neorealism, with the desperation of everyday life, these films are neither simple tributes to canonical realist approaches nor precursors to later "masterpieces" by their well-known directors. The films discussed here position neorealism as a starting point or source text, adapting and reproaching its strategies while suggesting that its aesthetic and political residues continue to retard the progress of cinema and contemporary life. Rather than either casually appropriating or blindly discarding postwar film practices, the second wave of films pilfer and pillage from the films discussed in chapters 3 and 4 to question the terms by which canonical neorealism negotiated Italy's international visibility. In the context of my larger argument, I am particularly interested in how these films draw on the corporealism of first-wave neorealism to critique the aesthetic means by which the earlier films made humanism a visual transatlantic commodity. In short, I want to argue that this second generation of postwar Italian films reproaches neorealism's use of the bodily image as a form of compassion-triggering testimony.

The visual narration of these later films confounds our ability to extract irrefutable knowledge from the image of the body and offers a compelling critique of neorealism's corporeal means of inviting a world spectator. My reading of Fellini's 1955 film *Il bidone,* for example, demonstrates how its deployment of corporeal spectacle antagonizes neorealism's mode of vision, troubling rather than welcoming the optics of bystanding and the liberal patronage it supports. As Simona Monticelli has suggested, the first neorealist films may have intended to oppose fascist culture, but they also register and participate in (perhaps against the intentions of their directors) a cultural shift in values that results in the victory of the Christian Democrats over the Communist Party in 1948. In this context, films like *Il bidone, Il grido,* and *Mamma Roma* work subtly to identify neorealism with a closing down of the counterpublics of the Resistance movement and its Marxist aspirations, and thus with the contraction of the public sphere demanded by the centrist logic of liberal humanist values. They should be read collectively to challenge rather than to extend the bourgeois transnational sovereignty implied in the ideology of the Marshall Plan, postwar NGOs, and what Pasolini would call the era of neocapitalism.

The films that I discuss in this chapter were all made when the Italian economy expanded tremendously in the decade after the Marshall

Plan. So dramatic and quick was the country's transformation in the 1950s from a primarily agrarian economy to a major industrialized, commodity-based economy that the period is known as Italy's economic miracle. Because the economic miracle, or *il boom,* provides important context for these films and their appropriation of national film culture, a brief excavation of the period's economic ideology is necessary. On the surface, the boom was triggered by a series of successful domestic initiatives: a rapid growth in factory manufacturing, the expansion of the steel industry, and the successes of product design. The economic miracle also describes the emergence of a vigorous consumer culture in which more Italians could afford the comforts of middle-class life than ever before: motor scooters, cars, sewing machines, washing machines, adequate plumbing, and disposable goods and clothing were within the reach of a much wider range of the population. Alongside these symbols of progress, the boom also brought waste, pollution, and the exacerbation of uneven development. The boom seemed to increase the nation's neglect of southern, rural, and impoverished areas, calcifying regional inadequacies. In fact, much of the boom's force came from its sustained ability to exploit labor from these zones. The urban influx of people migrating from the harder-hit and more remote areas of the country provided a seemingly endless source of cheap labor. In hindsight, the economics of this period also reveal a reorganization of national politics toward the needs of a global system: the boom was not only jump-started by the Marshall Plan, but it was also underwritten by the stabilization of the currency, the demand for steel created by the Korean War, the discovery of natural gas resources in the Po valley, and the successful brokering of low-priced oil from the Middle East. Would aligning the economy with a world system interfere with sociopolitical power or restrict the forms of agency and access necessary for democracy? Does a culture in which nearly all aspects of life are given relative monetary values limit the kinds of expression and living that one can do? I will argue that the films under consideration here raise the specter of neorealism in an effort to lend aesthetic force to precisely these kind of questions about the economic miracle and its extension of postwar politics. Moreover, these films seek to foreground social formations—occupations, activities, relationships, and bodies—that predate, ignore, or disrupt the apparent hegemony of Italy's new economy and redevelopment.

Attending to the relationship between earlier and later iterations of neorealism extends our ability to critically engage with the specificity of this concept, whose ambiguity grew alongside its increasing international prominence. In other words, a synthetic definition of neorealism emerges if we read the films of the earlier chapters alongside the analysis here. By considering the interactions of these later films with their canonical predecessors, we gain critical leverage on a concept muddled by its own terminological history.[1] To further contextualize the readings of the later films, I therefore want to address a terminological quandary that haunts the iterative history of neorealist film style as it spasms and sputters across various different genres during the 1950s.

Beginning in the early 1950s and before the rise of neorealism's second generation, a group of films, soon to be labeled "pink neorealism" *(neorealismo rosa)*, adopted the themes and outward look of the postwar cinema, while at the same time replacing desperate narratives of political strife, economic alienation, and moral tragedy with stories of romance, unwavering optimism, and happy endings. Despite their enormous box office success, these later films were savaged by critics for their formulaic appropriations of neorealism as simply a motif. Critics found inappropriate their watered-down and rose-tinted—hence pink—perspective on the hardships of daily life during the postwar reconstruction. Included in this category are films such as Renato Castellani's *Two Cents' Worth of Hope (Due soldi di speranza,* 1952) and the popular series of *Bread, Love, and . . .* films *(Pane, amore, e . . . ,* 1953–55), which were first directed by Luigi Comencini and then by Dino Risi. The latter director made several other films in this vein, including *Poor but Beautiful Boys (Poveri ma belli,* 1956), *Beautiful but Poor Girls (Belle ma povere,* 1957), and *Poor Millionaires (Poveri millionari,* 1959). In the mid-1950s, however, another group of films had emerged that also borrowed from neorealism. Now known as neorealism's second generation, these films were lower-budget productions by young directors who shared a realist background, having come directly from stints writing for and assisting neorealist directors, from making documentaries, or from both. What distinguishes this second group of films from pink neorealism? Why would films such as these, which hoped to be recognized for their artistic and intellectual distinction, exploit the same aesthetic tradition as the contemporaneous popular genre of pink neorealism, which had already been rejected by the film culture elite? What motivated filmmakers from a broad spectrum

of political backgrounds to work within an aesthetic whose boundaries were being so actively policed by critics?

Neorealism had generated tremendous international interest in Italian cinema and its directors, but many of its key films had failed to perform consistently at the domestic box office. By contrast, pink neorealism helped to reestablish the commercial viability of domestic productions in the Italian national market while preserving the outward appearance of a film style, neorealism, celebrated in international circles, recognized as exclusive to Italy, and symbolic of Italian cultural reconstruction.[2] Yet for its part, pink neorealism had failed to gain successful international distribution. From this perspective, then, it would be easy to identify the early works of this second generation as merely attempts to formulate an Italian cinema that was not only popular in markets domestic (like pink neorealism) and international (like neorealism proper), but also recognized as Italian in both contexts.

Fellini's *La Strada* (1954) was an incredibly successful first volley for this new generation. It received many awards (including an Oscar) and exceeded the expectations of distributors by attracting record national and international audiences. The film was scorned by many in the Italian press but won international acclaim from critics in Europe and the United States. In doing so, the film broke free from the otherwise necessary approval of many key Italian critics, who were often on a mission to shape and restrict the parameters of Italian film aesthetics. Beginning with *La Strada,* the films that Fellini made in the mid-1950s thrust his work onto center stage in a debate about the currency of neorealism. In a frenzy of dueling reviews, both Italian and international critics hotly debated these new films: Were they neorealist? What did they suggest about the status of neorealism in relation to contemporary Italian politics? Whose side was Fellini on? Did the social critiques of canonical neorealist films persist in current cinema? If so, how? And what did the persistence of these critiques suggest for contemporary Italy? Reading these debates now, it is striking how little they actually address Fellini's work and how intent they are on establishing a position in relation to the growing international attention that film imports had granted Italian national politics and culture. Neorealism's success in Europe and North America had raised the stakes of defining neorealism and had triggered an increased interest in the way film described both politics and the relationship of art to politics.

The seeming self-certainty of these critical polemics about the meaning and definition of first-generation neorealism should not cause us to forget that the definition of neorealism remained uncertain and undecided even in the mid-1950s. In considering the status of these films, therefore, it is crucial to bracket the political posturings that characterized the period's critical debates and efforts to install neorealism as a clearly defined aesthetic whose style and politics were givens. Failing to do so would risk missing how the films that Fellini made in this period, as well as those made by other young filmmakers such as Pasolini and Antonioni, both define and redefine neorealism. Here we see the value of the synthetic approach to understanding neorealism articulated earlier: to settle on a less dynamic definition would be to incorrectly restrict the conclusions we draw from these later films.

Historians argue that Fellini had buckled to pressure from co-producers and financiers; he reworked his initial ideas for *La Strada* and *Il bidone* to make the films appear more neorealist and thus more in keeping with international expectations for Italian imports. Scholars such as Millicent Marcus and P. Adams Sitney read these early films as evidence of a new epoch of European cinema marked by its mixture of reconfigured national politics, poetic themes, loosened narrative structures, and the expectation of an international audience. Marcus and Sitney also understand these films as part of a trend that eventually culminates with the art house or auteur cinema of the 1960s. These explanations do less to flesh out the complex dialogue these films establish with their neorealist precursors. To view these neorealist citations either as a marketing strategy or as a pit stop along the path toward an intensified modernism and the *cinema des auteurs* ignores these films' crucial reformulation of postwar Italian film aesthetics. These films function historically as more than just transitional works or career jump starts. In taking seriously their efforts to reevaluate neorealism, I hope to direct our attention to how these films intervene not only in a history of styles, but also in the geopolitics of cinema in the mid-twentieth century.

Il bidone

Il bidone calls up the neorealist mode of spectatorship, only to dismantle it in a sudden shift of identification and narrational authority.

Exposing a conservative epistemology at the core of neorealism, this film targets a particular textual mode of deploying the body and the image. At the level of the diegesis, it follows the emotional and practical concerns of three con artists, apparently from the middle class, as they bilk money from working-class residents on the outskirts of Rome. At the end of the film, we find Augusto, the group's leader and oldest member, participating in the con game that we witnessed him perform at the start of the film. In this scam, Augusto visits a small rural farm with a posse of accomplices dressed as clergy. Posing as a monsignor, Augusto convinces the farmer to turn over all of his cash to the church. As far as the spectator can tell, the con game proceeds as planned, until the farmer's wife reveals that her daughter has a severe physical disability. Suddenly something changes in Augusto's face, an expression pointed out to the viewer in a close-up. Is he reconsidering the ethics of his actions? Is he reminded of the fate of his own daughter, whom he has abandoned again and again over the course of the film?

As he walks off to rejoin his cohort, the farmer's wife asks him to meet her daughter and bless her. He reluctantly follows the wife to meet the young woman. He is left alone with the disabled daughter, and she confesses to him the conditions of her life and her fears of burdening her already poor parents with the care of her seemingly useless body. Toward the end of the scene, as Augusto rises to leave, the girl pulls herself up on her crutches and struggles to walk toward him. In this dramatic long take, the camera's position in relation to the girl's body aligns us with Augusto's look. To the viewer familiar with neorealism, it seems natural to find the gaze centered on a corporealized body at the ethical climax of a film.

Once Augusto and his team of fellow crooks have left the farm, they stop on the road to remove their priest costumes and to divide the money that he was to have collected. At this point, Augusto confesses that he has refused to take money from the farmer because of the daughter's physical condition. When his cohorts angrily question his sanity, he responds by asserting, "No, I just have a heart." The viewer is led to accept the truth of this statement, but Augusto's colleagues do not. They beat him and search his body, discovering, to our surprise, the stolen cash hidden in Augusto's shoe. Throughout this film, we have been aligned with his perspective, but in the end, we realize that the film has omitted several key moments and thus has caused us

to become yet another victim of his artistry. The impact of the film's surprise ending hinges on our expectation that the body of the farmer's daughter has provoked an unavoidable ethical response in Augusto.

Unlike *Rome Open City,* where the cruel and callous characters are deemed perverse and outside both the realms of possible redemption and the range of sustained spectatorial identification, Augusto is the center of the film's narrative. The viewer is asked by the narrative structure of the film to adopt his perspective—so much so that by the point that this final sequence occurs, the fact that we are no longer granted an omniscient perspective goes unrecognized except in hindsight.[3] We are never shown Augusto leaving the farm with the cash, nor are we shown him returning it. We are duped into thinking that he has returned it because we witnessed the daughter's body along with him. The film tricks us by staging a corporeal spectacle that seems to demand an ethical sea change in Augusto. To say that by the end we pity him because of his brutalization by his fellow con artists would be inaccurate, but our position as viewers has not prevented us from being victim to his crime. We have been swindled by *Il bidone.* The film leaves us with no ethical resolution or even a moral choice. Instead, it asks us to step outside the interiority of character psychology and inspect how our own investments in ethical, charitable tolerance can be easily exploited. The most complex moments of this film threaten to expose the manner in which neorealism constitutes and maintains spectatorial engagement. This film resists the neorealist impulse to grant the spectator the surety of an ethical gaze. Rather than redeem the viewer's position in relation to the brutality of daily life, it condemns the idea of a cinema of poverty. In other words, *Il bidone* shears the viewer away from neorealism, disallowing an elaboration of the spectator as the bystander who is simultaneously ethical and detached.

Unlike the grim endings of *Rome Open City, Germany Year Zero,* and *Bicycle Thieves,* moreover, the moral demise, or transformation, and death of Augusto happen in an unpopulated place. *Il bidone* in this sense refuses to embody justice in a crowd or hope in the children. The beaten Augusto dies alone; his pleas for help fall on an open landscape and beyond the earshot of a passing family. His death does not allow the film to stage a spectacle of diegetic looks, but rather one of diegetic blindness. The viewer witnesses his death without onscreen witnesses, which adds to the discomfort of this final scene: justice is

not served, hope is abandoned, and narrative closure appears to be as meaningless and useless as Augusto's life suddenly does. His moral failings serve as an example to no one but us. Because none of the film's other characters will know the truth of his final moments, his death seems thrust uncomfortably before our eyes alone. And because the film has betrayed us narrationally only moments before, thus infecting the range of our vision with epistemological uncertainty, our look here is given an awkward status. The film not only frustrates the idea that looking is a form of action; it suggests the futility of serving as an outside eyewitness. In reworking the terms of neorealism, *Il bidone* reformulates the cinematic language of social realism right before our eyes.

Even from this first analysis, we can already identify two means by which second-generation films intervene in the political aesthetics of neorealism. First, they attempt to dismantle the epistemological underpinnings of neorealism through an irreverent construction of the diegesis and a disarticulation of neorealism's patterns of visual narration. What they encourage instead is a form of spectatorial identification with the image that is anything but neorealist. *Il bidone* makes manifest the idea that seeing can sometimes encourage false beliefs. Although the film may rouse the ethical eyewitness in the spectator, this role provides little comfort or agency. In the film's bleak ending, which implicates the viewer in an act of seeing as the solitary witness, the privilege of this witnessing position affords the onlooker little more than frustration and dystopia. Second, this next generation of neorealist films appear to disarticulate the corporeal means by which neorealism orients the spectator to the image as testimony. These films question using images of the body as uncomplicated evidence; hence they critique attempts to represent the contingent or corporeal as substantiating the political potential of the cinematic image.

Mamma Roma

The titular character of Pasolini's *Mamma Roma* (1962) is desperate to leave the subproletariat life of a Roman streetwalker. Near the beginning of the film, she retrieves her teenage son, Ettore, who has been living in the countryside for his entire childhood. She brings him to Rome and hopes that they will soon move from her working-class hovel into an apartment in a newly built middle-class neighborhood.

Once Ettore begins hanging out with a tough gang of boys and sleeping with prostitutes, Mamma Roma begins to fear that her middle-class dreams are slipping away and develops a plan to get her unskilled son into a paying job and off the streets. In an odd morphing of conventional blackmail schemes, she concocts a scenario of public sympathy and charity that will end with a prominent restaurant owner, Cesare, giving Ettore a job. First, her fellow prostitute, Biancofiore, entraps the wealthy Cesare in a compromising position at her apartment. Biancofiore's pimp, Zacaria, then poses as her protective older brother coming back to the apartment. Discovering the seduction scene, Zacaria performs a fitful rage, slapping her, swinging a knife, and threatening to kill Cesare in order to revenge his "sister's" now-compromised honor. On cue, Mamma Roma arrives to break up the violence. Mamma Roma prevents Zacaria from further abusing Biancofiore and from harming the still-shocked Cesare. This simulated act of mercy succeeds by producing its intended effect on Cesare, who appears indebted to Mamma Roma and will eventually reward her by giving Ettore a job as a waiter in his popular trattoria.

In addition to the false seduction and the simulated violence of Zacaria slapping Biancofiore, Mamma Roma's staging of mercy is a key component of the swindle here, and thus supplies a significant corollary to *Il bidone*. Her swindle specifically involves performing her recognition of a man of goodwill. After wrestling the knife from Zacaria's hands, Mamma Roma feigns a sudden realization: "Wait, I know this guy. Aren't you Big-Tooth Maria's friend? I always wondered how you could go with such an ugly woman." Mamma Roma recognizes the victim as a man of charity. "He's a good person with a big heart. He never refuses to help someone if he can." The ruse is that she emancipates him from a violent outcome by claiming that he should be spared for his heart of gold. She tells Zacaria that Cesare is a man known for his unconditional humanism, a humanism endorsed by a love of the infamously ugly members of the community. Playing on this man's apparently public reputation for kindness and pity allows Mamma Roma to position herself as his rescuer while hailing the victim as a redeemer and thus well suited to be the future benefactor to her son. The swindling scenario has in these ways been carefully orchestrated to produce a series of effects in the businessman: first, it manufactures a false intimacy brokered by the oddly carnal moments of Biancofiore letting her hair down and brushing it against the victim's

face. The scene then creates an experience of guilt on Cesare's part for being caught, which next produces disgust toward the violence done to Biancofiore. Finally, he is made to fear that harm will come to his body. From the perspective laid out by the film for the viewer, this scenario's implicit message is complexly cynical. We realize that Cesare's ability to occupy the public persona of charity—his churchgoing piety and his willingness to embrace the abject members of the community—does nothing to insulate him from harm. Instead, such a persona makes him all the more vulnerable to being taken for a ride. In a final act of humiliation, Zacaria steals money from the traumatized Cesare's wallet, jeering, "I'll keep this for moral damages." For the viewer, the sarcasm of this statement makes a mockery of middle-class values. If Mamma Roma's buttering up of Cesare involves constructing him as a model humanist, a citizen who embodies a kind of fellow feeling that the scene ultimately ridicules, the film further condemns this figure of the humanist do-gooder by characterizing this wealthy man only through his perpetually dumbfounded countenance, cowering whimpers, and effeminate gestures of reticence. Bourgeois mercy benefits the working class in no way except as an opportunity for fraud. Moreover, the effectiveness of this fake incident depends on a performance of the body to draw an unsuspecting stranger into a scenario in which he can see and review his own fear, sympathy, and compassion. Here and elsewhere, this film indicts the kind of compassionate humanist spectator held open by the classical neorealist films discussed earlier, from the final forgiving stranger in *Bicycle Thieves* to Don Pietro in *Rome Open City*.

As the undisguised darkness and heavy bags that encircle Magnani's eyes attest, however, Pasolini's realism does not entirely dispense with corporeality. Instead, it often distends the corporeal in ways that make easy knee-jerk sympathy feel inadequate or uncomfortable.[4] Take, for example, the missing front tooth of one boy in Ettore's gang. It is not the asymmetry of the blank space in the boy's smile that is most disturbing. It is the jaggedness of his gum tissue, as if the tooth has only recently defected and left a rough but healthy gum behind. This detail is menacing in itself, but there is also an unsettling cruelty about a film that leaves such details so overtly unaddressed and uncured. The film also contains other oddly corporeal moments that evoke the registers of the sensual: the intimacy between Ettore and his friends as he moves into their faces to smell their breath after he has accused

them of stealing his cigarettes; or the unexpectedly illicit quality of the scene depicting Biancofiore bending over the head of the restaurant owner and sweeping her dangling hair back and forth over his face as a form of sexual foreplay.

These moments exemplify what Pasolini would later refer to as "physiognomic realism" or the cinematic indulgence of a "popular corporality," and what Antonio Costa defines as "the extreme form— already on its way to extinction—of a special kind of authenticity 'preserved' from 'the horrors' of a bourgeois consumerist culture."[5] Michele Mancini and Giuseppe Perrella's fascinating 1981 book *Pier Paolo Pasolini: Corpi e luoghi* compiles an archive from hundreds of

242

I modi del
comportamento

La rissa

17

15

16

15-18. Il pestaggio di Ettore da
parte degli amici. La ribellione di
Bruna. *Mamma Roma.*
16. La lotta a due.
17. Tutti contro Ettore.
18. Ettore massacrato di botte.

18

Michele Mancini and Giuseppe Perrella's book Pier Paolo Pasolini: Corpi e luoghi *catalogs the bodies and locations of Pasolini's films through the reproduction and sorting of frame enlargements. These two pages of this unique compendium are titled "The Fight" and "Death: Remains and Mutilations."*
Pier Paolo Pasolini: Corpi e luoghi. *Rome: Theorema, 1981.*

stills from Pasolini's films and organizes them into bodies and places. The shots of bodies are catalogued into modes of behavior *(i modi del comportamento)*. These modes include "The Gesture" (smiles, grimaces, laughter, teeth, nudity, and so on), "The Dance," "The Fight," and, most dramatically, "Dying." The editors suggest that Pasolini's cinema is one whose history is written on bodies, through living surfaces, and in a language of physical presence. One page has the crushed corpses from the dream sequence of *Accattone* (1961); another page collects stills of abandoned body parts and cadavers from a range of his films; another shows dead bodies on the road, eyes buried alive in *Teorema;* and so forth.[6]

252

I modi del
comportamento

Morire
Resti e mutilazioni

18. Resti del corvo. *Uccellacci.*
19. Corpo straziato di soldato:
repertorio di *Orestiade.*
20. Resti del soldato mangiato.
Porcile.
21. Corpi mutilati: la strage degli
innocenti. *Vangelo.*

I mention this catalog and its most startling section on death because the injured body familiar to us from the preceding chapters primarily offers *Mamma Roma* a means of undoing the humanism promised by neorealism. In one scene, Ettore is beaten by one of his fellow gang members for thinking that the young prostitute, Bruna, who regularly has sex with members of the gang, can be his private possession. The film uses a series of frenetic shots to describe the violence of the fight, becoming more spatially disorienting and almost elliptical as it begins to seem that Ettore is losing and has become the punching bag for the senseless, violent impulses of his opponent. In earlier scenes, the film asks us to invest in the warmth and intimacy of Bruna and Ettore's romance. Here the film abruptly reveals a colder and less compassionate reality to their relations. At the beginning of the fight, Bruna's response to watching her friend being beaten seems appropriate to the narrative: she pleads with the boys to pull the attacker off Ettore. But her concern doesn't last. When the pounding fists of the attacker eventually stop flying, Ettore is left nearly unconscious, his body prostrated on the ground and laid out in the frame in a manner that foreshadows his later death. The sight of Ettore's defeated and vulnerable form appears to have numbed Bruna's sympathy. She walks off with the gang, casually tossing her hair and shouting back over her shoulder, "See you tomorrow, Ettore." With Bruna's sudden disregard for Ettore's well-being, the film suggests the violenced body does nothing to effect an ethical humanistic response or moral intervention. The camera leaves us with Ettore, who alone must pick himself up. He staggers across the landscape in an excruciating series of shots, tripping over rocks and weaving erratically across the landscape in which he had earlier frolicked. Although we have been given a few moments to survey Ettore's physical well-being, any pity we have been allowed by the length of that shot is immediately interrupted by the ridiculing laughter of Biancofiore in the next scene as she heckles Mamma Roma: "God, you look horrid!" Over the course of the fight scene, a subtle ambivalence takes over the visual narration, as if to disallow the moral gaze the ability to maintain a consistent narrative space. The film sabotages our ability to locate a vector of concern, preventing the viewer from ever fully settling into an optics of sympathy. Maurizio Viano has suggested that we should understand this film originating in part from Pasolini's experience of rewatching *Rome Open City,* feelings expressed in his 1958

poem that describes his troubling "inability to feel unconditional sympathy" for the film.[7]

When talking about Pasolini's films from this period, John David Rhodes rightly characterizes the director's relationship to neorealism as aggressively oedipal. According to Rhodes, the realism of *Mamma Roma,* as with Pasolini's other early films, does not derive from its exclusive faith to the material real. Most of the film's images are structured by a critical polyvalence, a complex overlapping of sources and origins. The film's realism emerges from a tension between intertextual references and the contemporary social world. For example, Rhodes reads the cityscape depicted in a central shot in *Mamma Roma* as "a corrosive allusion to *Rome, Open City*'s last image."[8] This image simultaneously cites, contaminates, and breaks down Rossellini's vision of national regeneration. Thus *Mamma Roma* draws from the base of earlier films, but only through a caustic gnawing away at that base. The film parasitically nourishes itself on the neorealist aesthetic while breaking down the operating presumptions of that earlier movement. Pasolini's realism cannibalistically devours its forefathers, digesting its aesthetic progenitors. His films sustain themselves in the "corrosive appropriation and redeployment of the techniques, tropes, thematics, and literal bodies of neorealist cinema."[9]

For Rhodes, it is Pasolini's use of landscape that most clearly prosecutes the political failures of neorealism's mode of vision. However, bodies haunt both Rhodes's account and the films he discusses. For example, Anna Magnani's corporeality constitutes for Rhodes a key example of the film's parasitical citation:

> The interrogation (relentless and bitter) that Pasolini performs on the body of neorealism—particularly on the work of De Sica—is essayed not only through sharply defined cinematic allusions (i.e., the casting of [actors famously associated with neorealism], the recapitulation of narrative sequences, shot set-ups, editing strategies). It is also materialized through its location. *Mamma Roma* declares Pasolini's belief in the failure of neorealist ideology as it took shape in both cinema and architecture. Anna Magnani, herself very nearly a sacred, eucharistic embodiment of neorealist filmmaking, is degraded, deluded, and destroyed by neorealist architecture and city planning.[10]

Magnani's body extends the narration of the film beyond the confines of its diegesis. Definitionally, all star bodies are charged with making such leaps, but with this particular body on its screen, the film can

carry on a dialogue with film history. Magnani carries the audience not to a generic extradiegetic sphere, but to the diegesis of another generation of Italian films. Her body incites an exchange with the bodies in the films of Rossellini and De Sica, and thus with the neorealist politic. Viano takes this further, claiming that Mamma Roma's cries for her son echo Pina's screaming for Francesco in the moment just before she is so famously shot down before our eyes in *Rome Open City*. Marcia Landy associates her casting with the larger cultural practice of "linking . . . landscape, the urban landscape, and the human in the form of the female body."[11] Magnani and Pasolini famously squabbled on set: Magnani stubbornly maintained her high-pitched theatricality while Pasolini tried to temper her operatic acting at every turn, eventually stating publicly that he regretted casting her. Nonetheless, Landy sees Magnani's star persona, associated with neorealism, and her trademark performance style as crucial features of the film deployed repeatedly to establish the film's metacritical stance toward itself, realism, and the commercial success of Italian cinema abroad:

> [Magnani] functions as an oblique meditation on the apparatus of stardom. Thus Pasolini's film tears away clichés, but his use of Magnani . . . does not redeem the figure of Italy through the body of the woman; rather, it exposes the fraudulence of any attempt at symbolization and national recuperation. . . . *Mamma Roma* indicts existing forms of filmmaking for their complicity with the commercial film industry and their imbrication in the other financial structures that determine the world of commerce.[12]

In another jab at its forerunners, the film also casts Lamberto Maggiorani, the actor famous for playing the lead in *Bicycle Thieves,* as a hospital patient who becomes the victim of Ettore's thievery. For Rhodes, "This obvious allusion—part homage, part parody—is yet another move in Pasolini's withering take on neorealism."[13] Being caught stealing from the sick provides Ettore no epiphany, nor does the greater goodness of society step in to redeem his fate, as in *Bicycle Thieves.* Viano's analysis views the theft as "a violation of *our* norms, a transgression for which neorealism implored the kind of understanding that confirms the rule. By attacking *The Bicycle Thief,* Pasolini strips the mask of the universal, monocentric perspective from which neorealists saw reality."[14] In the place of redemption, Ettore is thrown into jail with a seasoned and callous crowd of criminals. There we find him neither in a puddle of remorse nor in deep thought, but writhing from

what looks to be a psychotic break not unlike the seizure of the thief in *Bicycle Thieves*. But Ettore's seizing body nets him no sympathy. After a few minutes, however, his groans do interrupt his otherwise oblivious inmates, who are hilariously resignifying Dante's *Divine Comedy*. One elderly inmate has been reciting a canto from Dante that describes the awakening of consciousness and the opening of one's range of sight.

> Broke deep the slumber in my brain a crash of heavy thunder, that shook
> myself as one by main force roused.
> Risen upright, my rested eyes I moved around, and searched with fixed ken,
> to know what place it was wherein I stood.

This second line about the advent of a new sighted perspective is heard as the camera pans across the faces of snickering and befuddled inmates. The final member of this group appears to hear Ettore's moaning and turns his head. The point of view of the older inmate reciting the canto now shifts to a long shot of Ettore moaning and writhing in his bed across the room. This shot represents the gaze of the younger inmate who is looking at the end of the last shot. "Hey, they put a crazy guy in with us," he says offscreen. The camera returns to the inmates in a reverse shot that shows them looking over their shoulders, and one of the inmates says, "Calm down." Another particularly seasoned inmate responds to this brief expression of concern with a stunning dispassionate prognosis for Ettore: "A guy like you came in here a month ago, and the next day he was dead." He chuckles, and they go back to the recitation of Dante:

> On the brink I found me of the lamentable vale, the dread abyss that joins
> a thunderous sound of plaints innumerable.
> Dark and deep, and thick with clouds o'erspread, mine eye in vain explored
> its bottom, nor could aught discern.
> Now let us to the blind world there beneath descend.

As if deflated by the dystopic sublimity of Dante's vision of vision, the cruel-humored inmate himself looks down, as though looking inward or blinded, and he begins to sing Mamma Roma's theme song. The sound of these lyrics reaches Ettore, and he calls out for help. The inmate continues singing, and Ettore screams for his release, running across the room in a panic. The camera tracks as Ettore runs to the cell door and the other inmates struggle to restrain his convulsing body.

In a medium framing, the camera fights to keep his body within the frame, but it does not pull out to broaden the range of its perspective. The frenzy of these shots, and their stammering framing of Ettore's restraint and removal from the common cell, contrasts with shots in the next scene depicting a solitary confinement cell. Here Ettore's body has been strapped to a table, his wrists restrained on either side of his head in a semicrucifix position. As has often been noted, the ensuing shots of Ettore's body echo some of the most famous Italian paintings of the Christ: the composition of Andrea Mantegna's *Lamentation over the Dead Christ* (1480) in particular, but also the chiaroscuro of Caravaggio's voluptuous realism, the majestic distortions of Masaccio's Christ paintings, and the sensual modeling of soft flesh in Giotto. The camerawork and mise-en-scène not only remind us of these works, but also highlight carnal eroticism's centrality to these paintings. These shots expose how a sexual charge simmers in the iconic Italian depictions of the sacred and the sacrificial.

Given both the discursive use of corporeality in the rest of the film and its overt citations of neorealism, this scene makes us boldly aware of our positions as witnesses, like *Rome Open City,* but refuses to grant that position any clear ethical aim. It purposefully meddles in the notion of moral sympathy by introducing a sadistic eroticism in which it vigorously partakes. Does the sublime beauty of the imperiled body really bring nobility to those suffering? When the camera moves in these shots, it does so in a plodding manner, descending down Ettore's body as if in tempo with Vivaldi's slowly crying violin. The camera stops and leaves us to take in his body from an angle below his feet. Not all mobile framings ask us to identify with the camera, but like the fast tracking and erratic shots that follow Ettore's rage in the previous scene, this methodical alternation between movement and stillness has an animating effect on the viewer. We watch from this odd angle as his body begins to move more, and the feeling of our collusion in his restraint is amplified. The framing here is so rigid and balanced that we feel both the camera and ourselves to be participants in his restraint. The same can be said of the oddly intimate moments showing Ettore's face after he has died. The proximity to his still body carries the feeling of violation. Unlike the scenes we are made to watch in *Open City,* there is an overt erotics indulged here. The camera positions the body as an object for display, for visual consumption. It is easy to watch these films, understand them in the context of Pasolini's

oeuvre, place them alongside his biography, and argue that his work provides a kind of ghetto chic. Following this line of thinking, we might argue that, like a Bruce Weber shoot for *L'Uomo Vogue, Mamma Roma* and *Accattone* make the world of the subproletariat into a sexual fetish and provide the mise-en-scène requisite for middle-class slumming fantasies.[15] Yet this logic both presumes the heterosexuality of the Italian subproletariat and misses what Pasolini's film attempts to contaminate in the aesthetic politics of realism. Indeed, Giuliana Bruno's rereading of Pasolini's writing argues for the poststructuralist implications of his realist semiotics, redeeming them from accusations of naive realism and describing the bodily qualities of his cinema in manner useful to understanding this sequence. Using *Mamma Roma* and his other earlier neorealist films as exemplars, she writes, "Pasolini's films are populated by corporeal signifiers. His cinema refigures the politics of the body, and reclaims the inscription of the lumpenproletariat physiognomy and the homosexual gaze in the filmic landscape."[16]

The eroticism of these final terrible moments of the film mainly forces us to question a politics based on the commodification of vulnerability. They expose how a postwar politics of need implies a subjective relativism. In its erotics, I am suggesting, *Mamma Roma* makes uncomfortable the vectors of power inherent in gestures of charity. This film's use of the body not only condemns the charitable gaze, but also perverts the otherwise generic and sanitized subject required by a postwar politics of need, exposing that subject (including us as viewers) as already contaminated by our investment in power differences enabled by market expansion, globalization, and cultures of social inequality. Through their contamination of the neorealist body, *Accattone* and *Mamma Roma* attempt to wrestle realism away from liberal humanism, to redeem it from its role as the handmaiden of neocapitalism, and to reclaim the cinematic gaze from a bourgeois mode of vision. Nathaniel Rich has suggested that beginning in his early adulthood, Pasolini used homoerotic fantasies of his own violenced body to mitigate his sexual desire and public abuse. Recounting a dream, Pasolini writes in an early diary, "My public martyrdom ended as a voluptuous image and slowly it emerged that I was nailed up completely naked."[17] In this context, we might say that Pasolini works to rewrite neorealist corporeality by resacrilizing the realist image of injury and death. Pasolini's erotics strives to create a cinema that redeploys the body of violent victimization as a transcendental and

erotic entity. It is in this sense ironic that Pasolini's oeuvre is now haunted by the biographer's constant impulse to revisit the gruesome finale of Pasolini's own body. In the compulsive repetition of the images of Pasolini's body, shot execution style and left on the beach in Ostia, it is as if Rossellini's corporeal neorealism returns with a vengeance. Although these brutal images surely testify to the persistence of hate crimes in 1980s Italy and speak to the vulnerability of even famous queer bodies, the endless repetition of such reportage feeds a liberal politics whose benefaction and tolerance need such scenes in order to sustain itself. Do we really want to leave the politics of films like *Accattone* and *Mamma Roma* mired in the rubble of Pasolini's maimed body?[18]

Il grido

The most conventionally neorealist of Antonioni's films, *Il grido* (1957), ends with the ambiguous death of its main character, Aldo. Much like *Germany Year Zero,* this narrative of a wandering protagonist ends with him ending his own life. Here, however, his dead body is not the site of our pity. Nor is his body, as the final shot makes clear, meant to act as the venue for a political or ethical awakening. *Il grido* distinctly confuses the viewer at its conclusion, forcing us to ask whether Aldo has purposefully jumped to his death or fallen because of an emotionally induced vertigo that causes him to lose his footing. Other bodily scenarios of this film echo those in De Sica's films, such as when Aldo publicly beats his estranged lover, Irma, or when his inattentive parenting almost causes him to lose his young daughter, Rosina, to a car accident. Yet unlike De Sica's films, *Il grido* offers no escape from these frailties of vision. The viewer's position is not morally buttressed by these moments of bodily danger; rather, they amplify the cynicism and disharmony that conclude the film.

Formally, the first shot of Aldo's corpse is something of an anomaly in the film's treatment of the human form. In a film that often places the body in the midst of an open composition of blank or nearly empty space, the frame's relationship to Aldo's corpse is unusual in how it crops and obscures our view of his human form. His body occupies the bottom quarter of the frame, part of his left arm remains off-screen, and his right arm is nearly obscured by the angle of the shot. The bottom half of his legs are obscured by the right side of the frame.

The shot as a whole awkwardly crops his body, leaving a composition that would be otherwise unbalanced were it not for the anchoring presence of Irma. Aldo's face, hands, feet, and all other parts of his flesh are cropped out of the shot, as if the film is purposefully keeping us from taking in the corporeality of this horrifying conclusion. The tufts of his hair above his coat are the only piece of his physical anatomy revealed, other than the form beneath his clothes. That form itself is limp and still, but there is no blood and there are no guts. His body shows no visible signs of injury or catastrophic contortion from the fall. This scenario offers little to those who are titillated by gruesome spectacle.

Irma remains physically restrained, as she has throughout the film. In a state of shock, she reaches out toward his body. Her hands hover over Aldo's body for a second, and then she pulls back, clasping her hands in her lap. She remains withholding, as though unwilling or unable to touch his body. This gesture demonstrates the finality of this body. She brings no funerary histrionics to the scene except her lone cry. This is no pietá, no operatic remorseful farewell of a suddenly realized love. After the sonic dissonance of her one scream, which is more Fay Wray than Anna Magnani in its shrillness, she seems unable to call for help. Rescue appears futile. Her behavior also suggests that any attempt at resuscitation would be pointless. Given the severity of what has occurred, her reaction bespeaks a deeper pattern of repression: a passivity, a reticence, perhaps even a form of traumatic exhaustion.

If *Germany Year Zero* uses a suicide to demonstrate the desperate need for a subjective rehabilitation that will jolt or trigger the world into a rebuilding of the subject, *Il grido* redeploys this tragic ending in a way that offers a far more cynical prognosis for the postwar subject. The film describes the impossibility of personal redemption, but it also disabuses its spectator of any hope of a future based on humanist connectivity. In 1961, Antonioni was asked whether differing "social climates" determined the fact that the endings of both *L'avventura* (1960) and *La notte* (1961) bring new awareness to their characters, while *Il grido* ends with suicide. In reply, Antonioni remarked,

> When the critics said—with regards to *The Cry [Il grido]*—that I was cold, cynical, and completely inhuman, they evidently weren't aware of what I was trying to say. . . . Human warmth is no longer of any value to [Aldo], insofar as it doesn't help to prevent him from destroying himself, the ending

of the film is more pessimistic than the [other films]. . . . In spite of every-
thing, this quality of human warmth expressed by the main character in
The Cry doesn't serve him at all as any link to the rest of humanity. He is
a person who is no longer attached to life.[19]

Aldo's alienation permeates this film's narration and its mise-en-scène.
Yet the desperation he experiences seems to have no social or political
origin: his skills as a mechanic seem to be always in demand, no mat-
ter where he goes. The film nevertheless narratively underscores the
seemingly more profound alienation of Aldo and Irma by continually
depicting them as socially marginalized and politically disengaged
from the world around them. The sequence at the end of the film
emphasizes this subjective discontinuity through their mutual oblivi-
ousness to the fate of the town, which has now exploded in protest. At
the beginning of this final sequence, Aldo has blithely crossed police
barriers. There is no social protest to his actions; he is just desperate
to see Irma. When an old friend tells him of the town's grave situation,
Aldo appears apathetic and distracted. Irma has not joined the protes-
tors when Aldo finds her at her house.

With the protestors, the film allows us to glimpse an alternative
response to alienation, one not premised on the comforts of a dis-
tanced liberal compassion. At the start of the film, the town is depicted
as a community connected by networks of gossip and moral suspi-
cion. At Aldo's return at the film's end, however, the townspeople
have become politicized. It appears that the majority of the towns-
people have become protestors motivated by a clear sense of populism,
nationalism, and local sovereignty. (The film's earlier sympathy for
Virginia's elderly father and his psychotic attacks on the new owners
of what was once his farmland anticipates this later interest in the
popular resistance to economic redevelopment and reconstruction else-
where.) When Aldo first returns to find Irma, he looks all over town,
never fazed by the political turmoil that is happening all around him,
and in his final desperate moment, he falls or jumps to his death from
the tower at his old workplace. Meanwhile, the local population has
taken to the streets to protest the government's appropriation of local
farmland to build an airfield that the film seems to suggest will pro-
vide a landing strip for military jets (implicitly citing the U.S. military
presence in Italy).

The last shot of the film incorporates the competing locally orga-
nized and alienated liberal humanist subjectivities around which this

film's conclusion is built, as well as the competing political modalities they represent. The shot begins in a confusing reorientation of our gaze. Coming immediately after the shot that follows Irma to Aldo's fallen body, this bird's-eye view of a refinery feels abrupt and confusingly inconsequential. Why has the film pulled away from the crucial scene of bodily crisis that was in the midst of unfolding? What information can this refinery hold that is more important to the narrative than that tragic scene? As we search for meaning in the motionless foreground of the refinery building, we begin to notice a steady stream of protesters rushing across the top right of the frame. The otherwise blank and still horizon becomes activated here with this line of marchers. The camera next pans across the refinery buildings away from the marching and eventually rests on a long shot of Irma and the body. This mobile frame allows us to recover our observation of the scene of trauma. It restores the conclusive compositionality that appears to follow from the previous shot. We see Irma kneeling hunched over Aldo. She briefly touches his back in a manner that resembles a genuflection or a putting to rest of his body. Then the word "Fine" comes over the scene, fixing Irma's body in the space between the "F" and the "i." Even with this concluding gesture, the oddness of the narration's elliptical disjuncture at the start of this final shot lingers. The protestors present a troubling formal and narrative presence that interrupts any tragic romanticism the ending might otherwise hold.

Although this film represents one of Antonioni's more direct critiques of the reconstruction and redevelopment of Italy, it remains unwilling to offer solutions or even final judgments. In recounting neorealism's imperiled body and ultimately rejecting that corporealism, the film questions the political subjectivities underwriting the economic miracle. One could read the final shot as an attempt to create an allegorical correlation between the expropriation and the violent end of Aldo. However, this reading fails to account for the film's insistence on narratively and formally differentiating Aldo from those protesting the economic renewal schemes and government appropriations. The final shot makes this political specificity unavoidable. The visual spectacle of the violenced body brings no ethical or political reckoning, either diegetically or for the viewer. By reintroducing the protestors in a shot that at first feels disjointed from the scene of trauma and then reveals itself to be contiguous to it, the film makes us confront the political futility and social inconsequence of Aldo's death. He is a martyr to

nothing. By rerouting the gaze of charity, the film refuses to pose the question of redevelopment and rehabilitation in terms that are immediately palatable to a world audience. The body offers no ethical clarity, a fact underscored by the film's refusal to declare his fall a mistake or a suicide. We cannot decide whether Irma's hesitant reaction reflects her shock, remorse, guilt, or relief. Instead, the film offers a much more discouraging final judgment of revitalization: a politics of pitiful spectacle and charitable gazes has led to government expropriation of land for projects of internationally endorsed national defense. We might say that the actual cry of *Il grido* is a plea against a politics of pity. Collectivity cannot and need not rest on corporeal excess.

In this sense, the dead body introduces a discomforting aporia in the final moments of *Il grido* that seems to perpetuate the nihilist scene of death at the end of *Il bidone*. The later film describes a world that treats the human body as just another form of rubble tossed aside by the world. As in Antonioni's *I vinti (The Vanquished,* 1952), a narrative film that explores a generation of violent youth for whom human life holds little value, corpses are treated with reckless disregard. The bodies that accumulate in these films confirm no humanistic platitudes; if anything, they clarify the failure of human relations in contemporary life. Bodies are just another form of waste. In this respect, *Il grido* also echoes *Tentato suicidio* (1953), the short docudrama that Antonioni made for the omnibus feature *L'amore in città (Love in the City),* which plainly describes the desperation of suicidal women. Bernardo Bertolucci's *The Grim Reaper (La commare secca,* 1962) and Francesco Rosi's *Salvatore Giuliano* (1962) similarly obsess over crime scenes. In neither case, however, does the witnessing of a crime or the visual investigation of the crime scene's bodies stabilize the narrative's moral or epistemological framework. The latter film begins with a kind of neorealist convergence of gazes on the dead body of the Sicilian bandit whose name titles the film. Yet this optical autopsy leads nowhere except to further erosions of justice, ending back at the original crime scene and with the revelation of a conspiracy that dispenses with closure or any sense of agency.[20]

Fists in the Pocket

As a gesture, a fist in a pocket speaks of unsuccessful repression. If a fist almost always signifies impending violence, then a pocketed one

flaunts this ferment while signaling its own awkward confinement: the tense spasmodic grasp may be covered, but its intent is hardly concealed. Clenched inside a pocket, a hand outgrows the space designed to contain it. Relaxed hands, a resting palm, and even grasping fingers readily slide from view in a pocket's depths. Once filled with rage, however, the hand—the fist—is much harder to put away. Critics and scholars often read Marco Bellocchio's 1965 debut film, *Fists in the Pocket (I pugni in tasca)*, as a premonition of unrest. For many, this film stands as a prophetic parable whose images, such as the fists evoked by its title, register the pent-up frustrations of mid-1960s youth in the West—a tension that would eventually lead to the mass political demonstrations of 1968. From this perspective, this film may seem out of place in the present discussion. Conventional histories place it in a moment and milieu detached from neorealism. Here, however, I want to offer a brief analysis of the film to demonstrate how our revised understanding of neorealism's legacy—as a humanism based on corporeality—transforms our understanding of later generations that include the art house films of the 1960s. *Fists in the Pocket*'s indulgence of gesture and violence suggests that before we rush to contain its visual volatility in the safe concept of the 1960s "youthquake" zeitgeist, we should consider how it not only retaliates against postwar Italian film aesthetics, and in particular neorealism, but also engages and confronts history and the persistent vestiges of fascist subjectivity in contemporary Italy.

This film describes the demise of a fatherless bourgeois family of adult children still living at home in their provincial villa with their blind mother. It immerses the viewer in the familiar claustrophobia of being trapped at home with relatives; think of an endless family vacation forced inside by inclement weather. This film suggests that the tedious tension of mandatory suppers, the taunting abuses of sibling hierarchies, and the weight of financial squabbles takes an unbearable psychological toll on the bourgeois Italian family of the mid-1960s. Each character appears undone by her or his role in the family, and what results is a dark stew of listlessness, psychosis, incestuous attractions, and homicide.

Within Bellocchio's scenes of ancestral claustrophobia lurks Buñuel's sense of the violence of upper-middle-class stagnation and the brutality of elitism. (Buñuel nonetheless publicly dismissed *Fists in the Pocket*.) Bellocchio also borrows from Hitchcock in his exploration of

how easily the sinister can grow out of the most intimate relations and the most familiar settings. The narrative closely follows the character of Alessandro, a restless and insane young antihero who begins to believe that the practical solution to the family's problems is to kill off first his mother and then a disabled brother. He carries out these murders with a calm and careful intensity. The deaths in this film occur through surprisingly gentle and unspectacular means: the tap of a finger, the delicate coaxing of a head slipped underwater, and, finally, the decision to stay in bed and do nothing. According to an interview with Bellochio, violence arises and breeds in a refusal to accept reality; the director goes on to describe Alessandro's character as "not only decadent but semi-fascist."[21] Alessandro emerges here not as a herald of '68 but as a symptom of fascism's lasting and subtle hold on subjectivity. In this respect, *Fists in the Pocket* may share as much with Rainer Werner Fassbinder's *The Marriage of Maria Braun* (*Die Ehe der Maria Braun,* 1979) as it does with *Germany Year Zero.*

In a manner similar to Antonioni's interrogation of relationships, Bellocchio's film deems the dominant mode of familial relations useless, outmoded, and even dangerous. For Antonioni, the clash between modern industrial society and human relations results in a sublime formal dissonance. Bellocchio's vision is more frantic and manic: family bonds dissolve into hysterical laughter, frenzied fits of anger, and dangerously willful paralysis. (The film uses the still photograph— family portraits with all their Barthesian connotations of loss, stagnating stillness, and irrecoverable presence—as a contrast to highlight ecstatic or seizing bodies.) *Fists in the Pocket* is an easy read for those who wish to indulge its historically reflective resonances: it is simultaneously autobiographical (Bellocchio, roughly the same age and class as his protagonists, grew up in the house where the movie was filmed) and nationally allegorical (the fatherless family may mirror the Mussolini-less Italy and its growing pains). At the time, Bellocchio believed that a work of cinema alone could not produce politics. Instead, he thought that films simply reflected political reality in varying degrees. At best, cinema served as a reaction against and provocation to the status quo. Yet the film also self-consciously interrogates the notion of reflection through the narcissistic antics of its characters (Alessandro and Guilia spend a great deal of time in front of the mirror) and the use of Eisensteinian modes of montage between and within individual shots. The editing of the film boldly dispenses with

many of the traditional transitions between scenes and spaces, thus encouraging a collision of two otherwise incommensurate ideas. Moreover, several long takes are composed so as to engage foreground and background in a dynamic dialogue. As a scene unfolds, otherwise banal background action gradually achieves semantic resonance, never upstaging the main action of the shot but extending and subtly complicating its meanings.

Gestures supply this film with a primary means of figuration, allowing *Fists in the Pocket* to shuttle between narrative and theme. By foregrounding and repeating certain gestures, the film forms a nonnarrative commentary on societal concerns, contemporary politics, cinema history, nationalism, and the dogma of organized religion. (Alessandro's genuflecting seems to anticipate the obsessive private rituals of *Taxi Driver*'s Travis Bickle.) The film's central gesture is the epileptic seizure. Bellocchio remarked at the time of the film's release, "Film sometimes needs symbols, and to me epilepsy meant all the frustration, all the troubles and weaknesses often found in the young."[22] Although it is tempting simply to dismiss a political aesthetic built in this way on the allegorizing of a disabled body, to either celebrate or ignore the film's symbolic use of a body in seizure avoids the important history of corporeality in Italian postwar cinema. We might instead view the seizures in this film as a self-conscious citation of the seizure at the moral and narrative crux of *Bicycle Thieves*. Although the extreme corporeality of certain scenes in *Fists in the Pocket* may seem like hokey hyperbole or overblown allegory, they take on a different cast when viewed through the aesthetic history of Italian cinema elaborated so far. The use of the body in this film speaks to those other texts—*Bicycle Thieves, Shoeshine, Rome Open City,* and *Paisan*—that we have seen accessing unprecedented depictions of the violated human body as a means of shoring up moral certitude.

What, then, is this film's take on the corporeal? In an early scene, Alessandro dances with gymnastic ecstasy on his bed while brandishing a small sword. At one point, he dives onto the sword, which seems to pierce his chest. Here the film leaves us hanging for a moment: have we just witnessed a suicide or not? Only moments later, Alessandro is up again, bouncing off the walls and continuing to rehearse a future killing—of himself or another. Scenes like this one suggest that we should never take *Fists in the Pocket*'s moments of violence, even its fits, as either literal or purely reflective. This film's turn to corporeality

instead aims to thwart a certain established species of moralism. By subverting realism's formal dependence on spectacles of violence and victimhood, *Fists in the Pocket* comments on the ideological limits of neorealism and attempts to break the political logjam created by postwar Italian cinema's dependence on the corporeal as a means of triggering universal humanist sympathy. The politics of *Fists in the Pocket* become more interesting to consider when we approach the film less as a barometer of an impending zeitgeist and more in its dialectic with the past. How this film articulates its place within and outside history may mark its most lasting significance.

Conclusion

In "The Existence of Italy," Fredric Jameson argues that the only essence of realism is its uniquely unstable conceptual grounding.[23] In his view, realism should not be regarded as a single practice or formal strategy, but rather as the activities of an infinite revision, perpetual disruption, and constant usurpation of all that precedes it. The word *realism* fails to describe a specific formal means of organizing concrete reality that will remain relatively consistent over time; in fact, we can guarantee that truly realist practices will never do so. For this reason, efforts to make equivalent or parallel diverse styles of realism will always fail unless they acknowledge realism's perpetual effort to dereify itself. Is realism then still useful? Yes, according to Jameson, and precisely because of its radical refusal to commit to specific modes of representation. Realism always involves a claim for changing the presiding modes of representing social life—a plea for a means of depiction better suited to describing what has escaped representation. A realist practice can promote its specific aesthetic only by exposing a disjuncture between the epistemological status quo and the collective experience of a given community's material existence. This new form of realism—a neorealism—makes manifest an attendant disjuncture between the established means of representation and the real, rendering the tried and true forms of knowing anachronistic or disorienting.

By challenging the canonical works of neorealism sixty years after their creation, I have made a particular effort to avoid restabilizing the relationship of Italy's reality to its images. As Jameson argues, realism is always relative, and this suggests the futility of attempting to define the term *neorealism* outside the world of competing representations.

Instead, I have drawn my conclusions from the set of relations emerging from film textualities themselves. Jameson's reconceptualization of realism finds potent confirmation in the practices that I investigate in this chapter. As Jameson recognizes, an authentic realism is always a simultaneously retroactive and proactive stance against the reification of the real.

Rather than celebrating postwar trauma as their heritage or embracing the optimism of *il boom,* the films in this chapter attempt an aesthetic attack on neorealism's articulation of class politics, its account of the human, and its assessment of the economic forces affecting Italian politics and society. Although these second-generation films evoke the specificities of the regional and the everyday, they also attempt to foreclose on the use of the image to ennoble the ethical onlooker or bolster the authority of an international bystander. Insulating the image from such instrumentalizations is never fully possible, but their efforts to question the neorealist optic betrays a concern for how displays of poverty and suffering function in global visual culture.

CONCLUSION

THIS BOOK EMERGED FROM an encounter with a film. It was not an Italian film but rather the well-known HIV/AIDS documentary *Silverlake Life: The View from Here* (Peter Friedman and Tom Joslin, 1993). That film raised questions for me about using the image of a suffering body to up the ante of political discourse. *Silverlake Life*'s bodies are of course inscribed by a different set of historical discourses than those in *Rome Open City*. This documentary is made from a series of video diaries kept by Tom Joslin, a gay filmmaker struggling with the final stages of AIDS, and by his partner, Peter Friedman. But this film isn't just any documentary. It positions itself as the ultimate expression of that genre's impulses in one remarkable act: it continues to record footage after the death of its filmmaker, showing us his corpse through the eyes of his beloved spouse, who has picked up the camera. In doing so, it performs a documentary coup d'état. As did *Psycho* with the horror genre, this film effectively calls the bluff of other documentaries. Documentation continues after the death of the documentarian.

Silverlake Life is a compelling narrative of pain and love, but like many such narratives, its representational conceits began to unsettle me the more I thought about their political consequences. What did it mean that the film asks us to watch a person look at his spouse's corpse? What made that scene legible as a political statement? Why did this film assume that all viewers would read its raw camerawork and brutally uncensored images of a dead person as a form of undeniable testimony whose meaning was clear? Was representing a dead body something that photographic media could contribute to political speech that other forms and genres of political rhetoric could not? If the film's revelation of the corpse raised the stakes of the political debate over

HIV/AIDS funding and the legal inequities of gay men's lives, did it not inadvertently obligate compassion in a manner consistent with the nightly newscast's catalog of ailing queer bodies? If early parts of the film play with the idea of what it means to be a victim and attempt to alter our conceptions of a sick body, didn't the corpse footage take away any possible reaction but sympathy? Why did it feel so hard to question the politics of *Silverlake Life*'s images without seeming anti-human? How could anyone argue with a film like that?[1]

Looking at the legacy of cinematic representations of the political in the late twentieth century, I realized that *Silverlake Life* shared with neorealist films a similar set of hopes for how the visualization of looking at suffering could transport political affect across social boundaries. Both *Silverlake Life* and neorealist films use shocking images of death to urge viewers to think beyond the relative comfort of their own lives and remind them that suffering persists; both encourage viewers to broaden the parameters of their ethical obligation. They do this by using the cinematic body as a means to politicize the act of watching. Here seeing qualifies as a political act. These films encourage the viewer to replace his or her own act of watching with a cinematic gaze—a diegetic space of watching. They suggest that desperate times call for a different politics of representation. The most difficult political and social struggles, they argue, require a new order of image aesthetics that blatantly pushes past the boundaries of what was hitherto acceptable to show on screen. It would seem that when advocating for disadvantaged, isolated, and misunderstood communities, only a brutal humanism has the capacity to jolt the rest of the world into awareness.

North Atlantic film culture understood the years immediately after World War II as a time when the ethical limits of what was permissible to watch at the movies required a radical expansion to accommodate a new geopolitics. The war's aftermath and anxieties about a shifting global order issued a moral imperative to visual culture: the truth must be shown, and by any means necessary. Pictures previously understood as unfit for public consumption contained content that was now thought to be vital for all to see. Calls for unshackling the image were articulated not only in journalistic and documentary ideologies of film, but also in the practices of fictional cinema. The period's films enact this change and in many ways invent a distinction

between old, repressed images and new, explicit ones. They also anticipate how this change will meet with resistance from various unmodern subjects. In their narratives, these films push us through and past the subjective frailties of adapting to a new visual order. In *Rome Open City*, fainting spells plague those characters who cannot stand to witness, thus leaving them condemned by the narrative as ethically weak, while amorality tinges those who are heartless enough to see without compassion. Similarly, American films preach a ruthless expansion of what the subject is expected to tolerate visually. Belligerent fits plague characters who refuse to look at the photographic documentation of war victims in *The Stranger* (Orson Welles, 1946) and *Boy with the Green Hair* (Joseph Losey, 1948). These films pathologize those subjects who are unable to bear witness, and frequently these films issue a sympathetic call for the rehabilitation of those who fail to witness.[2]

Because of the way the word *raw* captures the unmade and undigested as well as the naked, indecent, and laid bare, it frequently comes to describe this changing attitude toward the permissible limits of the visual. If this image has a character, it might be called unrelenting, and it is brutal because it is both brute and harsh. We have seen how U.S. advertising and the critical reception of neorealist films argue for just such an extreme image as a necessity for any accurate accounting of World War II. We have also seen how neorealist films themselves structure this rawness into a larger system of narration. Now that we are more than sixty years past the first neorealist films, it seems worth asking after the implications and responsibilities of such a brutal optics. How have subsequent film movements inherited the visual politics of a humanism pursued by any (visual) means necessary? And has the position of the tireless witness finally worn out its welcome?

It is crucial to remember here that not all the films I discuss in this book perform their subjection in a key pitched perfectly to the geopolitics of the North Atlantic community. As early as DeSica's *Il tetto*, we see films beginning to question what it means to force the victim to perform their subjectivity for others. Where the early neorealist films make the untenable qualities of limited sovereignty seem almost welcome, the later films refute the terms of postwar democracy. From Italian films of the 1950s onward, in other words, the value of a humanism based on brutality has been subject to sometimes more

and sometimes less rigorous interrogation. Part of neorealism's legacy is precisely a negotiation with the by-any-means-necessary visuality of brutal humanism. As many films as there are that draw from this brutal optic, an equal number of later films raise the specter of neorealism to question whether a brutal humanism is ever really necessary. These later films don't just seek to account for what neorealism cost mid-century Italy—a cost that the films in chapter 5 so eloquently make visible. They also seek to understand what it means to use neorealism's optics in their own historical moments.

Film history suggests that the international explosion of styles after 1960 would have been unthinkable without neorealism as a precedent. Neorealism remains at the core of a set of aesthetic values that define quality and significance for film criticism, as well as its system of evaluation for subsequent emerging movements of world cinema. Neorealism in many respects sets the standard for European new wave cinemas, postcolonial cinemas, cinemas of social change and political liberation, the American "new independents" of the 1970s, and late twentieth-century explorations of realism by Iranian, Danish, Romanian, and Chinese cinemas. Given this genealogy, my arguments here suggest that we would do well to ask whether images of human suffering have been integral to later political reclamations of cinema— and if so, to consider the consequences of this legacy. Moreover, neorealism's influence stretches beyond its obvious stylistic influence on the neoneorealist films that populate film festivals, cineplexes, and art houses today. It influences *Wendy and Lucy*'s (Kelly Reichardt, 2008) emblematic use of real locations, of course, but it also affects its ethical vocabulary. Films like *Elephant* (Gus van Sant, 2003) and *Children of Men* (Alfonso Cuarón, 2006) do not just push neorealism's trope of the long take to its ultimate realization; they also borrow from its idiom of bodily spectacle.

In light of the previous chapters, I want to insist that measuring neorealism's impact requires asking about the legacy of its particular instantiation of looking as witnessing, its optics of brutal humanism. Although a comprehensive survey of this legacy would involve a separate book-length project (or perhaps several), I would like in these final pages to begin exploring the stakes of this issue by briefly framing three film practices in the terms that I have developed in this book. I have chosen an odd group of films that extend beyond those typically

associated with neorealism's legacy. These diverse filmmaking practices emerge from different historical locations and modes of production: Italian horror of the 1960s and 1970s, Hollywood films about the Iraq war, and African American filmmaking associated with the UCLA school. I have chosen this dissimilar group of film practices in an effort to illuminate not only how postneorealist film culture enacts a constant struggle to define politics cinematically, but also more specifically to highlight how postneorealist filmmaking seeks to measure the costs of a brutal humanism against its rewards.

The critiques of brutal humanism that emerge from these practices involve five primary revelations. First, brutal humanism is a politics predicated on violence. For the category of the human to be invoked, harm must be done to a body. Here violence serves as the necessary predicate to humanist understanding. Second, brutal humanism hungers endlessly for both brutalized bodies and witnesses. As such, it reflects a compulsion to understand the world, truth, change, and history as a witness. Third, as a politics premised on witness testimony, brutal humanism can only consolidate itself after the fact, making change in the present less conceivable. Politics cannot be conceptualized in any temporal order other than one that recounts and counts losses. Fourth, brutal humanism formalizes the affective structures of charity. By lending form to a charitable subjectivity, it aesthetically strengthens and endorses a structure of international aid that risks perpetuating imperialism and produces economies of dependency and debt. Finally, a politics based on stabilizing meaning in the image through the body presents long-term problems and unduly limits the scope of political change to the parameters of individual human physiology. Ultimately, these revelations lead these films to pursue two crucial questions: Can there be a humanism that requires neither the specificity of a single body nor the erasure of bodily particularity? And is it ever appropriate to use a body as the unit of measure for political discourse?

The Brutality of Violence

At least from the 1960s onward, monographs, textbooks, museum film programs, and syllabi have figured neorealism as a testament to the perseverance of the human spirit and as a beacon of transcendental

humanism, all while largely neglecting the violence of these films. Meanwhile, a group of Italian genre films, the gothic horror known as *giallo,* made a huge splash in B-film markets. Though rarely read in the context of postwar filmmaking traditions and sometimes not even consumed as Italian films, these imports drew on neorealism's idiom of violence. These films also perform, however, a postmortem on neorealism's body, or in Bazin's terms, a "phenomenology of death" in postwar Italian film. They antagonize neorealism's corporeal premise, overtly acknowledging the imperiled body as a victim caught in a network of foreign and often explicitly American gazes. Take, for example, the *occulare testimoniale* that typifies the visual narration of Mario Bava's films.[3] To an international audience, this "witnessing eye" may have evoked a neorealist visual idiom of witnessing injury and death as much as it recalled the pulp literary tradition of its namesake. In the final story of Mario Bava's *The Three Faces of Fear (Black Sabbath; I tre volti della paura,* 1963), however, the visual encounter with a corpse does not guarantee ethical action. In fact, the opposite occurs, and the confrontation with a corpse leads to a breach of ethics: the looker steals from the dead. In Lucio Fulci's *Perversion Story (Una sull'altra,* 1969), the corpse in question similarly lacks immediate evidentiary substance. Carefully looking it over yields neither further information nor an ethical sea change in those who look. These viewings instead allow mistaken identity to be maintained, blocking access to accurate information. The body in this sense seems to induce a kind of ongoing epistemological crisis. Bava's seminal *giallo, The Girl Who Knew Too Much (La ragazza che sapeva troppo,* 1963), makes an even more forceful critique. Here an American's touristic gaze triggers violence in the postwar Italian context. In the most overt terms, the film issues a warning to young American girls who want to visit the tourist sites of Rome: these are dangerous places. As Noa Steimatsky suggests is the case with Pasolini's films, this film form thus rejects the new Italy and exposes the violence of "a depleted, homogenized, commodified Italy."[4] The film also offers a retort to simplistic notions of witnessing in more subtle ways, asking about the violence done by the compulsive desire to see and know everything of the world. Witnessing comes with an obligation to act, the film seems to warn, and those obligations cannot always be fulfilled by good intentions alone. Simply being aware of things is not enough, and this means that knowing may make living as you've always lived harder.

Another iconic Italian slasher horror film, Dario Argento's *The Bird with the Crystal Plumage* (*L'uccello dalle piume di cristallo*, 1970), entraps its American protagonist in the excruciating position of witnessing violence while being physically restrained from helping the victim. At first the film seems to be restaging the visual dramatics of *Rome Open City* in the glossy modernist mise-en-scène of Antonioni. In the end, however, we join the film's American in discovering that we eyewitnessed nothing but a deception: the person we took to be the victim of a violent event that we thought we had witnessed is in fact the killer. The idea of eyewitnessing as misrecognition calls into question the potency of our gaze in relationship to knowledge and justice. Lacking an understanding of how neorealism grounded its humanism in displays of a vulnerable and imperiled body, it is easy to miss what connects *giallo*'s *occulare testimoniale* to the unrelenting points of view offered by Rossellini's war trilogy.

An imperiled body struggles while an American eyewitness is trapped within a glass foyer. Production still from Dario Argento's The Bird with the Crystal Plumage.

The Brutality of the Witness

Vision rarely seems to stabilize itself over the course of a *giallo* film. Most often the opposite occurs. Vision's epistemological bearings deteriorate over the course of these films. In this sense, *giallo* would appear to be a direct effort to resist the pressure to make the world fully witnessable. Moreover, it describes that pressure as developing in the North Atlantic space. These films traffic in the spaces of Italy, the rest of Europe, and America; their narratives seem always to work within and against American gazes, whether expressed diegetically or through generic conventions. It would be wrong to say that in troubling witness politics, these films give up on history or the pursuit of knowledge. Read in the context of other postwar films, however, their pairing of the serial killer's gaze and the overly attendant one asks what kinds of history are lost when our world is driven by predatory voyeurism and what kinds of knowledge are obscured by the impulses of the *occulare testimoniale*. What cannot be accounted for in the space of witnessing?

Eric J. Sundquist poses similar questions about a late twentieth-century culture in which everyone feels a compulsion to serve as witness for every major historical event. In a key essay, he explains how one goal of literature in the years just after World War II was to devise a means of making "the Holocaust 'witnessable' by an American, as well as global, audience. . . . In each generation since, the problem of 'knowing' the Holocaust has paradoxically become more acute as various modes of second-order witness have become normative."[5] Sundquist asks: if we believe that the category of survivor should remain sacred and not expand beyond those who actually suffered in the Shoah, then why is the category of witness made so easily accessible? "Does one become a witness, even though every effort by a non-participant to know the Holocaust necessitates some kind of surrogate witnessing, but what kind—witness as spectator, as testifier, or both—and to what end?"[6] In other words, Sundquist suggests that this expansion of witnessability has proliferated without us ever having taken stock of what exactly "we have been enabled to witness."[7] While mostly concerned with literary and theoretical examples, his descriptions very aptly describe the paradigmatic terrain of the postwar cinematic witness. In examining the erosion of "the boundary between the original and the surrogate experiences,"[8] he lists recent theoretical tropes— secondary witnessing, cowitnessing, proxy witnessing, and witnessing

through imagination—that echo Iris Barry's very early description of cinema in 1926 as a form of secondhand emoting. And yet we still have only the most basic reckoning of what Sundquist describes as the process by which nonwitnesses continue to strive to "convince themselves and others that they too occupy a privileged position in relation to the event; by claiming to participate in, to have been imprinted by, its trauma, as though they 'really faced the Holocaust, felt its horror and remembered its victims.'"⁹

This postwar compulsion to use textual devices to appropriate the position of the witness can be seen to extend to more recent films. Mainstream American films about the second Gulf War, for example, deploy a sometimes uninterrogated witness politics in an attempt to get around their ambivalences toward the suffering of Arab or Middle Eastern bodies. For *Rendition* (Gavin Hood, 2007), witnessing the torture of an Egyptian American who has been wrongly accused of terrorism is the only path to political consciousness. The film appears to be unable to condemn state-sanctioned violence without structuring its climatic scene of gruesome torture around the gaze of the white Hollywood star, Jake Gyllenhaal, whose character is forced to watch this event. The scene cuts between his eyes and the images that will open his character's awareness to the truth of political violence done in the name of the U.S. government. Here we find a clunky reenactment of neorealism's optical politics. *The Hurt Locker* (Kathryn Bigelow, 2008) twists the terms of ethical encounters with the violenced body. Toward the middle of the film, the central characters make a terrible discovery: a bomb has been placed inside a young boy's mutilated body, which requires the film's main character, William James, to reach into that corpse's mangled inner cavity to disarm the bomb. The film misleads us into thinking that this body belongs to a mischievous but endearing young Iraqi whom the film earlier shows selling DVDs on James's army base and developing a charming repartee with the American soldier. As James confronts the young body and then works his hands through the interior of its torso, the film makes what we initially think is its strongest statement about the costs of the war to the dignity of human life. In front of this cadaver, the otherwise unshakable and emotionally distant James suddenly displays affect. In terms of character and narrative, this is the moral crux of the film. By attenuating his emotional transformation and linking it to our narrative investments in the film's earlier events, the film prompts us to

indulge our moral outrage. At last, the film seems to allow us some space for affect to carry narrative and political consequence. Later in the film, however, in place of an epiphany of pathos, we discover, along with James, that the young boy is still alive, and that the corpse was that of a stranger. Although this discovery may at first seem only to cloud further the film's already slippery politics, when read in the context of witness politics, it may actually suggest a purposeful questioning of sympathy and pathos. Realizing our mistake may serve to bind us to the utter dystopia that seems to plague James and that precipitates his final decision to return to the war. It also asks us what we think we know and how much we can know. If we feel a sense of loss when we realize the initial confusion about the boy's identity, then the film—and the overtness with which it misleads us—would seem to encourage us to reflect back on our own investments in pathos-generating spectacles of harm. It seems to expose the dependence of our politics on surrogate witnessing of the imperiled body. At the very least, it makes clear our desire to use encounters with violence as a means of getting closer to the event and making sense of the war. It leaves us to wonder why we were so invested in that mutilated body being the boy's.

The Brutality of Time

For cinematic witnessing to hold any kind of real authority, the time of spectating must be substituted with the diegetic time of suffering and the time of onscreen witnesses seeing that suffering. Our surrogate witnessing must always happen at a chronological remove. Throughout this book, I focused on the spatial vectors of this gaze. Yet there are also temporal lags involved when we accept the terms of surrogate witnessing. We can't do as much as those real witnesses can, and yet the film never suggests so much.

Haile Gerima's *Bush Mama* (1979) engulfs the viewer in a visual space and soundscape that formally complicates the notion that film-going is a form of political action and that cinema spectatorship is the end point of consciousness. This is a harrowing film, but it is not brutal in the terms described here. Instead, it relentlessly attempts to make impossible any proxied sympathy by unsettling the conventional modes of temporal orientation. Its narrative is only somewhat linear,

often jumping to flashbacks and flash-forwards without transition or indication to the viewer. Yet its story is forcefully clear and seldom hard to follow. The elliptical nature of this cacophonous mixing of past with present imagines an incessantly immersive spectatorial engagement. It attempts to make an inescapable moment of film; it is an attempt to create a politics of the present. There is no unitary present tense in the film. No sooner do we think that we've settled on the temporal register than it slips between our fingers. Layer upon layer of time, often through the various soundtracks, makes the public scenario of surrogating witnessing less possible. The film seems to dissect events by distending time to allow space for a rich network of subjective and objective registers. Although it is perhaps inaccurate to call the film "stream of consciousness," as many critics have, it does stream the histories, ideologies, and subjectivities that make up any given event. In its sometimes noisy manner, the film short-circuits typical modes of identification, working against the spatiotemporal modes that allow the secondary witnessing so characteristic of the charitable gaze.

Consider, for example, the political posters that a young activist neighbor periodically posts on the apartment walls of the film's main character, Dorothy. Dorothy appears to be politically apathetic for most of the film, and she barely registers the content of the political posters. The first of these posters appears to be in direct response to the police violence in the Watts uprising. This poster depicts the corpse of a man with multiple gunshot wounds all over his naked body and makes the claim that Watts parallels the dreadful violence of the Vietnam War and the Mai Lai massacre. We are permitted only a brief glimpse of this poster when the neighbor first hangs it on Dorothy's wall. As Dorothy comes into a more radical consciousness, however, we see more of the poster. At the end of the film, when Dorothy is confronted by terrible events in her own life and she is forced into a political awakening, we finally see along with her the terrible spectacle of police brutality that the poster's image depicts. The film makes us want to see the image, but it only shows it to us in a moment of complete despair. In a montage that eventually reveals details of the poster, a cacophony of horrific visions enters Dorothy's head as she sits at a women's health clinic, where we presume she has gone to have an abortion. The chiaroscuro of directional light and diagonal compositions of bodies (pregnant bellies, adult versions of fetuses on crosses) that appear

here uncannily echo *Mamma Roma*'s final images of Ettore's body. Over the sound of a baby crying, gunshots, and Dorothy's nonverbal sounds of distress, a familiar classical music score comes to dominate the soundtrack, again echoing Pasolini's use of composers such as Bach and Vivaldi. The film in this way uses a comparison to Pasolini's early films, as if to further differentiate itself from a humanist optics wherein our gaze is never limited or conditioned by the state of any character's political consciousness. In other words, *Bush Mama* represents a more dramatic inversion of neorealist narration, even while inviting its ghost. When the poster emerges as an element of this nightmarish daydream, Dorothy's embodied perspective overtly marks our vision of it. The poster is split down the middle by an absence that derives from her divided perspective. The poster goes in and out of focus as if in time with Dorothy's distressed inhalation and exhalation. When finally we are granted an unobstructed view of the maimed corpse that illustrates the poster, it is only in brief extreme close-ups that are intercut with close-ups of Dorothy intensely looking at it, but shown upside down as if to exaggerate our sense of her perspective. *Bush Mama* seems unwilling to lift its spectator to the realm of adjudication and external witnessing, and aesthetically, it attempts to bar any passage to a witness politics by disallowing either spatial or temporal distanciation. The poster's image of violence is part of the final undoing of this woman and of our mastery over the film. By collapsing the scale of affective relations, imploding spectatorial and diegetic subjectivities, the film forecloses on the charitable gaze and the ease of a safe distance.

The Brutality of Charity

In an interview with Michael Chanan, the Cuban filmmaker and theorist Julio Garcìa Espinosa admits that a chance encounter with Lamberto Maggiorani, the man who played the lead in *Bicycle Thieves,* initiated his concern for "the relationship between politics and art." In an open-air gathering of communist activists, he happened to meet Maggiorani and learned that the film had not led to Maggiorani's being able to live a more dignified life. "People talk about the aesthetics of nonprofessional screen acting, said Garcìa Espinosa, but no-one ever asks what happens to these people in their real lives afterwards."[10]

This realization is an overdetermined one for the history of both Cuban cinema and world cinema.

Some might have come away from meeting the down-on-his-luck Maggiorani convinced of the continued relevance of *Bicycle Thieves*. The film's claim would seem to have persisted into the subsequent decades: how sad that Italy had yet to resolve its economic problems even a decade after the war. Not Garcìa Espinosa. For him, this was an epiphany about aesthetics, a moment of reckoning when he realized that representation constituted a practice of politics. Why so? Although the Chanan interview tells us little about how exactly this experience affected his aesthetic philosophy, it is plain that meeting Maggiorani forced Garcìa Espinosa to confront the limits of the neorealist aesthetic. His message is clear: postwar Italian film's implementation of human suffering formalizes the structures of charity, but its gestures guarantee nothing for the future. Maggiorani's presence contaminates not only the cinematic body that his performance for De Sica's camera helped to create, but also the space of charity that his films enabled for viewers around the world. We need only think of the debates around the lives of the children in *Slumdog Millionaire* (Danny Boyle, 2008) to recall how "real" bodies are understood to complicate and interfere with the goodwill and liberal pathos created in the space of the spectator's consumption. When global identity is premised on a certain kind of prostration for sympathy, we must question what type of agency is being offered up.

In his later writings, Garcìa Espinosa went on to articulate his suspicion of sympathy-based art and to question the pleasures afforded audiences by films about suffering. "There are a great number of war films with pretensions of denouncing war which at the same time are great spectacles of war; and in the end the spectacle is what you enjoy about them."[11] We can see a similar sentiment in his earlier formulation of an imperfect cinema. In his critique of the role of suffering in Western notions of the tortured artist, a larger concern for the overvaluation of suffering can be heard as Espinosa lambastes the Western tradition that "identifies seriousness with suffering. . . . Only in the person who suffers do we perceive elegance, gravity, even beauty; only in him do we recognise the possibility of authenticity, seriousness, sincerity. Imperfect cinema must put an end to this tradition."[12]

The Brutality of Body Politics

I began this book by exploring the difficulty of extricating the corpo-real from the idea of the politically charged realist image. The porno-graphic or violently obscene always lurks in arguments for visual humanism. Might we see this midcentury moment as a precursor to a later twentieth-century move to take the body as a prized object of politics and a unit of measure for political discourse? During the late 1980s and early 1990s, cultural studies made an effort to redeem the contingencies of the body in an effort to align academic research with identity politics. As the body became a popular terrain of theoretical speculation, certain physical attributes acquired an oddly empirical kind of truth-value. By embracing the corporeal, scholars attempted to reconcile the incommensurability of biological fact and political agency. In the same period that dismissed a realist aesthetics for its naive or dangerous rendition of representation, then, a new reification took hold in the image: the gospel of the body as a material practice of politics. As a theoretical entity, the body gave depth and authority to categories of thought formerly dismissed as suspect—categories like affect, experience, the personal, and the subjective. Fredric Jameson has characterized the limitations of this tendency to reify the body in service of politics:

> The problem with the body as a positive slogan is that the body itself, as a unified entity, is an Imaginary concept (in Lacan's sense); it is what Deleuze calls a "body without organs," an empty totality that organizes the world without participating in it. We experience the body through our experience of the world and of other people, so that it is perhaps a misnomer to speak of the body at all as a substantive with a definite article, unless we have in mind the bodies of others, rather than our own phenomenological refer-ent. It is hard to see how theories of gender could support such a one body reference, which would seem rather to have its ideological kinship and pro-longation in current trauma theory.[13]

The constitution of a body is thus for Jameson a profoundly social and intersubjective project. A body never achieves unicity or autarky with-out the aid of ideological structures. And the process by which a body comes into being is always already a sociopolitical one.

I hope that I have demonstrated the necessity of attending to the complexities of the cinematic body as a narrative fiction, a historically

dynamic entity, and even a subject of the film camera's lens. Films almost always overlap and exchange the real contingencies of the pro-filmic body with the staged contingencies of the fictional. Cinema as we know it is a fierce admixture of virtual intimacies and absences made present. Cinema deploys the body as a sign, a complex interplay of profilmic, diegetic, virtual, and ideological physicalities. Neorealism exploits this composite quality of the body, and its reception demon-strates a postwar desire to rebrand these very characteristics of the image for a more politicized version of the medium. Neorealism wants to suggest that cinema's metaphysic (its intimacies, presences, contin-gencies) provides a unique opportunity to make an audience into a group of ethical and judicious "eyewitnesses" on an unprecedented scale.

From this vantage point, the injured or otherwise corporealized body stands as the ultimate manifestation of neorealism's politics of the image. The body allows these films to make sympathy into a visi-ble entity, to fashion ethical compassion into a recognizable spatial relationship, and to transform empathy into a visual commodity of universal exchange. This particular mode of narration requires the body not only to describe the costs of war, but also to anchor claims for the realism of cinema. Through corporeality, neorealism proposes to position the medium of cinema at the center of a twentieth-century politics of global empathy.

If Pasolini made some of the first films that attempted to renegoti-ate the terms of this optics of brutal humanism, John Waters's col-lage, *21 Pasolini Pimples,* extends, in a delightfully ludicrous fashion, Pasolini's project of both contaminating and redeploying Italy's suf-fering. Waters's work also implicitly recognizes the Italian suffering body as a key to the visual vocabulary of humanism. Through its seri-ality and opaque semantics, *21 Pasolini Pimples* suggests a methodi-cal, obsessive, and almost clinical consumer of film history. (Is this an art house spectator? The *occulare testimoniale?*) It also pokes fun at a neorealist optics that rests on the physicality of suffering (are these pimples in pain? or are they symptoms of pain?), all the while expos-ing the fragmentary and conditional nature of cinematic embodiment (do these pimples even belong to a body?). It could even be seen to mock the erotic investment of the body by identity politics (are these queer pimples?).

*John Waters's collage ironically reframes the erotics of the neorealist gaze and
its predilection for corporeal detail. John Waters, 21 Pasolini Pimples, 2006.
Twenty-one uniquely cut C-prints; framed: 35½ × 35½ inches. Courtesy of
Marianne Boesky Gallery, New York.*

In the final analysis, the postneorealist revelations about realism's
witness politics that I have just recounted ask us to explore further
neorealism's influence on political cinemas otherwise at odds with
the work of humanism. Did film movements aligned with Marxism,
for example, such as those in postliberation Africa and revolution-
ary Latin America, appropriate a logic of the image that undermines
their central project when they engaged neorealist aesthetics?[14] What
did queer practices of cinema, such as *Silverlake Life*, inherit from
this tradition? This book is meant as an initial step in this process of

specifying this legacy of neorealism. If the success of neorealist films in international venues beckoned a new era of world cinema, then it is critical to attend to how those films articulated the spatial scale of cinematic vision. The way that these films articulated spectatorship enabled their own success. It also helped to define the audience for and determine the structure of spectatorship in a cinema that would come to understand itself as a potent international and internationalizing force.

NOTES

Introduction

1. I have opted to use the current authoritative English translations of film titles. For example, I am using *Rome Open City* instead of its original U.S. release title, *Open City*. For films whose titles are rarely translated when in the United States, I have used the best-known titles. For example, *La strada, Il grido,* and *Il bidone* remain in Italian, reflecting the names used in the United States, while *Paisà* appears as *Paisan.* In the case of *Ladri di biciclette,* there has been a recent effort by scholars and others (including the Criterion Collection and IMDb.com) to pluralize the original release title *Bicycle Thief: Bicycle Thieves* more accurately reflects the film's climatic reversal, which suggests that we could all be thieves. Listing a single release date for each film also proves complicated in the context of this book's intervention, since I am largely interested in the international circulation of these postwar Italian films and since their releases were staggered from country to country. The dates listed after the first mention of a film reflect the release date in the film's country of origin. I have chosen this strategy because it tags the films with the dates that authoritative sources use to sort and reference films. The reader should compare IMDb.com to scholarly reference sources when compiling the complete release history of particular films.

2. Luc Boltanski, *Distant Suffering: Morality, Media and Politics*, trans. Graham Burchell (New York: Cambridge University Press, 1999), 3.

3. Angelo Restivo, *The Cinema of Economic Miracles: Visuality and Modernization in the Italian Art Film* (Durham, N.C.: Duke University Press, 2002); John David Rhodes, *Stupendous, Miserable City: Pasolini's Rome* (Minneapolis: University of Minnesota Press, 2007); Noa Steimatsky, *Italian Locations: Reinhabiting the Past in Postwar Cinema* (Minneapolis: University of Minnesota Press, 2008). Although not exclusively concerned with the postwar period, see also Giuliana Bruno, *Atlas of Emotion: Journeys in Art, Architecture, and Film* (New York: Verso, 2002).

4. Quoted in David Overbey, *Springtime in Italy: A Reader on Neo-Realism* (Hamden, Conn.: Archon Books, 1979), 84–85.

5. Quoted in Sidney Gottlieb, ed., *Roberto Rossellini's "Rome Open City"* (New York: Cambridge University Press, 2004), 169.

6. Karen Pinkus, *Bodily Regimes: Italian Advertising under Fascism* (Minneapolis: University of Minnesota Press, 1995); Angela Dalle Vacche, *The Body in the Mirror: Shapes of History in Italian Cinema* (Princeton, N.J.: Princeton University Press, 1992).

7. Boltanski, *Distant Suffering*, 3.

8. My argument against the liberal gestures of concern popular in this period echoes Saidiya V. Hartman's impulse, in another context, to question whether the constant repetition of "scenes of subjection" prevents or extends the violent structures of domination. Although her project addresses an earlier and significantly different episode of "horrible exhibition" and mediatized witnessing, her framing of the critical problem is helpful in how it asks, "What does the exposure of the violated body yield?" Like Hartman, my critique comes not from a wish to eradicate our records of suffering or to absent testimonials. Rather, I would like us to understand how certain displays of testimony are routinized because they are more palatable to dominant regimes of recovery than others. The subject whose liberation depends on exhibitions of a ravaged body provokes several questions. The questions I pose in this book concern how displays of the body circumscribe the sovereignty of the liberated subject. However, there is also a deeper concern here for the ways that such displays construct a spectator. In Hartman's words, "What interests me are the ways we are called upon to participate in such scenes." I will ask: Does the sympathy of eyewitnessing reveal a violent beholding? And what political parameters are assumed by that beholding? Saidiya V. Hartman, *Scenes of Subjection: Terror, Slavery, and Self-Making in Nineteenth-Century America* (New York: Oxford University Press, 1997), 3.

9. Mark Betz, *Beyond the Subtitle: Remapping European Art Cinema* (Minneapolis: University of Minnesota Press, 2009); Kerry Segrave, *Foreign Films in America: A History* (Jefferson, N.C.: McFarland, 2004); Barbara Wilinsky, *Sure Seaters: The Emergence of Art House Cinema* (Minneapolis: University of Minnesota Press, 2001); Michael P. Rogin, "Mourning, Melancholia, and the Popular Front: Roberto Rossellini's Beautiful Revolution," in Gottlieb, *Roberto Rossellini's "Rome Open City,"* 131–60. The reprint of Napolitano's fascinating 1966 essay is also interesting in this respect: Antonio Napolitano, "Neorealism in Anglo-Saxon Cinema," in *Italian Neorealism and Global Cinema,* ed. Laura E. Ruberto and Kristi M. Wilson (Detroit, Mich.: Wayne State University Press, 2007), 111–27.

10. Quoted in Mary Ann Doane, "The Close-up: Scale and Detail in the Cinema," *differences* 14, no. 3 (2003): 107.

11. Miriam Bratu Hansen, "*Schindler's List* Is Not *Shoah:* The Second Commandment, Popular Modernism, and Public Memory," in *The Historical Film: History and Memory in Media,* ed. Marcia Landy (New Brunswick, N.J.: Rutgers University Press, 2001), 212.

12. Dudley Andrew, "Time Zones and Jetlag: The Flows and Phases of World Cinema," in *World Cinemas, Transnational Perspectives*, ed. Natasa Durovicová and Kathleen Newman (New York: Routledge, 2010), 73.

13. Vernon Jarratt, *The Italian Cinema* (London: Falcon Press, 1951), 61.

14. David Forgacs, *Rome Open City (Roma città aperta)* (London: British Film Institute, 2000).

15. Christopher Wagstaff, "Italy in the Post-War International Cinema Market," in *Italy in the Cold War: Politics, Culture and Society, 1948–58*, ed. Christopher Duggan and Christopher Wagstaff (Oxford: Berg, 1995), 89–115.

16. Catherine O'Rawe, "'I padri e i maestri': Genre, Auteurs, and Absences in Italian Film Studies," *Italian Studies* 63, no. 2 (2008): 173–94; Daniela Treveri Gennari, *Post-War Italian Cinema: American Intervention, Vatican Interests* (New York: Routledge, 2009).

17. Jennifer Fay and Justus Nieland, *Film Noir: Hard-Boiled Modernity and the Cultures of Globalization* (New York: Routledge, 2009).

18. Coproductions were cross-national funding structures encouraged by European governments during the late 1950s and 1960s. The strategy involved pooling the capital and talent of individual nations in an effort to compete with the massive resources available to Hollywood productions.

19. "The New Pictures [*Paisan* review]," *Time* 51 (April 1948): 95.

20. Rocchio discusses the need to "displac[e] the focus on Neorealism as a thing in itself," warning that essentializing the label or even thinking of neorealism as a conscious movement "allows Neorealism—ontologically—to become the cause of its own creation: influencing, as it does, the very films which comprise it." Vincent F. Rocchio, *Cinema of Anxiety: A Psychoanalysis of Italian Neorealism* (Austin: University of Texas Press, 1999), 147.

21. Overbey, *Springtime in Italy*, 11. Overbey goes on to state: "It is not clear exactly where the term 'neo-realism' came from, nor who was the first to use it. Morlion claims rather vaguely that it was invented by unnamed Catholic critics. Visconti claimed his editor Mario Serandrei first used it after seeing the rushes of *Ossessione*. Umberto Barbaro, evidently, was the first to use it in print in *Cinema* in 1942, but applied it to French cinema" (32n1).

22. Ibid., 1.

23. Ruberto and Wilson, *Italian Neorealism*, 5.

24. Ibid., 7. The full Zavattini essay is reprinted in Overbey, *Springtime in Italy*, 67–78.

25. John Mason Brown, "A Tale of One City," *Saturday Review of Literature* 29, no. 14 (1946): 16–18.

26. Ruberto and Wilson, *Italian Neorealism*, 7; also in Millicent Joy Marcus, *Italian Film in the Light of Neorealism* (Princeton, N.J.: Princeton University Press, 1986), 23.

27. Thomas Elsaesser, "Primary Identification and the Historical Subject: Fassbinder and Germany," in *Narrative, Apparatus, Ideology: A Film Theory Reader*, ed. Philip Rosen (New York: Columbia University Press, 1986), 549.

28. De Grazia offers one model for understanding the importance of culture in the constitution of the North Atlantic community as a dominant postwar political economy. Victoria de Grazia, *Irresistible Empire: America's Advance through Twentieth-Century Europe* (Cambridge, Mass.: Belknap Press of Harvard University Press, 2005). Bret Benjamin has also provided an interesting way of thinking of the relationship between cultural and shifting economic configurations in this period. Bret Benjamin, *Invested Interests: Capital, Culture, and the World Bank* (Minneapolis: University of Minnesota Press, 2007).

29. André Bazin, *What Is Cinema?*, trans. Hugh Gray, 2 vols. (Berkeley: University of California Press, 1967, 1971), 2:20, 71.

30. Ibid., 2:55.

31. Ivone Margulies, ed., *Rites of Realism: Essays on Corporeal Cinema* (Durham, N.C.: Duke University Press, 2002).

32. Steimatsky, *Italian Locations*, xxiv.

33. Keathley narrates this history. Christian Keathley, *Cinephilia and History, or The Wind in the Trees* (Bloomington: Indiana University Press, 2006). See also Elena Gorfinkel, "Cult Film or Cinephilia by Any Other Name," *Cineaste* 34, no. 1 (2008): 33–38; and Paul Willemen, "Through the Glass Darkly: Cinephilia Reconsidered," in *Looks and Frictions: Essays in Cultural Studies and Film Theory* (Bloomington: Indiana University Press and British Film Institute, 1994).

34. Laura Mulvey, *Death 24 × a Second: Stillness and the Moving Image* (London: Reaktion Books, 2006). See also Mary Ann Doane, *The Emergence of Cinematic Time: Modernity, Contingency, the Archive* (Cambridge, Mass.: Harvard University Press, 2003).

1. An Inevitably Obscene Cinema

1. Bazin, *What Is Cinema?*, 2:137.

2. Linda Williams, *Hard Core: Power, Pleasure, and the "Frenzy of the Visible"* (Berkeley: University of California Press, 1989), 185.

3. Ibid.

4. Carolyn J. Dean, *The Fragility of Empathy after the Holocaust* (Ithaca, N.Y.: Cornell University Press, 2004). I discuss Agee in chapter 2.

5. André Bazin, *Qu'est-ce Que Le Cinéma?* (Paris: Les Éditions du Cerf, 1981), 254; Bazin, *What Is Cinema?*, 2:173. Bazin is referring here to his usage of the word in an earlier piece of writing, possibly "Death Every Afternoon," in Margulies, *Rites of Realism*, 27–31.

6. Bazin, *What Is Cinema?*, 2:138.

7. Ibid., 1:162.

8. Ibid., 2:21.

9. Dudley Andrew, *The Major Film Theories: An Introduction* (Oxford: Oxford University Press, 1976), 169.

10. Dudley Andrew, *What Cinema Is!* (Malden, Mass.: Wiley-Blackwell, 2010), 107–8.

11. Andrew, *Major Film Theories*, 170.

12. Andrew, *What Cinema Is!*, xix.

13. Bazin, *What Is Cinema?*, 2:21.

14. Ibid., 1:67.

15. Ibid., 2:20.

16. André Bazin, *Bazin at Work: Major Essays and Reviews from the Forties and Fifties*, ed. Bert Cardullo, trans. Alain Piette and Bert Cardullo (New York: Routledge, 1997), 187–88.

17. Bazin, *What Is Cinema?*, 1:51. In "Cinema and Exploration," he also references a post–World War II demand for films to be "believable" and carry "documentary authenticity" (155). "The prevalence of objective reporting following World War II defined once and for all what it is that we require from such [films]. Exoticism . . . has given way to a taste for the critical handling of the facts for their own sake" (158).

18. Bazin, *Bazin at Work*, 188. Even within his more universalizing descriptions of the human subject, he admits that certain periods are more conducive for evolving social needs and amplifying universal ones.

19. André Bazin, *Jean Renoir*, ed. François Truffaut (New York: Da Capo Press, 1992), 116.

20. Rosen theorizes Bazin's paradoxical historical determinism in "Subject, Ontology, and Historicity in Bazin"; see in particular 31–41. Philip Rosen, *Change Mummified: Cinema, Historicity, Theory* (Minneapolis: University of Minnesota Press, 2001).

21. Jean-Louis Comolli, "Machines of the Visible," in *The Cinematic Apparatus*, ed. Teresa de Lauretis and Stephen Heath (New York: St. Martin's Press, 1980), 134.

22. Bert Cardullo, introduction to Bazin, *Bazin at Work*, xiii.

23. André Bazin, "The Great Diptych: Geology and Relief," in *Orson Welles: A Critical View* (New York: Harper and Row, 1978), 80.

24. Bazin, *What Is Cinema?*, 2:71.

25. For a fascinating alternate reading of Bazin as a posthumanist, see Jennifer Fay, "Seeing/Loving Animals: André Bazin's Posthumanism," *Journal of Visual Culture* 7, no. 1 (2008): 41–64. Here Fay argues that Bazin's humanism does not limit itself to human bodies and may best be understood in relation to animals.

26. André Bazin and François Truffaut, *French Cinema of the Occupation and Resistance: The Birth of a Critical Esthetic* (New York: F. Ungar, 1981), 136, 138, 136.

27. Ibid., 138.

28. In Bazin's view, even American war documentaries and newsreels can be escapist.

29. Bazin and Truffaut, *French Cinema*, 138.

30. Ibid., 136, 137.

31. Bazin is most clearly interested here in recognizing a trans-European spectator. The essay's transnationalist tendencies at times hinge on the distinctness of

European cinema as apart from U.S. films. Americans do not seem to share the common experience of occupation that binds Europeans. In this sense, the transatlantic possibilities of cinema might seem to be laid aside. However, the essay's concern for Hollywood culture and its possible renovation along the lines of American literary traditions implies a wider scope for Bazin's internationalist vision. In the slippage between American films and American culture, it is unclear whether Bazin includes the American viewer. Bazin obviously sees the potential for American culture since he celebrates American novelists here and ends the essay by hoping for "cinematic production in every way worthy of American literary production." Ibid., 141.

32. Ibid., 137–38.

33. André Bazin, *What Is Cinema?*, trans. Timothy Barnard (Montréal: Caboose, 2009), 222.

34. Susan Sontag, "Looking at War," *New Yorker* 78, no. 38 (December 9, 2002): 97.

35. Jean Béranger and Howard B. Garey, "The Illustrious Career of Jean Renoir," *Yale French Studies*, no. 17 (1956): 35.

36. It should be noted how *The River* uses contrasting corporealities and comparative degrees of physical ableness to describe the breakdown of white colonial identity. In broad and bodily strokes, the film suggests the inevitable "loss of innocence" besieging Britons in India at the end of the 1940s. In this reading, the film could be seen to exploit corporeality as a means of explicating for the viewer what Britons felt when confronted by their own impotence in the face of change.

37. Henri Agel, "What Is a Cursed Film?," *Hollywood Quarterly* 4, no. 3 (1950): 297. Quéval's 1950 report for *Sight and Sound* on French attitudes toward British films describes Bazin as the typical French film critic, more essayist and aesthetician than movie reviewer. Jean Quéval, "France Looks at British Films," *Sight and Sound* 19, no. 5 (1950): 198–200. In 1952, *Sight and Sound* included Bazin in its roster of international critics whom the magazine polled for their personal choices of the best films of all time. "As the Critics Like It," *Sight and Sound* 22, no. 2 (1952): 58.

38. Cardullo, introduction to Bazin, *Bazin at Work*. For more on Bazin's presence at festivals, see Dudley Andrew, *André Bazin* (1978; reprint, New York: Columbia University Press, 1990), 205–6.

39. Louis Marcorelles, obituary of Bazin, *Sight and Sound* 28, no. 1 (1958–59): 29.

40. The journal of religion, *Cross Currents*, published a translation of his review of *La strada* in their summer 1956 issue (vol. 6, no. 3, pp. 200–203). *Time* magazine recognizes him as an expert on the western, synopsizing the major section of his book *Le Western, or Le Cinema Americain par Excellence* and quoting it at length. André Bazin, "Cinema: Le Western," *Time*, July 4, 1955. Long passages of the Stalin myth essay appear in J. G. Weightman, "The French Reviews," *Twentieth Century* 149 (1951): 41–47. "Jean Gabin—Tragic Hero" was published in the "Sense and Censorship" volume of *Impact on Film* (1949).

41. Andries Deinum, "Review: World Communications: Foreign Books," *Audio Visual Communication Review* 1, no. 3 (Summer 1953): 197–204; Georges-Michael Bovay, ed., *Cinema: Un Oeil Ouvert sur le Monde* (Lausanne: La Guilde du Livre, 1952); UNESCO, "Bibliography of Books and Articles on Mass Communication," *Reports and Papers on Mass Communication*, no. 21 (December 1956): 42.

42. Before becoming the first editor of *Film Quarterly* in 1958, Ernest Callenbach attended many of Bazin's film society screenings while in Paris to attend the Sorbonne's Institut de Filmologie in the early 1950s. In his recent recollection of starting the magazine and editing it for over thirty years, Callenbach notes the important influence of these months immersed in Paris film culture, highlighting the influence of Georges Sadoul and Bazin on his intellectual development. Ernest Callenbach, "Da Capo," *Film Quarterly* 2008.

43. Antonio Petrucci, ed., *Twenty Years of Cinema in Venice* (Rome: International Exhibition of Cinematographic Art, 1932–52), 359–77, 368.

44. Henri Agel, "Celluloid and the Soul," trans. Raymond Giraud, *Yale French Studies*, no. 17 (1956): 72.

45. Bazin, *Jean Renoir*, 124.

46. For Agel, realism's moral mission is to remind us of life's "becomingness." It exposes us to the spontaneous, the contingent, the pathetic. Here Agel elucidates what he takes to be the dominant features of midcentury realism. These same qualities often appear in Bazin's work.

47. Bazin, *Jean Renoir*, 124; Bazin, *What Is Cinema?*, 1:29.

48. Bazin, *What Is Cinema?*, 2:21n.

49. Ibid., 2:31.

50. Daniel Morgan, "Rethinking Bazin: Ontology and Realist Aesthetics," *Critical Inquiry* 32, no. 3 (Spring 2006), 443–81, 463.

51. Charles S. Peirce, *The Philosophy of Peirce: Selected Writings*, ed. Justus Buchler (New York: Harcourt, Brace, 1940), 108–9.

52. Peter Wollen, *Signs and Meaning in the Cinema*, 3rd ed. (Bloomington: Indiana University Press, 1972), 125–26.

53. Mulvey, *Death 24 x a Second*, 54–66.

54. Keathley, *Cinephilia and History*, 37.

55. Tom Gunning, "Moving Away from the Index: Cinema and the Impression of Reality," *differences* 18, no. 1 (2007): 29–52. Tom Gunning, "What's the Point of an Index? or, Faking Photographs," in *Still Moving: Between Cinema and Photography*, ed. Karen Beckman and Jean Ma (Durham, N.C.: Duke University Press, 2008), 23–40; Morgan, "Rethinking Bazin."

56. Quoted in Cardullo's introduction to Bazin, *Bazin at Work*, xi. In a similar vein, Monaco suggests that Bazin's critical approach thus mirrors the approach to reality taken by the realist films he celebrates: "Bazin was working to develop a theory of film that was deductive—based in practice. Much of this work proceeded through identification and critical examination. . . . Whatever conclusions Bazin drew were the direct results of the experience of the concrete fact of film." James Monaco, *How to Read a Film: The World of Movies, Media, Multimedia*, 3rd ed. (New York: Oxford University Press, 2000), 410.

57. There are of course moments when Bazin does mention features of the "total cinema" that extend beyond the animation of photography. For example, Nadar's vision of a moving image includes a soundtrack. Even here, however, the body grounds the myth. Bazin quotes Nadar: "My dream is to see the photograph register the bodily movements and the facial expressions of a speaker while the phonograph is recording his speech." Bazin, *What Is Cinema?*, 1:20. Synchronization requires a body that has been recorded in extreme detail, measured by the camera. As with sound, the possibility of further expansions to the medium— stereoscopy, for example—demands a kind of synchronization determined by visuals of moving bodies. Again, sound occurs as a secondary feature of this fantasy. Here the unrealistic and disruptive nature of this primitive soundtrack seems in direct contrast to the "flow of life" embodied in the image. Ibid., 1:21. Likewise, the passage from *L'Eve Future* quoted above ends, "Suddenly was heard a flat and unnatural voice, dull-sounding and harsh." In Nadar's quotation, the addition of sound appears as a secondary impulse or an add-on. Although another further advancement toward realization of the myth comes with a synched sound track, an innovation to cinema more new than old at the time of Bazin's writings, animation still stands as the primary and original actualization of the myth's long gestation. As it happens, Bazin's momentary emphasis on sound track stands out as an idiosyncrasy of this essay when we compare it to his disregard for the importance of sound in his other writings on cinema's ontology. Later essays seem more willing to assert the image as the primary feature of cinema's medium specificity. "The Evolution of the Language of Cinema" goes so far as to say that the advent of sound is somewhat inconsequential to filmmaking aesthetically realizing the full potential of cinema as a medium.

58. Akira Mizuta Lippit, "Digesture: Gesture and Inscription in Experimental Cinema," in *Migrations of Gesture*, ed. Carrie Noland and Sally Ann Ness (Minneapolis: University of Minnesota Press, 2008), 113–14.

59. Bazin, *What Is Cinema?*, 1:20.

60. Ibid., 1:20–21.

61. Gilles Deleuze, *Cinema*, trans. Hugh Tomlinson and Barbara Habberjam, 2 vols. (Minneapolis: University of Minnesota Press, 1986), 1:5.

62. Sean Cubitt, *The Cinema Effect* (Cambridge, Mass.: MIT Press, 2004); Lev Manovich, "What Is Digital Cinema?," http://www.manovich.net/TEXT/digital-cinema.html; Gunning, "Moving Away from the Index"; Lippit, "Digesture." See also Keathley, *Cinephilia and History*, 71.

63. Gunning, "Moving Away from the Index," 39.

64. The work of Doane and Heath remain among the most forceful articulations of the cinematic body. Both theorists investigate the relationship between the phantasmatic body of the film text and the production of bodies on screen, suggesting that the filmic representation of the body is linked to the conflation of the cinema with filmed images. Mary Ann Doane, "The Voice in the Cinema," *Yale French Studies* 60 (1980): 33–50; Stephen Heath, "Body, Voice," in *Questions of Cinema* (Bloomington: Indiana University Press, 1981), 176–93. Star studies

substantiates this cinepresence in documenting how the Hollywood industry exploits a mix of diegetic and nondiegetic figurations and textual and extratextual bodies. Benjamin's account of the film actor's estrangement and the cult of the movie star also contains a corollary dualism. Walter Benjamin, "Work of Art in the Age of Reproducibility," *Walter Benjamin: Selected Writings* (Cambridge, Mass.: Harvard University Press, 2003), 4:261.

65. Edward Branigan, *Projecting a Camera: Language Games in Film Theory* (New York: Routledge, 2006), 79.

66. Bazin, *Bazin at Work,* 192n5.

67. Here Lippit would part ways with Bazin, seeing this form of reconstituting the body, or what he calls "digesture," as central to cinema as a medium. Heath and Doane also understand the cinematic body's phantasmatic qualities as extending across shots and over edits. Doane, "Voice in the Cinema"; Heath, "Body, Voice."

68. Bazin, *Bazin at Work,* 192.

69. Bazin, *What Is Cinema?,* 1:35, 36, 26, 37.

70. Ibid., 1:35–36, 25.

71. Ibid., 1:34.

72. Ibid., 1:38.

73. Ibid., 1:81.

74. Ibid., 1:80. Other cultural forms known for their corporeality, such as commedia dell'arte and the Grand Guignol, also constitute key reference points in Bazin's history of the years before cinema. See Andrew, *André Bazin,* 89.

75. Bazin, *What Is Cinema?,* 1:52, 52.

76. Bazin uses children's fairy tale films and slapstick comedies as extreme test cases for what he regards as the realist basis of all cinema. At the end of "The Virtues and Limitations of Montage," which compares two children's films, Bazin concludes that even fantasy or gag sequences "must have the spatial density of something real" for them to succeed. Ibid., 1:48. For Bazin, the cinematic reality of one children's film "could not do without its documentary reality, but if it is to become a truth of the imagination, it must die and be born again of reality itself." Ibid., 1:47. In other words, the ability of slapstick comedy and fantasy films to take certain liberties with the laws of physics rests paradoxically on a visual insistence upon the physicality of the world. Andrew glosses this complex turn in Bazin's writing as "a certain transcendence of the physical by the physical." Andrew, *André Bazin,* 192.

77. Bazin, *What Is Cinema?,* 1:44, 49, 49, 50n.

78. Again, Bazin is careful here to designate this body as what we would call a cinematic body, an entity whose corporeality exists filmically. This is neither just a body depicted on screen nor the actual body of the actor.

79. Daney continues: "For the coexistence of crocodile and heron, tiger and star, in front of the camera, is not without its problems (particularly for the heron and the star), and to talk of 'heterogeneous' elements is a euphemism when it is a question of a violent incompatibility, a fight to the death." Serge Daney, "The Screen of Fantasy (Bazin and Animals)," in Margulies, *Rites of Realism,* 32–33.

80. Bazin, *What Is Cinema?*, 1:50, 50.

81. In one key passage in which Bazin criticizes analytical editing, he implies that this doorknob realism deems details useless, parasitical, and dispensible in the system of pregiven purpose and meaning set up in the structure of editing. Interstestingly, most of the details he cites ("dirt marks left at the level of the hand, the shine of the metal, the worn away look") suggest the evidence of a once-present human. Bazin, *What Is Cinema?*, 2:38.

82. Ibid., 1:161.

83. Ibid., 1:162, 163, 163. For more examples of how Bazin uses images of the body in danger to discuss contingency and the unique materiality of cinematic representation, see his "Death Every Afternoon."

84. Bazin, *What Is Cinema?*, 1:95.

85. Ibid., 1:97.

86. On the first page of this essay, Bazin declares, with misleadingly false certainty, "There is no answer to this argument." Ibid., 1:95.

87. Ibid., 1:96.

88. Ibid.

89. Ibid., 1:97n.

90. Ibid.

91. Ibid., 1:96, 96, 97.

92. Ibid., 1:96–97.

93. Ibid., 2:64–65.

94. Quoted in Andrew, *André Bazin*, 121.

95. Bazin, *What Is Cinema?*, 1:110–11.

96. Bazin advocates the wide framing of shots. This open framing, along with longer takes, allows for a more inclusive range of looks and is, for Bazin, more akin to the wide field of vision that a viewer encounters in everyday life outside the cinema.

97. Ibid., 1:98.

98. Ibid., 1:109–10.

99. Bazin's statements here and elsewhere seem to advocate for the end of the star system. To achieve a fully cinematic cinema, the stature of the star should be reduced, his or her appeal dwarfed, and his or her performance reincorporated into the film as just another element of the mise-en-scène.

100. Ibid., 2:56, 60.

101. Andrew, *Major Film Theories*, 169.

102. Bazin, *What Is Cinema?*, 2:20.

103. Quoted in Andrew, *André Bazin*, 80.

104. Keathley, *Cinephilia and History*, 53; Bazin, *What Is Cinema?*, 2:82.

105. André Bazin, *The Cinema of Cruelty: From Buñuel to Hitchcock* (New York: Seaver Books, 1982), 20.

106. Keathley, *Cinephilia and History*, 48.

107. Bazin, *What Is Cinema?*, 1:37, 39.

108. Ibid., 2:32. For more on the idea of transfer, see Morgan, "Rethinking Bazin," 449.

109. Bazin, *What Is Cinema?*, 2:38.

110. In writing about a group of neorealist films that respect the power of the long take, Bazin argues that two of the more violent moments in *Paisan*, the marsh sequence and the death of the peasants, are the opposite of doorknob realism— that is, analytical editing. He is careful to point out that *Paisan*'s shots never represent the totality of the real, but that each is a "fragment" or "image fact" operating on its own, preceding any meaning, and making "manifest an equally concrete density." In doorknob realism, much of what *Paisan*'s camera shows the viewer would appear "useless," as things to be "dispensed with," or, we could say, simply ignored. Ibid., 2:37.

111. "While the other arts survive precisely upon . . . imitation, the basic appeal of cinema is its connectedness to the event represented, a connectedness no other art enjoys. Bazin's criticism continually developed ways of determining the relation and effect of the origin of an image on its visual quality." Andrew, *André Bazin*, 110. For more on the figure as a feature of realist space, see Bazin's analysis of the kitchen scene in *The Magnificent Ambersons* in Bazin, *Orson Welles*, 68.

112. Bazin's celebration of "decoupage in depth" is particularly useful to consider here. Rather than cutting up an event into individual shots, this technique allows the event to unfold in depth and exposes the event's movement through depth. What depth enables the image (and spectator) to achieve would be unrecognizable were it not for performance or movement.

113. In discussing Bazin's relevance to current film theory, Margulies redefines "the epistemological promise of referential images" by raising the specter of cinematic representations of "possession ritual, animal sacrifice, torture, or physical disability." In other words, she seems to ask whether cinematic representation has a unique hold on "events that most stubbornly resist the notion of duplication because of their close association with carnality of the body and decay." Margulies, *Rites of Realism*, 1.

114. At least two of Bazin's essays address cinema's capture of life's unrepeatability through the filming of irreparable physicality—that is, bodies being injured, maimed, or dying. "Cinema and Exploration" and "Death Every Afternoon." Sobchack's essay, "Inscribing Ethical Space: Ten Propositions on Death, Representation, and Documentary," provides an interesting corollary to Bazin's work on the imbrications of photographic documentation, duplication, and the mortal body in the cinematic image. Vivian Sobchack, *Carnal Thoughts: Embodiment and Moving Image Culture* (Berkeley: University of California Press, 2004).

115. Margulies, *Rites of Realism*, 3. Comolli argues for reading the excesses that arise from an actor's physical incongruity with our sense of the historical figure that actor is playing. The actor's bodily presence raises a specter of incommensurability with the historical fiction that Comolli suggests warps the narrative conceits of historiography and in the end produces a more interesting kind of history. He cites Bazin's argument that Renoir's perpetual miscasting helps his films. The potency of these character to actor mismatches draws our attention to the obstinate presence of the actor's body in such a way as to actually amplify the

film's "powers of suggestion" and trump any literary versions of the same story. Jean-Louis Comolli, "Historical Fiction: A Body Too Much," trans. Ben Brewster, *Screen* 19 (1978): 47n8. See also Margulies's reading of Comolli's use of Bazin; *Rites of Realism*, 4.

116. Bazin, *What Is Cinema?*, 2:23, 23, 24.

117. Bazin, *Bazin at Work*, 182–83.

118. Bazin, *What Is Cinema?*, 2:23.

119. Ibid., 2:24.

120. Ibid., 2:57, 56, 50, 56.

121. Ibid., 2:56, 54–55, 55.

122. Ibid., 2:52, 57–58.

123. Andrew, *What Cinema Is!*, 33.

124. Bazin, *What Is Cinema?*, 1:110, 110.

125. Ibid., 2:69, 34n, 69.

126. Ibid., 1:162.

127. Andrew, *Major Film Theories*, 141.

128. Andrew, *André Bazin*, 105.

129. Bazin, *Bazin at Work*, 191.

130. Ibid., 189.

131. Here I am borrowing from Andrew's correction to the English translation of the Renoir book, which insists on the corporeal dimensions of Bazin's metaphors. Andrew, *Major Film Theories*, 258n9.

132. Bazin, *What Is Cinema?*, 2:76.

133. Ibid., 2:77–78.

134. Ibid.

135. Ibid., 2:77.

136. Ibid.

137. Again, the statement that the photograph "embalms time" asserts, at least figuratively, that time is a body on which the medium acts. Ibid., 1:14.

138. Cardullo, introduction to Bazin, *Bazin at Work*, xii.

139. Rosen, *Change Mummified*, 31–41.

140. Ibid., 41.

141. Mulvey, *Death 24 × a Second*, 100–101.

142. Dudley Andrew tells us that the "Ontology" essay was written in the climate of "death and deferral" of the occupation. For Andrew, this infects the essay with morbidity. Andrew, *What Cinema Is!*, 11.

143. I am aware that most actual mummification techniques involved embalming fluids or other preservation treatments. I am exploring the idea of mummification here as Bazin did: less as a historical phenomenon and more as a rich visual metaphor.

144. "The photographic image is the object itself . . . it *is* the model." Bazin, *What Is Cinema?*, 2:98. For a crucial rereading of this passage and a careful expansion of Bazin's denial of the ontological distinction between image and object, see Morgan, "Rethinking Bazin."

145. In current vernacular, the term *genetic* may carry an association with absolute determinism in ways it did not in the era that predates the human genome mapping project, cloning, and the use of DNA evidence in courts. For Bazin, the term *genetic* definitely spoke of origins, but was also probably tempered by the mystery of nature itself. Genetics implied a hidden code, inaccessible to human knowledge, and thus a code that could not simply be deciphered, but whose meaning evolved and developed over time through its expression. Consequently, I use the word *organic* as a loose approximation of Bazin's use of the word *genetic*. *Organic* also encapsulates the lexicon of other adjectives that Bazin used to invoke the ever-evolving quality of nature. This broad lexicon speaks of his commitment to finding the best methods to describe how cinema retains the shape of the transformations over time that reality always involves. *Organic* also suggests that the image and its meanings grow on its own accord and with the least amount of human intervention.

146. In his words, "'camera' comes to stand for a way of viewing in which we justify a (preexistent) procedure of looking." Edward Branigan, "What Is a Camera?," in *Cinema Histories, Cinema Practices,* ed. Patricia Mellencamp and Philip Rosen (Frederick, Md.: University Publications of America, 1984), 98.

147. Rosen, *Change Mummified,* 19.

148. Bazin, *What Is Cinema?,* 1:142.

149. Keathley, *Cinephilia and History,* 186n3.

150. Quoted in ibid., 63. Annette Michelson, introduction to Noël Burch, *Theory of Film Practice* (New York: Praeger, 1973), xi.

151. Andrew, *What Cinema Is!,* 9.

152. We can see this move anticipated in Serge Daney's writings on death. More recently, Oeler argues that Bazin's realism is as much about the power to destroy as it is about the impulse to preserve. "Cinema, for Bazin, is not only an instrument of preservation, but of loss." Karla Oeler, "André Bazin and the Preservation of Loss," *Film International* 5 no. 6 (2007): 82.

153. Bazin, *What Is Cinema?,* 2:57. Andrew suggests how Bazin's cinema invites a widening of the viewer's perception through an image that is lacking. Cinema forces us to "grasp" at what the image hints at, always pulling toward an encounter with that which is "just out of reach." Andrew, *What Cinema Is!,* 88. Along with Andrew, others read this partiality as a form of modernist intervention, a surrealist shattering of the world's completeness. See Adam Lowenstein, "The Surrealism of the Photographic Image: Bazin, Barthes, and the Digital Sweet Hereafter," *Cinema Journal* 46, no. 3 (2007). Morgan, "Rethinking Bazin."

154. Andrew says Bazin's image "traffics with absence, often *in absentia.*" Andrew, *What Cinema Is!,* 37. Rosen's initial and influential unpacking of Bazin's temporality argues that his image flaunts its pastness. A realism based on an indexicality presumes "a different *when* from that of the spectator." Rosen, *Change Mummified,* 20.

155. Andrew, *What Cinema Is!,* 9.

156. Bazin, *What Is Cinema?,* 1:108.

157. Keathley, *Cinephilia and History*, 53.

158. Brigitte Peucker, *The Material Image: Art and the Real in Film* (Stanford, Calif.: Stanford University Press, 2007), 64–65.

159. Gunning, "Moving Away from the Index," 47.

160. Ibid.

161. Lisabeth During, "Innocence and Ontology: The Truthfulness of André Bazin," in *European Film Theory*, ed. Temenuga Trifonova (New York: Routledge, 2009), 260.

162. Andrew, *What Cinema Is!*, 9.

163. Cardullo, introduction to Bazin, *Bazin at Work*, xiii.

164. Roland Barthes, *Camera Lucida: Reflections on Photography*, trans. Richard Howard (New York: Hill and Wang, 1981), 55–57. For more on the relationship between Barthes's ideas and Bazin, see Colin MacCabe, "Barthes and Bazin: The Ontology of the Image," in *Writing the Image after Roland Barthes*, ed. Jean-Michel Rabaté (Philadelphia: University of Pennsylvania Press, 1997), 71–76.

165. Lippit, "Digesture," 116.

166. Ibid., 122.

167. As Laura Mulvey points out in her discussion of Bazin, in "its most material aspect, the physical, 'existential,' link between object and image, gives rise to the most elusive and ineffable properties of this particular sign." *Death 24 × a Second*, 65. Lippit negotiates this complexity with a similar description of how cinema undoes our conventional understandings of presence: "Although cinema generates, perhaps more than any other medium, the effect of verisimilitude bordering on hallucination, the perceived proximity of bodies is balanced by the fundamental disappearance of the body as such in cinema, which is to say, the body is both virtually present and absent in filmic representation." "Digesture," 115.

168. Williams, *Hard Core*, 186.

169. Andrew, *Major Film Theories*, 169.

170. This ambivalence is also clear in the essay on war documentaries discussed earlier in this chapter. André Bazin, "On *Why We Fight*," in *Bazin at Work*, 187–92.

171. Philip Rosen, "History of Image, Image of History: Subject and Ontology in Bazin," *Wide Angle* 9 no. 4 (1984): 9.

172. Morgan, "Rethinking Bazin," 451–52.

173. Bazin, "Death Every Afternoon."

174. Ibid., 31.

175. Andrew, *What Cinema Is!*, 42.

176. Lippit, "Digesture," 115.

177. Rosen, *Change Mummified*, 13.

178. Bazin, *Bazin at Work*, 124

179. As Grist, a contemporary scholar rereading this analysis, puts it, in that face, the film's realism is exemplified as the "transmission of a manifest, unsettling indeterminacy." Grist sees the equivocation that the face introduces in precisely these antirealist terms: "Such captivation by the equivocal, by the indeterminate,

moreover, tends to imply an engagement with and advocacy of not so much realism as modernism." Leighton Grist, "Whither Realism? Bazin Revisited," in *Realism and the Audiovisual Media,* ed. Lúcia Nagib and Cecília Mello (New York: Palgrave Macmillan, 2009), 23.

180. Bazin, *What Is Cinema?,* 2:100.

181. Ibid., 2:64–65. This same obstinate presence hits us in *The Little Foxes* when we watch Bette Davis able to carefully control her breath as her husband struggles to breathe in the background of the shot. Although we are prevented from fully seeing his body writhe and convulse—it is just out of the range of focus, and it is sometimes obscured—her on-screen embodiment dominates. With this arrangement, Bazin says, her "frightening immobility takes its full impact." *Bazin at Work,* 4.

2. The North Atlantic Ballyhoo of Liberal Humanism

1. "Italian Film Invasion," *Life,* October 20, 1952, 107–13, at 107. The film used by this article to exemplify Italian cinema is *La voce del silenzio* (1953, G. W. Pabst).

2. Mario Verdone, "The Italian Cinema from Its Beginnings to Today," *Hollywood Quarterly* 5 no. 3 (Spring 1951): 270–81.

3. See chapters 15 and 16 of Kristin Thompson and David Bordwell, *Film History: An Introduction,* 2nd ed. (Boston: McGraw-Hill, 2003).

4. See Douglas Gomery, *Shared Pleasures: A History of Movie Presentation in the United States* (Madison: University of Wisconsin Press, 1992), 181. This critical history is narrated in Robert B. Ray, *A Certain Tendency of the Hollywood Cinema, 1930–1980* (Princeton, N.J.: Princeton University Press, 1985), 130–52. For more on the art film and American cosmopolitanism, see Peter Lev, *The Euro-American Cinema* (Austin: University of Texas Press, 1993), 5, 31.

5. Lev, *Euro-American Cinema,* 5.

6. In her detailed history of arthouse distribution and exhibition in this period, Wilinsky offers a summary of these accounts in *Sure Seaters.* See also chapter 2 in Tino Balio, *The Foreign Film Rensaissance on American Screens, 1946–1973* (Madison: University of Wisconsin Press, 2010).

7. *Bicycle Thieves* press clippings scrapbook, Billy Rose Theater Collection, Performing Arts Research Library, New York Public Library at Lincoln Center, New York.

8. Mark Betz, "Art, Exploitation, Underground," in *Defining Cult Movies: The Cultural Politics of Oppositional Taste,* ed. Mark Jancovich (Manchester: Manchester University Press, 2003), 202–23.

9. Thomas Elsaesser, "Putting on a Show: The European Art Movie," *Sight and Sound* 4, no. 4 (1994): 25.

10. See also Wilinsky, *Sure Seaters,* and Ray, *Certain Tendency.* Mark Betz's account of how the discipline of film studies understands this period's spectator has been indispensable to my thinking here. See Betz, "Art, Exploitation,

Underground." Some recent studies do not wish to condemn such positions of affect but rather celebrate the implosion of high and low. With a modernist flair, these studies seem to delight in exposing the "unseemly" attractions of films canonized for their moral strength. This tendency is found, for example, in Joan Hawkins, *Cutting Edge: Art-Horror and the Horrific Avant-Garde* (Minneapolis: University of Minnesota Press, 2000), 3–32. Some industry analysts of the period believed that two distinct audiences were coming to these films; see, for example, "Art, Exploitation Audiences Bait for TV; Only Sex Lures 'Em Back," *Variety*, July 23, 1952, 18; quoted in Balio, *Foreign Film Rensaissance*, 42.

11. Barbara Wilinsky, "Discourses on Art Houses in the 1950s," in *Exhibition: The Film Reader*, ed. Ina Rae Hark (New York: Routledge, 2002), 67.

12. Doane describes how cinema can implode the traditional distinction between pathos and ethos in ways that productively refuse the bifurcation of feeling and thinking. Mary Ann Doane, "Pathos and Pathology: The Cinema of Todd Haynes," *Camera Obscura* 19, no. 3 (2004): vi, 1–21.

13. Betz, "Art, Exploitation, Underground," 204.

14. Tag Gallagher, *The Adventures of Roberto Rossellini* (New York: Da Capo Press, 1998), 175.

15. *Germany Year Zero* press book, Superfilm Distributing Corp., New York.

16. Harold Barnes, "The Truth Exactly" (review of *Germany Year Zero*), *New York Herald Tribune*, September 20, 1949.

17. Review of *Open City*, *Philadelphia Evening Bulletin*, May, 6, 1946.

18. Bazin desires "both a more active mental attitude on the part of the spectator and a more positive contribution on his part to the action in progress. . . . It is from [the viewer's] attention and his will that the meaning of the image in part derives." Bazin, *What Is Cinema?*, 1:35–36. In singing the praises of Welles's "decoupage in depth," an aesthetic whose intentions Bazin frequently links to neorealism, he writes that it is "[m]ore realistic and at the same time more intellectual, for in a way it forces the spectator to participate in the meaning of the film. . . . [The spectator is] obliged to exercise his liberty and his intelligence." Bazin, "Great Diptych," 80. For Bazin, profilmic contingencies open up the image's ambiguity for the viewer and encourage a higher level of brain function, a greater freedom of thought, deeper mental activity, and even, in places, a moral engagement with what is represented: the more realist the image, the more intellectual the spectatorial participation. Realism refigures the category of awareness, linking the most local form of awareness, which is sensory experience, to the most global version of humanist awareness, thereby precipitating the international audience of newly engaged humanists that Bazin often envisions as neorealism's contribution to global culture. This follows at least in part from the cinematic image's innate capacity, already discussed in chapter 1, to permit access to times and spaces other than our own.

19. Bazin, "Great Diptych," 80.

20. Bosley Crowther, "Ultimate Irony of War" (review of *Paisan*), *New York Times*, April 11, 1948.

21. Arthur Mayer, who along with Joseph Burstyn distributed many canonical neorealist films, including *Paisan* in America, writes in his memoir: "The only sensational successes [we] scored . . . were [with] the pictures whose artistic and ideological merits were aided and abetted at the box-office by their frank sex content." Arthur Mayer, *Merely Colossal: The Story of the Movies from the Long Chase to the Chaise Longue* (New York: Simon and Schuster, 1953), 233. See also Eric Schaefer, *Bold! Daring! Shocking! True! A History of Exploitation Films, 1919–1959* (Durham, N.C.: Duke University Press, 1999), 334. This passage reminds us that in the 1950s vernacular for wide profit margins, the word *sensational* borrows from the language of affective responses.

22. *Open City* press book, Arthur Mayer and Joseph Burstyn, Inc., New York.

23. Linda Williams, "Film Bodies: Gender, Genre and Excess," *Film Quarterly* 44, no. 4 (Summer 1991): 2–13.

24. Schaefer, *Bold! Daring! Shocking! True!*, 330–37.

25. *Paisan* press book, Arthur Mayer and Joseph Burstyn, Inc., New York.

26. Likewise, the *New York Herald Tribune*'s characterization of *Germany Year Zero* as "most savage and shattering" does not prevent the same review from declaring it "profoundly imaginative [and] artistically . . . superlative." September 20, 1949.

27. Review of *Germany Year Zero, Newsweek*, September 26, 1949, 90. Cited in *Germany Year Zero* press book.

28. Responding to censorship of *Bicycle Thieves,* Joseph Burstyn, the film's distributor, issued a similar challenge in a national magazine, suggesting that the truly ethical viewer can tolerate content otherwise deemed offensive: "I dare any civic-minded man or woman to find anything in the picture offensive." "Banned Bicycle," *Newsweek,* March 13, 1950, 78.

29. Siegfried Kracauer, *Theory of Film: The Redemption of Physical Reality* (New York: Oxford University Press, 1960), 57.

30. Ibid., 58. Emphasis added.

31. Ibid. Emphasis added.

32. Crowther, "Ultimate Irony of War."

33. Lee Morris, "'Open City' Has Spirit That Makes a Movie—and a People—Great," *Philadelphia Sunday Record,* 1946, Museum of Modern Art, New York, clippings file.

34. Neorealism's corporeal spectacles involve male and female bodies as well as male and female viewers. *Rome Open City*'s extended scenes of torture, for example, focus on exposed male bodies that were often subjected to the gaze of female characters.

35. Significantly, voyeurism is depicted as an activity that engages both male and female viewers.

36. Similarly, accounts of other neorealist films emphasized being on the scene: "*Open City* is a shocking picture. It is shocking to home-body sensibilities that have not faced beachheads and foxholes, and even perhaps to veterans who were

not at Belsen or Dachau." Kenneth MacGowan. "Summer Films, Imported and Domestic," *Hollywood Quarterly* 2 (1946–47): 91.

37. "Italian Film Invasion," 108.

38. Manny Farber, review of *Open City, New Republic,* July 15, 1946.

39. John Beaufort, "Rossellini Film Shown in New York," *Christian Science Monitor,* September 24, 1949.

40. Gallagher, *Adventures,* 177.

41. United States Congress, House, Special Committee on Post-War Economic Policy and Planning, 79th Cong., 2nd sess., December 20, 1946, part 9. Quotation from statement by Eric Johnston reprinted in the proceedings on 2598. Expanding on the views of art historian Arnold Hauser, David Riesman would write in *Film Culture*: "The movies, of course, are a boundary-annihilating form, easily transmissible past linguistic and cultural barriers (as well as barriers of literacy), . . . a democratizing form because of their mobility." David Riesman, "The Oral Tradition, the Written Word, and the Screen Image," *Film Culture* 2, no. 3 (9) (1956): 2.

42. Gerald M. Mayer, "American Motion Pictures in World Trade," *Annals of the American Academy of Political and Social Science* 254 (1947): 35.

43. Ibid., 36. Additionally, McCarthy's work on 1950s television offers an interesting parallel history in its tracing of the early contours of neoliberalism and the invention of the cold war citizen. In particular, chapter 3, "The Ends of Middlebrow," resonates with my description of a North Atlantic eagerness to imagine a global spectator in step with the concerns of a new world order. She writes, "Liberal reform fantasies crystallized . . . around . . . the possibility that Americans were unprepared and uneducated when it came to meeting the challenges and responsibilities of the postwar world." This chapter concerns one particular example of the cultural readjustment that cold war liberals believed would help strengthen the American subject: *Omnibus,* a program that broadcast snippets of other texts, including a section of Rossellini's *The Flowers of St. Francis,* which was excerpted to highlight its neorealist style. Anna McCarthy, *The Citizen Machine: Governing by Television in 1950s America* (New York: New Press, 2010), 119.

44. The United Nations Film Board used this description as part of the banner for its "Film News" column, which was a regular feature of the *U.N. Bulletin* starting with volume 5 (1948): 840. For more on the liberal politics of the United Nations' film projects, see Zoë Druick, "'Reaching the Multimillions': Liberal Internationalism and the Establishment of Documentary Film," in *Inventing Film Studies,* ed. Lee Grieveson and Haidee Wasson (Durham, N.C.: Duke University Press, 2008), 66–92.

45. A reference librarian contributed a short review of Rossellini's *The Miracle,* which concludes: "People who dislike its theme are not compelled to see the picture; neither should they be allowed to prevent other people from doing so." *Library Journal* 76 (March 1, 1951): 418. In an essay entitled "Your Patrons Need Films," Glen Burch, director of the Film Council of America, argues to his audience of librarians: "The extensive use of films and other audio-visual materials during World War II opened the eyes of millions of Americans to the tremendous

potentialities of this new medium of communication. In the period of uneasy 'peace' which has followed the cessation of hostilities, more and more people in this country are turning to films as one of the most effective instruments for education." Citing UNESCO education films and documentaries, Burch claims that more than "book learning" or any amount of "verbalizing" cinema with its "graphic presentation of the moral problem" of peacetime "promotes understanding" and has the possibility of "solving the great problems presented by the peace." *Library Journal* 74 (March 15, 1949): 413, 416, 417.

46. Jack Ellis, "Theatrical Film on 16mm," *Sixty Years of 16mm Film* (Evanston, Ill.: Film Council of America, 1954), 179.

47. For example, see the 1951 and 1953 editions of the Education Film Guide; both feature many neorealist films in their resource listings, including *Rome Open City, Paisan,* and *Bicycle Thieves.* Alongside similar listings in the December 1956 issue of *Educational Screen and Audio-Visual Guide,* there appears an advertisement for Brandon Films' Grand Repertory World Cinema division, which includes a description of *Shoeshine* in its featured offerings (473).

48. October 1946, 473; *Educational Screen,* January 1947, 38, 39.

49. Advertisement for Films of the Nations, *Library Journal* 74 (March 15, 1949): 423.

50. Cecile Starr, ed., *Film Society Primer* (Forest Hills, N.Y.: American Federation of Film Societies, 1956). "Foreign Films Movie Club Launched," *Foreign Film News* 1, no. 8 (February 1949).

51. "Religion: The Miracle," *Time,* February 19, 1951.

52. *Joseph Burstyn, Inc. v. Wilson,* 343 U.S. 495 (1952).

53. Bosley Crowther, "The Strange Case of 'The Miracle,'" *Atlantic Monthly* 187 (April 1951): 36.

54. Raymond Spottiswoode, *Film and Its Techniques* (Berkeley: University of California Press, 1951), 21.

55. *Selling Democracy: Films of the Marshall Plan, 1948–1953,* exhibition catalog, Sandra Schulberg and Ed Carter, curators (Academy Film Archive of the Academy of Motion Picture Arts and Sciences, 2005–6), 10.

56. The text of Marshall's speech is available at http://www.marshallfounda tion.org/library/doc_marshall_plan_speech.html.

57. De Grazia, *Irresistible Empire,* 338, 343, 347. For more on the idea of liberalization, see 341.

58. For a propagandistic invocation of this "limited sovereignty" from a contemporary voice, see the Republican activist and Motion Picture Association of America president Eric Johnston's pro-American capitalist rant in the essay "The World We Live In." With a condescending tone that mocks Italians and their provincialism, he justifies American intervention in the Italian national elections of 1948. Attempting to validate this intervention and the presumption of a world in which all people automatically know that they should vote market-savvy political parties into power, he writes: "The Italian elections remains a great dramatic story . . . [whose] significance lies in the fact that elections everywhere around the

world will follow the same pattern from now on; will continue to catch our interest [as Americans] and catch it because we know the outcome will affect us. Elections aren't going to be local any more anywhere. . . . The Luigis and the Carlos around the world aren't going to slink back humbly into being pushed around as part of a 'faceless mass.' They have tasted the heady wine of political power, and they are going to use that power for their economic betterment." Johnston, *We're All in It* (New York: E. P. Dutton, 1948), 11–28, 20–21.

59. Paul Strand, "Realism: A Personal View," *Sight and Sound* 18 (January 1950): 26.

60. Ibid.

61. James Agee, *Film Writing and Selected Journalism* (New York: Library of America, 2005), 268.

62. Ibid., 311.

63. Ibid., 476.

64. Ibid., 475–76.

65. Ibid., 475.

66. James Agee, "Films," *Nation,* March 24, 1945.

67. For a different reading of Agee's use of the term *pornography* as a means of describing how violent images produce subjective exhaustion in the context of postwar culture, see chapter 1 of Dean, *Fragility of Empathy.*

68. Agee, *Film Writing,* 179.

69. Ibid., 516.

70. Ibid., 328.

71. Jonathan Rosenbaum and Adrian Martin, *Movie Mutations: The Changing Face of World Cinephilia* (London: British Film Institute, 2003), vii.

72. Jonathan Crary, *Techniques of the Observer: On Vision and Modernity in the Nineteenth Century* (Cambridge: MIT Press, 1993), 21.

73. For a cultural history of Italian political affiliations in this period, see Stephen Gundle's *Between Hollywood and Moscow: The Italian Communists and the Challenge of Mass Culture, 1943–1991* (Durham, N.C.: Duke University Press, 2000).

3. Rossellini's Exemplary Corpse and the Sovereign Bystander

1. In this introductory narration, Scorsese explains how watching these films forced him to see his grandparents as immigrants for the first time, exposed him to the world they had left behind, and acquainted him with their sense of dislocation—historically, geographically, and culturally. Despite having grown up in a neighborhood at the center of Italian immigrant culture, Scorsese claims it was not until seeing neorealist films on TV that he learned about Italy and began to understand what it meant to be Italian at the middle of the century. He also seems to have learned about the potential for cinema to provide its audiences with a social and political experience outside themselves, or as he puts it, "All of a sudden my world became much bigger." Hence the experience of watching televised Italian

films with his extended family commemorates in Scorsese's memory a loss of child-hood innocence: a conjunction between his growing awareness of the difficulties of adulthood and of Italians in the world. Here I am asking through what aesthetic means neorealist films triggered the simultaneous awakening of various identities: adult, Italian, Italian American, cinephile, international spectator, and presum-ably nascent auteur.

2. This neglect is especially striking given both Scorsese's intense aesthetic engagement with violence throughout his own films and his status as a midcentury American spectator.

3. Overbey, *Springtime in Italy*, 1.

4. An example of the latter tendency can be found in the work of Liehm, who has written that the director "saw film as an instrument of a modern vision, a way of seeing things 'with one's own eyes.'" Mira Liehm, *Passion and Defiance: Film in Italy from 1942 to the Present* (Berkeley: University of California Press, 1984), 65. The influential critiques of realism published in *Screen* saw this unselfcon-scious mode of looking as ideologically suspect. See in particular Colin MacCabe, "Realism and the Cinema: Notes on Some Brechtian Theses," *Screen* 15, no. 2 (1974): 7–27.

5. Even in statements that more boldly defer to the profilmic, Rossellini main-tains the centrality of cultivating a distinct point of view: "I try to interfere the minimum amount possible with the image, my interference is only to find the point of view and to say what is essential, no more. . . . My purpose is never to convey a message, never to persuade but to offer everyone an observation." Andrew, *André Bazin*, 120–21. Here again the construction of a particular point of view—one that must be found—appears as a crucial goal of Rossellini's realism. In exchange for a cinema of persuasion, Rossellini proposes a cinema in which point of view, obser-vation, and universal accessibility are one and the same.

6. In the classical Hollywood text, the image cannot register any formal pecu-liarities in representing the gaze of one character versus another. To do so would violate the narrational and formal premise of the mainstream film text as defined by Bordwell, Thompson, and Staiger, among others. Even fantasy films are con-fronted with the problem of how to differentiate kinds of looking without calling into question the realism of the image. For example, the world seen through the eyes of the Wicked Witch of the West does not appear to be different from the world that Dorothy sees. (The witch's crystal ball is, perhaps, a device that enables a representation of her specific and violent vision without infecting the narration.) Points of view of drunken, drugged, and otherwise optically inebriated characters are minor exceptions to this rule.

7. The work of Colin MacCabe motivates the central conceptual questions posed by this chapter in three ways. First, his writings from the mid-1970s re-main the most substantial theorization of the importance of visual narration and point of view to realist films. Also important to this chapter are his specific anti-Bazinian insights on neorealism. He reminds us that Roberto Rossellini's realism resides not in the subject matter but in "the way the subject matter is ordered and

articulated," an idea that we see contextualizes the comments of Rossellini cited above and urges us not to overemphasize random details as evidence of realism on their own. Realism is constituted neither in the registration of minutiae nor in the faithful adherence of the image to its profilmic origins. Rather, we must address corporeal moments as key to the structure of the film and not simply as excesses added to provoke a Barthesian "reality effect." We can infer here that MacCabe would view Rossellini's seemingly innocuous act of providing the viewer with a point of view as one of the most political operations of a film. Finally, MacCabe also suggests that Rossellini's films are structurally fragmented and lack the resolution of mainstream cinema, often frustrating the viewer's ability to identify with characters and introducing discourses that operate in spite of the dominance of the narrative. MacCabe, "Realism and the Cinema," 20. See also Colin MacCabe, "Theory and Film: Principles of Realism and Pleasure," *Screen* 17, no. 3 (1976): 7–28.

8. Hence the Nazi point of view and the Resistance perspective present a representational problem for the film. The film must devise a way to specify a new perspective without surrendering the image to the particularities of the point of view of a single character or that of a group of characters.

9. My phrasing here again borrows from MacCabe. "Realism and the Cinema," 20.

10. Marcus, *Italian Film,* 44.

11. Comolli, "Historical Fiction," provides an interesting analysis of how films rechannel eruptions of bodily excesses within the image.

12. My reading of the film also conflicts with accounts that read the brutalized body as a symbol. In one example of this type of reading, Armes argues that Manfredi's body offers a surface onto which the film projects, through a depiction of brutal torture, the conflict between Resistance politics and the Church. Manfredi's unwavering courage in the face of his horrendous torture turns his scarred and prostrated body into a symbol not of defeat but of defiant martyrdom, an "idealized picture of Communist and Catholic working in total unison." Roy Armes, *Patterns of Realism* (South Brunswick, N.Y.: A. S. Barnes, 1971), 74. Liehm follows a similar trajectory, identifying various moments when the film indulges the Christian iconography of martyrdom. Liehm, *Passion and Defiance,* 63. Millicent Marcus has also commented on the pained body as a stand-in for the larger issues addressed by the film. Marcus points to a boy on crutches in the film's last scene, reading the boy's missing leg as a metaphor for postwar Rome itself, a city maimed and disabled. Marcus, *Italian Film,* 49.

13. The first sequence sets the pattern for this process of disengagement, which the film articulates through offscreen sound and frame composition. Offscreen sound triggers directional looks. A next shot presents a closer framing of characters as they look out the window into offscreen space. The shot that follows represents their point of view by keeping an architectural threshold of the characters' space within the frame (edges of the window frame and gate of the balcony) while introducing the scene outside. This momentary emphasis on framing (and the mediation of the world through characters' eyes) gives way immediately to a series of

objective camera shots almost documentary in their roving character. Before returning to its point of origin, the visual narration devolves from character point of view as the camera explores outside events around and about the city. These shots include arenas of action well beyond the range of an onscreen character's physical capabilities. This same structure of shots repeats with only slight variation.

14. Armes, *Patterns of Realism*, 71.

15. Her death is also a shock for many other reasons, including the fact that because Francesco and Manfredi are being hunted by the Germans, the viewer is liable to assume that they are the ones most likely to die.

16. Wagstaff narrates an interesting comparison: "A scrupulous *narrative* film director will either include 'establishing shots' in his montage, to orient the viewer topographically, or he will avoid the need for this by one of two methods: either by choosing his angles so as to preserve a coherent point of view or by developing his scenes in long takes in which characters move around the location. Rossellini does neither of these things." Christopher Wagstaff, *Italian Neorealist Cinema: An Aesthetic Approach* (Toronto: University of Toronto Press, 2007), 168.

17. Wagstaff provides a fascinatingly detailed history of the camera work and editing of this sequence. By means of an almost archeological approach, he suggests how unpacking these few minutes of the film demonstrates the willingness of Rossellini's filmmaking to tolerate and incorporate the contingencies of making films in Italy at this time. Ibid., 167–71.

18. Bazin, *What Is Cinema?*, 2:32, 33, 20. Marcus describes the film as having a "newsreel quality," suggesting that scenes such as Pina's death reveal "a roughness and spontaneity matching the very historical circumstances of its birth." Marcus, *Italian Film*, 34, 35. For a particularly careful analysis of the documentary posturings of this scene, see Forgacs, *Rome Open City*, 9. Rancière's reading of Pina's death in "Falling Bodies: Rossellini's Physics" is fascinating for how it reframes the film's most corporeal moments as both documentary and gestural, conscious and unconscious. Pina's corpse becomes a site of exploration for the theorist, where the accidental is not the disruption of grace but its elaboration, and the contingencies of a body emerge as a form of arabesque. Jacques Rancière, *Film Fables*, trans. Emiliano Battista (Oxford/New York: Berg, 2006).

19. See Forgacs, *Rome Open City*, 55, 54.

20. The sequence that immediately precedes Pina's death offers an interesting contrast. The conclusion of a chase, a sequence that includes overtly handheld camera work used to follow the movement of characters up and down the stairs, results in the simulated death of an old man. The violence is captured offscreen and the revelation of the "corpse" occurs in a traditionally composed and balanced shot.

21. Eric Rohmer and François Truffaut, "Interview with Roberto Rossellini," in *Cahiers Du Cinéma: The 1950s, Neo-Realism, Hollywood, New Wave*, ed. Jim Hillier (New York: Routledge & Kegan Paul/British Film Institute, 1985), 210.

22. Ibid., 210, 13.

23. Martin Walsh, "Re-evaluating Rossellini," *Jump Cut,* no. 15 (1977): 13–15.

24. Peter Bondanella, *Italian Cinema: From Neorealism to the Present* (New York, 1983), 40.

25. Serge Daney, "The Tracking Shot in *Kapo,*" *Senses of Cinema,* no. 30 (2003), http://www.sensesofcinema.com/contents/04/30/kapo_daney.html.

26. Alan Millen, "Francis God's Jester," in *Roberto Rossellini: Magician of the Real,* ed. David Forgacs, Sarah Lutton, and Geoffrey Nowell-Smith (London: British Film Institute, 2000), 85–86.

27. To be clear, I am not saying that the film provides two separate and contradictory accounts of the same event. It is just that one perspective dies off.

28. For a discussion of the centrality of the scapegoat to this film, see P. Adams Sitney, *Vital Crises in Italian Cinema: Iconography, Stylistics, Politics* (Austin: University of Texas Press, 1995), 36.

29. For example, P. Adams Sitney contends that the sounds, not sights, of the torture redeem the realism of the otherwise stagy melodrama of this section of the film: "The cries which can be heard in Bergmann's office through opening doors whenever his aide enters or leaves heighten the cruelty of his hyperstylized mannerisms and suggest, because they leave so much to our imagination, an arena of pain surrounding the cramped theater of Nazi posturing. . . . The well-timed punctuation of torture sounds distracts us from the trite cinematic conventions of the headquarters dialogues, but more profoundly, they create a context in which the very staginess of the German scenes can be absorbed into a rhetoric of realism." Yet I would suggest that the offscreen status of Manfredi's torture only invites a spectatorial desire to see what is being done. His offscreen screams of pain, even when heard at a distance or muffled by a closed door, supplement not only the building narrative tension but also the visual spectacle, triggering us to look and focus on certain features of the image over others. Sitney is correct to assert that most of Manfredi's beating occurs off camera. However, this does not detract from the intense spectacle of what is shown. The viewer is asked to step into a position of rubbernecking uneasiness, oscillating in a "show me/don't show me" duality between a desire to know via sight and a fear of being shown something disturbing. Sitney's characterization of the sequence elides the fact that the film portrays not only the visual evidence of offscreen torture, but also violence in action. Ibid., 37. Similarly, Bondanella writes: "Manfredi's torture is one of the most horrifying of many such scenes in the history of filmmaking; yet Rossellini achieves this startling effect on the viewer not by showing us merely the reality of the torture with minute attention to detailed close up shots, but rather, by exploiting the power of our imagination and focusing upon the reactions of Don Pietro." *Italian Cinema,* 41.

30. The contrast between critical accounts of the violence in this film may be due in part to the various prints in circulation and reflect the film's complex history of release prints. Until the recent restoration by the Criterion Collection, the DVD version most easily available in the United States, released by Kino Video, was slightly less explicit in its depiction of the torture. Missing are several gruesome

detail shots of the torture procedures and Manfredi's lesions. This earlier DVD uses U.S. prints, including what appears to be the relatively sparse subtitling originally commissioned by Burstyn and Mayer. According to Gallagher, Burstyn and Mayer toned down references to Marina's cocaine use and removed detail shots of torture in anticipation of American censors, but the distribution history of the film here is murky. Interestingly, the most controversial parts of the film for the Legion of Decency and the MPPA were two shots of a baby boy urinating and then being held up half-naked by his sister and put into his bed, his leg still wet with urine. Gallagher, *Adventures,* 175. The shot list in the English recreation of the script also reflects this more complete version of the torture sequences. Roberto Rossellini, Stefano Roncoroni, and Sergio Amidei, *The War Trilogy [of] Roberto Rossellini,* trans. Judith Green (New York: Grossman, 1973). This volume is not a production artifact but rather a descriptive reconstruction and transcription of the film culled from various prints. It is clear that the film was shown in the United States both with and without these detail shots. My discussion here uses a more complete version, one that retains the shots of Manfredi being beaten on camera. In either case, American critics described the film as containing unusually graphic depictions of violence for the U.S. market. I originally saw this more explicit version in Italy and then found a similar version on VHS released by Connoisseur Collection with a 1991 copyright held by Renzo Rossellini and a 1945 copyright held by Excelsa.

31. Bondanella comments on the flexibility of the Nazis, who travel between the radically different zones of the mise-en-scène in this section of the film. With indifference, Bergmann travels from the luxurious drawing room to his office to the torture chamber. Bondanella, *Italian Cinema,* 41. Because according to Mulvey the articulation of the gaze is structured around sexual difference, the same-sex desiring look may have the potential to upset mainstream cinema's structuring of the gaze, destabilizing hierarchies of power and vision and violating the traditions of who is looked at by whom. Laura Mulvey, "Visual Pleasure and Narrative Cinema," *Screen* 16, no. 3 (1975): 6–18. For more analysis of this film's use of homosexuality, see Sitney, *Vital Crises,* and Forgacs, *Rome Open City.* In addition, *Germany Year Zero, Shoeshine,* and *Bicycle Thieves* rely on the figure of the homosexual pervert to depict bad looking, unethical witnessing, or moral depravity. The films use these figures as symptoms of the larger collapse of values in Italian society and the need for an external and adjudicating gaze. According to this homophobic logic, we know a nation is on the brink of catastrophe when it allows the gazes of predatory sexual/gender deviants to roam its public sphere. Bernardo Bertolucci's *The Grim Reaper* (*La commare secca,* 1962) might be seen as a reworking of this trope: it positions the homosexual pederast as the ethical observer.

32. Marina's fainting spell is interesting to consider in this respect. It suggests that her status as Italian trumps her status as a collaborator and Nazi sympathizer.

33. For more on the complex relationship between point-of-view shots and patterns of spectatorial identification, especially with villains, see Edward Branigan, *Point of View in the Cinema: A Theory of Narration and Subjectivity in Classical Film* (New York: Mouton, 1984); chapters 1 and 4 in Carol J. Clover, *Men, Women,*

and Chain Saws: Gender in the Modern Horror Film (Princeton, N.J.: Princeton University Press, 1992); and chapter 7 in Williams, *Hard Core*.

34. The Nazi soldiers are associated with unethical gazing in this sequence as well. Just before the capture of Francesco and the death of Pina, the soldiers break from their search for Francesco in the basement to peer up at the legs of the women who wait on the street outside. Later, the German guard on the street leers at Pina.

35. Rather than turn himself away from the sculptures, he turns the saint away from staring at the naked Venus.

36. Buss writes that compared to fascist films, neorealism was brutally grim and grisly to the point of sadism, but at the same time not excessive because of its purpose: "There is more overt violence, taken almost to the point of sadism, in Rossellini's *Roma, città aperta,* but Rossellini's view of the war is heroic: the heroes die but not in vain." Robin Buss, *Italian Films* (New York: Holmes & Meier, 1989), 25.

37. Marcus, *Italian Film,* 48–49.

38. Ibid., 52–53. Landy provides a fascinating perspective on the issue of openness in her reading of this film. Marcia Landy, *"Rome Open City:* From Movie to Method," in *Film Analysis: A Norton Reader,* ed. Jeffrey Geiger and R. L. Rutsky (New York: Norton, 2005), 400–421.

39. Rogin, "Mourning, Melancholia," 152.

40. Peter E. Bondanella, *The Films of Roberto Rossellini* (New York: Cambridge University Press, 1993), 69.

41. Neorealism's means of coding the U.S. intervention in Europe often depends on African American male characters as the apparently overtly identifiable evidence of the American presence in Italy, whether it be the M.P. officer, Joe, in part 2 of this film, a similar figure at the start of *Sciuscià,* or the characters featured in *To Live in Peace (Vivere in pace,* Luigi Zampa, 1946) and *Without Pity (Senza pietà,* Alberto Lattuada, 1948). It appears as though these films use a raced body to signify American intervention, but further study is required to adequately address this issue.

42. Dalle Vacche argues that the corporeal dimension of this film was particularly important to early Italian scholars of neorealism, such as Brunello Rondi. National history was both registered on these bodies and moved forward by them. For Rondi, she argues, "the faces, gestures, and movements of non-actors in *Paisà* carry history *in* them, while carrying *forward* the story." *The Body in the Mirror,* 213. Brunello Rondi, *Il Neorealismo Italiano* (Parma: Guanda, 1956).

43. Although this is an Italian film, this first sequence, along with the English voice-over narration for the U.S. release, clearly locates authority outside the geographies of the diegesis. The Italian version of the film retains the American dialogue that accounts for the majority of the speaking in this film. Both releases include subtitles.

44. For more on the visual politics of this display, see Rogin, "Mourning, Melacholia."

45. Toward the end of the episode, a body twisting on a noose maintains a similar dynamism.

46. Sandro Bernardi, "Rossellini's Landscapes: Nature, Myth, History," in Forgacs, Lutton, and Nowell-Smith, *Roberto Rossellini,* 54.

47. The camera work performs a similar function later in the episode, when Dale and Alan return to the partisan home that hid Dale earlier and discover that Nazis figured out the allegiances of this family, leaving a gruesome scene outside the house. The camera's tracking motion, which here divulges the massacre for the viewer, overtly dispenses with any diegetic eyewitness in a way that prevents either the bodies from being memorialized or the gaze from being granted any nationalist specificity.

48. More than in the other chapters of this book, Steimatsky touches here on neorealism's corporeal character, examining the suicide of the young central character in *Germany Year Zero* and the ancient petrified corpses in *Voyage to Italy* (*Viaggio in Italia,* Rossellini, 1954). Steimatsky, *Italian Locations,* 41.

49. Ibid., 43.

50. Discussing the difficulties of defining realism in cinema, Hallam and Marshment propose the idea of a "relative realism": "As Noel Carroll puts it, 'realism is not a simple relation between films and the world but a relation of contrast between films that is interpreted in virtue of analogies to aspects of reality'. . . . A film or film style may be deemed realistic because it differs from current films or film styles, where the difference is construed as revealing a reality that was formerly hidden or absent. Carroll maintains that because realism is a term whose application rests upon a historical comparison with other films and film styles, it cannot be used unprefixed; hence the use of terms such as Soviet realism, neorealism and 'kitchen sink' realism are all descriptions of attempts to depict a reality that was absent from other styles at the time of the conception of the category. . . . Realism continues to be used as a yardstick." Julia Hallam and Margaret Marshment, *Realism and Popular Cinema* (Manchester: Manchester University Press, 2000), xi.

51. Landy, *"Rome Open City,"* 419.

4. Spectacular Suffering

1. Overbey, *Springtime in Italy,* 88.

2. Bert Cardullo, *Vittorio De Sica: Director, Actor, Screenwriter* (Jefferson, N.C.: McFarland, 2002), 168.

3. Cesare Zavattini, "Some Ideas on the Cinema," *Sight and Sound* 23, no. 2 (1953): 64–69, 66.

4. Bazin, *What Is Cinema?,* 2:60.

5. Hermine Isaacs, review of *Shoeshine, Theater Arts* 31 (1947): 53.

6. Cardullo, *Vittorio De Sica,* 43.

7. In their eagerness to imagine the emancipation of a charitable humanism, these films undermine the agency of the intranational gaze, suggesting that the redemption of our world relies on recognizing the outsider's agency. These films do

not exactly shun a domestic viewer, but they are inhospitable to any perspective that delimits the authority of the gaze within local borders. In the end, the films compel the domestic viewer to adopt the foreigner's gaze, as is reflected in the politics of the day known as "self-imposed limited sovereignty."

8. Agel, "Celluloid and the Soul," 72.

9. Vittorio De Sica, "The Most Wonderful Years of My Life," *Films and Filming* 2, no. 3 (1955): 6.

10. Marcus, *Italian Film*, xiv.

11. Here it is interesting to consider how *Shoeshine,* like *Rome Open City,* goes beyond simply typifying Colin MacCabe's definition of realism. According to MacCabe, most conventional films share a particular realist epistemology: knowledge is organized by a hierarchy of discourses. In this hierarchy, certain discourses are more or less reliable. Across the board, what we are shown always remains true. In other words, the visual track of a conventional film reigns as the supreme and uncontradicted source of truth. The image provides the film with its meta-discourse; the image is able to comment on and expose the partiality of other types of discourse in the film (for example, sound). *Shoeshine* not only follows MacCabe's hierarchy; the film actually creates a fable of that hierarchy in its narrative. The primacy of seeing is not a general ideological condition of the subject inherited from the Enlightenment (as it is for MacCabe). In this film, the hierarchy of the visible holds a specific moral prerogative. Unhindered vision emerges not simply as the surest path to truth; the awareness brought on by the freedom to look also stands as the precondition of postwar social being. The supremacy of the visual over all other forms of experience is a prerequisite of a humane and stable world. Marxist commitments drive MacCabe's analysis: the Enlightenment subject contaminates the twentieth century's most prominent technology of vision, the cinema, with the myopia of individualism—a myopia well suited to market capitalism, and one that occludes other forms of human experience. Given its own overt self-awareness, *Shoeshine*'s treatise on vision enunciates a spectator that MacCabe's paradigm, with its interest in the *longue durée* of Enlightenment subjectivity, cannot accommodate. The film forwards the primacy of the visual as a means of endorsing specifically mid-twentieth-century aspirations for the subject: to open out the film spectator's purview, expand the parameters of that spectator's authority, certify film consumption as a universal means of experiencing the connectivity of human life, and reclaim cinema as the medium of globality. MacCabe, "Realism and the Cinema."

12. Pauline Kael, *For Keeps* (New York: Dutton, 1994), 16–17.

13. Bert Cardullo. "The Art of *Shoeshine,*" in *Vittorio De Sica: Contemporary Perspectives,* ed. Stephen Snyder and Howard Curle (Toronto: University of Toronto Press, 2000), 135. Also reprinted in the Criterion Collection's booklet of extras for the U.S. DVD.

14. Ibid., 134.

15. Idid., 133. Cardullo does mention other relations reflected in the shine of the G.I. shoes, including "Italian society find[ing] the image of its own disarray and

poverty." It is fascinating to consider how in this reading, Italians' sense of their own situation is mediated through the United States. Especially in the context of the final sentence, however, he emphasizes the American perspective.

16. Quoted in John Hess, "Neo-Realism and New Latin American Cinema: *Bicycle Thieves* and *Blood of the Condor*," in *Mediating Two Worlds: Cinematic Encounters in the Americas*, ed. John King, Ana M. López, and Manuel Alvarado (London: British Film Institute, 1993), 107.

17. Kristin Thompson, *Breaking the Glass Armor: Neoformalist Film Analysis* (Princeton, N.J.: Princeton University Press, 1988), 216.

18. Frank P. Tomasulo, *"Bicycle Thieves:* A Re-reading," *Cinema Journal* 21, no. 2 (1982): 2–13.

19. Marguerite R. Waller, "Decolonizing the Screen: From *Ladri di biciclette* to *Ladri di saponette*," in *Revisioning Italy: National Identity and Global Culture*, ed. Beverly Allen and Mary J. Russo (Minneapolis: University of Minnesota Press, 1997).

20. Carlo Celli, *"Ladri di biciclette/The Bicycle Thieves*," in *The Cinema of Italy*, ed. Giorgio Bertellini (London: Wallflower, 2004), 43–50.

21. Godfrey Cheshire, "A Passionate Commitment to the Real," in *On Bicycle Thieves*, DVD booklet (Irvington, N.Y.: Criterion Collection, 2007), 10.

22. Both Christopher Wagstaff and Geoffrey Nowell-Smith identify the visual narration of the film as unique for the ways it labors to achieve a distanciated observation. Wagstaff argues the film only makes sense in the viewer's adoption of an exteriority, a mode of "objective reflection" defined against what he sees as the spectatorial pleasurable catharsis that comes from watching suffering in other genres such as slapstick and melodrama. What interests Nowell-Smith about the film is less its message, which he sees as "vaguely humanist and at times almost sentimental in its stress on the sufferings of the poor," and more its means of holding "a certain distance from the characters." He describes the film's point of view as a "narrational stance [that] occupies a position both within the action and at a slight distance from it." Christopher Wagstaff, "Comic Positions," *Sight and Sound* 2, no. 7 (1992): 25; Geoffrey Nowell-Smith, "Bicycle Thieves: The Resilience of Neorealism," in Geiger and Rutsky, *Film Analysis*, 433–34.

23. Bazin, *What Is Cinema?*, 2:54.

24. Ibid., 2:59–60.

25. Ibid., 2:60.

26. Ibid., 2:59.

27. Ibid., 2:58.

28. Ibid., 2:60.

29. See Burnett's essay in the *Bicycle Thieves* DVD booklet.

30. Carlo Celli, "The Legacy of Mario Camerini in Vittorio De Sica's *The Bicycle Thief* (1948)," *Cinema Journal* 40, no. 4 (2001): 11.

31. For an exemplary reading of this film in relation to architectural politics and history, see Bruno Reichlin, "Figures of Neorealism in Italian Architecture (Part 2)," trans. Tony Shugaar and Branden W. Joseph, *Grey Room*, no. 6 (2002): 110–33.

32. For John David Rhodes, this film's exploration of urban redevelopment stands as a crucial precursor to Pasolini's use of landscape in *Mamma Roma*. Rhodes, *Stupendous, Miserable City*, 131–33.

33. Quoted in Cardullo, *Vittorio De Sica*, 68.

34. Howard Curle, "A Home in the Ditch of Saint Agnes: De Sica's *The Roof*," in Snyder and Curle, *Vittorio De Sica*, 211.

35. Quoted in ibid.

36. Ibid., 218, 17.

5. Neorealism Undone

1. Geoffrey Nowell-Smith writes: "With the passing of time Italian neorealism has become not only historically remote, but conceptually nebulous. That something existed—or happened—which at the time received the name neorealism, remains undoubted. But there is an increasing uncertainty (not to mention indifference) as to what that something was." "Cinema Nuovo and Neo-Realism," *Screen* no. 4 (Winter 1976–77), 111. Quoted in Rocchio, *Cinema of Anxiety*, 147.

2. Pierre Sorlin, *Italian National Cinema, 1896–1996* (New York: Routledge, 1996).

3. Here it is interesting to consider Pasolini's theorization of indirect point of view.

4. In his reading of *Accattone*, Rhodes calls this quality "a willful dilation of the 'tenets' of neorealism . . . exaggerating and deploying neorealist formal tendencies in an intentionally misunderstood (i.e., misappropriated) manner . . . [to] mount a devastating counterargument to neorealism." *Stupendous, Miserable City*, 61.

5. For more on Pasolini's definition of "physiognomic realism," see Maurizio Sanzio Viano, *A Certain Realism: Making Use of Passolini's Film Theory and Practice* (Berkeley: University of California Press, 1993), 268; Antonio Costa, "Pasolini's Semiological Heresy," in *Pier Paolo Pasolini*, ed. Paul Willemen (London: British Film Institute, 1977), 33.

6. Michele Mancini and Giuseppe Perrella, eds., *Pier Paolo Pasolini: Corpi e luoghi* (Rome: Theorema, 1981).

7. Viano, *Certain Realism*, 85.

8. Rhodes, *Stupendous, Miserable City*, 120.

9. Ibid., 131. Earlier Rhodes states that Pasolini "adopts the trappings of neorealism in order to push past what he believed were its sentimental progressive politics and into a realm in which the ideas of social mobility and personal or collective betterment are negated. Actors, events, locations—Pasolini has appropriated what we call the mise-en-scène of neorealism of De Sica while calling what he regards as the idealism and humanism (perhaps even sentimentality) of its politics into question" (59).

10. Ibid., 130.

11. Marcia Landy, *Italian Film* (New York: Cambridge University Press, 2000), 279.

12. Ibid., 282–83.

13. Rhodes, *Stupendous, Miserable City,* 124.

14. Viano, *Certain Realism,* 88. For another perspective on the relationship between neorealist aesthetics and Pasolini, see Sam Rohdie, "Neo-realism and Pasolini: The Desire for Reality," in *Pasolini Old and New: Surveys and Studies,* ed. Zygmunt G. Baranski (Dublin: Four Courts Press, 1999), 163–84.

15. Dyer elaborates a similar semiotics when he urges us to consider the politics of the gaze in Pasolini's more homoerotic images of young men. Dyer argues that these images carry with them an implicit looker who is older and of a higher class. As such, they contain a hierarchy with the spectator looking down on a subproletariat body; "what is stressed is inequality." Richard Dyer, "Pasolini and Homosexuality," in Willemen, *Pier Paolo Pasolini,* 56–63, 60.

16. Giuliana Bruno, "Heresies: The Body of Pasolini's Semiotics," *Cinema Journal* 30, no. 3 (1991): 37. Pasolini's invocation of the body in his own writings is important to consider in this discussion. See especially "Observations on the Sequence Shot," "The 'Cinema of Poetry,'" and "The Written Language of Reality," in Pier Paolo Pasolini, *Heretical Empiricism,* 2nd English ed., trans. Louise K. Barnett and Ben Lawton (Washington, D.C.: New Academia, 2005).

17. Quoted in Nathaniel Rich, "The Passion of Pasolini," *New York Review of Books* 54, no. 14 (2007): 78.

18. Bernhart Schwenk also connects the photographs of Pasolini's corpse to his film aesthetic: "As though Pasolini had known how the mass media would pick up this image, distribute it, and inject it into the collective visual memory of the public, he lay there—like a 'piece of garbage,' as the woman who found his body said . . . like the protagonist of Pasolini's very first film, who himself lay in the street dying." Pier Paolo Pasolini et al., *P.P.P., Pier Paolo Pasolini: Pier Paolo Pasolini and Death* (Ostfildern, Germany: Hatje Cantz, 2005), 48.

19. Michelangelo Antonioni et al., *The Architecture of Vision: Writings and Interviews on Cinema* (Chicago: University of Chicago Press, 2007), 38–39.

20. Torlasco identifies a principle concern for the postneorealist Italian films of the 1960s and 1970s in the renegotiation of the crime scene's conventional epistemologies: the past event, death, and witnessing. Examining the films *The Passenger, The Night Porter,* and *Oedipus Rex,* among others, Torlasco finds the emergence of "another mode of cinematic engagement," one whose revision of the terms of time and vision undoes the presumed impulses of police investigation and writes a different kind of spectator. In fairness, Torlasco posits *Ossessione* and neorealism proper as the sites where "the dissolution of the crime scene is inaugurated." She writes of Antonioni, "The return to the crime scene here coincides not with the discovery and ultimate possession of evidence, but with the performance of a double disappearance—the sliding away of image and spectator alike." Domietta Torlasco, *The Time of the Crime: Phenomenology, Psychoanalysis, Italian Film* (Stanford, Calif.: Stanford University Press, 2008), 8–10.

21. Christian Braad Thomsen, "Bellocchio" (interview), *Sight and Sound* 37, no. 1 (Winter 1967–68): 15.

22. Ibid., 14–15. It is worth noting that an epileptic seizure is often called a *crisi epilettica* in Italian. Thus, to the Italian ear, the word *crisi* connotes not only a political, social, or moral predicament, such as *crisi finanziaria* or *crisi d'identità*, but also a traumatically somatic episode.

23. Fredric Jameson, "The Existence of Italy," in *Signatures of the Visible* (New York: Routledge, 1992), 158.

Conclusion

1. For an alternative, and perhaps more generous, reading of *Silverlake Life,* see Roger Hallas, *Reframing Bodies: AIDS, Bearing Witness, and the Queer Moving Image* (Durham, N.C.: Duke University Press, 2009).

2. Two recent studies of films from this period provide an interesting corollary to my argument about the political necessity of visual witnessing: Lisa Cartwright, *Moral Spectatorship: Technologies of Voice and Affect in Postwar Representations of the Child* (Durham, N.C.: Duke University Press, 2008), and Cindy Patton, *Cinematic Identity: Anatomy of a Problem Film* (Minneapolis: University of Minnesota Press, 2007).

3. It is important to see the *giallo* as part of a larger landscape of overlapping transatlantic exchanges and cycles of the crime genre that includes dime store fiction, the *poliziesco,* the hard-boiled detective novel, and film noir. The most famous of these exchanges happened when *Ossessione* was made before *The Postman Always Rings Twice,* both of which adapted James M. Cain's novel. Of course, the history of neorealism is not unrelated to these genres, with *Ossessione* widely regarded as one of neorealism's most important progenitors. In fact, the term *neorealismo nero* describes films like *The Bandit (Il bandito)* and *Bitter Rice (Riso Amaro),* which bring a noiresque narrative feel to the neorealist milieu. For more on the relationship between noir and neorealism, see Fay and Nieland, *Film Noir.*

4. Steimatsky, *Italian Locations,* 167

5. Eric J. Sundquist, "Witness without End?," *American Literary History* 19, no. 1 (2007): 67.

6. Ibid., 4.

7. Ibid., 3.

8. Ibid., 5.

9. Ibid., 4.

10. Michael Chanan, *The Cuban Image: Cinema and Cultural Politics in Cuba* (London: British Film Institute, 1985), 82.

11. Julio García Espinosa, "Meditations on Imperfect Cinema . . . Fifteen Years Later," in *New Latin American Cinema,* ed. Michael T. Martin (Detroit, Mich.: Wayne State University Press, 1997), 84.

12. Julio García Espinosa, "For an Imperfect Cinema," in *New Latin American Cinema,* ed. Michael T. Martin (Detroit, Mich.: Wayne State University Press, 1997), 1:80.

13. Fredric Jameson, "The End of Temporality," *Critical Inquiry* 29, no. 4 (Summer 2003): 713.

14. For more on the aesthetic and philosophical legacies of neorealism in African and third cinemas, see Willemen, *Looks and Frictions,* and Rachel Gabara, "'A Poetics of Refusals': Neorealism from Italy to Africa," *Quarterly Review of Film and Video* 23, no. 3 (2006): 201–15.

INDEX

Page references in italics refer to illustrations

KARL SCHOONOVER is assistant professor of film studies at Michigan State University. He is the coeditor of *Global Art Cinema: New Theories and Histories.*